Marie-Antoinette

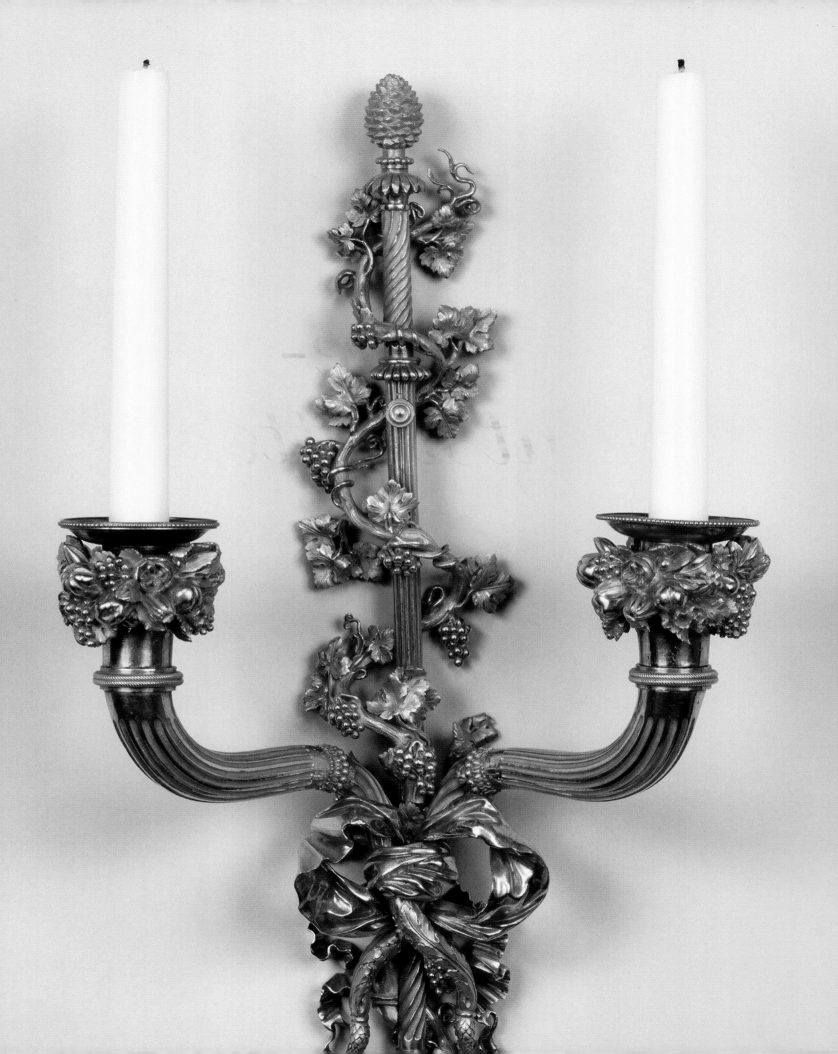

Marie-Antoinette

Hélène Delalex

Alexandre Maral

Nicolas Milovanovic

J. PAUL GETTY MUSEUM · LOS ANGELES

Contents

Preface 6

Foreword 7

At the Viennese Court 9

The Dauphine 18

The Queen 52

Mother and Lover 148

Torment 176

A Tragic End 199

Bibliography 210

Illustration Credits 211

Preface

Marie-Antoinette's death on the scaffold gave her life meaning and stature. She was the last French queen. And, perhaps because of that, in the eyes of the world she remains "the" queen, a figure who captures the imagination and fills the dreams of people far beyond the borders of France. From Japan to the United States, passions are still kindled by the legend of a monarch who, overwhelmed at first by a role that was beyond her, fulfilled it with strength and dignity during her tragic downfall. The image of a woman who tried to bring a breath of freedom into the stifling formality of the Versailles court also has an enduring appeal. In 2006, Sofia Coppola's film turned her into a star, after Stefan Zweig's famous biography had portrayed her as a romantic heroine. The media scrutinized her life in much the same way as that of Princess Diana. Though her portrayal constantly changes with new historical research, Marie-Antoinette's story is also full of anachronisms. She exerts the same kind of fascination over us today as she did over her contemporaries, a fascination with a life that was turned into a paradox by its tragic end.

In a short life of thirty-seven years, she went from the throne to the scaffold, showered with adulation at first and then treated with abject cruelty, until in the end her exemplary dignity earned her respect. The authors of this book, Hélène Delalex, Alexandre Maral, and Nicolas Milovanovic, know the Château of Versailles intimately and are therefore well placed to present the story of Marie-Antoinette in its historical context. A new and illuminating biography, this book is also a catalogue of all the artworks and objects through which we learn the details of her life, in Versailles, the Petit Trianon, and the Hameau. Even in the smallest of its everyday events, her private life elucidates her story and gives it color and nuance. We follow the authors in the footsteps of Marie-Antoinette, a young woman who experiences her triumphant journey to France "like a dream." As a fifteen-year-old, the dauphine wins the hearts of the court. Yet her mother, Maria Theresa of Austria, constantly warns her against too much lightheartedness, too much frivolity. At eighteen, she becomes queen of France, the center of a world whose rules and rituals she finds oppressive. She does not openly challenge the rigid etiquette of the court but interprets it in her own way, insisting on her right to choose where and with whom to spend her time. Even when she retreats from the Château of Versailles, she is still the center of attention. We follow her to the Petit Trianon. She is a queen and a woman. More woman than queen? And then, at last, she becomes a mother. We witness her daily life with her children, the dauphin and the dauphine. Now she is queen and mother. More mother than queen? The world around her is collapsing. She becomes the focus of public hatred, the target of venomous lampoons and caricatures. She does not want to see them.

On October 5, 1789, Marie-Antoinette is at the Petit Trianon when she learns that the forces of the Revolution are marching on Versailles. On this day her life is turned upside down. She returns to the palace to join the king. She does not flee, she does not shirk her duty. Thus begins her longest journey.

A pen-and-ink sketch records her final moments . . . Sometimes pictures say more than words. In this book, they lend a startling immediacy and intimacy to the text. The authors do not judge, but rather tell a story. As it progresses, seemingly trivial details reveal their significance and take on a more and more tragic dimension. Brilliantly told, this story will captivate its readers.

Catherine Pégard
President of the Public Establishment of the
Château, Museum, and Public Estate of Versailles

Foreword

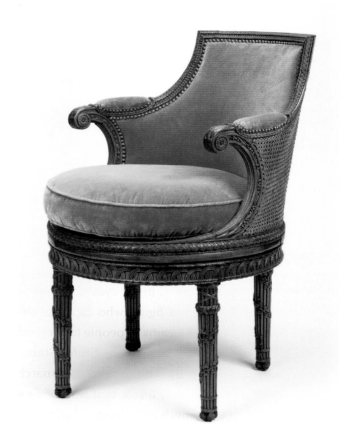

Swivel chair commissioned for Marie-Antoinette's bedchamber at the Petit Trianon.

As a patron of the decorative arts, Marie-Antoinette personified the elegant extravagance of the *ancien régime*. A serious connoisseur, she was the only French queen to have her own collection, the Garde Meuble de la Reine, and she spared no expense. Jeweled Sèvres porcelain, inlaid and gilded furniture, Japanese lacquer: her material legacy is a trove of exquisite objects representing the sophistication of eighteenth-century Parisian artistic culture at its very best.

Marie-Antoinette's possessions, along with all of the art and furnishings of the royal palaces, were seized by the debt-ridden revolutionary government after the fall of the monarchy in 1792. Some of the works of art, furniture, and porcelain were kept for the nation, and some were sold at auction to French and foreign buyers, many eventually making their way into collections around the globe.

The J. Paul Getty Museum's collection of French decorative arts is one of the finest in the world. It includes several rare items once owned by Marie-Antoinette, each of which provides a glimpse into the life of a fascinating and complex historical figure.

An unusual chair (above) was part of a suite ordered for Marie-Antoinette's bedchamber at the Petit Trianon. Made in the Neoclassical style, which was by then replacing the more ornate Rococo, its ingenious design contains a swiveling mechanism that allowed the queen to turn gently as her hair was being styled and powdered.

Four giltwood side chairs were used by the queen to entertain guests in an octagonal garden pavilion known as the Belvedere. She received her brother the Holy Roman Emperor Joseph II there, as well as the future Czar Paul I of Russia and his wife.

A set of four wall lights, modeled by the Parisian bronzer Claude-Jean Pitoin, illuminated the Cabinet de la Méridienne, a small private room at the Château of Versailles where the queen rested in the afternoons. They were gilded through a process combining gold with volatized mercury, which intensified dramatically the sparkle of the candles.

The J. Paul Getty Museum and the Château of Versailles enjoy a longstanding relationship that includes a history of reciprocal loans, a joint exhibition, and other professional collaboration. We are delighted to continue this association with the publication of the English edition of *Marie-Antoinette*.

Timothy Potts
Director, J. Paul Getty Museum

7

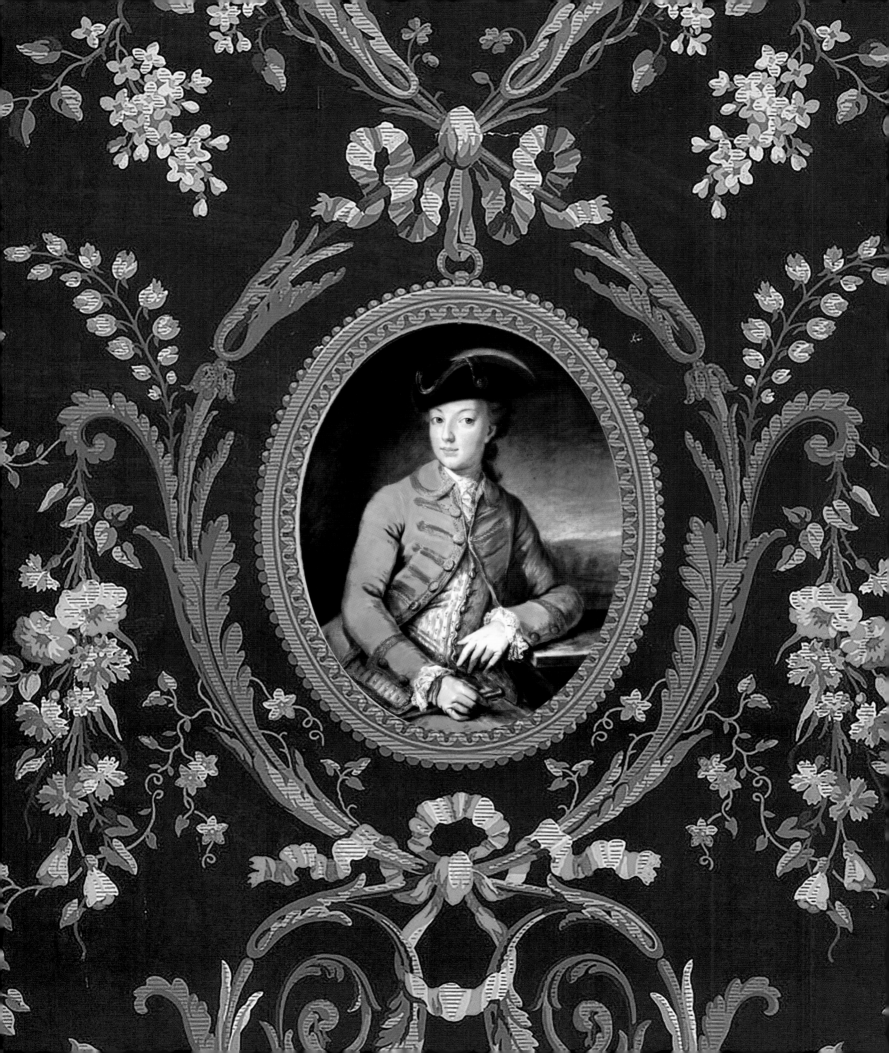

At the Viennese Court

During her first fourteen years, Marie-Antoinette led a happy and carefree life. Her indulgent tutors placed few demands on the child, leaving her plenty of time to enjoy the numerous distractions offered by the Viennese court. But from her birth, on November 2, 1755, the "Diplomatic Revolution" brought about by Austria and France had destined her to be the French queen.

A Diplomatic Earthquake

Marie-Antoinette was the fifteenth child of Emperor Francis Stephen of Lorraine and Maria Theresa of Habsburg. Her godfather and godmother were the king and queen of Portugal, which had just been hit by an earthquake on November 1, 1755. This catastrophe, which had almost entirely destroyed the capital city of Lisbon and killed 60,000 people in a single day, would be seen as a fateful omen.

Maria Theresa was a powerful woman, who in 1740 became archduchess and the first female ruler of the hereditary Habsburg dominions; in 1745, she secured the election of her husband as emperor. To consoli-

date Austria's position in Europe, she now had to develop a matrimonial strategy for her numerous children.

Maria Theresa had been seeking an alliance with France since 1755, and in 1756 she received a favorable response from Louis XV. Deceived by Frederick II of Prussia, who had concluded a treaty with Britain without informing his French ally, Louis admired Maria Theresa's courage and character. Above all, he was concerned about maintaining the balance of power in Europe. By putting an end to an ancient enmity, the alliance with Austria would also help to boost French influence in Central Europe. The reversal of longstanding alliances in Europe after the First Treaty of Versailles (May 1, 1756) was badly received by the French public, who still regarded Austria with deep hostility. It was also one of the principal causes of the disastrous Seven Years' War (1756–63), in which Austria and France fought against Prussia and Great Britain.

To strengthen the Austrian alliance, rendered fragile by the outcome of the Seven Years' War, the duc de Choiseul, foreign secretary of Louis XV, supported the idea of an Austrian marriage. He met opposition from the dauphin, the son of Louis XV, and his wife, Maria Josepha of Saxony, the future parents of Louis XVI.

Their deaths, in 1765 and 1767 respectively, enabled Choiseul to convince the king to conclude the matter, and in July 1769, the official marriage proposal was taken to Vienna. Marie-Antoinette was just thirteen years old.

Facing page:
This portrait from 1771 by Joseph Kranzinger shows Marie-Antoinette at a time when she was married but not yet queen of France. Her noble features and rather proud pose are striking. As a young woman, Marie-Antoinette often went hunting, which explains her attire.

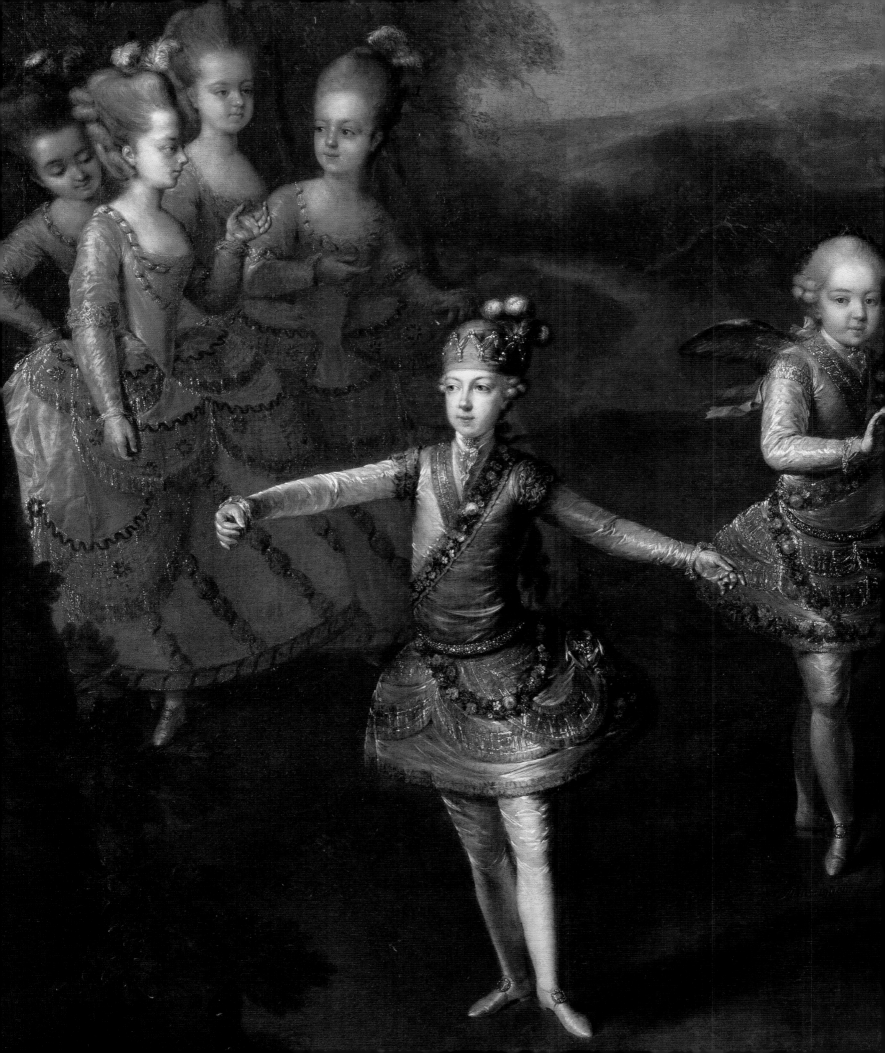

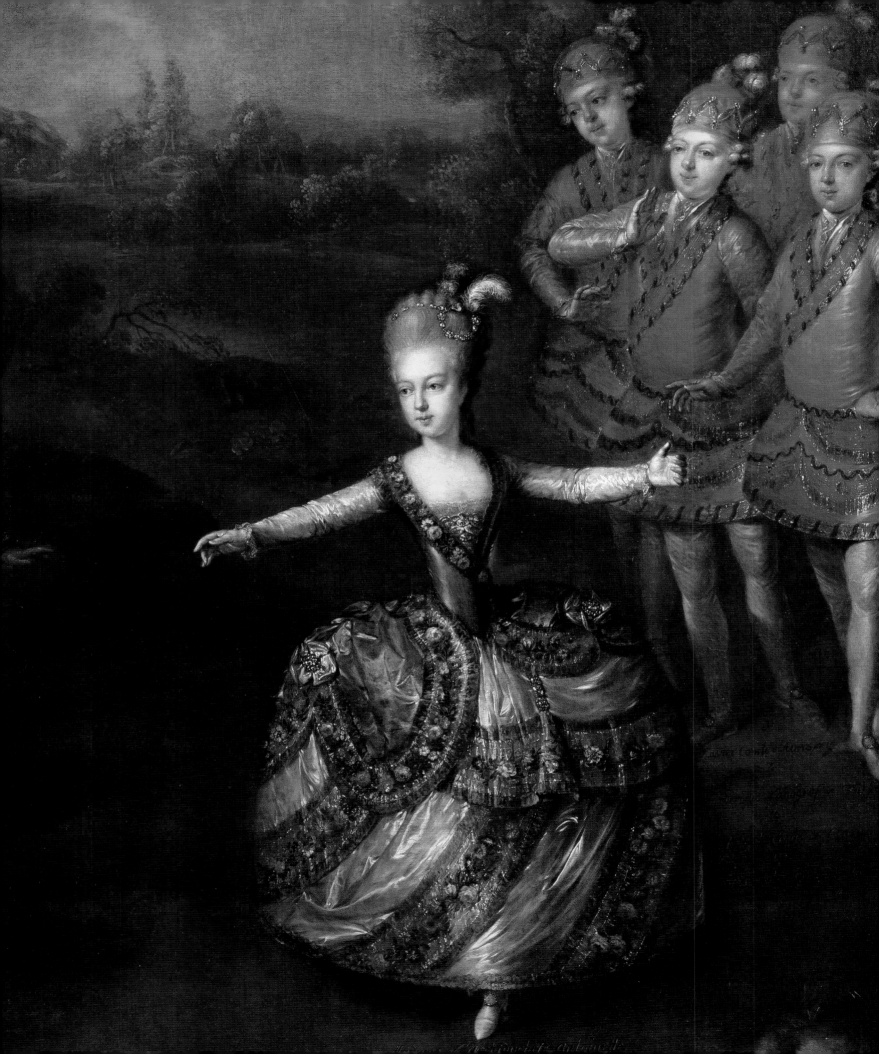

The Pleasures of Vienna

Marie-Antoinette's childhood was a happy one. At both the Hofburg in Vienna and the nearby Schönbrunn Palace, the empress's many children enjoyed considerable freedom. Life at court was far from rigidly formal, and there were plenty of games and amusements.

To entertain her offspring, Maria Theresa invited the young Wolfgang Amadeus Mozart to Schönbrunn in 1762. Born in 1756, the child prodigy was only three months younger than Marie-Antoinette and, according to an apocryphal story, expressed his wish to marry the young archduchess.

Until 1769, Marie-Antoinette received an education that was relatively free of constraints and which aimed above all to foster a strong and independent character. The instruction that she received under the supervision of her affectionate governess, the Countess von Brandeis, concentrated on imparting religious and moral principles and teaching her to read and write and to play the harpsichord and the pianoforte. Marie-Antoinette was very close to her mother, especially after the death of the emperor in 1765, and enjoyed considerable freedom thanks to the etiquette of the Viennese court, which was exceptionally informal.

One of the first known portraits of Marie-Antoinette dates from 1765: it is a canvas attributed to Johann Georg Weikert, commemorating the ballet *Il Trionfo dell'Amore* (The Triumph of Love), danced by the archduchess and her brothers and sisters in 1765 at Schönbrunn. The imperial family divided their time between this residence on the outskirts of Vienna and the ancestral palace of the Hofburg in the heart of the old city.

In 1769, French pastelist Joseph Ducreux painted another portrait of Marie-Antoinette, one that perfectly renders the beauty and the charm of the girl, her blond hair and blue eyes, the oval face and high forehead. It was this portrait that was dispatched to France to show the court the features of the future queen.

The Education of a Queen

Maria Theresa was now keen to complete the education of her daughter to prepare her for her role as French queen. Therefore, apart from Countess Lerchenfeld, who was charged with helping the girl to catch up rapidly with the gaps that she had in various disciplines, the celebrated French ballet master Jean-Georges Noverre was also called to Vienna to give the young archduchess lessons in deportment, while a French hairdresser and dentist were brought in to make her face more beautiful.

And, on the recommendation of Choiseul, the abbé de Vermond, doctor of the Sorbonne and librarian of the College of the Four Nations, was employed to teach Marie-Antoinette the subtleties of the French language. He noted his impressions about his pupil: "I am certain that our court and the French nation will be delighted with our future dauphine. She has a charming face and a most attractive character and, once she matures a little more, as we have every reason to hope, she will possess all the desirable attributes of

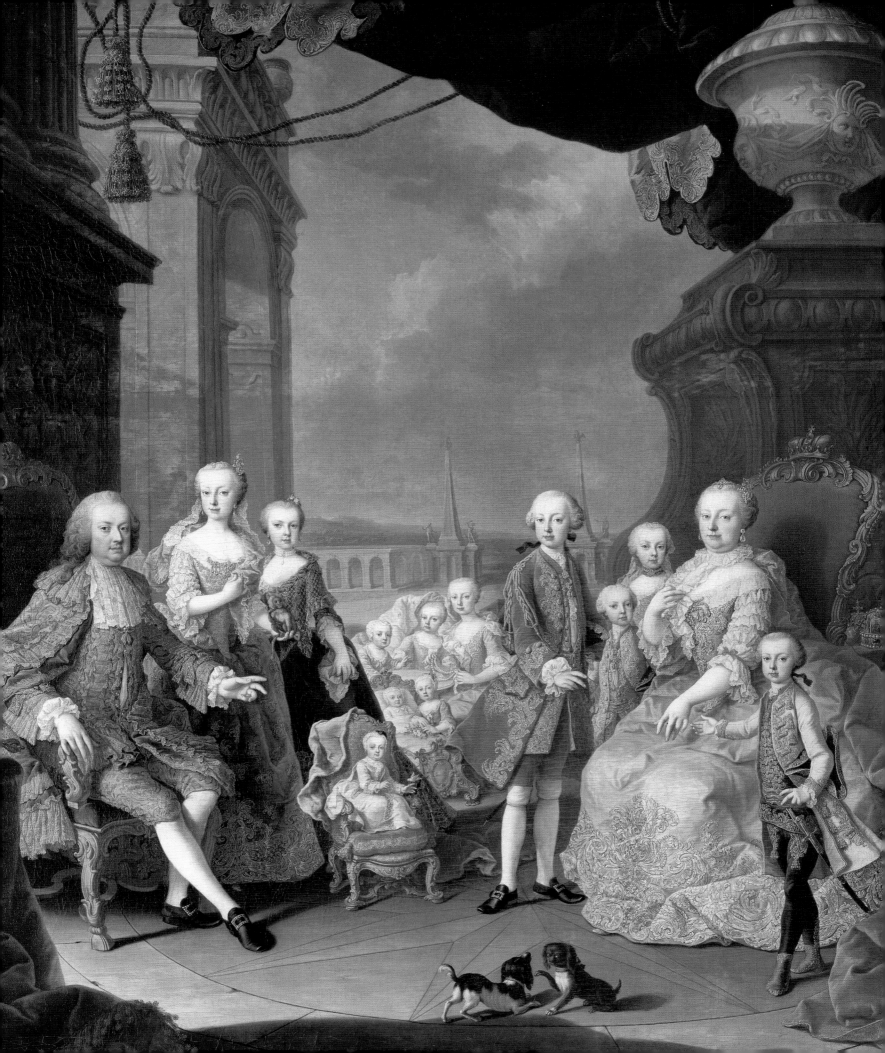

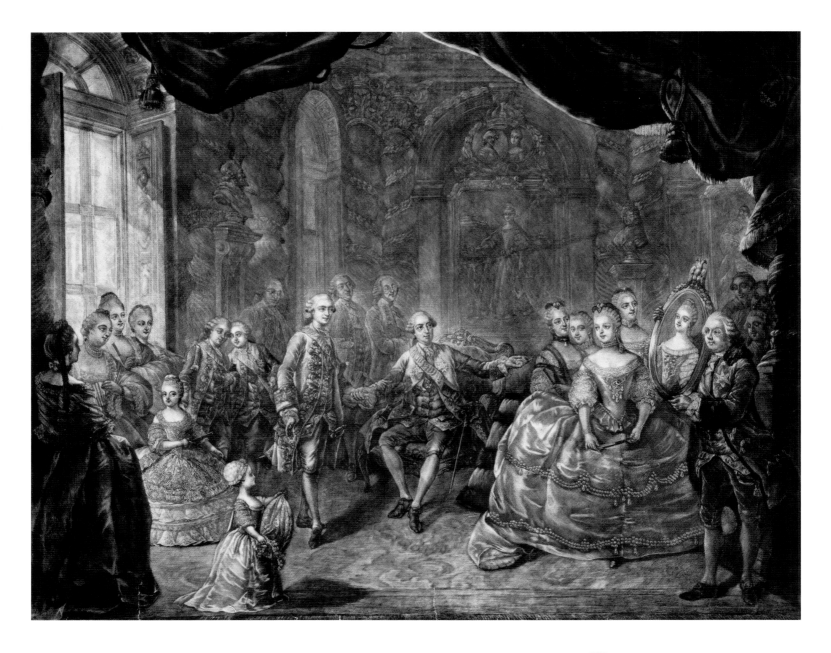

Above:
Louis XV Presenting the Portrait of Marie-Antoinette to the Dauphin by Jean-Baptiste André Gautier-Dagoty. The future Louis XVI, standing on the left, is shown a portrait of his wife-to-be. The audience includes the daughters of Louis XV and the dauphin's brothers and sisters, the comte de Provence and comte d'Artois and Mesdames Clotilde and Élisabeth.

Right:
Louis XVI as Dauphin, after L. M. van Loo, ca. 1769–70, by Peter Adolphe Hall, after Louis Michel van Loo.

Facing page:
Marie-Antoinette, Dauphine of France, painted around 1770 by Joseph Ducreux.

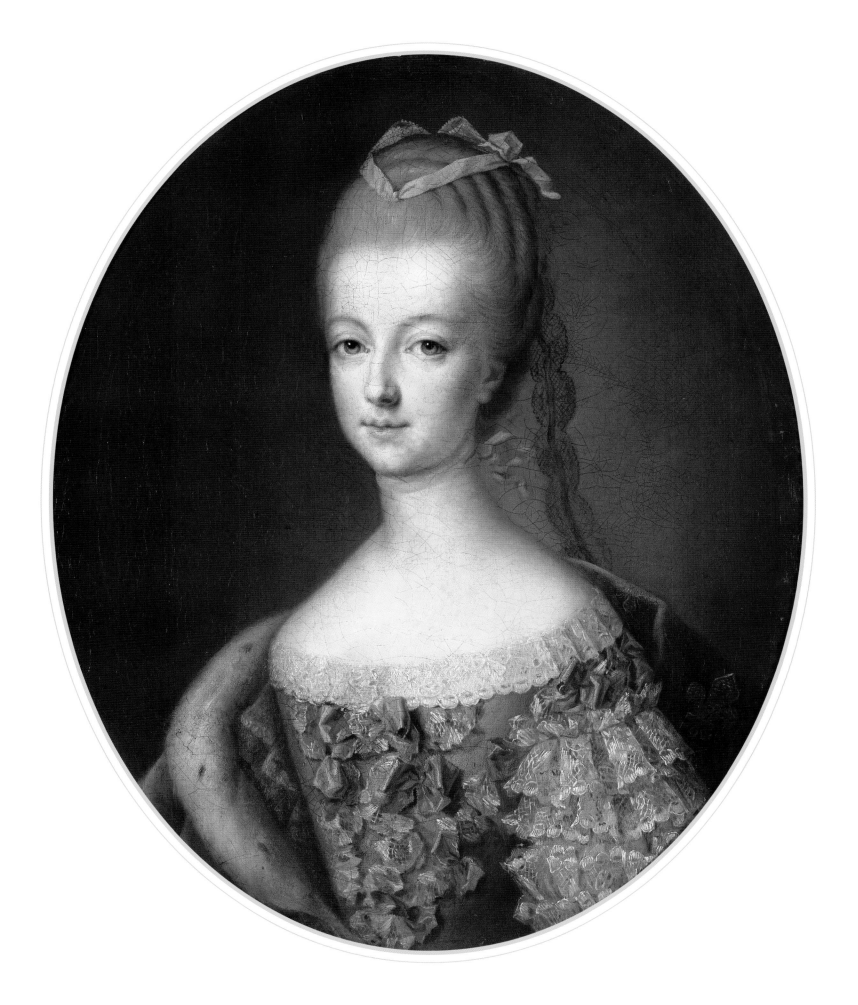

a princess of the highest rank. Her character and her heart are quite admirable. All that she needs is to acquire more confidence and freedom in her speech for her to share her mother's excellent gift of always saying the most pleasant and agreeable things."

Vermond nevertheless recognized that his lessons faced serious obstacles: "She possesses greater intelligence than was believed for a long time. Yet sadly no one had put this intelligence to the test before she was twelve. A degree of laziness and considerable levity on her part have made my instruction difficult. I began by devoting six weeks to the principles of literature. She understood well when I explained ideas very clearly. Her judgment was almost always correct, but I could not persuade her to examine any matter thoroughly, though I sensed that she could do so. I found that one could only lead her to apply her mind to anything by amusing her."

Marie-Antoinette clearly did not lack intelligence but she must have been a difficult and wayward pupil for the abbé de Vermond, who had perhaps been called in too late. Although she made remarkable progress in speaking French and in the art of conversation, she remained attached to the world of her childhood and seemed incapable of facing up to the challenges of her new situation.

Maria Theresa: Confidante and Counselor

As Marie-Antoinette's departure for France drew nearer, her mother took a direct hand in her education, with a series of relatively informal private conversations. She went so far as to give her daughter a bed in her own room so that she could give her instruction whenever she had time, thus deepening the bond between mother and daughter. As Simone Bertière points out in her biography of Marie-Antoinette, the nature of these discussions is probably well summarized in the letter from Maria Theresa that Marie-Antoinette received on her arrival in Versailles:

Madame my dear daughter,
So there you are—where Providence has settled you must live. If one is to consider only the greatness of your position, you are the happiest of your sisters and all princesses. You will find a loving father who will also be your friend if you deserve it. You may trust him completely; you will risk nothing. Love him, obey him, try to guess his thoughts; you cannot do too much of this at the time I must lose you. This same father and friend is the one who consoles me, lifts my deep sadness, is my only consolation, hoping that you will heed my counsel to devote yourself to him, and follow all his orders and instructions. As to the Dauphin, I say nothing; you know how touchy I am on that point; the wife must be completely submissive to her husband and must have no business other than to please him and obey

him. The only true happiness in this world is a happy marriage: I can say so freely. All depends on the wife, on her being willing, sweet, and amusing.[1]

On April 16, 1770, at the Hofburg, the marquis de Durfort, French ambassador in Vienna, transmitted to Empress Maria Theresa the official marriage proposal, accompanied by a medallion containing the portrait of the future king, which was hung around Marie-Antoinette's neck. The next day, the archduchess swore on the Bible that she would renounce her rights to the Austrian hereditary territories. On April 19, 1770, in the Church of the Augustine Friars in Vienna, in the parish of the court, Marie-Antoinette married the French dauphin Louis Auguste, duc de Berry. The marriage was celebrated as a proxy wedding, with Archduke Ferdinand, one of Marie-Antoinette's brothers, taking the place of Louis. Born on August 23,

1754, Louis was then fifteen years old, one year older than Marie-Antoinette.

At the moment of her departure, Marie-Antoinette's tearful mother gave her a letter to take to Louis XV:

Monsieur, my brother, it is my daughter, or rather Your Majesty's daughter, who will have the pleasure of bringing you this letter. As I lose a child so dear to me, my only consolation is to hand her into the charge of the best and kindest of fathers. I beg Your Majesty to guide and command her. She is full of goodwill, but given her tender age I beg your indulgence should she ever be careless or foolish. Her greatest wish is to merit Your Majesty's kindness in all she does. I commend her to Your Majesty once more as the dearest pledge of the bond that exists so happily between our Estates and Houses.

The Dauphine

The festivities organized at the Château of Versailles to welcome Marie-Antoinette and celebrate her marriage to the dauphin, the future Louis XVI, were beyond description. The four years Marie-Antoinette spent at the French court before being crowned queen gave her plenty of opportunities to display her true character, which was headstrong and uncompromising. From Vienna, her mother attempted to reason with her, sending her lengthy instructions on how she should behave.

Marie-Antoinette, Archduchess of Austria.
This superb pastel by Joseph Ducreux, painted in Vienna in 1769 and then sent to France, was the portrait that allowed the French court to see Marie-Antoinette's face for the first time.

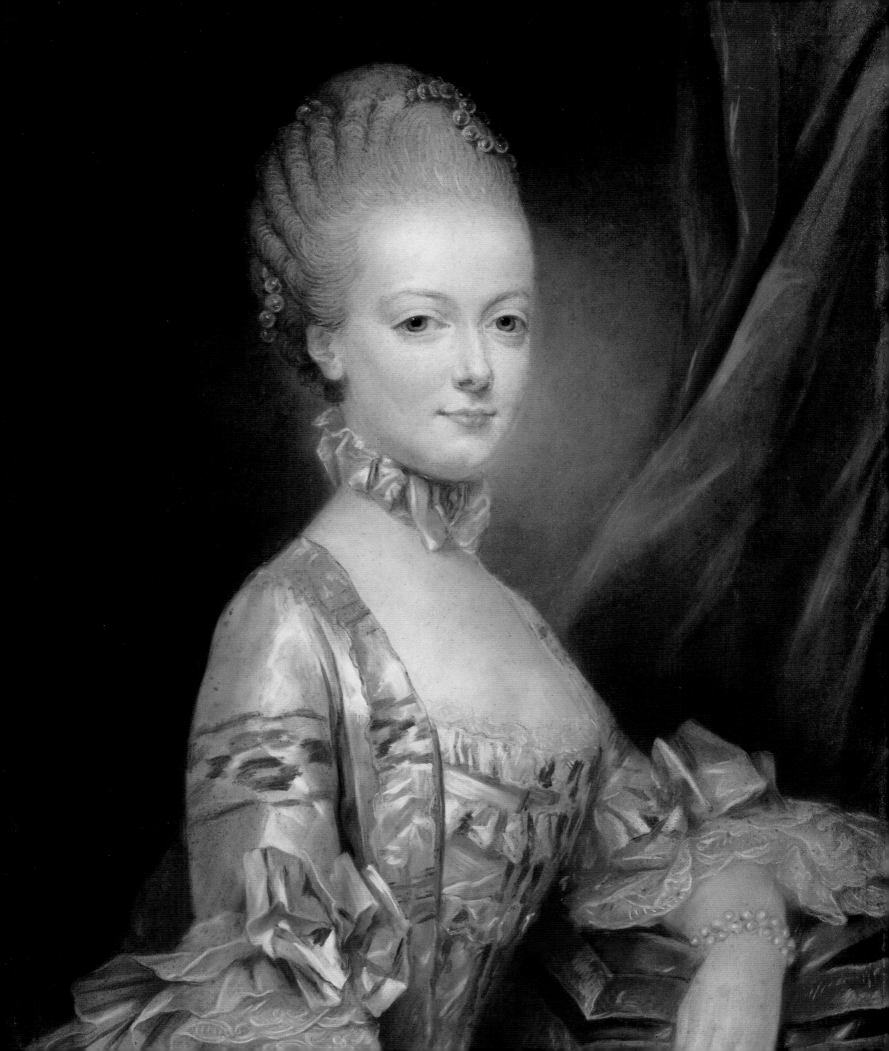

From Vienna to Versailles

Marie-Antoinette left Vienna on April 21, 1770. She took with her the *Rules to be read every month*, a list of obligations prepared by her mother that emphasized the importance of daily prayer and examination of conscience, attending Mass and reading spiritual texts. Maria Theresa also gave her *Particular instructions*, a manual of practical advice such as, "do not take any recommendation," "listen to no one," "do not be curious," "answer everyone with grace and dignity."

The new dauphine arrived in Strasbourg on May 7. Her formal move to her adoptive country was celebrated on the Île aux Épis, an island in the middle of the Rhine. A large wooden pavilion was erected containing a room where the handover of the archduchess to France would take place. Marie-Antoinette sat on a chair that had two legs on the French side and two on the other side of the border. The writer Johann Wolfgang von Goethe, who was a student in Strasbourg at the time, was surprised to see tapestries illustrating the myth of Medea on the walls of the pavilion. The sinister spectacle of a mother who kills her own children seemed to him a bad omen.

Marie-Antoinette was deeply distressed at the idea that she might never see her mother or homeland again. Nonetheless she had the presence of mind to express her commitment to her new status as future queen of France: "Do not speak to me in German, monsieur, from now on I want to hear no other language but French." With this she interrupted the first words that were addressed to her after she had crossed the Rhine. Respecting the tradition observed by foreign princesses who married a French king or future king, Marie-Antoinette bade farewell to her Austrian attendants and henceforth would dress as a French woman.

Having traveled through Lorraine, on May 14 the cortège arrived in Compiègne, where the dauphine met her husband and his grandfather Louis XV. On May 16, without going via Paris, the young couple made their entry into the Château of Versailles. Two adjoining apartments on the first floor of the château had been prepared for the dauphin and his wife as a temporary measure until the building work on the queen's quarters on the second floor was completed.

Above:
Gold-mounted morocco leather casket with the coat of arms of Marie-Antoinette, dauphine of France.

Facing page:
Colored engraving depicting the arrival of the archduchess Marie-Antoinette at the Château of Versailles in a carriage on May 16, 1770.

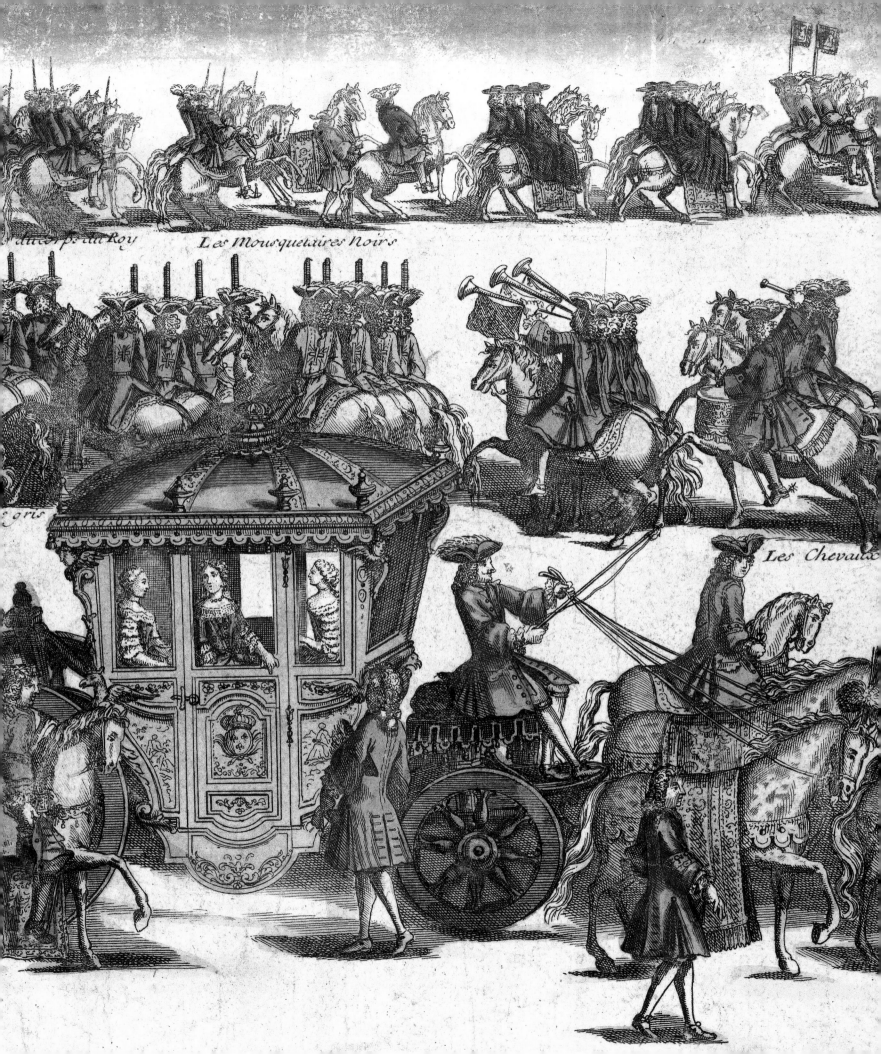

du corps du Roy Les Mousquetaires Noirs

gris

Les Chevaux

A Princely Wedding

Only hours after their arrival at the Château of Versailles, the newlyweds were conducted to the royal chapel for a magnificent ceremony. Strictly speaking, this was not a wedding since the pair had already been married by proxy in Vienna, but rather a service of nuptial blessing, during which the parish priest of Notre-Dame de Versailles presented the marriage contract, which had to be signed and then lodged with the parish registry. So nervous was Marie-Antoinette that she left a large inkblot on the document as she signed her name.

As was the custom at princely weddings, on leaving the chapel the young couple made their way to the Great Hall, also known as the Hall of Mirrors, where a large audience watched Louis XV and his entourage engaged in a ceremonial gaming session known as *le jeu du roi,* or king's game.

On the evening of May 16, the wedding banquet was held at the palace's new, recently completed Royal Opera. Built in less than two years by the architect Ange-Jacques Gabriel and the theater machinist Blaise-Henri Arnoult, the theater was intended to host some of the wedding festivities. It was a versatile space suitable not only for theatrical performances but also other events, such as balls and banquets. Thanks to a system enabling the stalls to be raised to the same level as the stage, the theater could be transformed into one large oval space with room enough to accommodate the vast regal table, with the musicians on the stage while courtiers admitted to the ceremony could stand and watch from the boxes.

The next day, May 17, saw a performance of Jean-Baptiste Lully's *Persée* (Perseus), a *tragédie lyrique* with a libretto by Philippe Quinault. A tradition handed down from Louis XIV dictated that the work chosen should be from the French repertoire. Then, on May 19, the room became a ballroom for a third great wedding celebration, a grand ball. Couple after couple took to the floor in a carefully established order of precedence, while the king and his courtiers looked on. The night of May 19 was lit up by a spectacular fireworks display in the palace gardens. While large crowds outside the gardens pushed and shoved to see the show, the royal family watched in comfort from the windows of the Hall of Mirrors.

Above:
Entry token allowing the royal staff access to the Royal Opera of Versailles on the day of the marriage festivities, May 16, 1770.

Facing page:
On the morning of May 16, 1770, the nuptial blessing was celebrated in the royal chapel at Versailles.

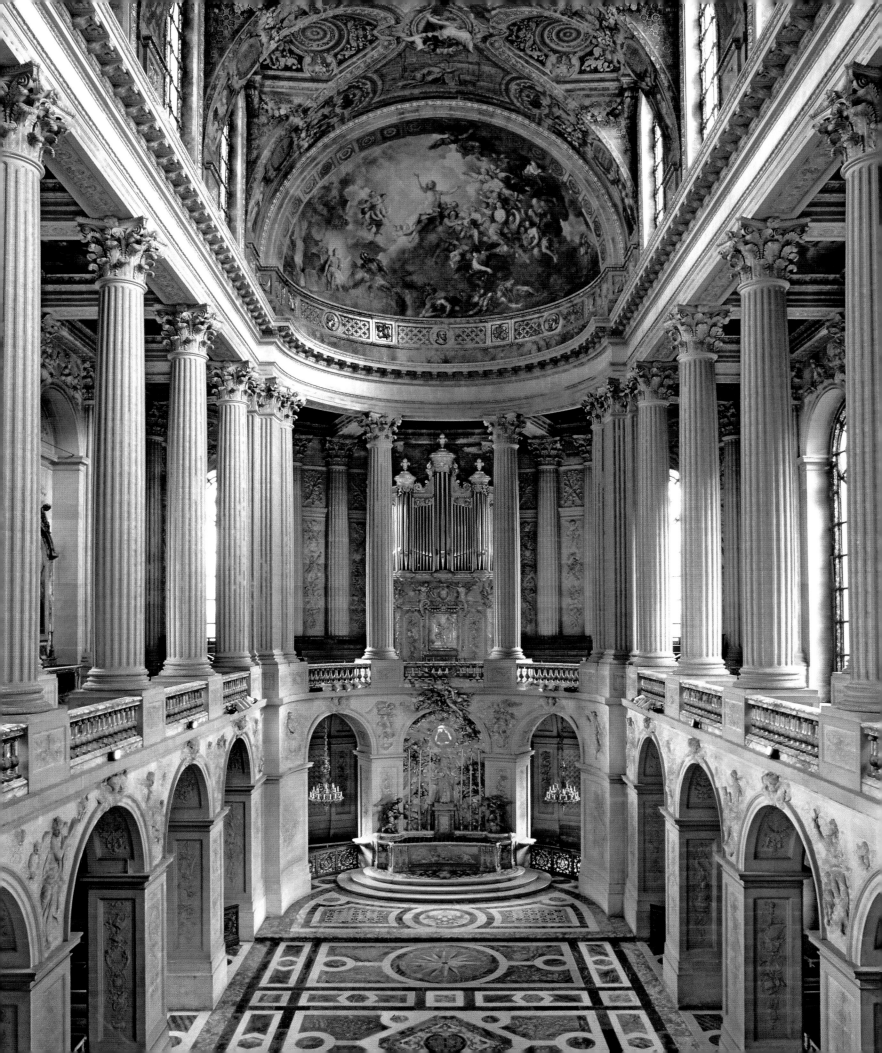

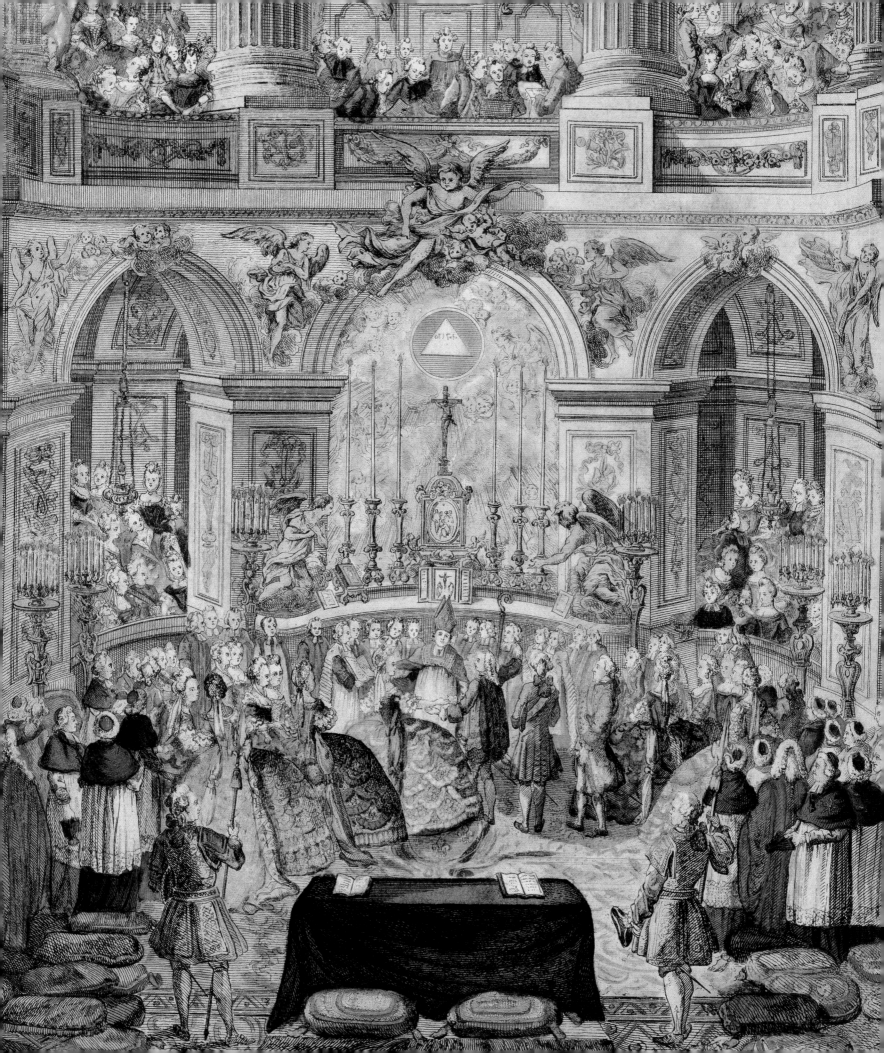

Celebrations of the marriage continued until July 14, 1770, with a masked ball in the Hercules Salon, while the Royal Opera staged a succession of works. *Persée* was given a repeat performance, followed by Jean-Philippe Rameau's *Castor et Pollux*—also a second showing—and two plays by Voltaire, *Tancrède* and *Sémiramis*. There were also productions of works by lesser-known authors, which included Philippe Poisson's comedy *L'Impromptu de campagne* (A Rural Impromptu) and *La Tour enchantée* (The Enchanted Tower) a blend of dance and song, known as *ballet figuré*, with libretto by Nicolas-René Joliveau and music by Antoine Dauvergne, featuring a cast of nearly a thousand.

The wedding cost more than two million livres—a considerable amount at a time when the state finances were already seriously strained. Louis XV's prime concern was to show the world that his kingdom continued to prosper despite its recent defeat in the Seven Years' War. He was also keen to promote the alliance between France and Austria, even though the French people were far from unanimous in their approval of the direction the nation's diplomacy was taking.

Public celebrations had also been organized in Paris. But on May 20 during a huge fireworks display on Place Louis XV—now Place de la Concorde—disaster struck. Panic broke out in the crowd, possibly because a stray spark had started a fire, and more than a hundred people were killed in the ensuing stampede. Marie-Antoinette, still in her coach, was forced to turn back. Such was her first encounter with the people of Paris.

Facing page:
Engraving depicting the renewal of marriage vows in the presence of the Grand Almoner of France, Monseigneur de La Roche-Aymon.

THE ROYAL TABLE

Since the reign of Louis XIV, dinner and supper had become high points in the court's daily rituals. At one o'clock the king would take his dinner *au petit couvert,* in other words, alone. In the evening, suppers *au grand couvert* were a public and more splendid affair, with the monarch and royal family feasting amid great pomp and ceremony. These meals were meticulously choreographed, with a procession of *officiers de la Bouche du roi* (the king's personal cooks) spreading the table with the finest delicacies. These arrived in five stages, or *services,* closely supervised by the *Premier maître d'hôtel,* the master of the royal household. While Louis XIV followed this daily ritual, Louis XVI and Marie-Antoinette preferred more private suppers, limiting the wearisome business of eating in public to Sundays and holidays. As the ancien régime neared its end, one of the most memorable aspects of life at court was the sumptuous royal table, with its exquisite gold, silver, and porcelain tableware, such as the Sèvres dinner service, with its richly colored and gilded border, made for Marie-Antoinette, the most expensive order ever fulfilled by the Royal Porcelain Manufactory.

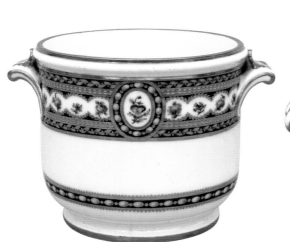

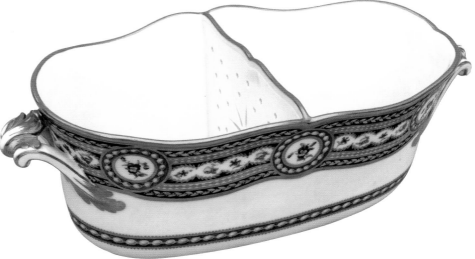

Above:
Wineglass cooler and double bottle cooler from the dinner service with a richly colored and gilded border delivered to the Château of Versailles in 1784. The service, which included more than three hundred pieces, bears the queen's favorite decorative pattern of pearls and flowers.

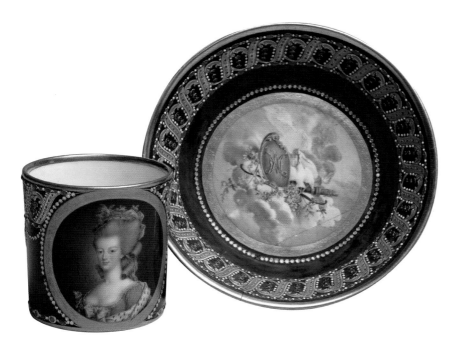

Left:
Cup and saucer with a portrait of Marie-Antoinette made by the Royal Porcelain Manufactory in Sèvres in 1782.

Facing page:
Drawing by Jean-Michel Moreau le Jeune depicting the wedding banquet for the dauphin and Marie-Antoinette in the Royal Opera of Versailles on May 16, 1770.

Following double page:
Foyer of the Royal Opera of Versailles and details of the painted decorations on the royal box.

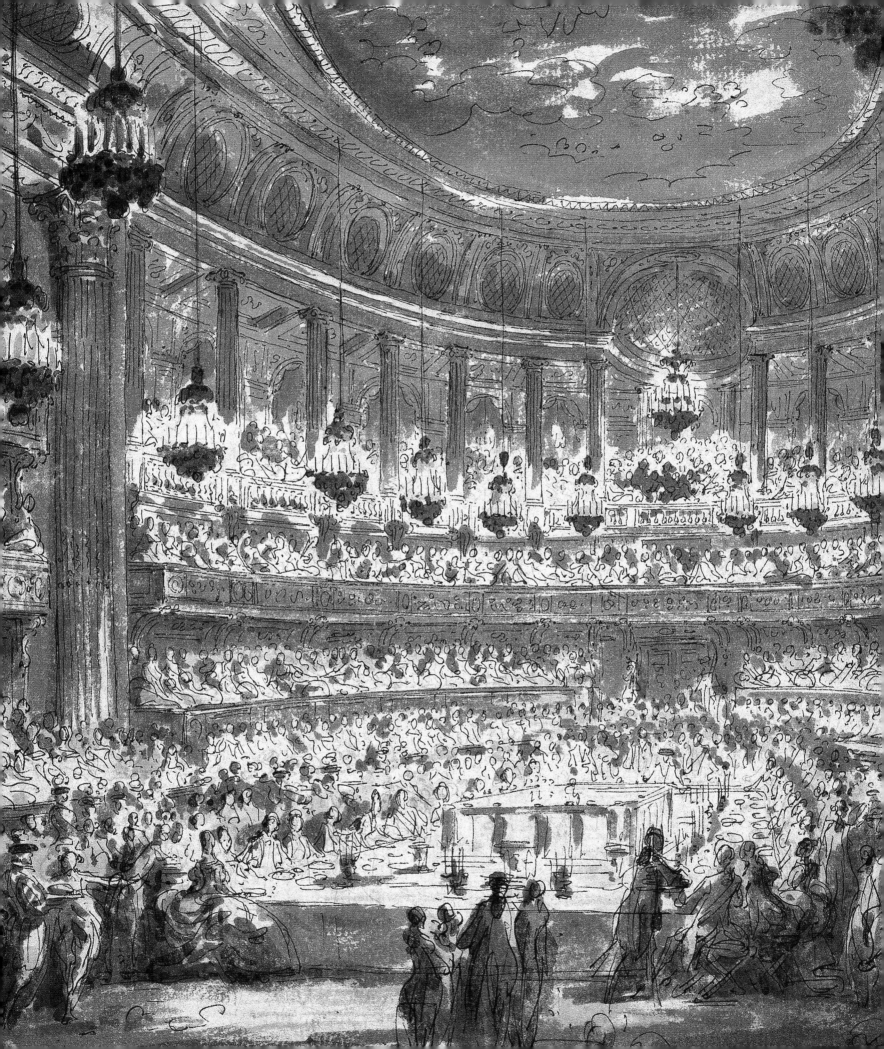

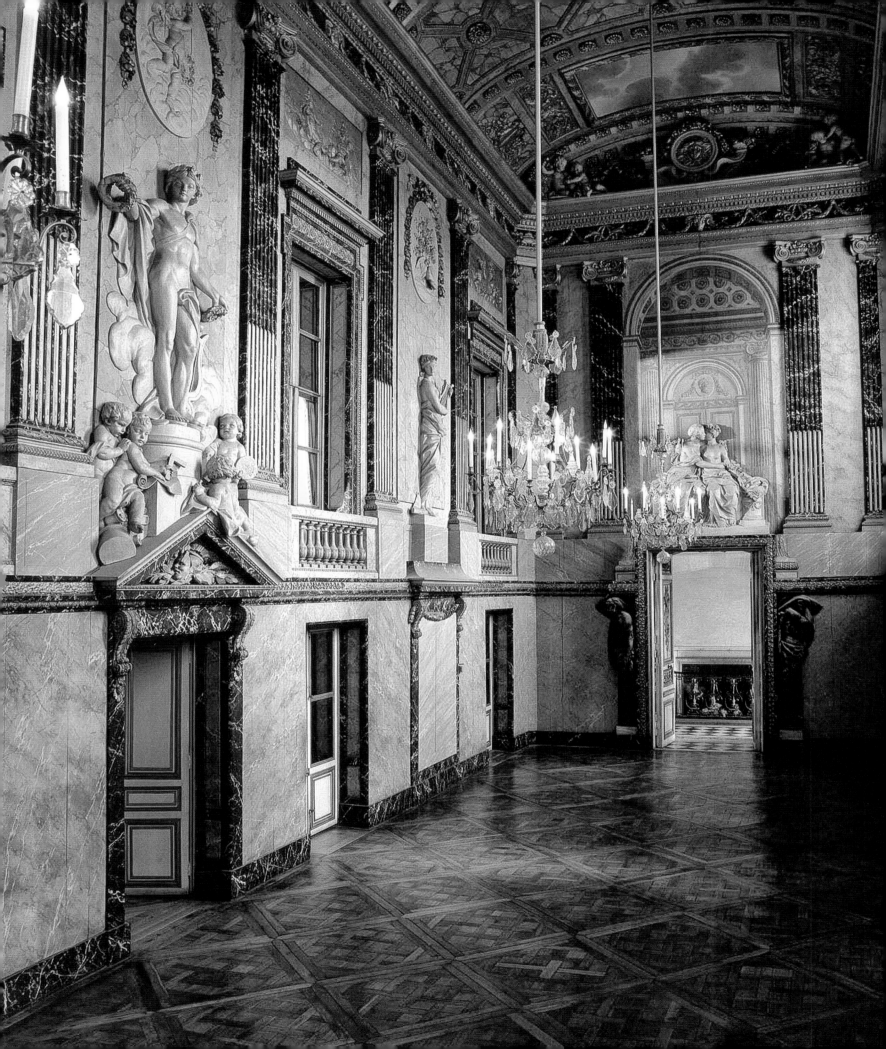

OPERA

Marie-Antoinette loved music and enjoyed singing. She preferred the operas of the German composer Christoph Willibald Gluck, considered more modern, to those by representatives of the established, grandiose French repertoire, such as Lully and Rameau. Between 1774 and 1779, Gluck lived in Paris, where he set out to revitalize French music. Marie-Antoinette was also enthusiastic about a new genre, comic opera, a field in which another of her favorites, the Liégeois composer André Grétry, had distinguished himself.

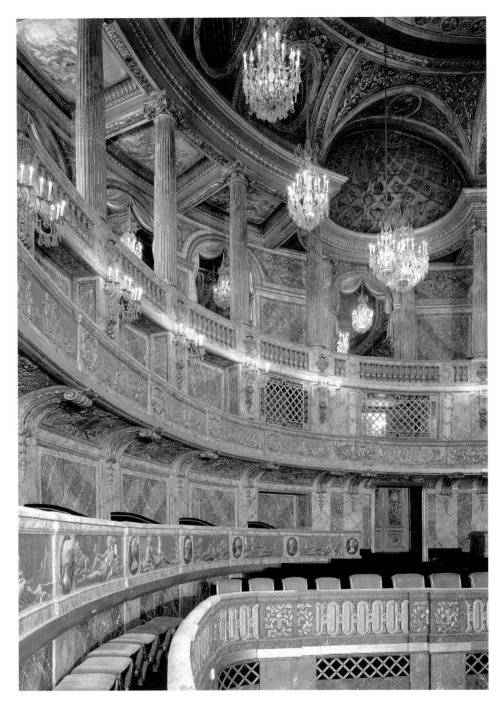

Above:
Built in record time, between 1768 and 1770, the Royal Opera of Versailles is one of the most sumptuous theaters and opera houses of the eighteenth century.

Below:
Marie-Madeleine Guimard, depicted here by Jean-Honoré Fragonard, was the leading ballerina of the Paris Opera. Marie-Antoinette saw her dance in Lully's *Persée* at the Royal Opera of Versailles in 1770.

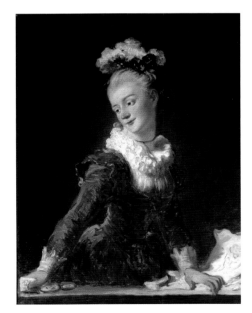

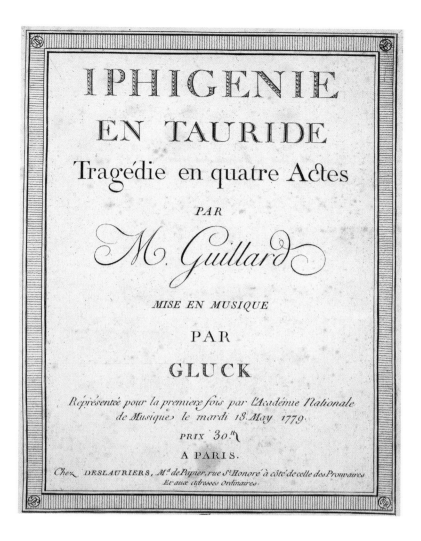

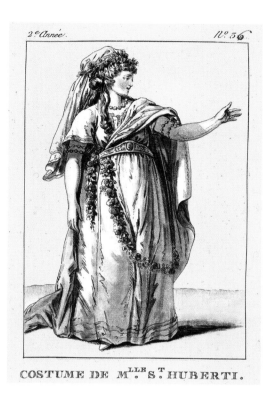

COSTUME DE M.ᴸᴸᴱ S.ᵀ HUBERTI.

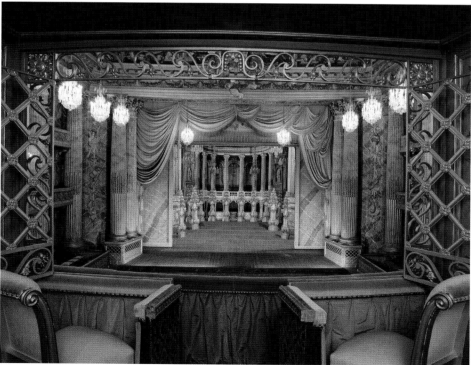

Above left:
Marie-Antoinette was present at the premiere of the opera *Iphigénie en Tauride* by Gluck at the Paris Opera (officially called the Académie Royale de Musique) in 1779.

Above right:
The opera singer Antoinette Saint-Huberty made her Paris debut in 1777 at the Académie Royale de Musique. Her performances in Gluck's operas were much acclaimed.

Left:
The monarchs used the royal box at the Royal Opera at Versailles when they did not sit in the stalls.

Too Young to Be Married

O n the evening of May 16, 1770, the newlyweds were escorted to Marie-Antoinette's bedroom on the first floor of the palace, which was, in fact, the dauphin's room. The king's chaplain, the archbishop of Reims, proceeded to bless the bed. Once the couple had reclined, tradition demanded that the bed hangings be drawn back to confirm to the courtiers present that the marriage was about to be consummated.

However, no consummation took place that night, or indeed for many nights to come. The bride and groom were still very young—she was fourteen, he fifteen—and both were extremely shy, a trait not helped by their puritanical upbringings, nor by court etiquette, which dictated that each of them have a separate apartment. Besides, it seems that Marie-Antoinette was revolted by the idea of intercourse, and her husband probably had a similar inhibition. This disastrous marriage resulted in a long period during which the couple displayed mutual indifference and largely avoided each other. The situation was made worse by the fact that Marie-Antoinette was very reluctant to have children too soon. As weeks turned to months and months to years, the relationship appeared to be running smoothly, but tongues were wagging. Rumors spread through the French court and among the public at large that the dauphin was impotent, but neither could his spouse be blameless.

Back in Vienna, Maria Theresa was deeply troubled at the couple's failure to consummate their marriage, which could be annulled at any moment, thus endangering the Franco-Austrian alliance. She expressed this concern in her frequent letters to her daughter. At the same time, her desire to avoid Marie-Antoinette being held responsible for the failure in matters of such magnitude led her to suggest that the dauphin needed a surgical operation to enable the future Louis XVI to carry out his conjugal duty.

Facing page:
Marie-Antoinette practicing the spinet in this detail from a 1770 painting by Franz Xaver Wagenschön.

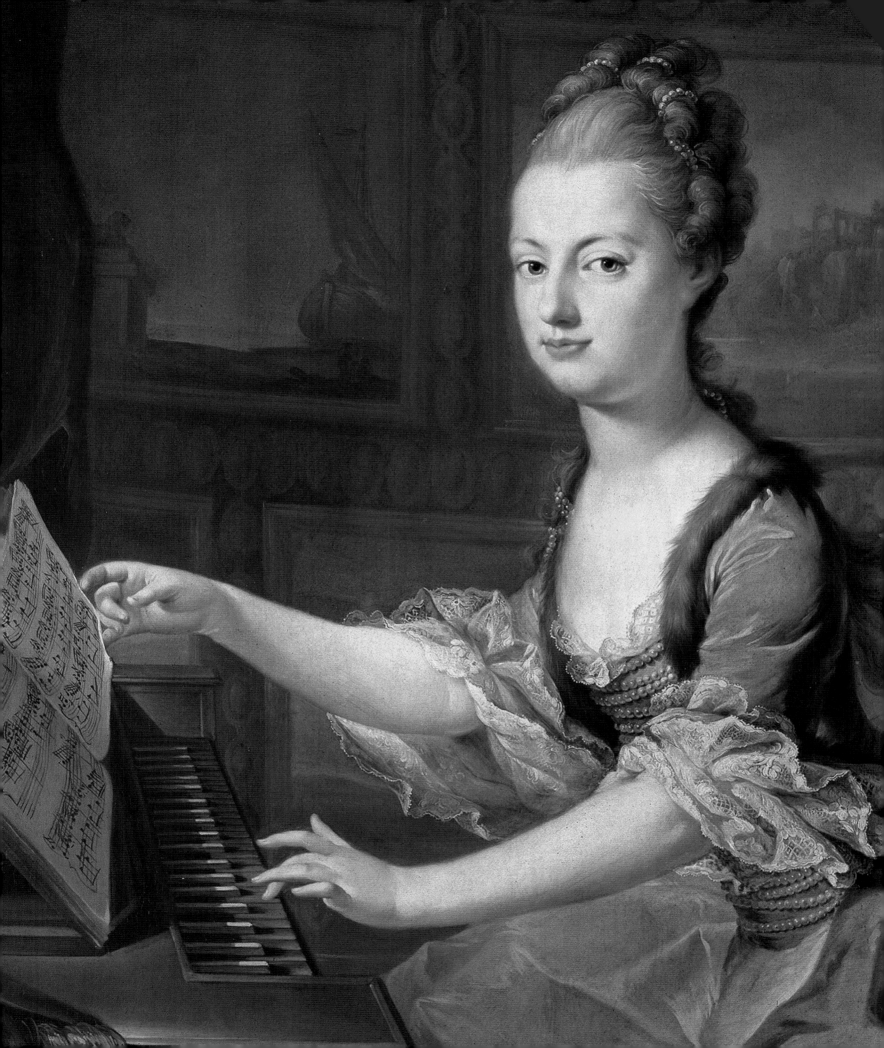

READING
AND
WRITING

Marie-Antoinette did not enjoy reading. As befitted her status as queen, her apartments at the Château of Versailles and the Petit Trianon were provided with extensive libraries. The abbé de Vermond, who had been her tutor in Vienna, was employed as her reader until 1789. He also made sure that, as dauphine and then as queen, she wrote regularly to her mother, Empress Maria Theresa. In her letters she had to report on her reading and other activities, as well as passing on the news from Versailles. The result was a vast correspondence, which was published at the end of the nineteenth century. The elegant prose of these letters owes much to the abbé, who helped Marie-Antoinette compose them and even dictated certain passages when asked.

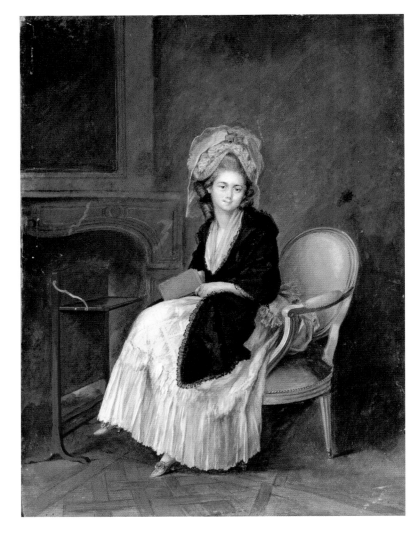

Below:
Books from Marie-Antoinette's library in the Petit Trianon with her coat of arms on the covers.

Above:
In the eighteenth century reading was one of the favorite pastimes for women of the nobility.

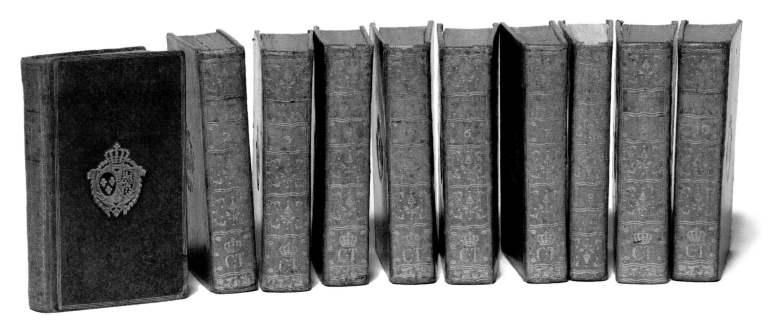

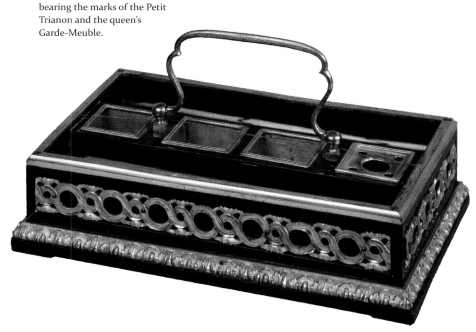

*j'ai appris monsieur, par madame de
Tourzel la part que vous avez prise à
l'allegresse publique sur l'heureux evenement
qui vient de donner à la france un heritier
a la couronne. Je remercie dieu de la grace
qu'il m'a fait d'avoir comblé mes voeux et
me flatte de l'espoir que s'il daigne nous
conserver ce cher enfant, il fera un jour
la gloire et les delices de ce bon peuple.
j'ai été sensible aux sentiments que vous
m'avez exprimés dans cette circonstance,
ils m'ont rappellés avec plaisir ceux que
vous m'avez autrefois inspirés chez ma mere,
vous assurant monsieur le Duc, que
depuis ce moment ils n'ont pas cessés
d'etre les mêmes pour vous et que
personne n'a le plus vif desir de vous
en convaincre que
marie antoinette*

versailles ce 15 avril

Left:
In this letter dated April 15, 1781, Marie-Antoinette expresses her happiness at having given birth to an heir to the throne, the first dauphin.

Below:
Stamped Adam Weisweiler, this writing table, delivered in 1784, stood in the *cabinet doré* of Marie-Antoinette's private apartments at the Château of Versailles. Its legs are decorated with gilt-bronze caryatids, its apron with Japan lacquer panels. It is a magnificent example of French furniture from the last years of the eighteenth century.

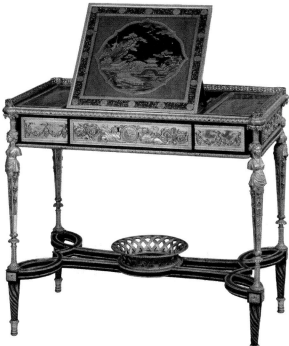

Below:
Marie-Antoinette's inkstand bearing the marks of the Petit Trianon and the queen's Garde-Meuble.

Following double page:
Left: *Portrait of Marie-Antoinette with a book* by Élisabeth Louise Vigée-Lebrun.

Right:
Green library in the queen's private apartments on the second floor of the palace of Versailles. Some of the "bookshelves" are in fact doors hidden by trompe l'oeil paintings of books.

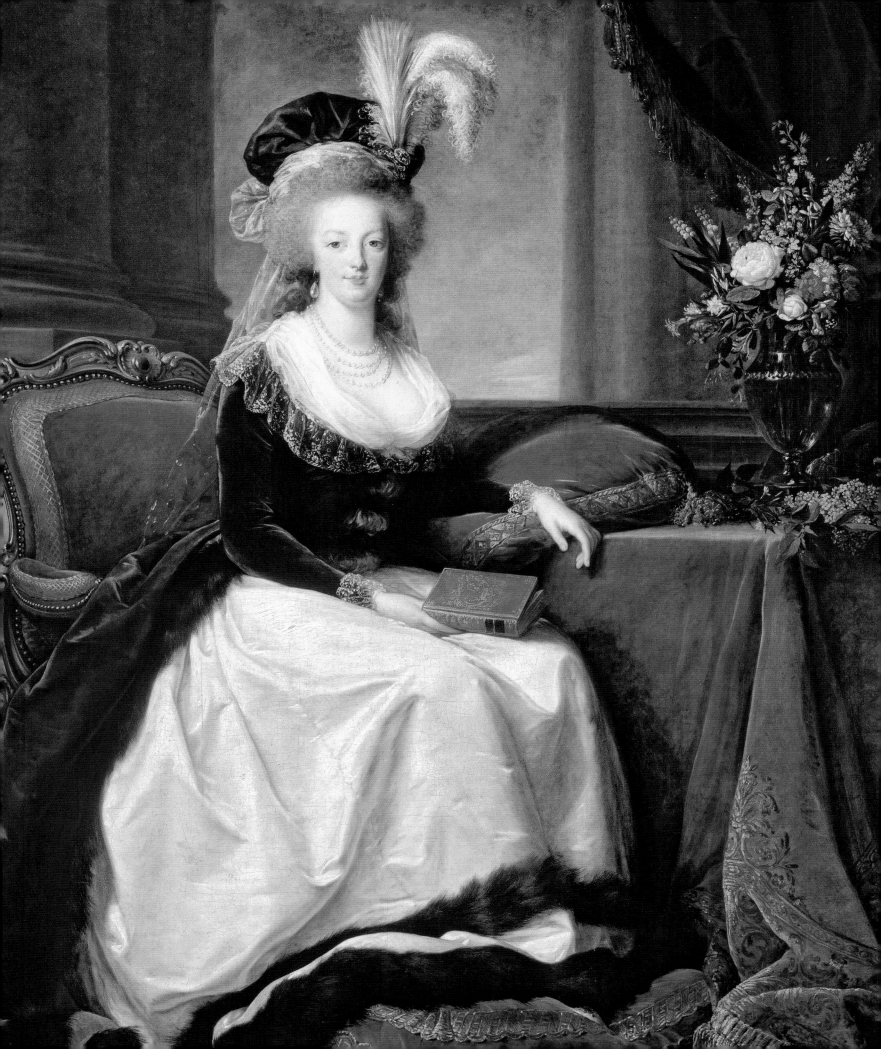

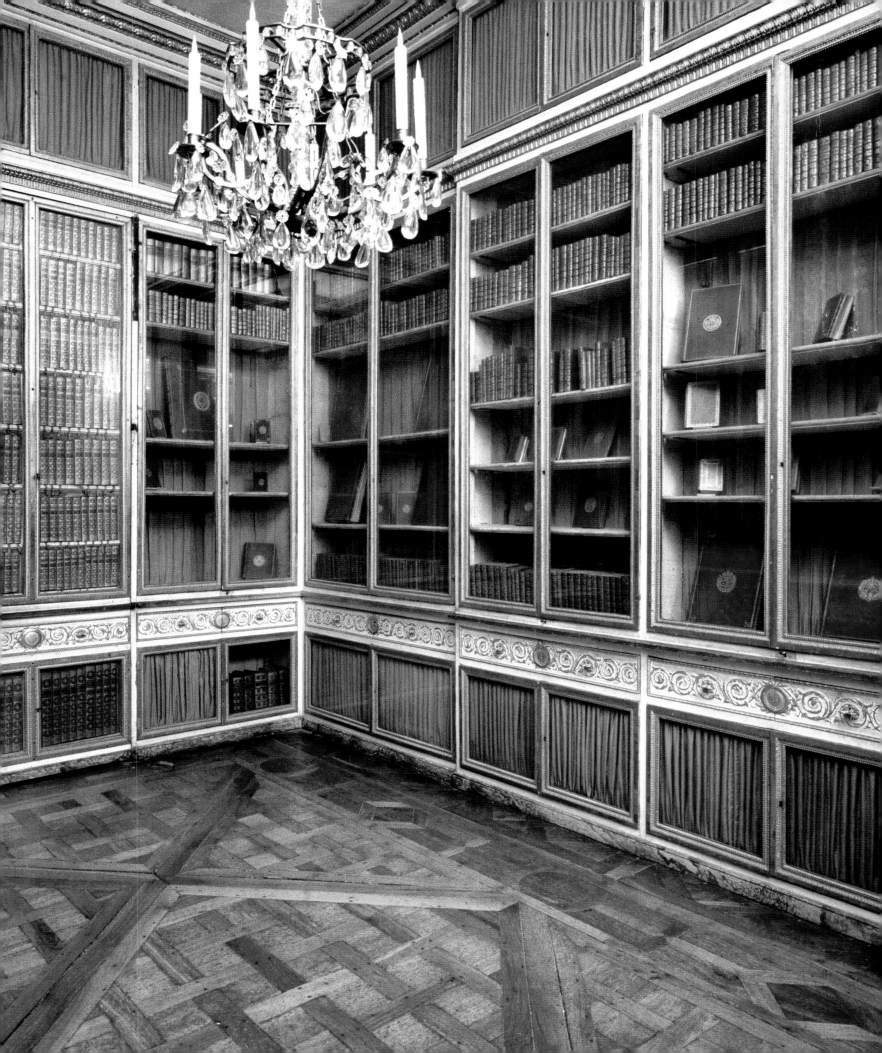

The Eye of Vienna

Breaking with custom, Louis XV allowed Maria Theresa to keep up an extensive correspondence with Marie-Antoinette, whose education was not yet complete. For the empress, this exchange of letters was also the means by which she could maintain her influence over her daughter in ways that would serve Austrian interests. Every month, Austria's ambassador to Paris, the comte de Mercy-Argenteau, would transmit Maria Theresa's latest letter to the dauphine. The empress demanded she be informed about every detail concerning her daughter, including her menstrual cycle, and even asked her to write reports on books that were on her required reading list. But Mercy would also give his own confidential reports on the new dauphine's behavior and reception at court to the couriers carrying Marie-Antoinette's answers to Vienna. His main informer was the abbé de Vermond, former tutor and now reader to Marie-Antoinette, who enjoyed daily contact with her and was beyond suspicion. Thanks to this spy, the young woman was now kept under the watchful eye of Vienna.

This correspondence gives us a picture of the dauphine's daily life, full details of which she provided in a long letter dated July 12, 1770: "I will tell you therefore, that I get up at ten, or at nine thirty and that, having been dressed, I say my morning prayers; then I breakfast and then go to my aunts [Mesdames], where I usually find the King. That goes on until ten thirty."[2] The "aunts" here are the daughters of Louis XV, who had given Marie-Antoinette a warm welcome.

Marie-Antoinette's letter goes on: "After that, at eleven, I go to have my hair dressed. [...] At noon we have Mass. If the King is at Versailles, I accompany him, my husband, and my aunts to the Mass; if he's away, I go alone with M. le Dauphin, but always at the same time. After Mass we have dinner together in public, but it is over by one thirty because we both eat very quickly."[3]

After the midday meal, Marie-Antoinette explained, there was time for reading, writing, music—she played the harpsichord and sang—and her needlework. She concluded: "At seven we sit down to cards until nine, but when the weather is nice, I go for a walk, and the card playing takes place not in my apartment but in my aunts'. At nine we have supper, and when the King is away, my aunts come and have supper with us, but when the King is there, we go to their

Above:
Marie-Antoinette received this precious jewel coffer, decorated with porcelain plaques by the Sèvres Manufactory, as a wedding present.

Facing page:
Empress Maria Theresa, mother of Marie-Antoinette, shown here in mourning dress in a painting by the workshop of Anton von Maron from ca. 1772.

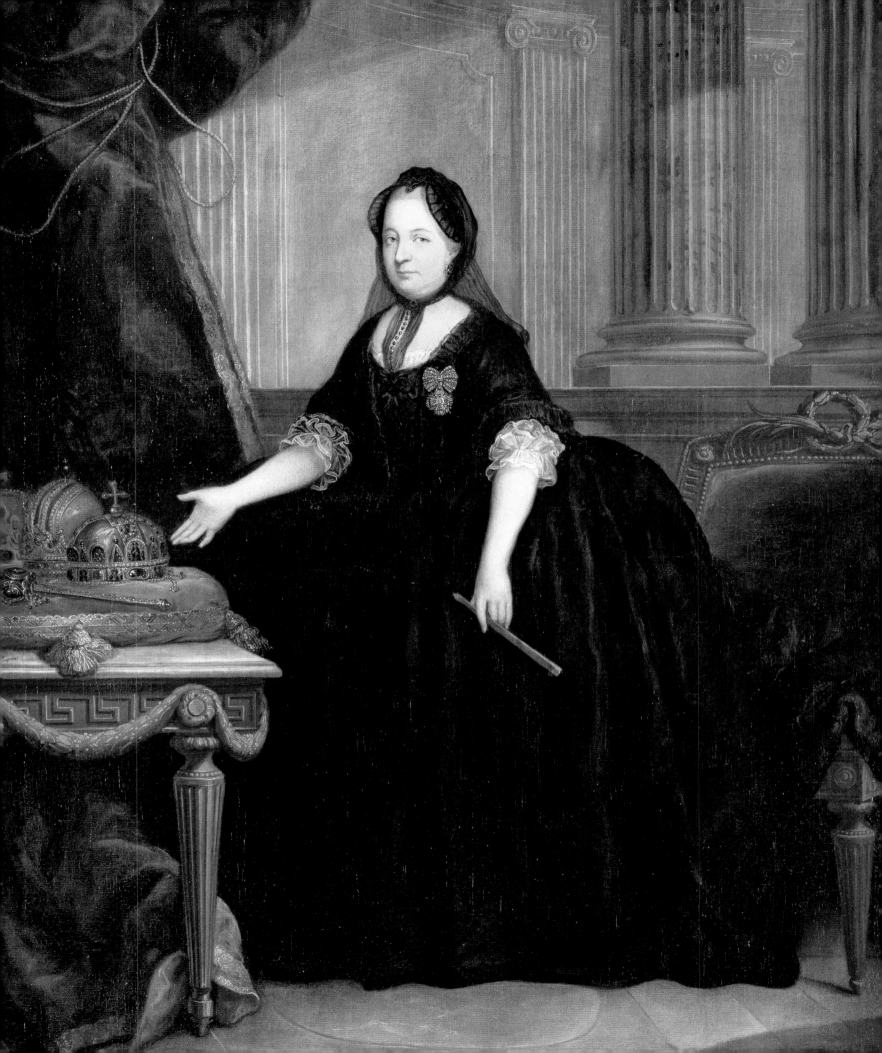

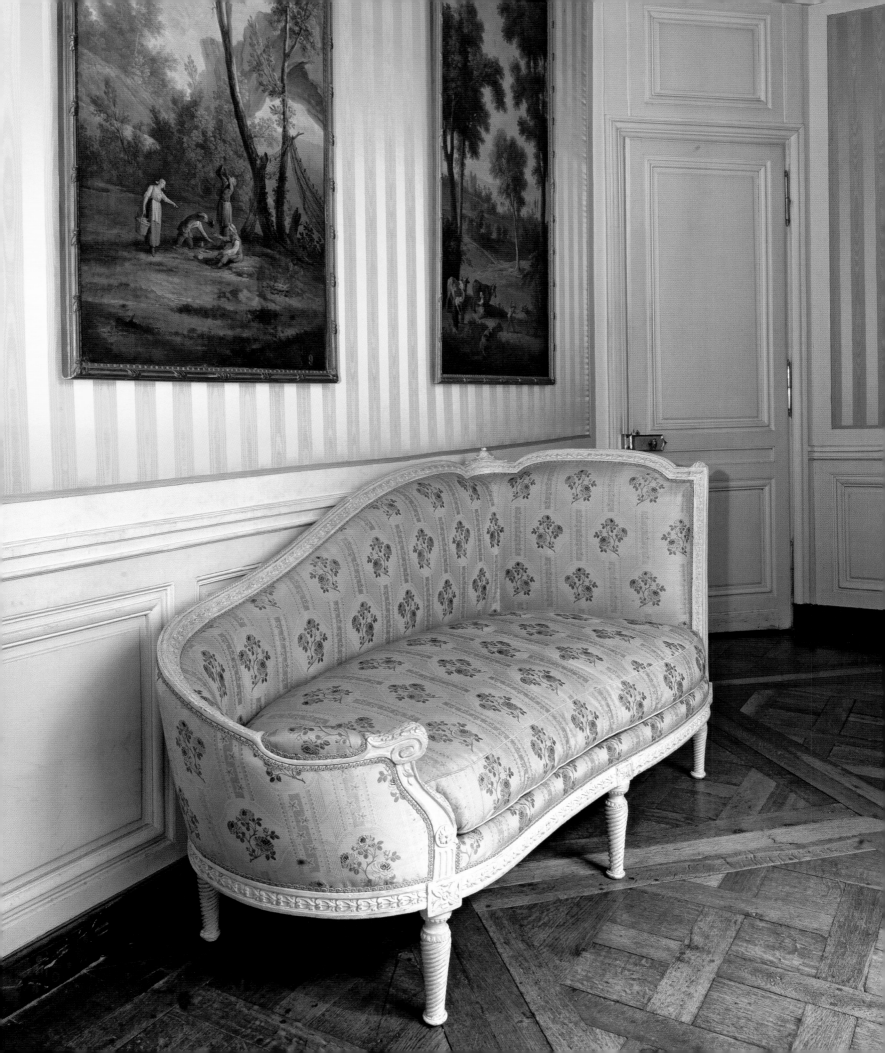

apartments after supper and wait for him; he usually comes at ten forty-five, but, while waiting for him, I lie down on a large sofa and sleep until he arrives; if he's away, we go to bed at eleven. That is our whole day."[4]

Empress Maria Theresa, for her part, was a frequent letter writer. She told her daughter to do her best to please Louis XV, the Versailles court, and the French people. She worried that Marie-Antoinette was becoming unpopular because of her Austrian origins and, in particular, because she scorned court etiquette. Tacitly, Maria Theresa also pursued political ambitions, as her ambassador Mercy revealed in one of the confidential letters he wrote to her: "Given the character and personality of Monsieur le dauphin, it is virtually inevitable that Madame la dauphine will one day govern France."

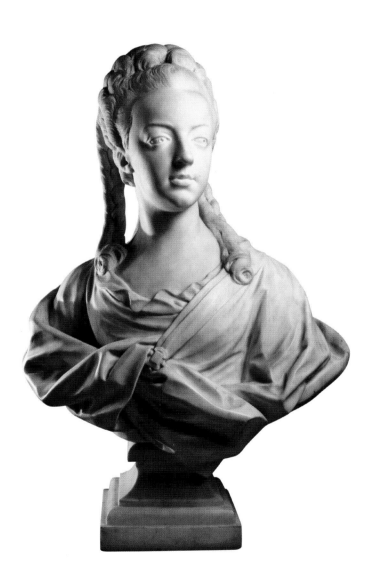

Facing page:
Daybed (*canapé de repos*) in Marie-Antoinette's private apartments at the Château of Versailles.

Opposite:
This marble bust of Marie-Antoinette by Jean-Baptiste Lemoyne from 1771 was sent to Vienna, where it is still kept today.

NEEDLEWORK

Sewing, embroidery, lacemaking, tapestry, or knitting—needlework in all its forms was part of the education of every girl from the nobility. Marie-Antoinette could not avoid it, even though it seems she did not find it very appealing. Only after the royal family had to leave the Château of Versailles in 1789 did she take it up in earnest, filling part of the long days of enforced idleness in the Tuileries by embroidering a large tapestry with her sister-in-law, Madame Élisabeth.

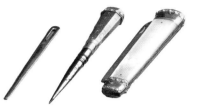

Left, above, and below:
Gold sewing *nécessaire* with its case, decorated with fish-scale pattern and mother-of-pearl.

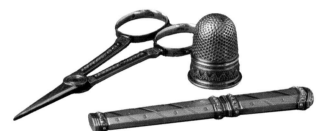

Below:
Marie-Antoinette spun wool on this spinning wheel when she was imprisoned in the Temple from August 1792.

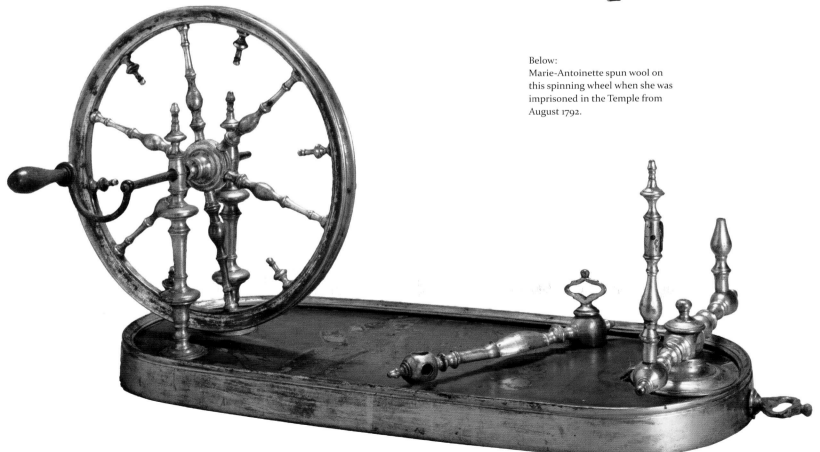

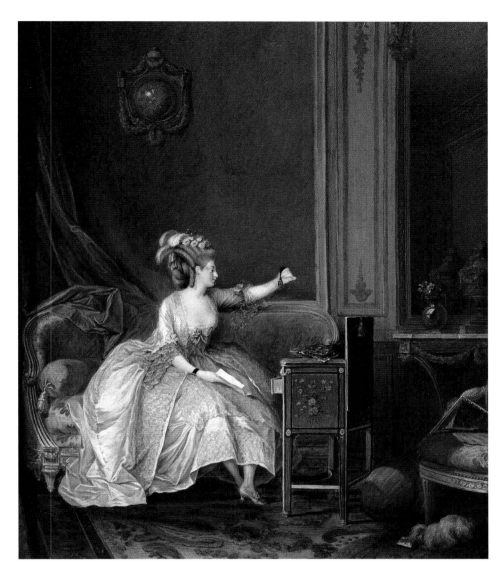

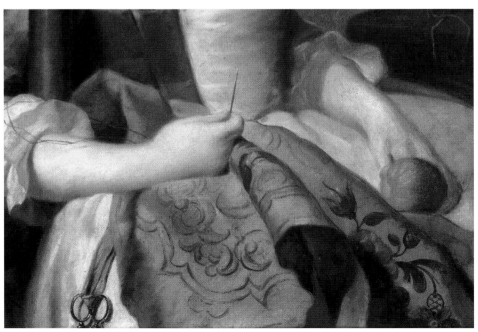

Above:
Woman from the nobility beside a piece
of furniture containing sewing materials.

Above right:
Needlework *nécessaire* in silver and
mother-of-pearl. It contains a folding
knife and sewing scissors.

Right:
Young Girl Embroidering (detail), pastel
by Jean-Étienne Liotard.

Following double page:
Left:
Tapestry made for Marie-Antoinette's
bedchamber at the Château of Versailles
(detail). Silk lampas, designed by Philippe
de Lasalle, silk designer, manufacturer,
and merchant in Lyon.

Right:
Pastel by Jean-Étienne Liotard from 1762
depicting the seven-year-old Marie-
Antoinette knotting thread with a shuttle.

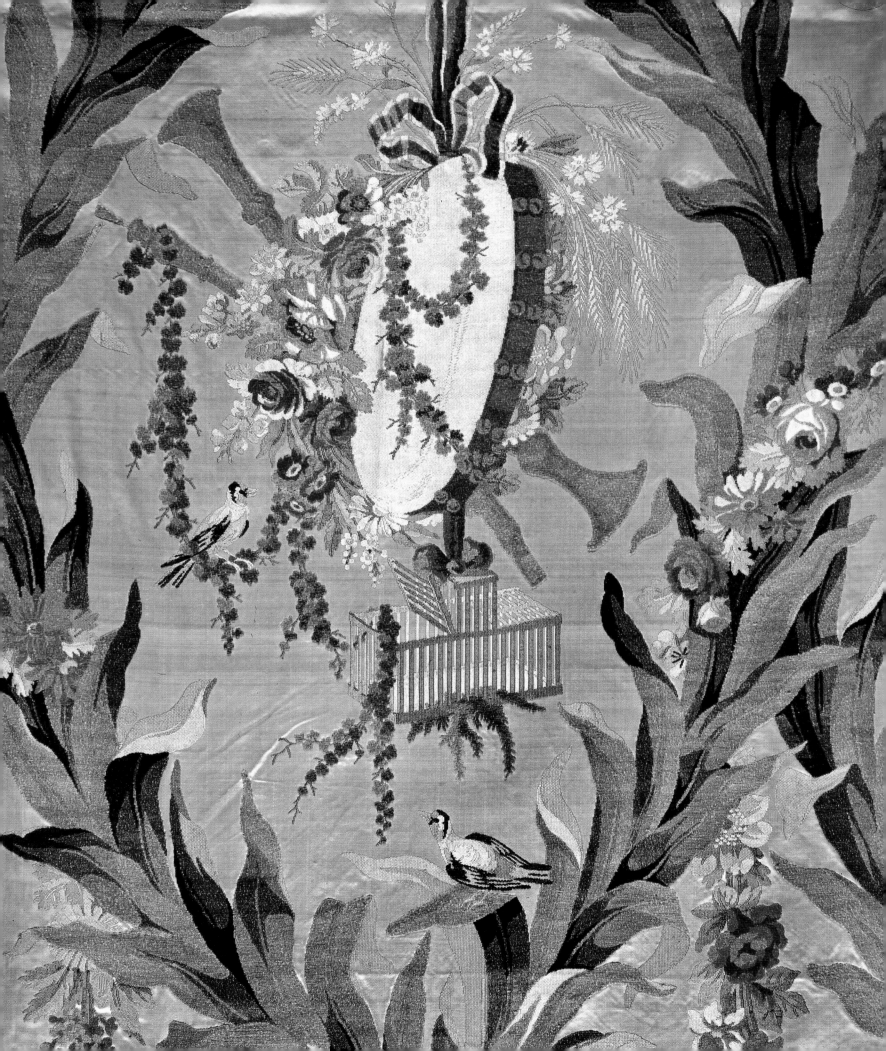

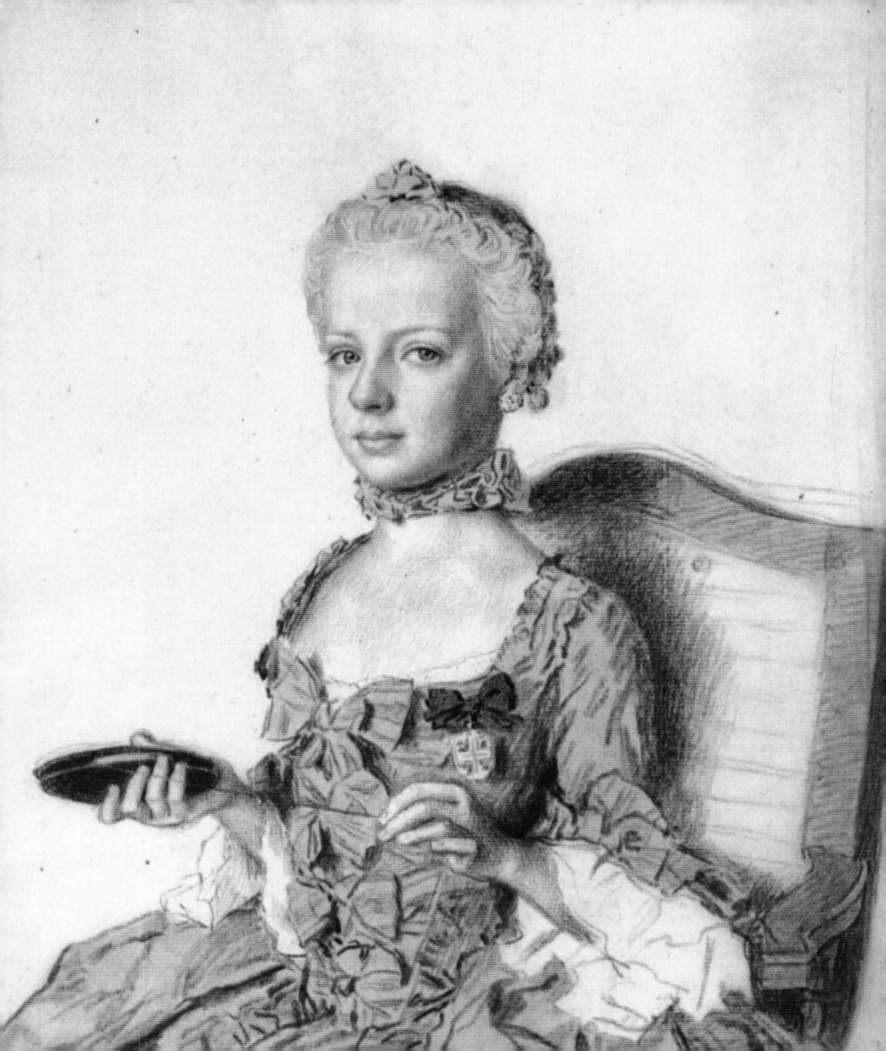

The Du Barry Affair

Among Maria Theresa's many instructions to her daughter, the most imperative was that she must win the approval of the king, the court, and the people over whom she would one day reign. The empress was particularly concerned that Marie-Antoinette, whom she chided for being lazy, easily distracted, and unruly, might damage Austria's reputation. After Louis XV dismissed the duc de Choiseul, a loyal supporter of the Franco-Austrian alliance, in December 1770, Maria Theresa became even more perturbed by her daughter's behavior, especially as Marie-Antoinette had been undiplomatic enough to take sides against Madame du Barry.

Presented at court in April 1769, the comtesse du Barry, née Jeanne Bécu, was the king's mistress. The ladies of the court, not least Choiseul's sister, who was disappointed by her own failure to achieve that coveted position, felt insulted that a woman of such humble status should enter their ranks. Marie-Antoinette joined the chorus of disapproval against the new countess out of loyalty to Choiseul and her personal dislike of this lower-class upstart. While the dauphin, not wishing to see his grandfather publicly criticized, came out in his support, his young wife made no attempt to hide her contempt for du Barry. Exasperated by the dauphine's attitude, Louis XV sent her a message via the comte de Mercy-Argenteau demanding that she speak a few pleasant words in public to Madame du Barry. Rebukes from her mother added to the pressure, and eventually Marie-Antoinette complied. On January 1, 1772, she publicly addressed her famous and somewhat ambiguous remark to the king's mistress: "There are a lot of people at Versailles this evening!"

Above:
Portrait of Louis XV by Armand Vincent de Montpetit, dated March 1774, two months before the king's death.

Facing page:
Portrait of Madame du Barry as Flora by François Hubert Drouais from 1769. Marie-Antoinette had nothing but contempt for this woman of low birth.

The Future Queen of France

The dauphin and Marie-Antoinette, who represented the future of the kingdom, were unwitting beneficiaries of Louis XV's unpopularity. On their formal entry into Paris in June 1773, they were given an ecstatic welcome. After attending Mass in Notre-Dame and saying a short prayer at the relics of St. Geneviève, the city's patron saint, they made their way to the Tuileries, where they dined in public. Commenting on the cheers from the crowd the dauphine received, the duc de Brissac whispered in her ear, "Madame, you have here 200,000 people in love with you!"

A few days later, Marie-Antoinette and her husband went to the Comédie-Française where, in a total breach of etiquette, they began to applaud the performance, inviting the rest of the audience to do likewise. On April 19, 1774, at the Académie Royale de Musique, they were present at the opening night of Gluck's opera *Iphigénie en Aulide*. The composer, recently arrived from Vienna, had adapted Jean Racine's *Iphigénie* to shake up French operatic tradition. Once again, Marie-Antoinette eagerly applauded the opera, not least because she wanted to show her support for a compatriot.

Paris offered the dauphine the opportunity to join in festivities without the constraints of the Versailles court. In January 1774, at Carnival time, Marie-Antoinette and the dauphin attended the masked ball at the Paris Opera. It was there that she first danced with Axel von Fersen. Born, like the dauphine, in 1755, this handsome young Swedish officer had been sent to France by his father to complete his education.

Eager to free herself of the shackles of court protocol, Marie-Antoinette distanced herself from her *dame d'honneur* (the title given to the first lady-in-waiting), the comtesse de Noailles, whom she quickly dubbed "Madame Etiquette." It was around this time that she formed a close relationship with the young princesse de Lamballe, whom she had known since 1770. When Marie-Antoinette became queen, she revived the ancient post of Superintendent of the Queen's Household, to which she appointed the princess, prompting the comtesse de Noailles to resign.

Opposite:
The auditorium of the Théâtre-Français in Paris. In 1782, Marie-Antoinette inaugurated this new building for the Comédie-Française. It later became the home of the Théâtre de l'Odéon, now called the Odéon-Théâtre de l'Europe.

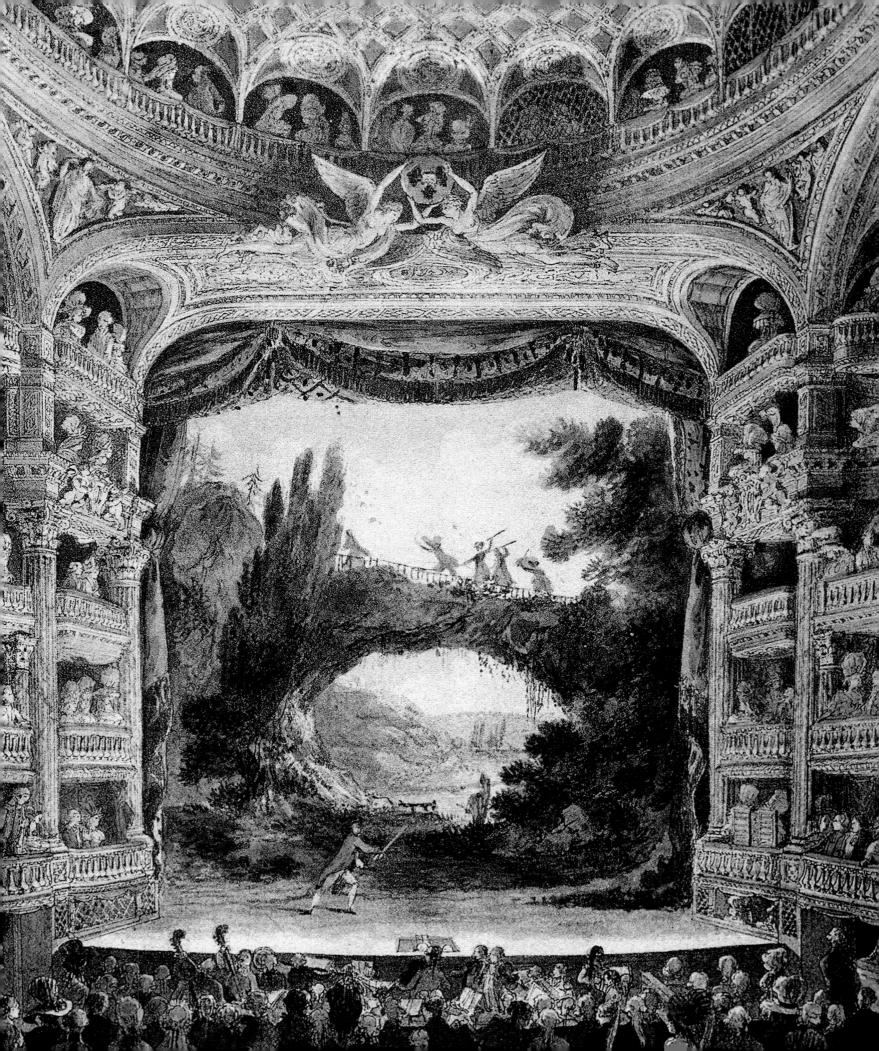

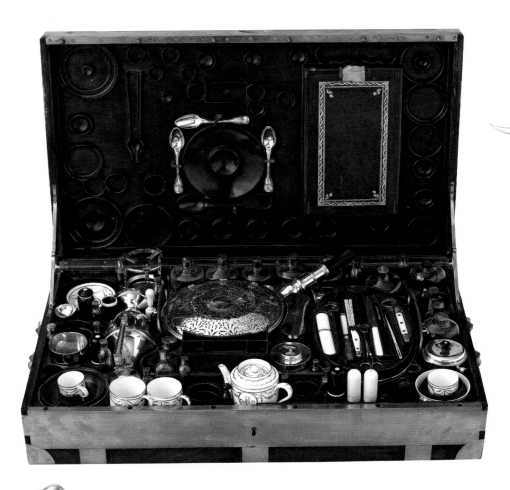

TRAVELING

During the reign of Louis XIV, the introduction of the first "modern coach"—with its large, fully enclosed body, glazed windows, and front wheels that could turn ninety degrees—marked the beginning of rapid developments in modes of transport. Then as now, traveling in style cost money, and each vehicle reflected the social status of its owner. The Berlin—so called because it was invented near that city—was introduced in the eighteenth century and came equipped with windows that could open and a compartment in the undercarriage for storing refreshments. Its design made travel safer and more comfortable, mainly due to improvements in the suspension. Also indispensable for the traveling aristocracy was the *nécessaire*, a case holding a range of useful items. These personal accessory cases were often masterpieces of decorative art.

Above:
Every need was catered to in Marie-Antoinette's large travel *nécessaire*, which contained tools and utensils for meals and snacks, washing, dressing, sewing, writing, and drawing.

Right:
This engraving by Louis Prieur shows the coach used by Louis XVI for his coronation in Reims on June 2, 1775. A veritable throne on wheels, covered in emblems of royalty, this monumental coach was destroyed on the orders of the National Convention in 1794.

Above:
View of the north gardens and parterres of the Château of Versailles from the Bassin de Neptune by Jacques André Portail, ca. 1740. Only the king's carriage was allowed to have eight horses; the queen's had six.

Left:
Travel trunk bearing the arms of the dauphine Marie-Antoinette.

The Queen

In 1774, Marie-Antoinette became queen of France, "the most
beautiful kingdom in Europe." The young sovereign was
admired and idolized with every public appearance more
sensational than the last, leaving the crowd longing for more.
Swept up in a whirl of amusements and entertainment, the
queen had her own circle, her "set," with whom she could hide
away in the enchanting surroundings of the Petit Trianon. But
beyond its walls, enemies lay in wait. Beneath the mask of
allegiance, those who had served the "old court" but had been
sidelined and sometimes humiliated were intent on revenge.
They chose to arm themselves with a formidable weapon they
could handle to perfection: slander.

This portrait, painted around 1785 by the copyists of the king's Cabinet of Paintings after an original by
Élisabeth Louise Vigée-Lebrun, shows Marie-Antoinette in a court dress worn over very wide panniers.

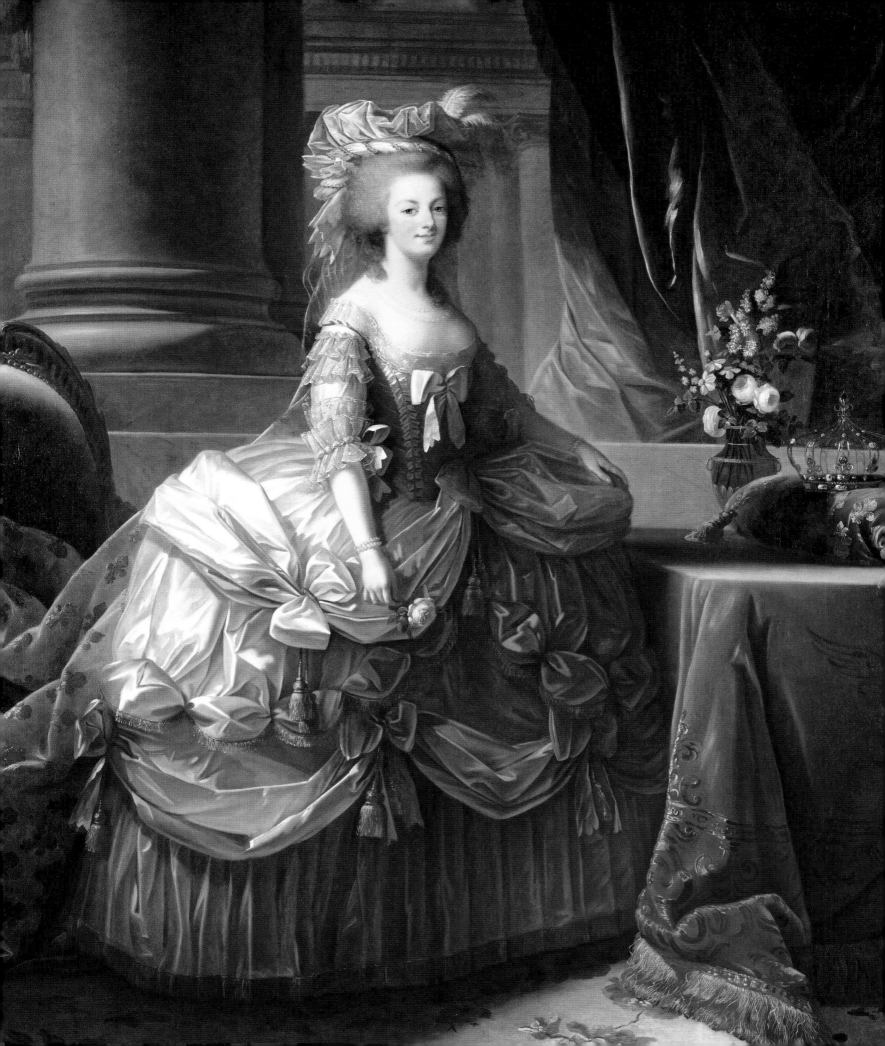

The King Is Dead,
Long Live the King !

O n May 10, 1774, all eyes were fixed on the flickering flame of a candle in a window at the Château of Versailles. For more than a month Louis XV had been struggling with smallpox. His face blackened and deformed by the illness, the king was dying, and the risk of contagion meant that he could no longer see his family. At a quarter past three in the afternoon, the flame went out. Almost immediately, with a thunderous roar, a crowd of courtiers rushed to the dauphine's apartments on the first floor. The comtesse de Noailles was the first to curtsy before the new queen of France. The young husband and wife fell to their knees, murmuring, "O God! Guide us, protect us, we are too young to reign!"

One year later, Louis XVI was anointed, crowned, and enthroned at Reims Cathedral. The coronation, the most important of all royal ceremonies under the ancien régime, conferred legitimacy on the sovereign by revealing the divine origin of his powers. The event emphasized the fact that, in France, the queen had no political role whatsoever: arriving by night, with no cortège or public entrance, Marie-Antoinette witnessed the ceremonies, banquets, and processions as a mere spectator. But the magnificence of her clothes was already attracting attention.

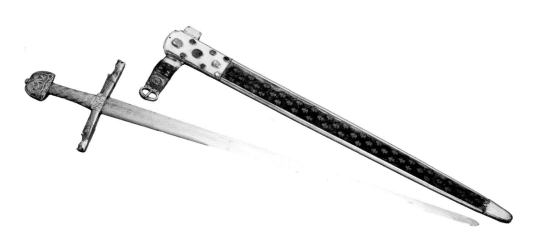

Facing page:
Portrait by the workshop of Joseph-Siffred Duplessis of Louis XVI in coronation robes, with some similarities to the famous portrait of Louis XIV by Hyacinthe Rigaud.

Opposite:
Charlemagne's personal sword, *Joyeuse*, was used from the thirteenth century for the coronation of the kings of France.

Following double page:
Colored engraving with gouache depicting the coronation of the king, from the official coronation album, the *Album du Sacre de Louis XVI*. Marie-Antoinette was visibly moved to tears at the event.

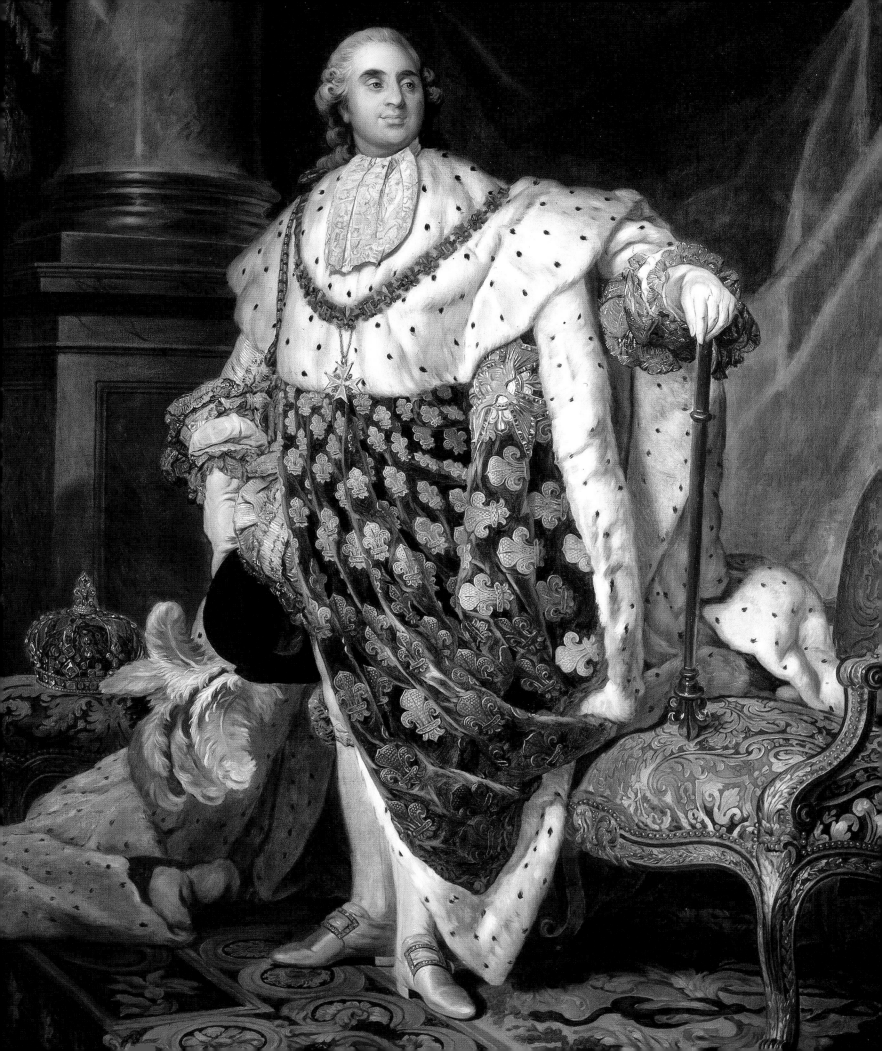

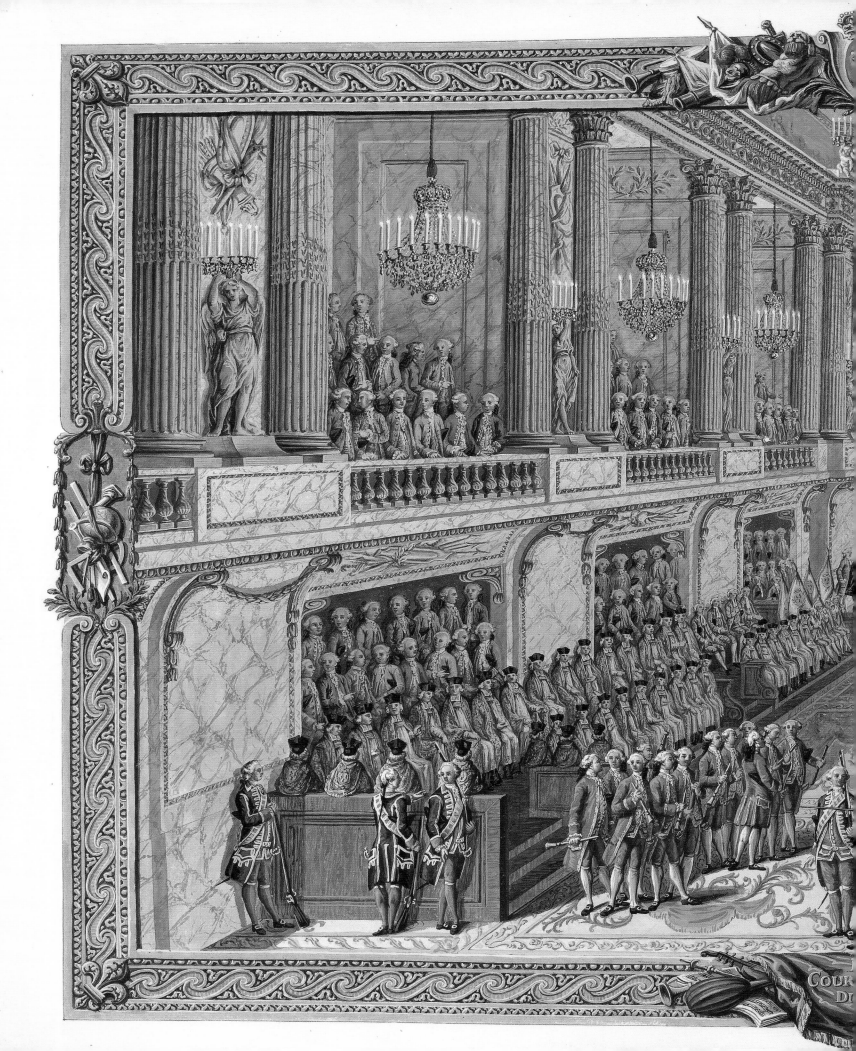

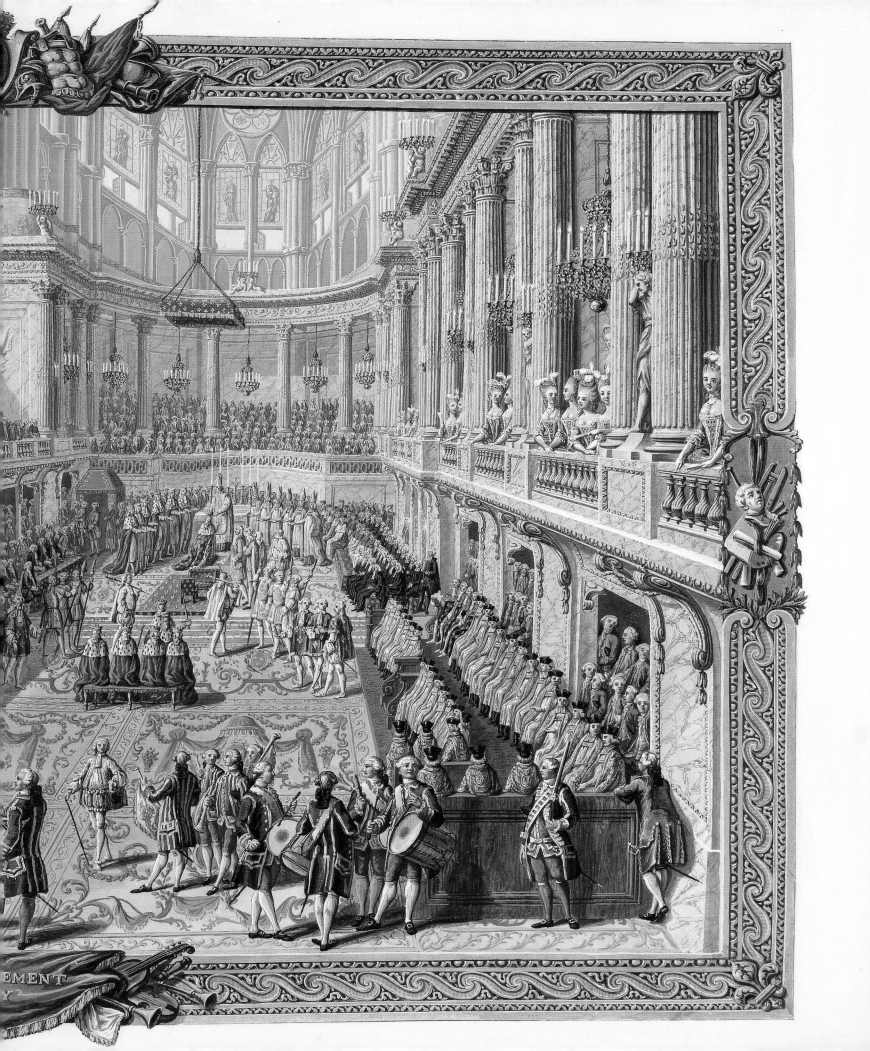

Queen of Europe's Greatest Kingdom

lthough God caused me to be born in the rank I now occupy, I cannot resist admiring the arrangements of Providence who chose me, the youngest of your children, for the greatest kingdom in Europe,"[5] wrote Marie-Antoinette to her mother a few days after her accession. Full of youthful beauty, charming and vivacious, the eighteen-year-old queen was adored by the people of Paris and greeted with cheers on every public appearance, something that touched her deeply.

What was needed now was someone to capture a true likeness of the new queen, but this proved to be as difficult as it had when she was dauphine. Empress Maria Theresa continued to press her to send "a fine full-length formal portrait." "I am indeed sorry I have not yet been able to find a painter who can make a portrait look like me,"[6] replied Marie-Antoinette. "The painters kill me and make me despair." Having little understanding of painting, for her an exact likeness was all that counted. In July 1775, Jean-Baptiste André Gautier-Dagoty, a second-rank artist from a famous dynasty of engravers, delivered the first official portrait: it showed Marie-Antoinette in a spectacular court gown and a mantle decorated with fleurs-de-lys and lined with ermine, her hand resting on a terrestrial globe. When it was displayed in the Hall of Mirrors, it drew harsh criticism: the queen's expression was said to be arrogant, and the lack of facial resemblance was considered a crime of *lèse-majesté*! It was Élisabeth Louise Vigée-Lebrun, an exact contemporary of the queen, who in 1778 finally created the portrait for which Marie-Antoinette had long been waiting. The sittings soon became special moments between two new friends. While adhering to the formal tradition of the grand court portrait, the painter breathed new life into the genre by eliminating the stiffness and heaviness, a lightness that can be seen in the fleurs-de-lys train that seems to float behind the grand robe like delicate gauze. The luminous white of her dress brings out the youthful radiance of the queen. The painting was soon sent to Vienna, where it remains to this day. "Your large portrait delights me!" wrote the empress to her daughter on April 1, 1779.

Above:
Copy of a portrait of Marie-Antoinette by Élisabeth Louise Vigée-Lebrun, drawn in sanguine chalk between 1805 and 1810 by her niece, Eugénie Tripier-Lefranc, née Lebrun.

Facing page:
Marie-Antoinette wearing a court dress with her right hand resting on a terrestrial globe. This portrait by Jean-Baptiste André Gautier-Dagoty from 1775 was judged by the royal court to be a bad likeness.

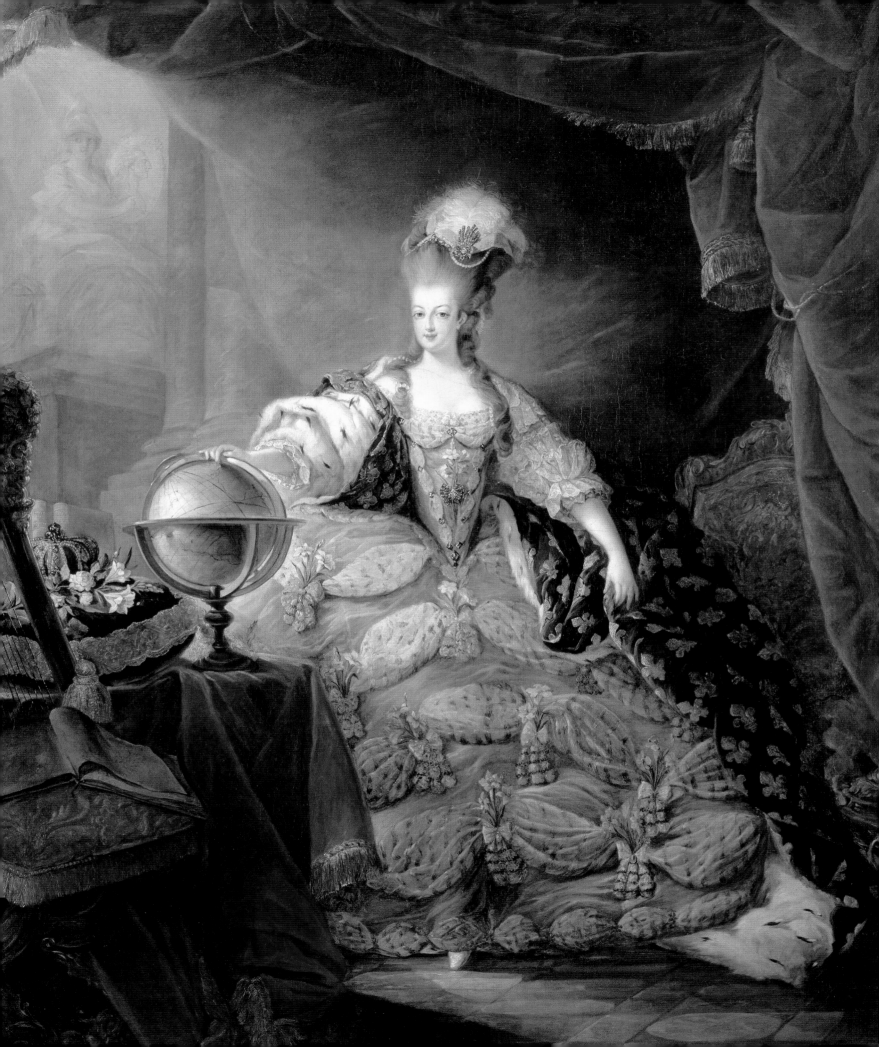

THE QUEEN'S
COLORS

Marie-Antoinette had strong ideas about color, preferring pastel shades, with a predilection for blue. In her youth she was equally keen on pink, but suddenly stopped wearing it as soon as she turned thirty. New colors formulated by dye makers sometimes had regal connections. A cindery beige called "queen's hair" was inspired by Marie-Antoinette's own shade of blond. The color puce—in French "puce" means "flea"— became all the rage after Louis XVI remarked that his wife's brownish-mauve gown was "the color of a flea." The dye makers then devised a whole range of flea colors and gave them humorous names such as "flea's thigh," "flea's belly," "flea's back," or "old flea."

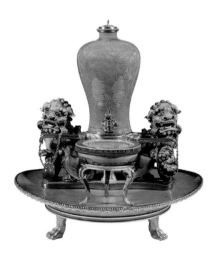

Above:
Perfume fountain, Chinese turquoise-blue porcelain.

Right:
Design for the bolster, headboard, and rear canopy of Marie-Antoinette's state bed in her royal bedchamber at the Château of Versailles.

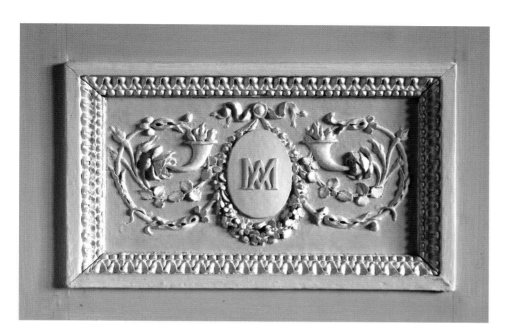

Opposite:
Marie-Antoinette's monogram—the interlaced initials M and A—on a dado panel in the "cabinet of moving mirrors" at the Petit Trianon.

Below:
Miniature portrait of Marie-Antoinette as Hebe in a blue dress, with a backdrop of roses.

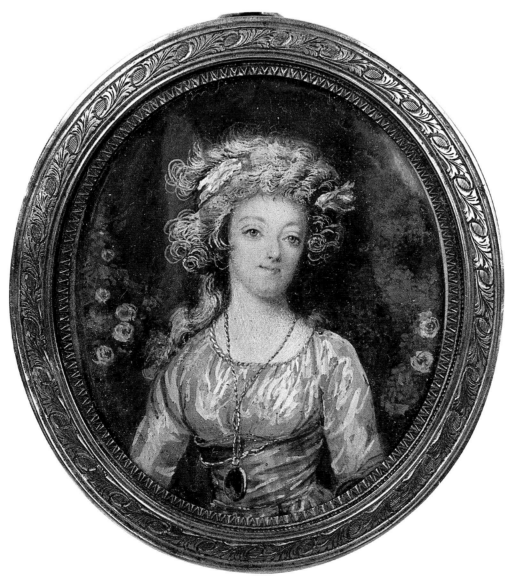

Following double page:
Left:
Ivory miniature depicting Marie-Antoinette playing with her two eldest children.

Right:
Details of the decoration in the Cabinet of the Meridian at the Château of Versailles.

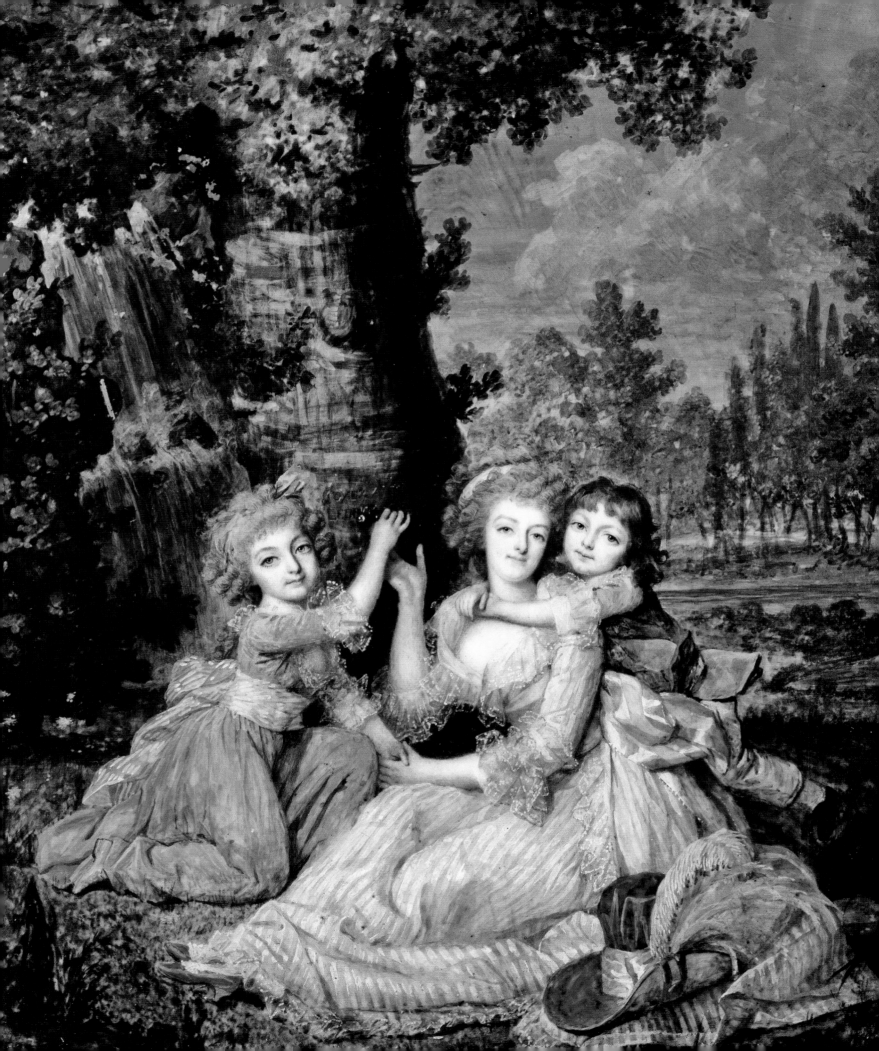

Marital Problems

I do not share the king's tastes. He is only interested in hunting and metal-work. I am sure you will agree that I would look quite awkward standing at a forge; I would not make a good Vulcan and if I were to play the role of Venus that would bother him far more than my real tastes, which he does not seem to mind," wrote Marie-Antoinette to her friend Count Rosenberg on April 17, 1775. The king and queen certainly had little in common. While Marie-Antoinette was light-hearted, mischievous, and pleasure-loving, her husband was earnest and good-natured, with a rather brusque and awkward manner. He loved hunting, science, and working with his hands; he cared little for frivolous amusements.

The couple had an affectionate, cordial relationship. But the marriage had still not been consummated. Marie-Antoinette's correspondence with Maria Theresa provides plenty of details on this delicate subject. She assured her mother that "the laziness is certainly not on my side," explaining that she had left the conjugal bed because of her husband's wish to have a separate room and forcefully defended herself against the accusation of "not taking this matter sufficiently to heart." Very soon the court was buzzing with gossip: songs were written mocking the debauched queen and impotent king who only loved hunting, while rumors circulated about a mysterious secret physical abnormality from which Louis was suffering.

This soon went beyond court whispers to become a full-blown affair of state. Since the first duty of a queen was to ensure the continuity of the royal blood-line, in the absence of an heir the very presence of Marie-Antoinette in France could be challenged, and this in turn could bring down Austria's entire diplomatic strategy. Something had to be done. In April 1777, at the initiative of the empress, Marie-Antoinette's brother, the future Joseph II, made the journey to the Château of Versailles. Joseph was given precise anatomical details about Louis XVI, who suffered from phimosis. Noting that Louis took no pleasure in sexual relations, Joseph became exasperated: "They are, together, two complete blunderers." But he managed to win the king's confidence and persuade him of the need to undergo a "little operation." Joseph's visit bore fruit: on August 18, after seven years, the marriage was finally consummated. Marie-Antoinette immediately informed her mother of this "great event."

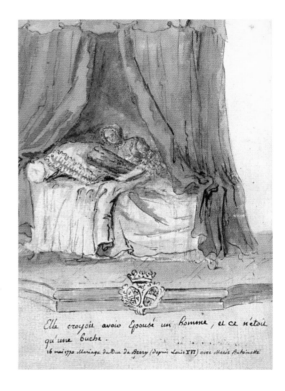

Above:
Caricature of Marie-Antoinette's marriage by Charles-Germain de Saint-Aubin: "She thought she had married a man but it was only a log."

Facing page:
At the time of their marriage, the bride and groom were very young: he was fifteen, she only fourteen years old.

Following double page:
The queen's bedchamber, rich in its symbolism of power and prestige, is one of the most sumptuous rooms of the Château of Versailles and was completely redecorated according to Marie-Antoinette's wishes.

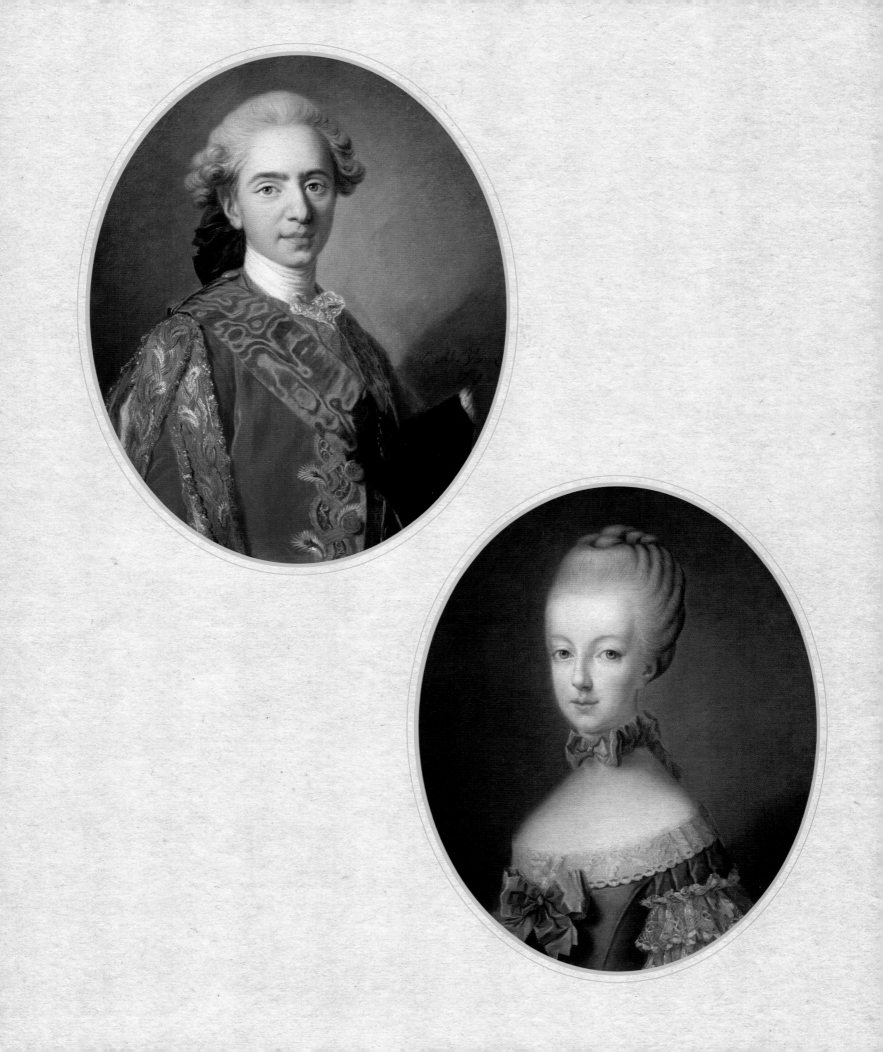

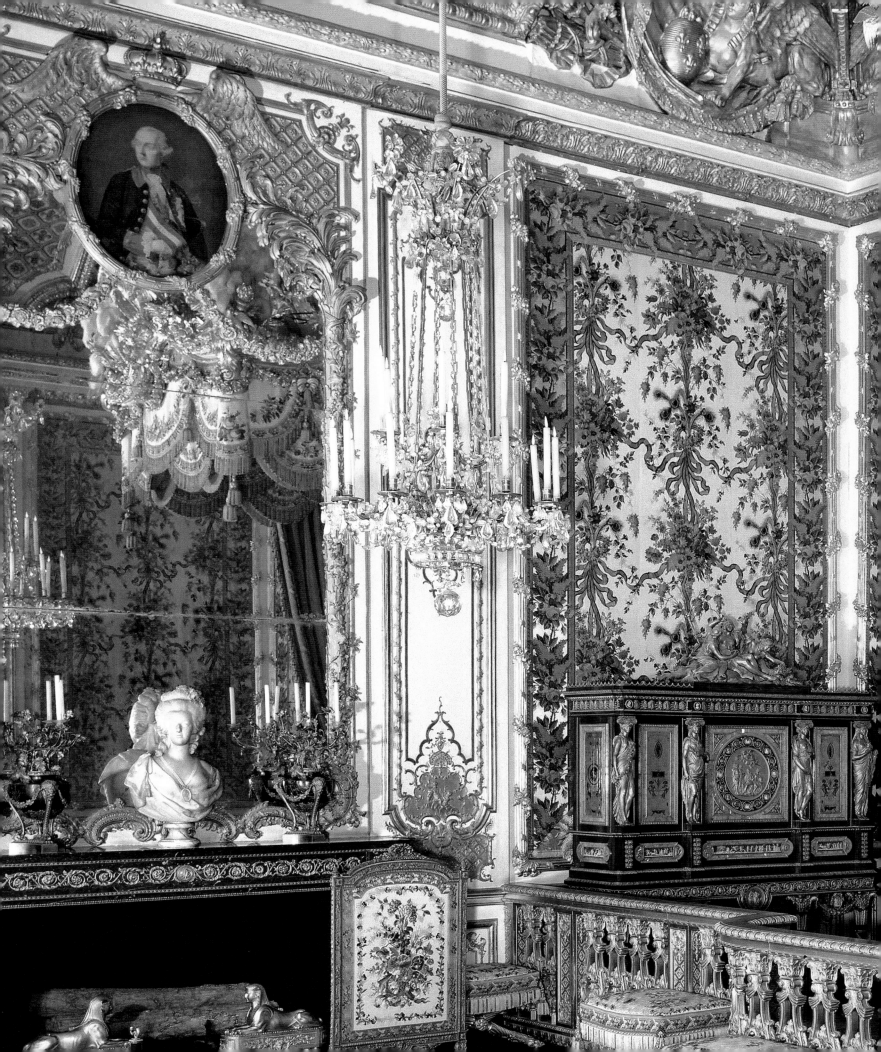

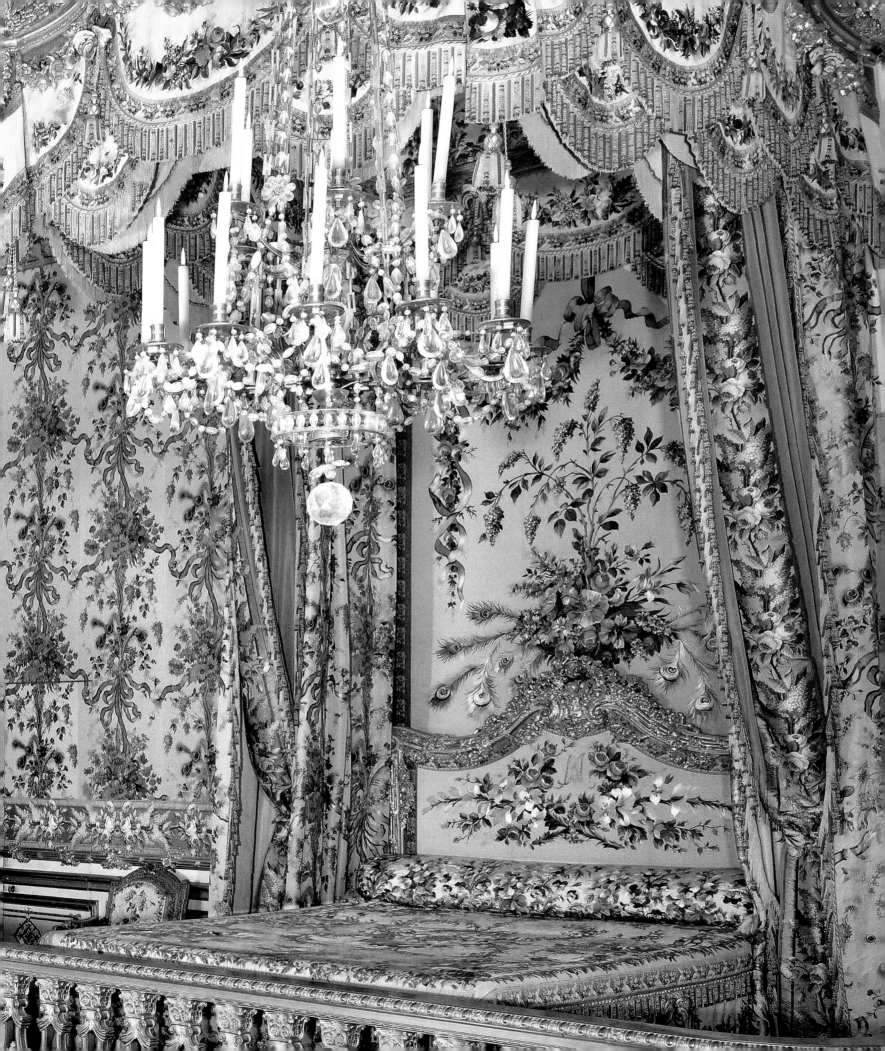

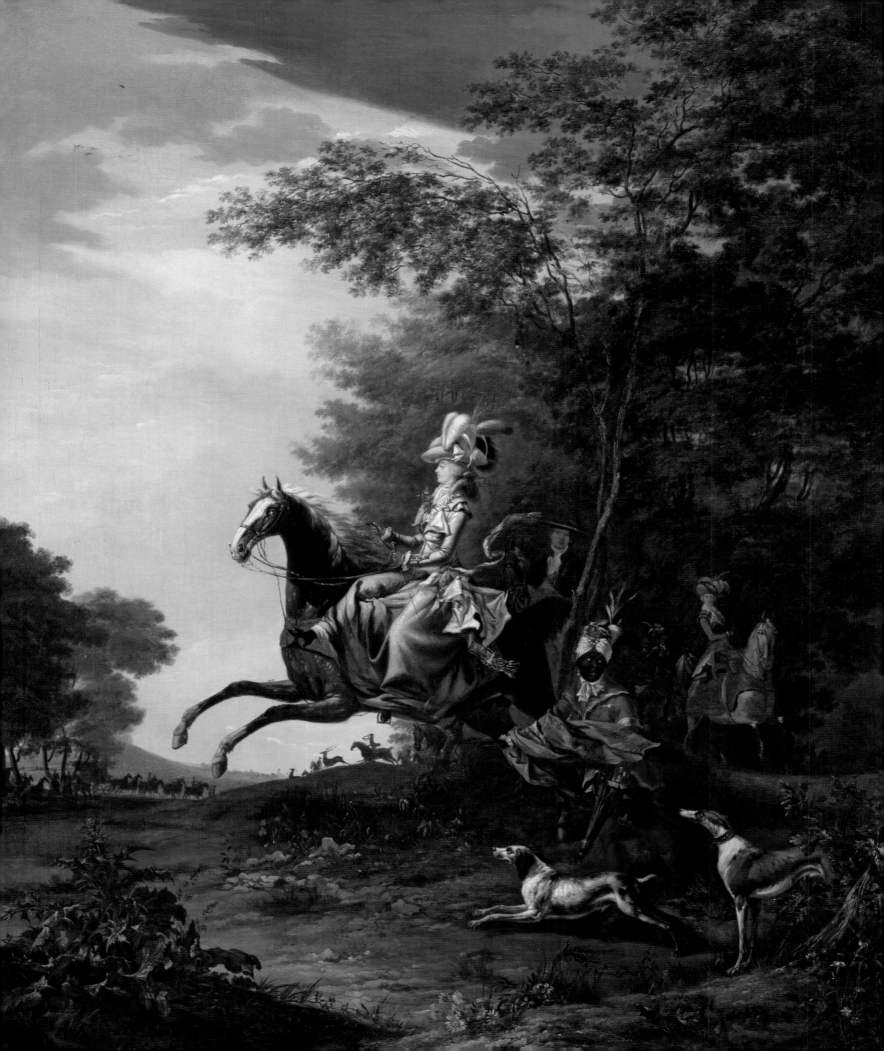

HUNTING

Marie-Antoinette shared her husband's love of hunting. Despite repeated warnings from her mother, Empress Maria Theresa, that riding could cause her to miscarry, she enjoyed it far too much to stop. She followed the hounds in pursuit of the fox or stag and even agreed to be painted on horseback, seated astride or sidesaddle. Like Louis XVI, the queen kept careful records of the quantity and kind of game killed, year by year. But eventually she lost interest, weary of the king's obsession with hunting.

Facing page:
Hunting scene painted by Louis-Auguste Brun, showing Marie-Antoinette riding sidesaddle, accompanied by a servant, a hunting dog, and a greyhound.

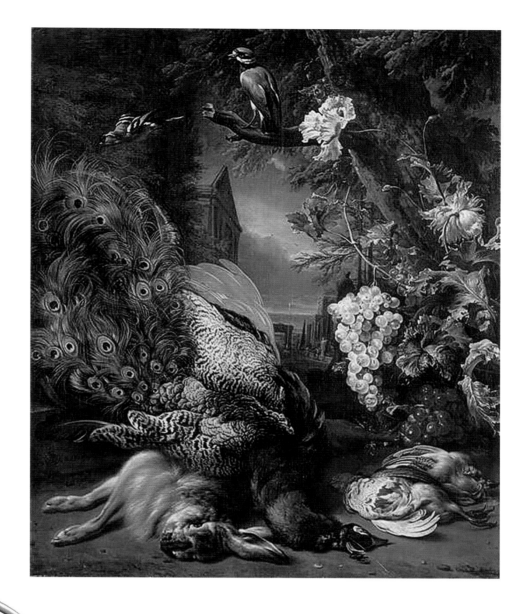

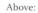

Above:
Dead Peacock and Game, 1707, by Jan Weenix.

Left:
Hunting horn, used for hunting with hounds.

Following double page:
Painting on porcelain depicting Louis XVI on a hunt near Compiègne. Marie-Antoinette watches from a boat while the pack of hounds chase a stag.

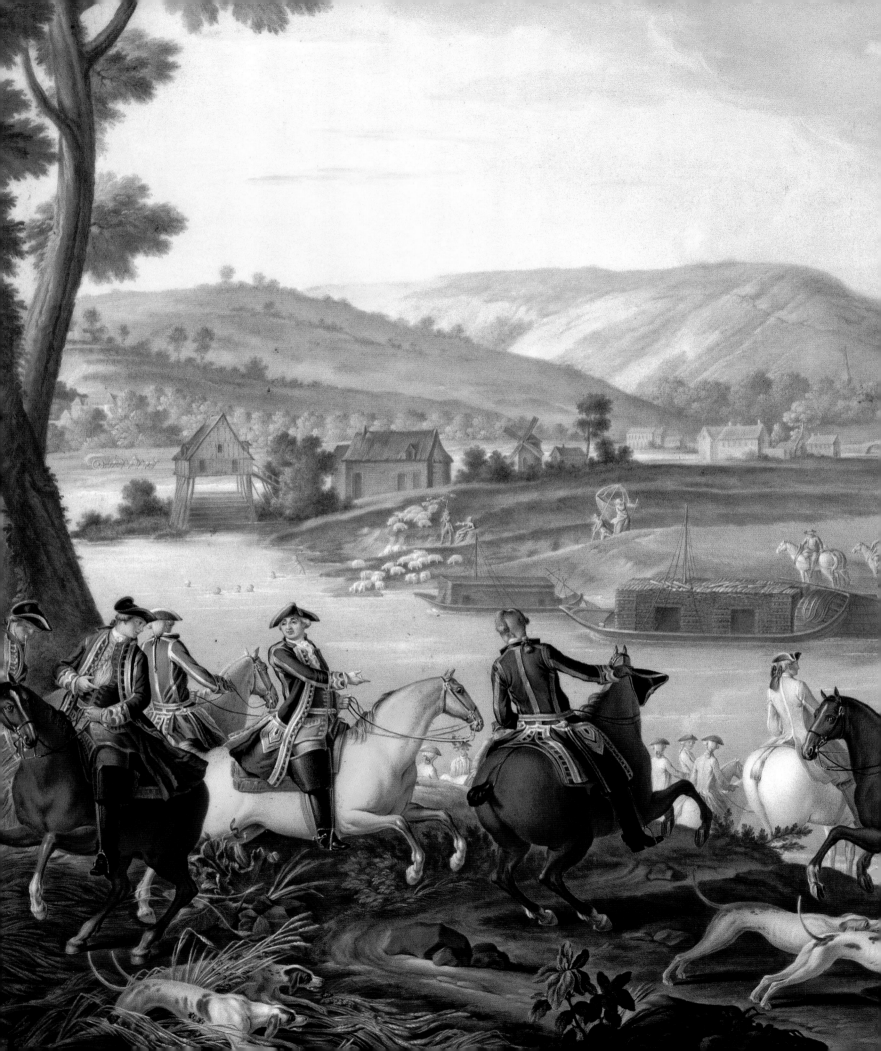

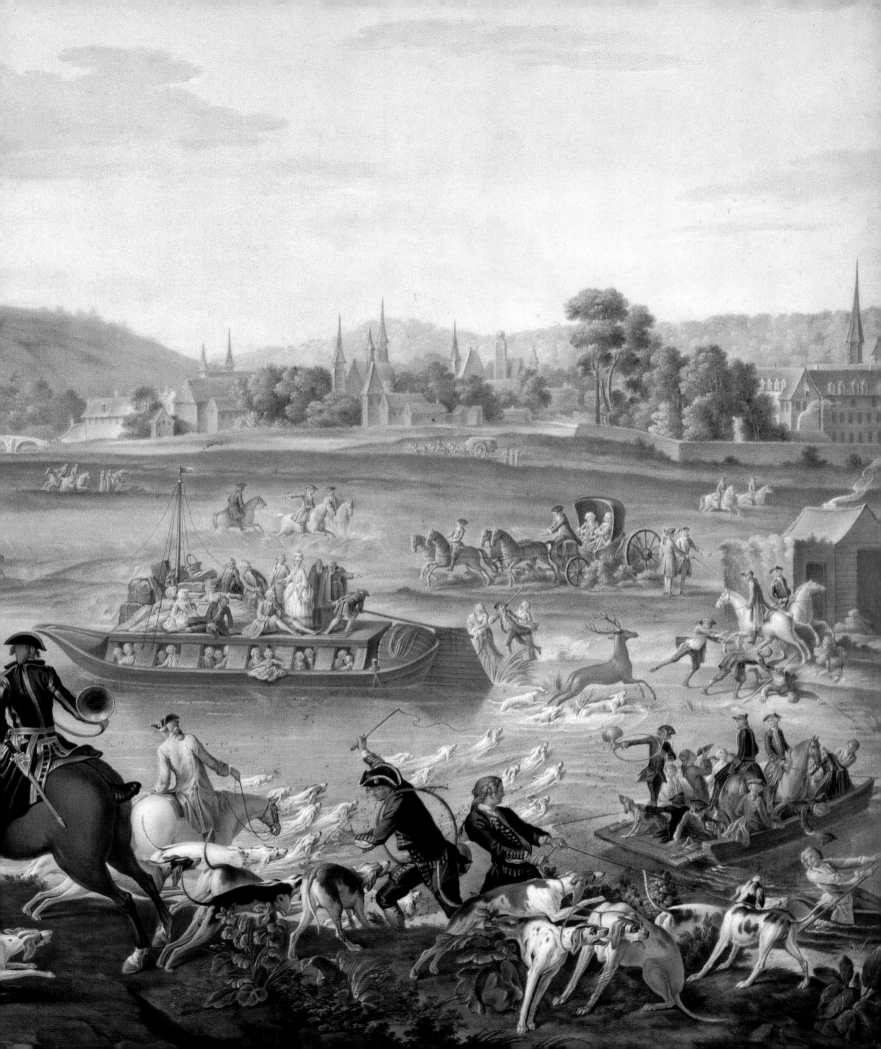

The Queen and Her Circle

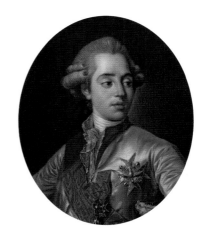

Little by little, the queen abandoned the "old court" in favor of a set of young courtiers of her own age, who came to be known as *Société Particulière de la Reine*—the Queen's Private Society. These "bosom friends" and favorites of the moment included the comte de Vaudreuil, the princesse de Guéméné, the duc de Coigny, the baron de Besenval, Count Esterhazy, whom she called "my brother," the duc de Guînes, the "handsome Lauzun," a womanizer with a turbulent love life, and her indispensable companion Axel von Fersen. Her high-spirited brother-in-law, the comte d'Artois and future Charles X, a notorious spendthrift, was always there to join in the fun and games.

One member of this inner circle, Yolande Martine Gabrielle de Polastron, comtesse de Polignac, deserves special mention. Her contemporaries were full of praise for her extraordinary beauty, on clear display in her portrait by Élisabeth Louise Vigée-Lebrun. The countess is depicted wearing a *gaulle*, a lightweight, airy, white muslin shift. Its scooped neckline is emphasized by a ruffle gathered by a sky-blue ribbon, and, as in children's dresses, a broad sash is tied around the waist and knotted at the back. Her straw hat is adorned with wild flowers and a downy black feather. She looks utterly natural and charming with her big, expressive blue eyes, dark brown, silky hair, and fresh, sparkling complexion. For the Goncourt brothers, everything about her was "angelic, but angelic like the dark-haired misnamed angels of Italy, who are in fact *amorini*." Marie-Antoinette noticed the striking young woman at a ball at the Château of Versailles in the autumn of 1775 and was captivated by her lively sense of fun. When the queen expressed surprise at not having seen her at her wedding celebrations, the countess confessed she had kept away from court because she was in serious financial straits and therefore unable to make a good impression. The queen was touched by her honesty. To keep her new friend close and to compensate for the misfortune she had suf-fered, she showered her with gifts and favors. These included an allowance of 80,000 livres, "the finest apartment at Versailles," and, in 1782, the title of duchesse and the appointment as Governess to the Children of France. The duchesse de Polignac soon supplanted the princesse de Lamballe in the queen's affections. Marie-Antoinette's deeply felt attachment to her would endure until her death.

Above:
The comte d'Artois, Marie-Antoinette's brother-in-law and the future Charles X, a key figure in her social circle.

Facing page:
Yolande de Polignac, depicted here by Élisabeth Louise Vigée-Lebrun in 1782, played a very important role in Marie-Antoinette's world. The two women were intimate, devoted friends.

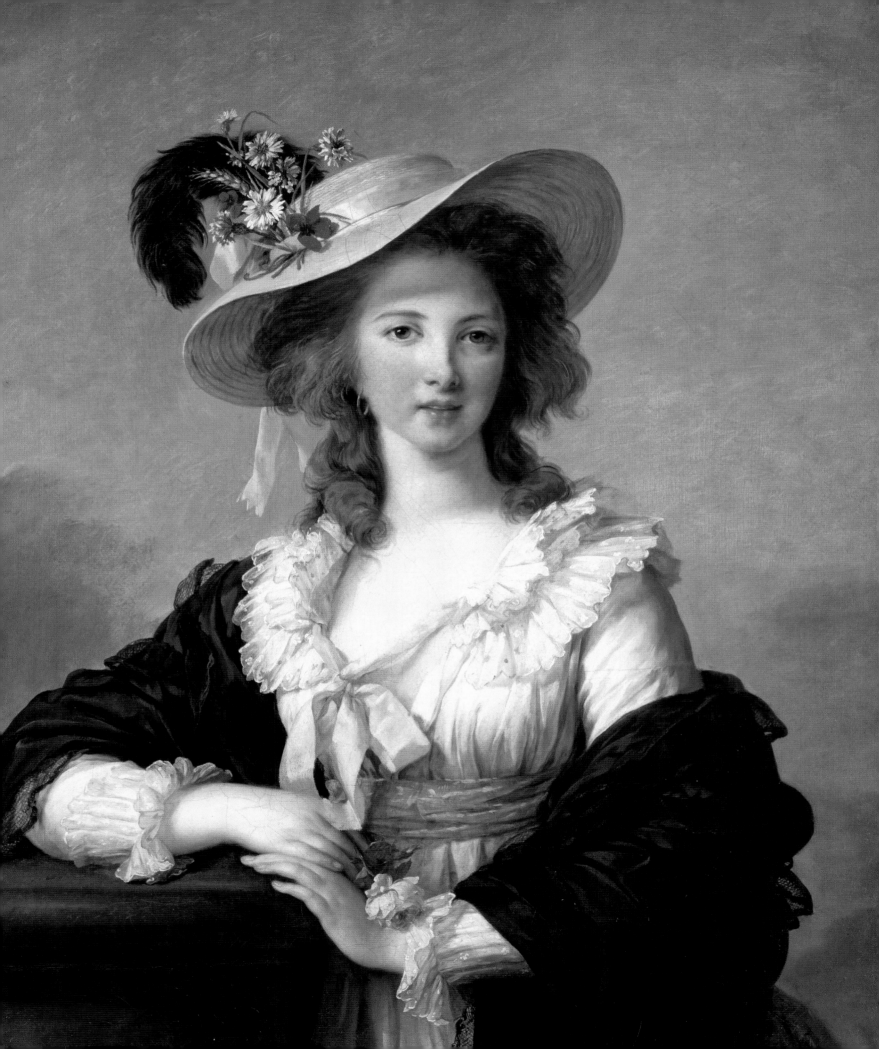

FUN AND GAMES

Games were an essential part of eighteenth-century social life—games of skill, riddles and brainteasers, games of chance, and gambling. Marie-Antoinette was a keen gambler and had a special fondness for faro, a card game played for high stakes, which could last all day. These diversions offered an outlet for her love of risk taking and served to show the court that a French queen was not afraid of losing money. They also helped her cultivate the art of conversation.

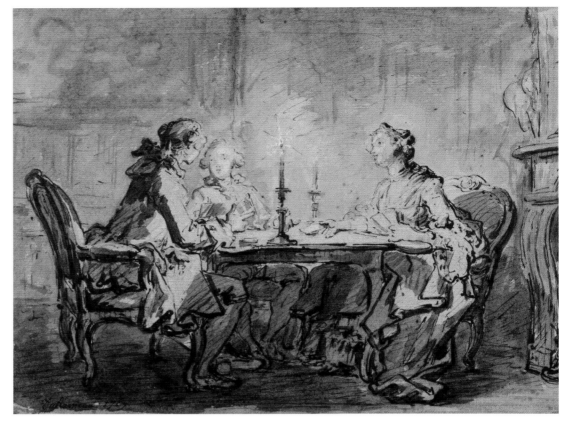

Below:
Counter box "at the sign of the purple monkey," with mother-of-pearl counters, eighteenth century, by Martin-Guillaume Biennais.

Above:
This drawing by Louis Jean-Jacques Durameau shows a lady and two gentlemen playing cards by candlelight.

Below:
Playing cards that belonged to Marie-Antoinette; some have the names of other players written on them in Marie-Antoinette's handwriting.

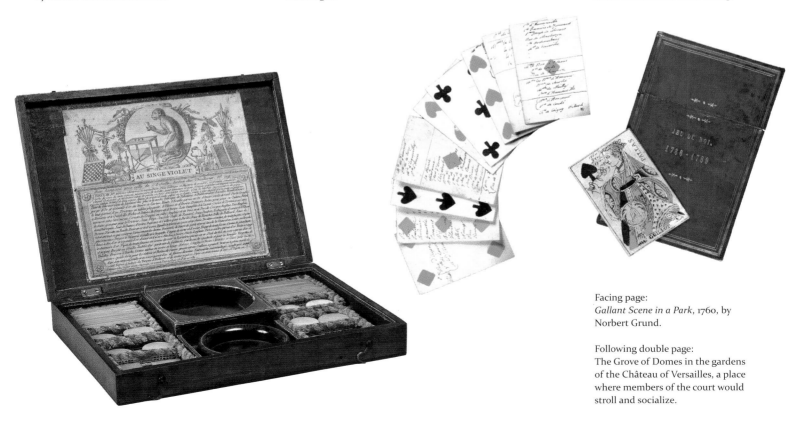

Facing page:
Gallant Scene in a Park, 1760, by Norbert Grund.

Following double page:
The Grove of Domes in the gardens of the Château of Versailles, a place where members of the court would stroll and socialize.

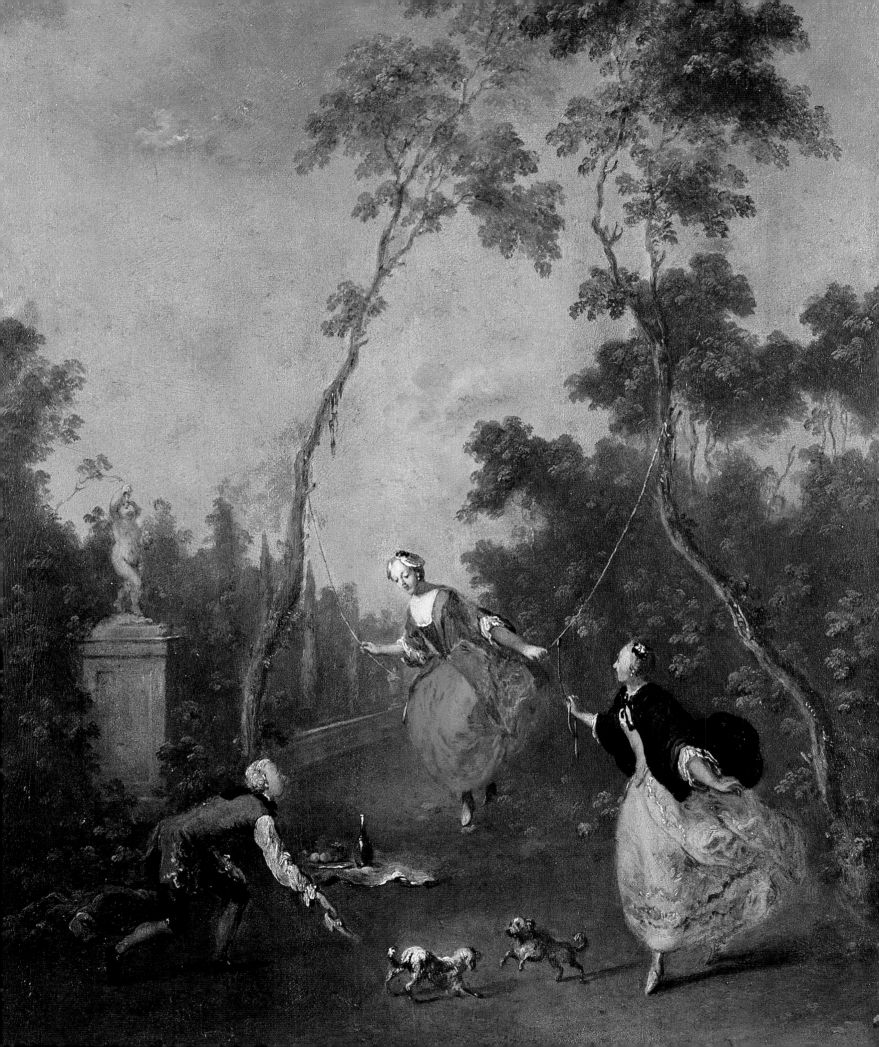

Dressing the Queen:
"A Masterpiece of Etiquette"

The queen's clothing was managed by the *service de la Garde-Robe*, one of the five departments of the Queen's Household. This was directed by the *dame d'atours* (Mistress of the Robes), a post first held by the duchesse de Mailly and then, from 1781, by Madame d'Ossun. The latter supervised a number of *femmes de chambre* (Women of the Bedchamber) and other staff, such as chambermaids, seamstresses, menders, and valets. The *dame d'atours* was responsible for providing a fixed number of dresses divided into three groups: twelve *grands habits* for important state occasions, twelve slightly less formal *robes à la française*, then *à la turque* toward the end of her reign, and twelve informal *robes à la polonaise*, as well as simple white *chemises* in the English style, to be worn at card games and private suppers. Velvet in winter, satin in spring, light silk and gauze in summer, these dresses were replaced at the end of each season. Following court etiquette, the discarded dresses were distributed among the staff in a clearly defined order according to rank, which explains the rarity of royal costumes in French collections, unlike those from other European courts. The National Archives possess a rare volume bound in green parchment inscribed on the cover *Madame la comtesse d'Ossun. Garde-robe des atours de la reine. Gazette pour l'année 1782*. Inside are fabric samples from the dresses worn by Marie-Antoinette from 1782 to 1784, stuck on big white pages with red sealing wax. They reveal a palette of bright colors and fresh and lively patterns.

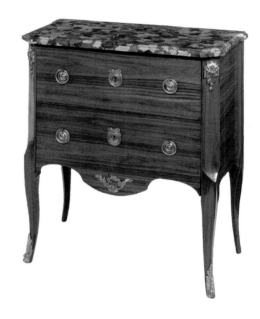

Even though court etiquette had been relaxed to a certain extent since the reign of Louis XV, the queen's day was still regulated like clockwork. She rose at eight o'clock. The First Woman of the Bedchamber gave her a folder containing samples of the different dresses of the day. Marie-Antoinette marked her choices with a pin. She was then brought a covered basket containing the different outfits for the day, along with handkerchiefs and brushes. This was followed by bathing—the queen took a bath nearly every day—and breakfast, which would usually be a cup of coffee or chocolate, followed by prayers, *petites entrées* (ordinary receptions), and private audiences.

Above:
Regency commode delivered for the Petit Trianon, bearing the mark of the queen's Garde-Meuble.

Facing page:
Page from the queen's pattern book, the *Gazette des atours de la reine*. Next to each swatch of fabric are different names, including those of the *marchande de mode* Rose Bertin, the dressmaker Le Normand, and the haberdasher Lévesque. The engraving shows the queen in a lavish court dress.

Polonaise ~~robe turque~~ levite

le normand~~polonaise~~ garnie de blonde
~~turque~~ les vite

13

14

vegne

Lévitte garni par Mlle Bertin

15

mand ~~α~~

16

Mme de Norm

17

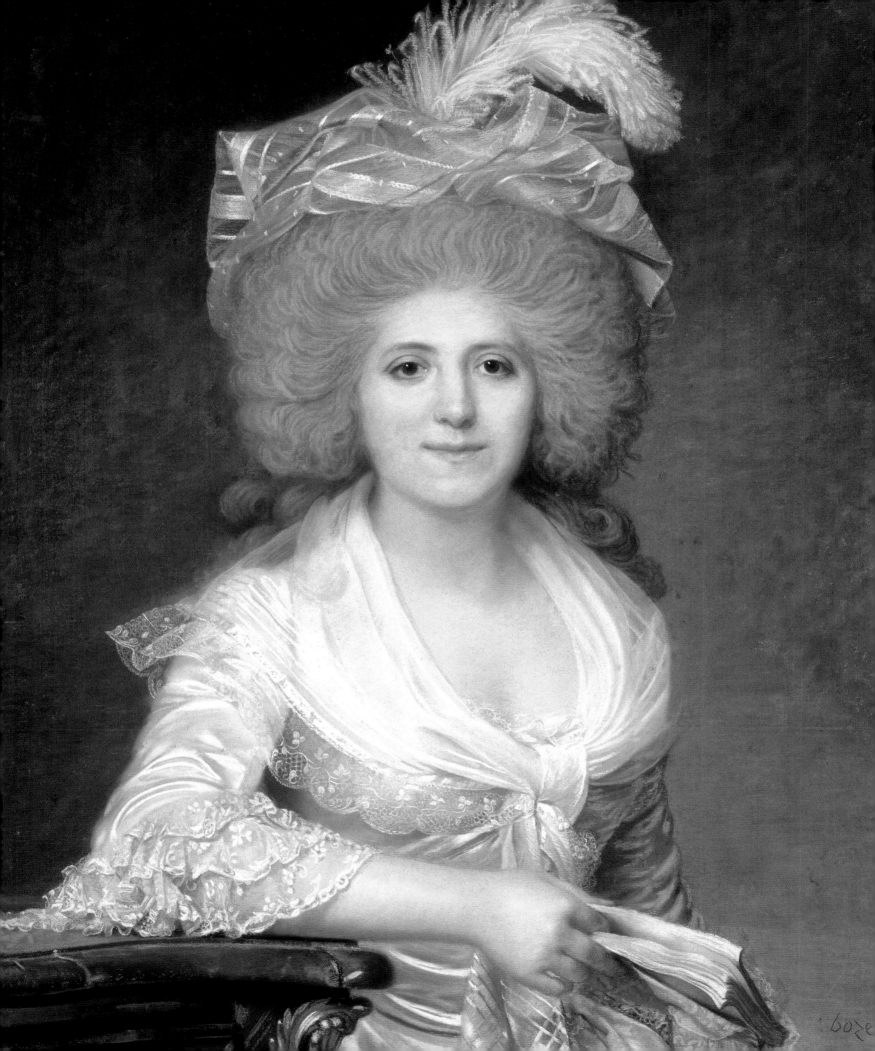

Next came the ceremony of the *toilette*, during which dignitaries who had the privilege of *grande entrée* would be received: the table, covered with a cloth on which the articles used for dressing were arrayed, was moved to the center of the room, and the queen's coiffure began. And finally there was the dressing ceremony, attended by an assembly of ladies of upper nobility seated on folding stools arranged in a quarter circle around the queen.

In a famous passage of her *Memoirs*, Madame Campan, First Woman of the Bedchamber to Marie-Antoinette, describes the dressing ritual, a "true masterpiece of etiquette," which followed the queen into the most intimate corner:

Everything was done in a prescribed form. Both the dame d'honneur *and the* dame d'atours *usually attended and officiated, assisted by the first* femme de chambre *and two ordinary women. The* dame d'atours *put on the petticoat and handed the gown to the Queen. The* dame d'honneur *poured out the water for her hands and put on her linen. When a princess of the royal family happened to be present while the Queen was dressing, the* dame d'honneur *yielded to her the latter act of office, but still did not yield it directly to the Princesses of the blood; in such a case the* dame d'honneur *was accustomed to present the linen to the first* femme de chambre, *who, in her turn, handed it to the Princess of the blood. Each of these ladies observed these rules scrupulously as affecting her rights. One winter's day it happened that the Queen, who was entirely undressed, was just going to put on her shift; I held it ready unfolded for her; the* dame d'honneur *came in, slipped off her gloves, and took it. A scratching was heard at the door; it was opened, and in came the Duchesse d'Orleans: her gloves were taken off, and she came forward to take the garment; but as it would have been wrong for the* dame d'honneur *to hand it to her, she gave it to me, and I handed it to the Princess. More scratching: it was Madame la Comtesse de Provence; the Duchesse d'Orleans handed her the linen. All this while the Queen kept her arms crossed upon her bosom and appeared to feel cold; Madame observed her uncomfortable situation, and, merely laying down her handkerchief without taking off her gloves, she put on the linen, and in doing so knocked the Queen's cap off. The Queen laughed to conceal her impatience, but not until she had muttered several times, "How disagreeable! How tiresome!"*

Marie-Antoinette could not see the need for many of these rituals and constraints and did her best to escape them. Little by little she replaced the protocol of the Château of Versailles with that of Vienna. She did not yet realize how serious a mistake she was making, but these were matters about which she felt very strongly.

Above:
Patch boxes for beauty spots. The spots were used to emphasize the beauty and whiteness of women's faces, which were very valued at the time.

Facing page:
Pastel representing Madame Campan, Marie-Antoinette's First Woman of the Bedchamber, by Joseph Boze, 1786.

Following double page:
Detail of a full-length portrait of Marie-Antoinette by Élisabeth Louise Vigée-Lebrun from 1778. The queen wears a spectacular white satin court dress.

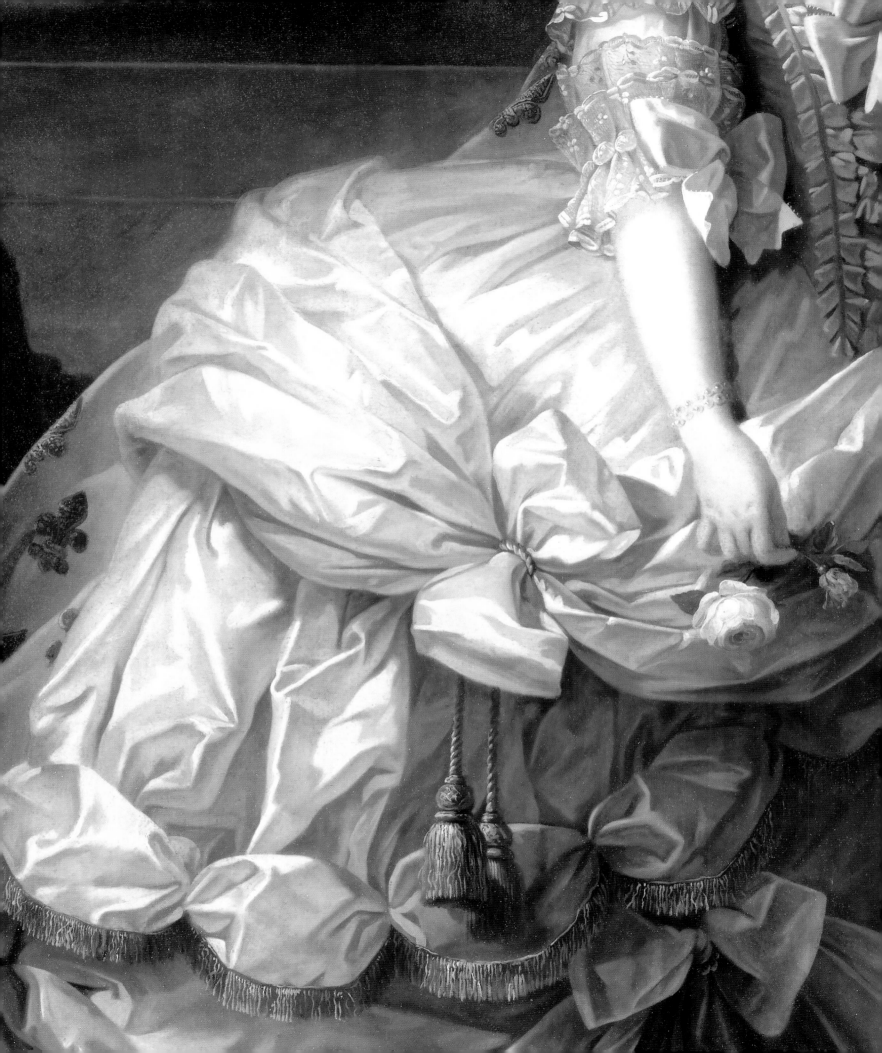

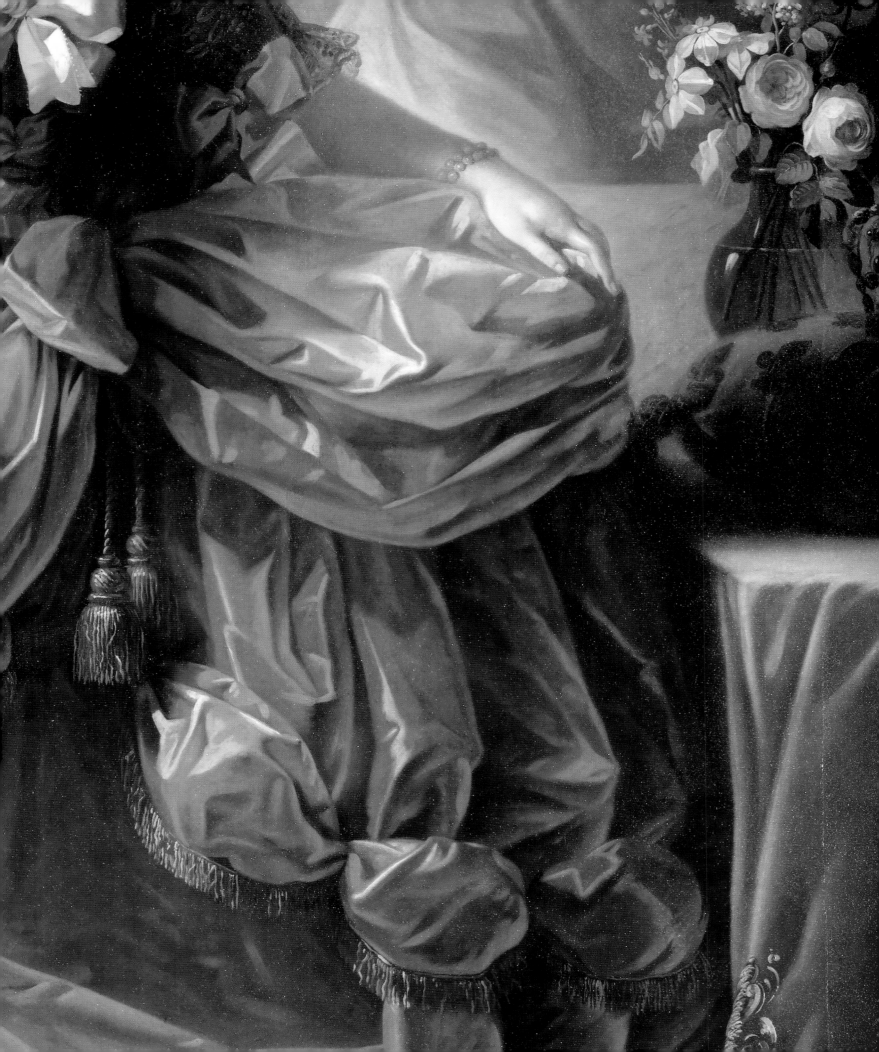

BATH TIME

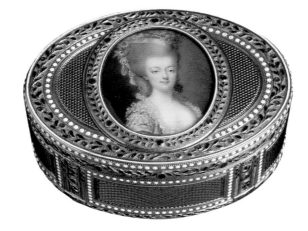

In Louis XIV's day, people were still wary of water. They thought that opening the pores, as water did, would allow disease to enter the body through the skin. Usually personal hygiene was limited to a rubdown with a clean, damp cloth. In those days, it was far more important to be seen wearing spotlessly white clothes. The cleanliness of the "underneath," namely the skin, came to symbolize a person's social status. As the notion of privacy became accepted in the eighteenth century, the pleasures of bathing were rediscovered, bringing with them a previously unparalleled array of sophisticated toiletries, such as perfumed soaps, scents, and the pomatums applied to the hair before powdering it, all created by Jean-Louis Fargeon, the queen's *maître gantier parfumeur*—master glove maker and perfumer. There were also beautifully crafted cosmetic containers, such as rock crystal scent bottles, cases of agate or enameled gold or silver for powder or rouge, as well as combs made of ivory or mother-of-pearl.

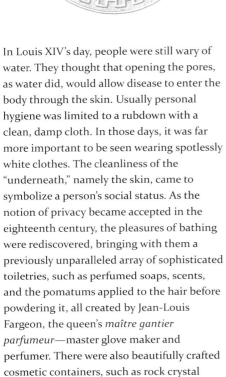

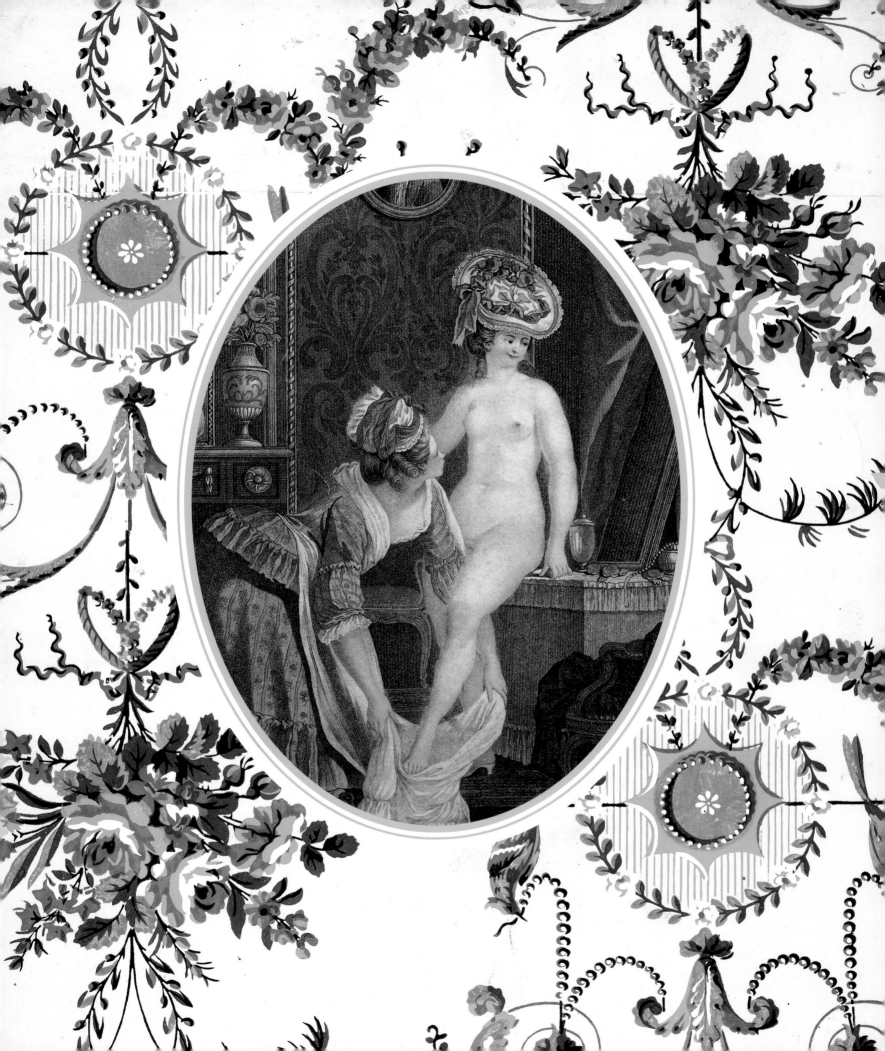

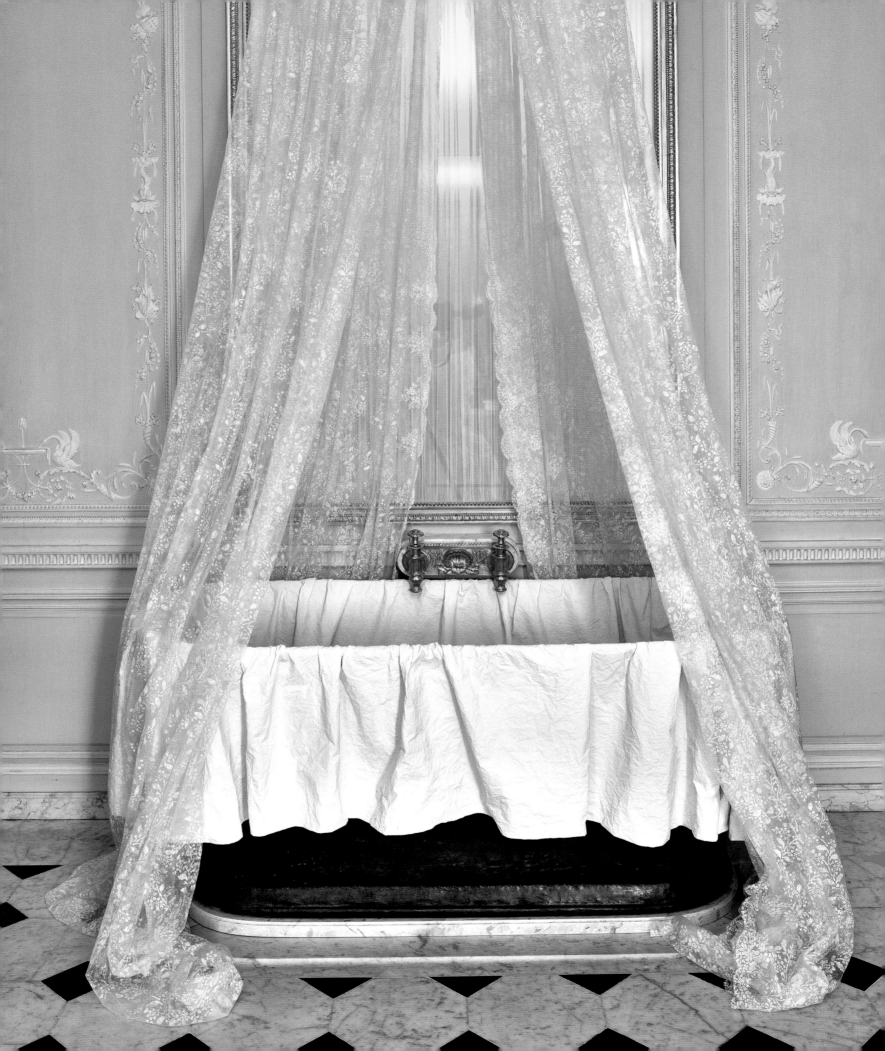

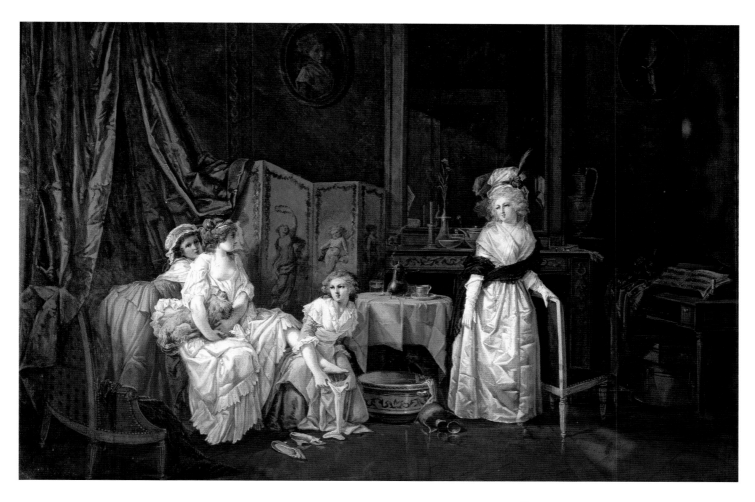

Above:
La toilette by Jean-Baptiste Mallet.

Facing page:
Marie-Antoinette's bathroom in her private apartments on the first floor of the Château of Versailles. It was reached via a staircase behind the queen's bedchamber.

Left and below:
Ewer and basin, soft-paste porcelain decorated with Chinese motifs. Toilet jar with Chinese motifs delivered by the Saint-Cloud porcelain factory.

Queen of Fashion

In matters of fashion, Marie-Antoinette, described by the Goncourt brothers as "the most womanly of all the women at court," was the trendsetter and arbiter of style. At court and in Paris, all the ladies strove to emulate her. Her intense interest in fashion was sparked by her introduction to Marie-Jeanne (commonly called Rose) Bertin, a humble dressmaker, whose rise in society had been spectacular. Thanks to her avant-garde creations, her shrewd marketing sense, and a celebrity status that was exceptional for a commoner, Bertin laid the foundations for haute couture, transforming the clothing industry from a craft into an art. Her Paris shop, Grand Mogul, already had a number of prestigious patrons when she was appointed the queen's official *marchande de modes*, or stylist, and she was rapidly dubbed "Minister of Fashion."

They were a perfect match. Marie-Antoinette was dazzled by Rose Bertin's creations, while for Bertin the beautiful, rich queen, hungry for novelty and always in the limelight, made a perfect "model." She guaranteed that Bertin's designs would be the talk of Europe. *Grands habits*—formal court attire—in heavy silk brocade woven in Lyon; ball gowns with several layers of skirts, tucked up with ribbons and lavishly decorated with tassels, fringes, bouillons, ruches, embroidered garlands of flowers, silver sequins, and spangles; new, lighter gowns *à la polonaise* or *à l'anglaise*, gauze fichus, fans, lace mantlets . . . With so much to choose from, Marie-Antoinette spent lavishly on Madame Bertin's ever-changing collection.

However, the most iconic image of the wildly extravagant French fashion of the time was the "pouf," a headdress created by Rose Bertin and Léonard, the queen's hairdresser. Supported by wire scaffolding, the pouf was made from various materials including horsehair, cloth, and the wearer's own hair, built up high above the forehead. All manner of objects were piled on top of it, including still lifes of flowers and fruit, birds, landscapes with gardens, theatrical scenes, and even ships plowing through rough seas. These showpieces also served as commentaries on current affairs. After Louis XVI and his brothers finally agreed to undergo the newly discovered medical procedure of inoculation, later known as vaccination, against smallpox, Marie-Antoinette proudly

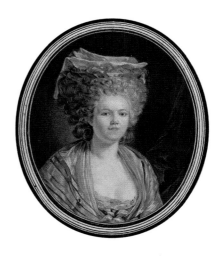

Above:
Mademoiselle Rose Bertin, Dressmaker to Marie-Antoinette by Jean-François Janinet, after Jean-Honoré Fragonard.

Facing page:
Fashion engraving: *New* robe à la circassienne *in Italian gauze lined with Indian taffeta*. With the enormous sums she spent on clothes, Marie-Antoinette caused a scandal and seriously damaged her image. She was now seen as a fashion queen, used as a showcase by the Parisian dressmakers who worked for her. On one occasion she rebuked a lady of the court for her modest attire, provoking the response: "Madame, we do not only have to pay for our own dresses, we also have to pay for yours!"

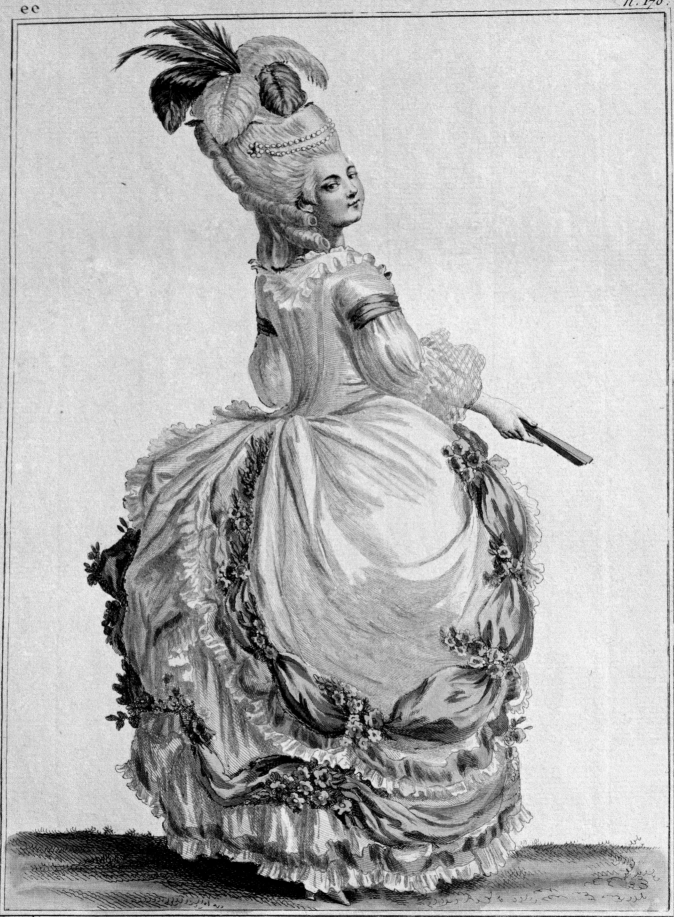

Desrais del. Pelissier Sculp.

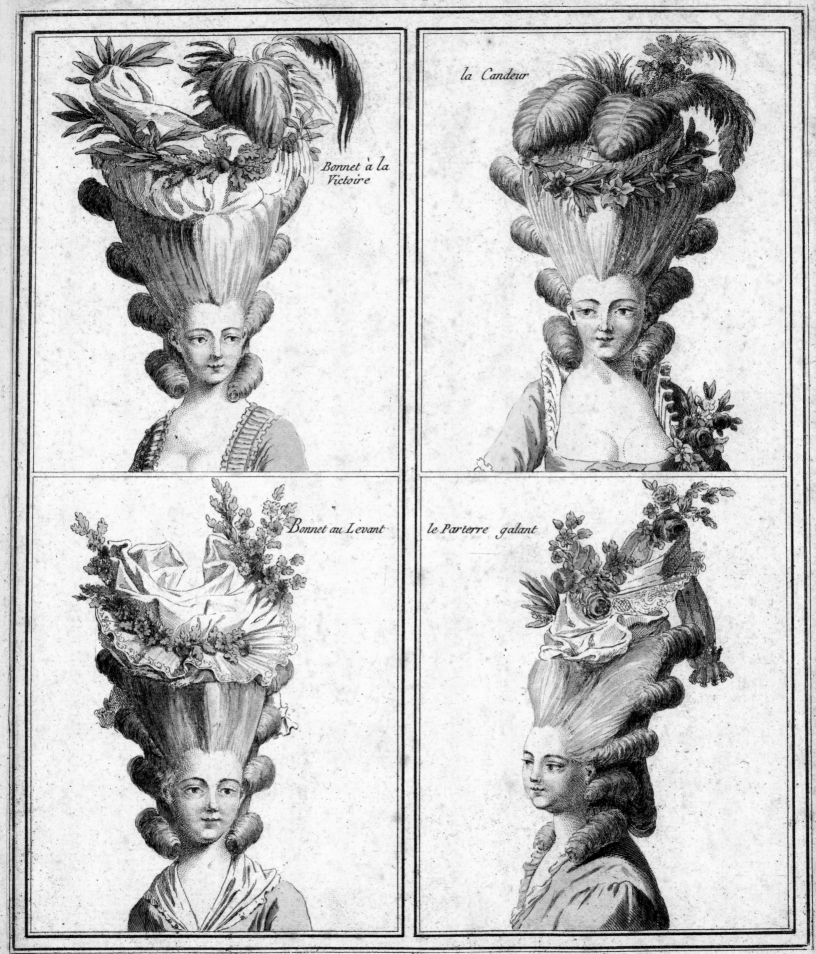

Bonnet à la Victoire

la Candeur

Bonnet au Levant

le Parterre galant

A Paris chez Esnauts et Rapilly rue St. Jacques à la Ville de Coutances.

sported an incredible *pouf á l'inoculation*, adorned with a rising sun and an olive tree in full fruit. A serpent, entwined around the trunk and threatened by a club garlanded with flowers, symbolized the triumph of science over disease and the dawn of a new golden age.

Louis XVI, who was unimpressed by this particular brand of sophistication, presented his wife with a diamond aigrette, which she promptly added to her forest of ostrich feathers! Her mother, the empress, was not at all happy about these coiffures, which were rising to increasingly dizzying heights. When she was shown a portrait of her daughter wearing the latest fashions, she sent it back, with the angry comment: "No, this is not the portrait of a queen of France. There has been some mistake. It is a portrait of an actress!"

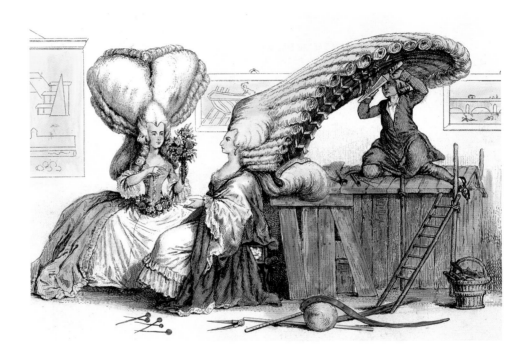

Facing page:
First series of French designs for coiffures from 1776 by Gabriel Jacques de Saint-Aubin.

Above:
Colored engraving mocking the elaborate, towering coiffures that Marie-Antoinette helped to make fashionable.

Right:
Hair aigrette from Marie-Antoinette's time with gold and silver and set with amethysts.

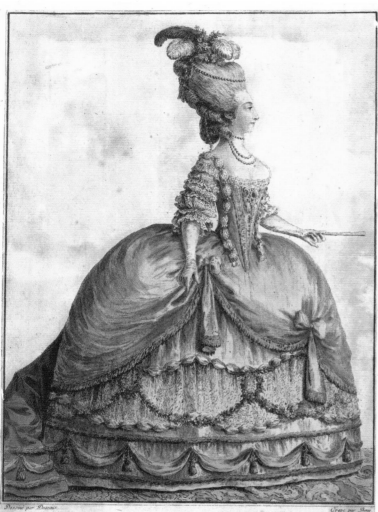

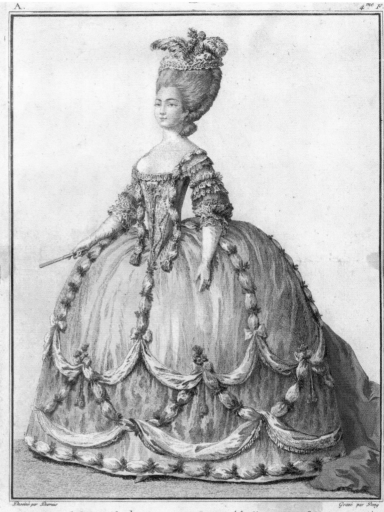

Above:
Colored fashion engravings by
Claude-Louis Desrais depicting
Marie-Antoinette's two sisters-
in-law.

Right:
Shoes from Marie-Antoinette's
time.

Facing page:
Portrait of Marie-Antoinette
attributed to François-Hubert
Drouais, which the queen gave
her confessor as a gift in 1781.

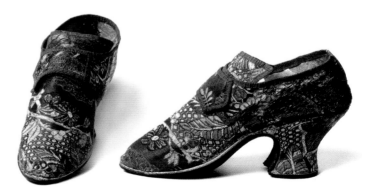

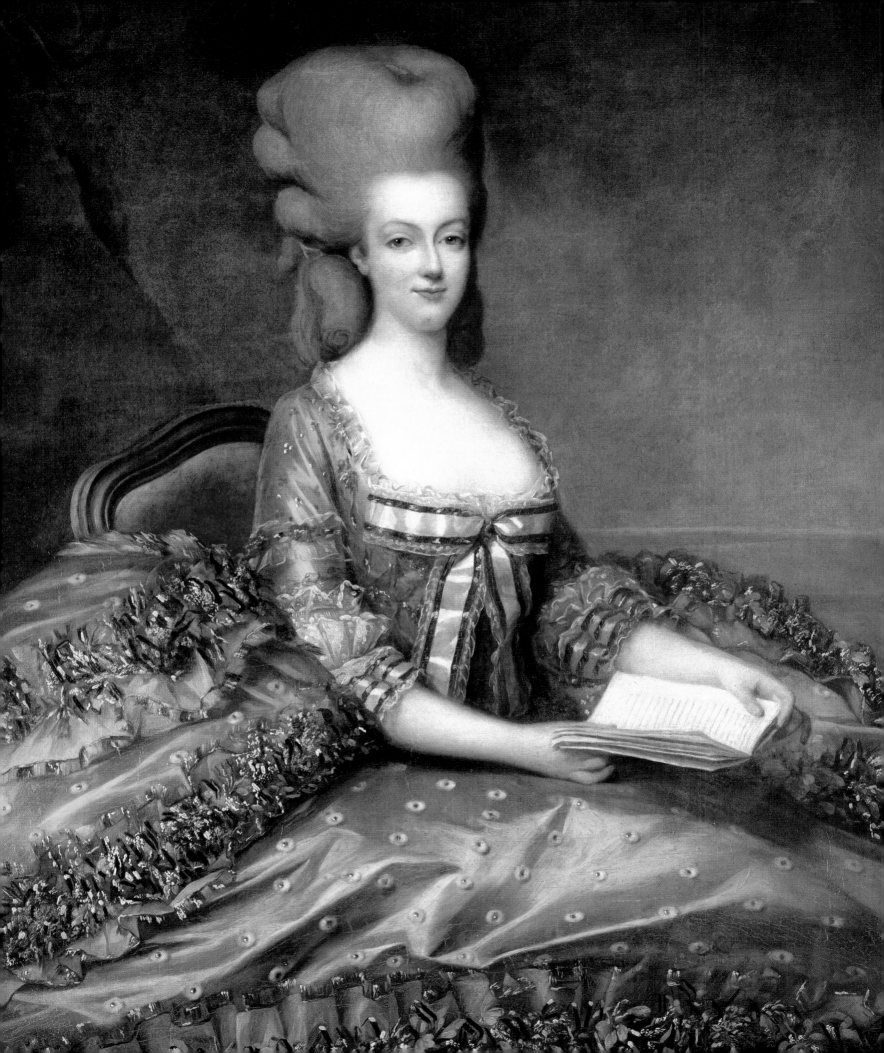

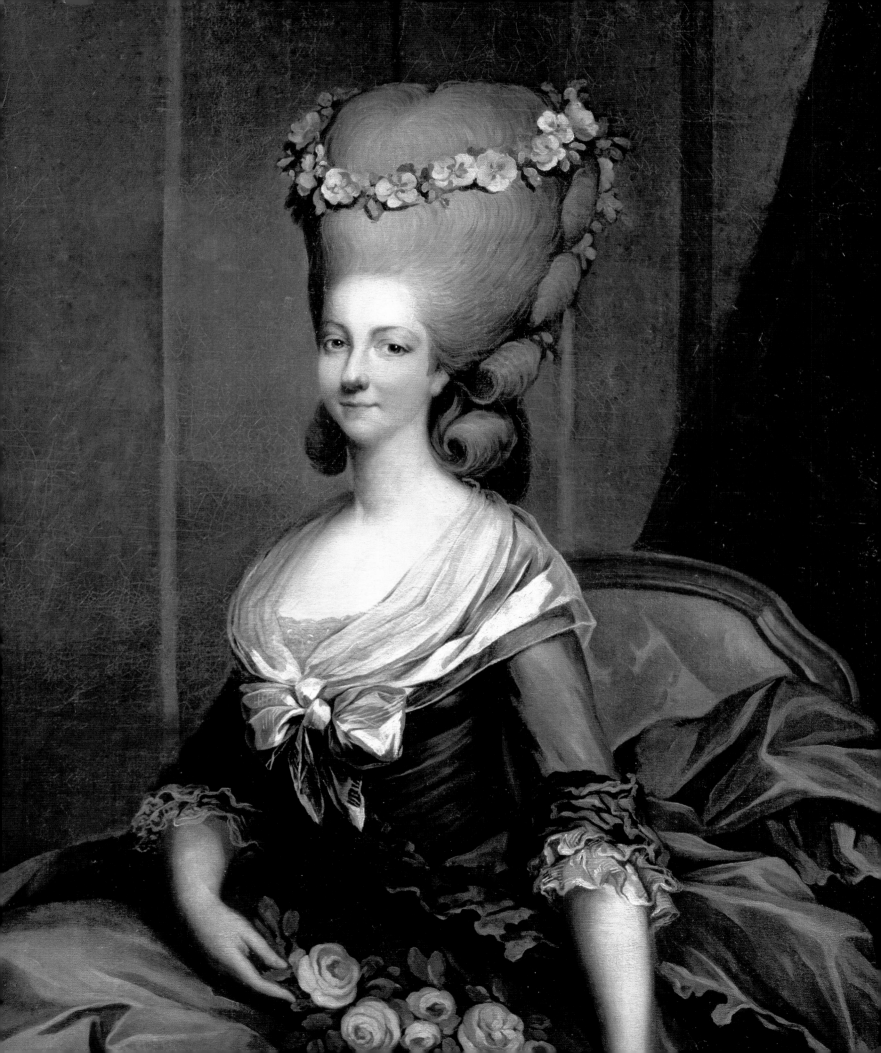

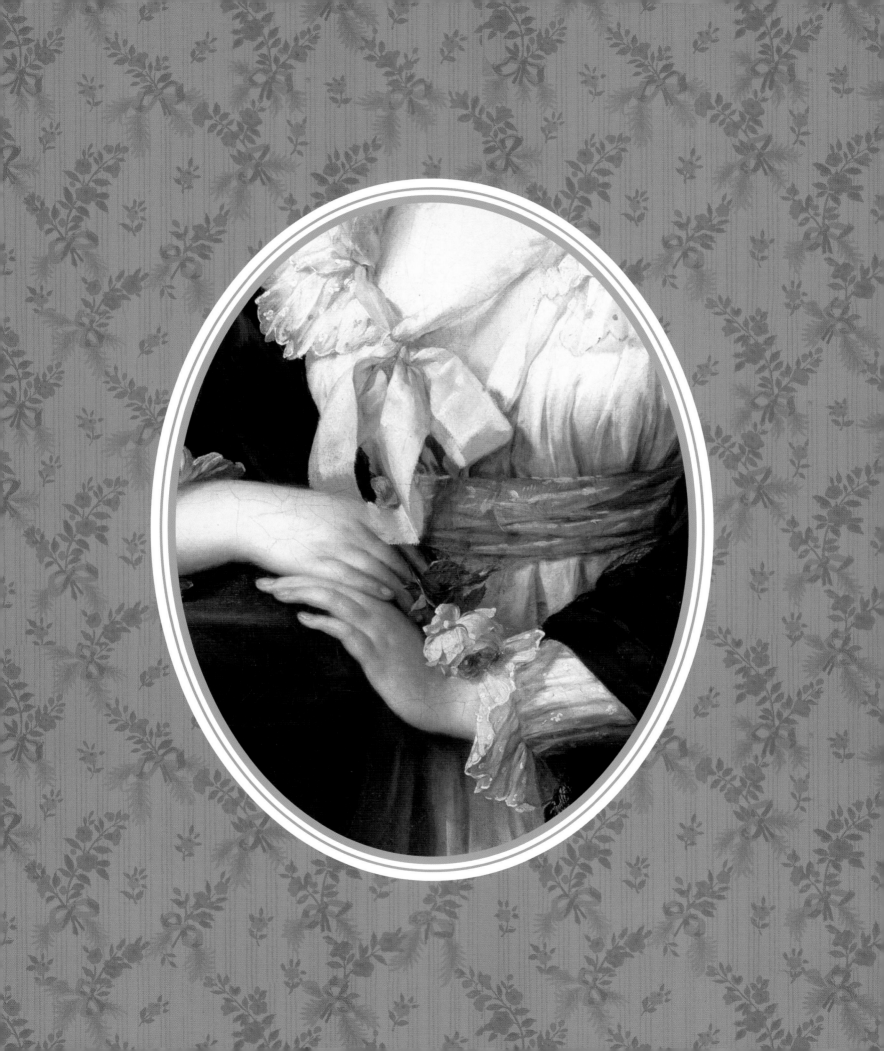

A Whirlwind of Pleasures

Carefree and "empty-headed," as her family described her, Marie-Antoinette was swept away in a giddy whirl of amusements. At the Château of Versailles there were the grand balls that she revived in the Hercules Salon, the games tables where she lost astronomical sums of money, and the sled races on the snow-covered avenues of the park and, when it froze over, on the Grand Canal. She wanted to enjoy all the pleasures that being queen of France could offer, at Versailles, Trianon, Marly, Fontainebleau, Saint-Cloud, or Rambouillet. For her, this was the real world, and she would increasingly sacrifice the essential for the superficial.

These traditional amusements were quite permissible within the walls of the Château of Versailles and in the king's presence. But Marie-Antoinette also went to balls at the Paris Opera without the king and sometimes incognito. Her brother Joseph II was horrified: "Do you imagine that it will not be common knowledge by the very next day?" he wrote to her. "You leave the king behind all night in Versailles while you mix with all the riffraff of Paris!" In her letters, Marie-Antoinette described the tricks she played on her husband—putting a clock forward one evening so he would retire earlier, for example—leaving her free to go out and enjoy herself. She also revealed how she manipulated the king. Somewhat naively, she told her friend Count Rosenberg how she had induced Louis XVI to arrange a meeting for her with the duc de Choiseul. "I managed it so well," she wrote, with a mixture of contempt and pity, "that the poor man settled himself the hour at which it would be most convenient for me to see him." *The poor man . . .* her phrase would spread throughout Europe. It stunned Maria Theresa, who suddenly grasped how little respect there was for Louis XVI, not only from his wife but also at the French court, and soon from the people of France. She sent her daughter a sharp warning: "What a tone! 'The poor man!' Where is the respect and the gratitude you owe him for all his kindness? [. . .] you may be plunged, by your own doing, into the greatest calamities. [. . .] You will realize all this one day, but it will be too late. I hope not to survive that dreadful time."[7]

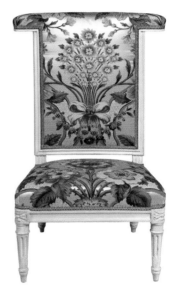

Preceding double page:
Left:
A portrait of the princesse de Lamballe by the workshop of Antoine-François Callet. She was Marie-Antoinette's first close female friend, before being supplanted in the queen's favor by Madame de Polignac. After the latter went abroad, Madame de Lamballe regained her place in the queen's heart. She was savagely beheaded and disemboweled during the massacres of September 1792.

Right:
A portrait of Madame de Polignac (detail) by Élisabeth Louise Vigée-Lebrun.

Above:
Voyeuse chair from Marie-Antoinette's game room at the château de Fontainebleau. Chairs like these allowed people watch a game without taking part in it.

Facing page:
The Belvedere pavilion in the gardens of the Petit Trianon illuminated for a festival on a summer night in 1781, immortalized by Claude-Louis Châtelet.

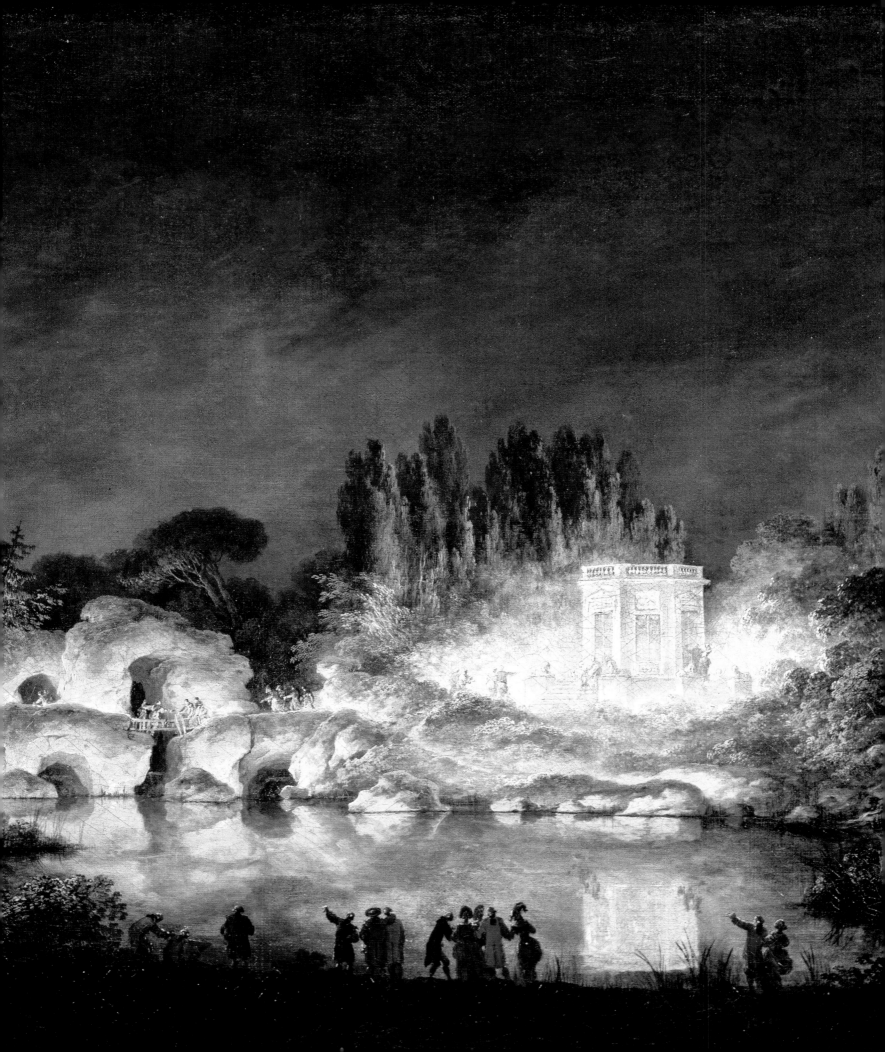

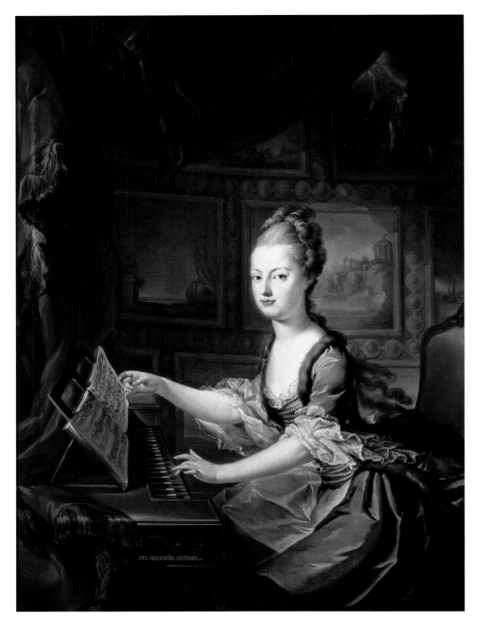

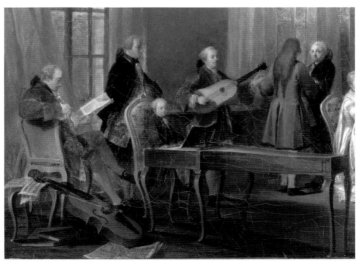

Above:
Marie-Antoinette practiced playing
the harpsichord and the spinet from
childhood. She is depicted playing
the spinet in this painting by Franz
Xaver Wagenschön from 1770.

Right:
Detail of the painting *English Tea
Served in the Salon des Glaces at
the Palais du Temple in Paris in
1764* by Michel Barthélémy Ollivier,
showing a reception for the young
Mozart organized by the prince
de Conti. The child prodigy from
Salzburg had also played at the
court in Vienna.

Far right:
Detail of an eighteenth-century
wallpaper.

98

MUSIC

Like most princesses of the period,
Marie-Antoinette received a sound musical
education. She played the harp and the
harpsichord and also sang. Her favorite
composers were Gluck and Grétry, as well
as Pierre-Alexandre Monsigny, Antonio
Sacchini, and Giovanni Paisiello. Many
concerts were held at the Château of
Versailles, often in the open air in the
palace gardens, and Marie-Antoinette also
organized small recitals in her private
apartments and at the Petit Trianon. "I
arrange a concert every Monday, which is
delightful," she wrote in 1775. "All the rules
of etiquette are forgotten, I sing with a
company of chosen ladies, who also sing.
There are some agreeable men, too."

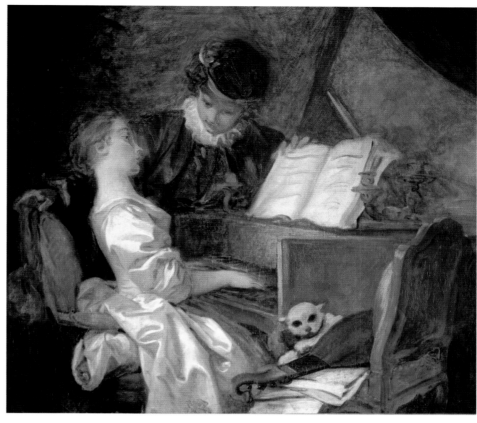

Above:
The Music Lesson, ca. 1769, by
Jean-Honoré Fragonard. The young
woman plays the harpsichord; a lute
rests on the chair.

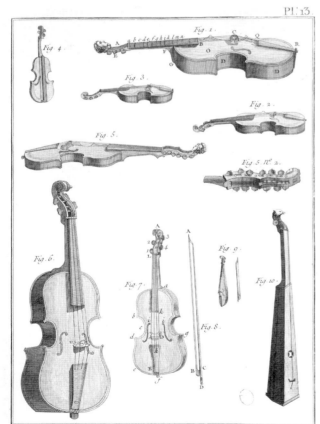

Instrumens de Musique, Instruments qui se touchent avec l'Archet.

Above:
Detail of an eighteenth-century
wallpaper.

Left:
*Musical instruments played
with a bow*, plate from the
Encyclopédie. Marie-Antoinette
did not play the violin but often
listened to violin music.

Following double page:
Left:
The *cabinet doré*, on the second
floor of the Château of Versailles,
is one of the most beautiful rooms
of the queen's private apartments.

Right:
Jean-Baptiste André Gautier-
Dagoty depicts Marie-Antoinette
playing the harp in her
bedchamber, surrounded by
singers; behind her a guitar sits on
a folding stool.

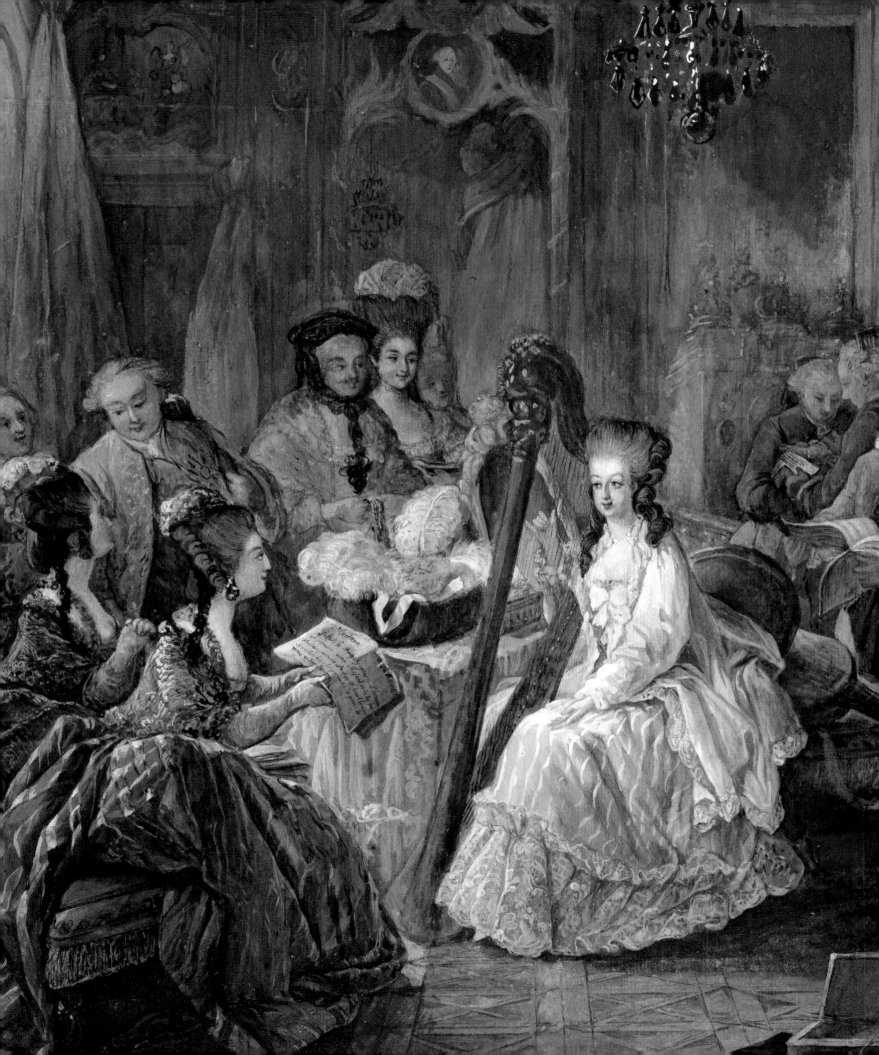

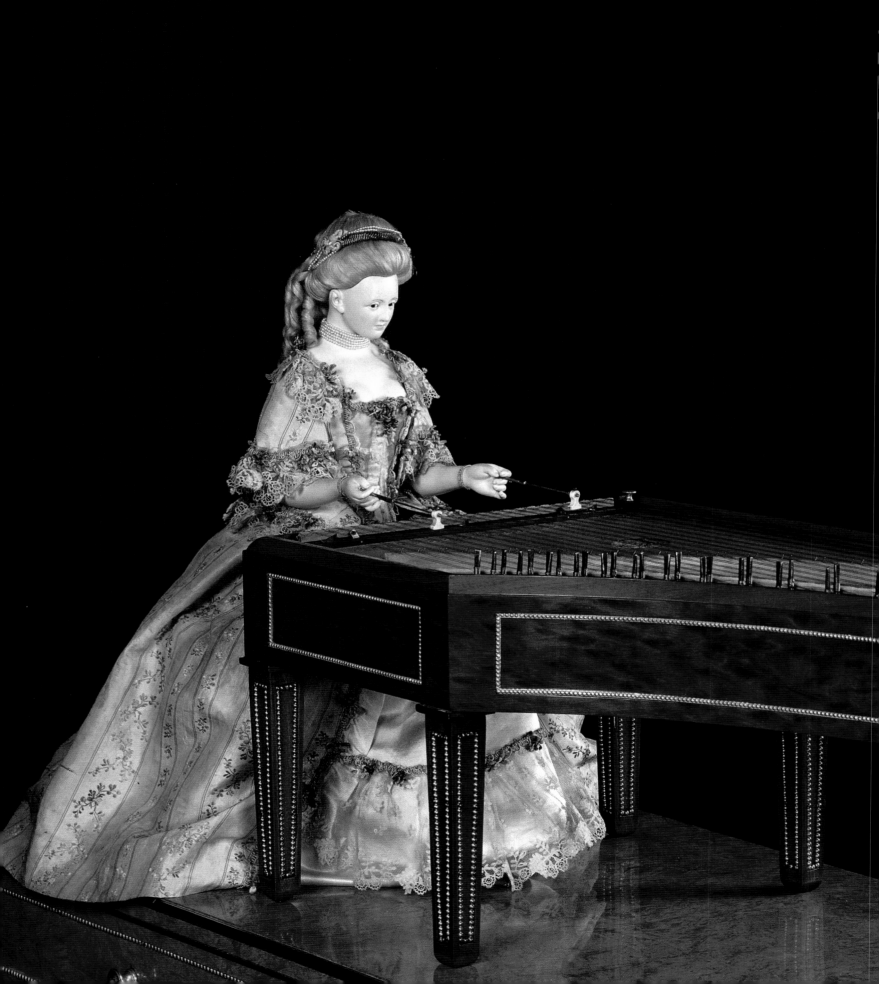

When Marie-Antoinette saw this dulcimer-playing automaton, created in Germany by the clockmaker Peter Kintzing and cabinetmaker David Roentgen, in a concert at the Château of Versailles in 1784, she was so impressed that she immediately bought it for the French Academy of Sciences. The dulcimer's mechanism, hidden under the skirt, is extremely complex: like a true musician, the young woman strikes its metal strings with two tiny hammers. It is kept today at the Musée des Arts et Métiers in Paris and still plays eight different pieces of music.

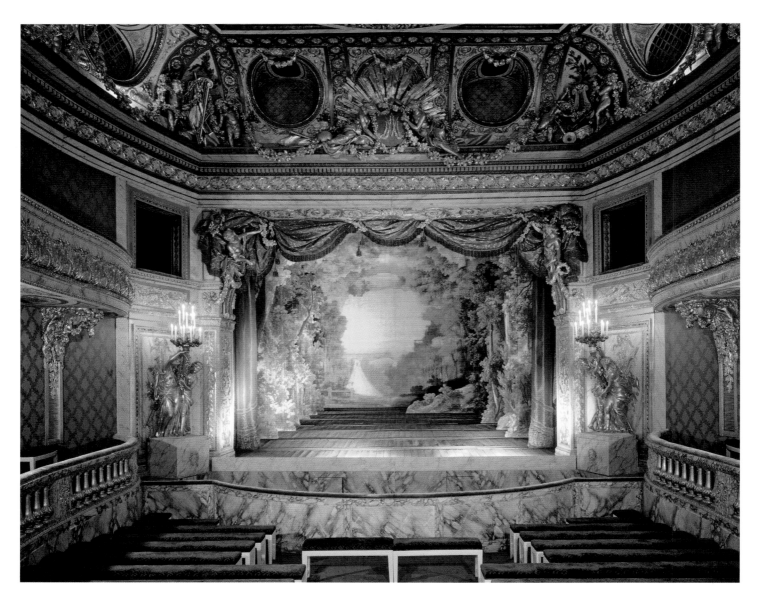

Above:
Built between 1778 and 1780, the Queen's Theater at the Petit Trianon is one of the very few from this era to still have its stage machinery in working order. Marie-Antoinette stopped performing in plays after 1785.

THEATER

Marie-Antoinette loved to act on stage. She had a little theater built at the Petit Trianon, where she performed in comedies and comic operas. According to Madame Campan, her First Woman of the Bedchamber, a spectator at one performance remarked, "Well, this is royally ill-played." In response, the queen formed her own theater company with friends, the *Troupe des Seigneurs*, and handpicked the audience, which inevitably led to jealousy and resentment at Versailles.

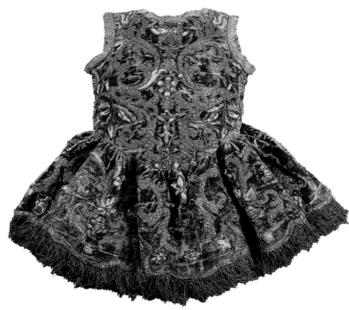

Left:
Stage costume from the early eighteenth century made from velvet and silk and embroidered with gold metallic thread.

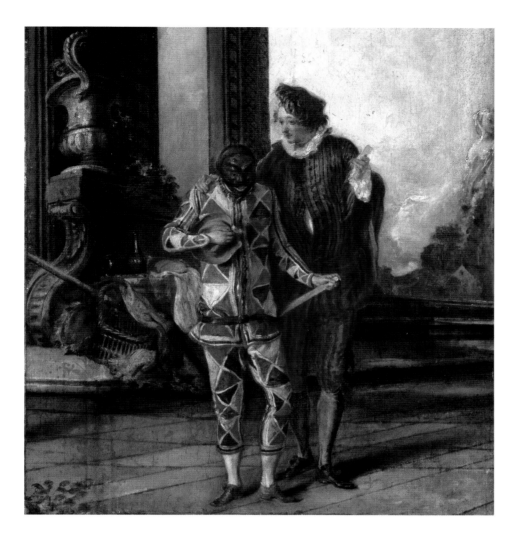

Above left:
Harlequin with the actor Luigi
Riccoboni in a scene from the Comédie
Italienne. The Comédie Italienne
troupe performed regularly at the
court.

Above right:
Telescopic opera glasses from the early
nineteenth century.

Right:
Crowd watching a performance by a
popular troupe of players at an open-
air theater on the boulevard du Temple
in Paris.

DANCE

A keen dancer, Marie-Antoinette was taught in Austria by the French ballet master Jean-Georges Noverre. Soon after her arrival at Versailles, the grand ball to celebrate her wedding gave her the chance to take to the floor. Although she did not always keep in step with the music, courtiers were ready to forgive the young dauphine. As Horace Walpole so elegantly put it: "They say she does not dance in time, but then it is wrong to dance in time." Marie-Antoinette also regularly attended Paris Opera balls, and on becoming queen, she established a series of Carnival balls at the Château of Versailles, held between Twelfth Night and Shrove Tuesday. These were an opportunity for courtiers to get together and enjoy themselves, but also for the queen to spread a more relaxed, informal atmosphere in the court and to show off new and ever more extravagant outfits. She also transformed the dance repertoire, gradually replacing the antiquated minuet with the livelier quadrille. From 1786, wooden pavilions were erected in the Royal Courtyard and the Parterre du Midi to create more space for the growing numbers of courtiers invited to the balls.

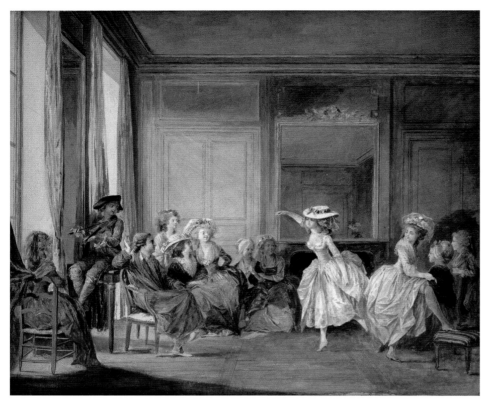

Above:
A depiction of a dancing lesson from Marie-Antoinette's time. Dancing was very much a social art form; it helped to teach correct deportment and to instill the rules of courtesy.

Left:
Case for dance cards in the shape of a viola da gamba.

Right:
The Ball by Louis-Nicolas van
Blarenberghe; miniature painted
on the lid of a snuffbox.

Below:
Marie-Anne Cupis de Camargo,
depicted here by Nicolas Lancret,
was one of the greatest ballerinas
of the eighteenth century in Paris.
She died in 1770.

Following double page:
The circular salon of the
Belvedere at the Petit Trianon.
Marie-Antoinette used this small
pavilion as a music room.

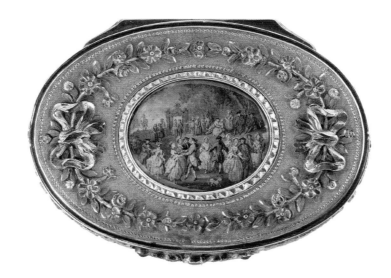

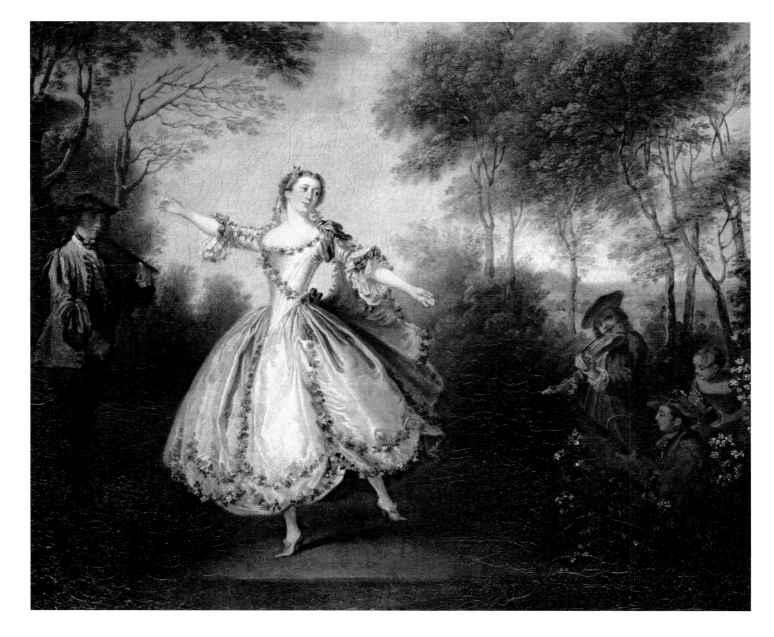

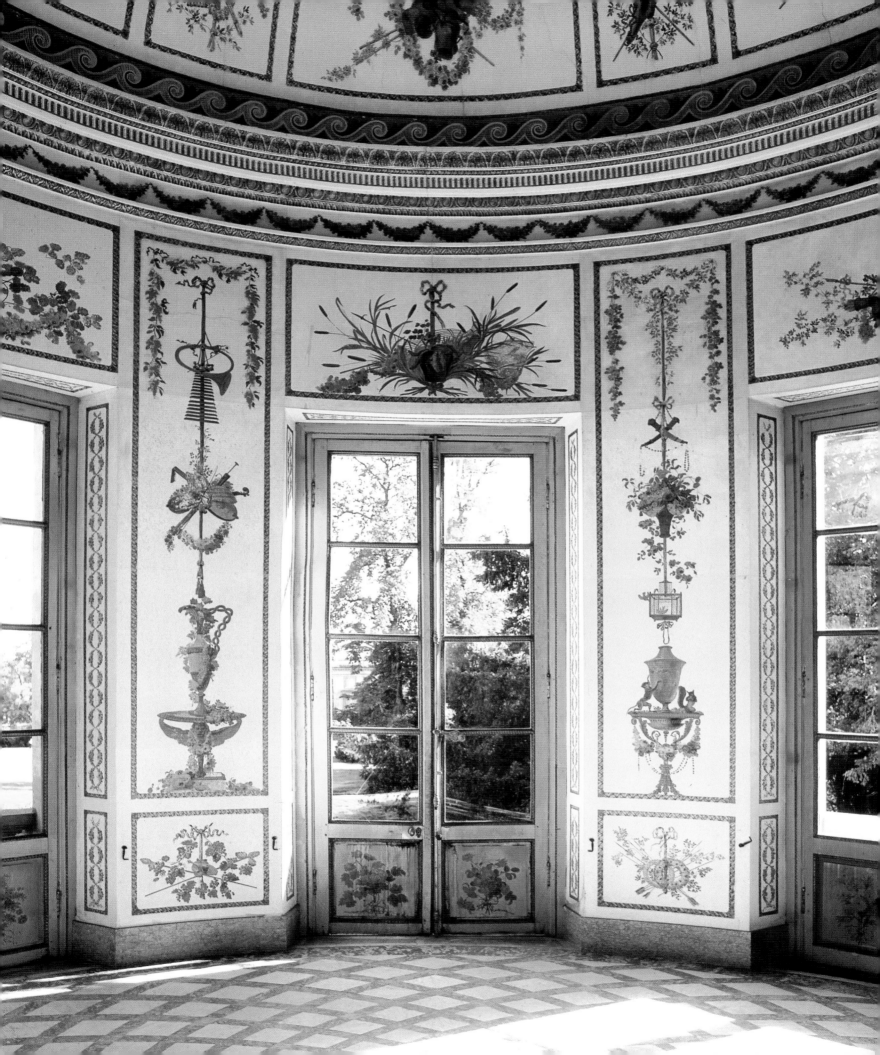

Petit Trianon—
The Queen's Refuge

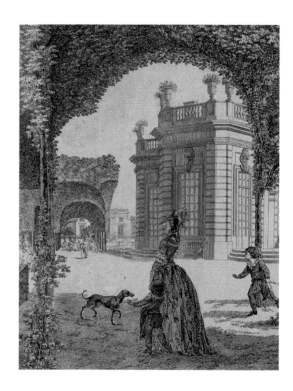

On May 24, 1774, Louis XVI made a gift to Marie-Antoinette of the Petit Trianon, a small château on the grounds of Versailles, and she soon turned it into her personal domain. It came to be seen as her own private version of Versailles, a place where she set the rules; the queen sheltered in this idyllic fantasy world until the end of her life.

Designed by Ange-Jacques Gabriel in the reign of Louis XV, this elegant Neoclassical building has a square floor plan, a flat roof with balustrades, and a five-bay façade. The interior decoration was refined yet simple, with far less gilding and embellishment than the Château of Versailles. As Pierre de Nolhac aptly put it, "Pure taste replaced the luxury one might have expected." In addition to the reception rooms, the queen had three salons on the mezzanine, a dressing room, a bedchamber, and a boudoir now known as the "cabinet of moving mirrors" because there was a mechanism for turning windows into mirrors, cutting off the outside world. On the walls, Marie-Antoinette hung many pictures to remind her of her family, so much so that some referred to the château as the sovereign's "little Schönbrunn."

But it was above all the enchanting gardens that made the Petit Trianon so special to the queen. Originally commissioned by Louis XV, the gardener Antoine Richard and the botanist Bernard de Jussieu had created a botanical garden that became famous across Europe for its elaborate floral displays, known as *théâtres de fleurs*, and its hothouses bursting with rare and exotic species—pineapples, coffee plants, aloes, zizania, prickly pears, and Chilean strawberries. All this held little appeal for Marie-Antoinette, who decided to follow the contemporary taste for "imitating nature" and replace it with an Anglo-Chinese garden. The work, directed by the architect Richard Mique and the painter Hubert Robert, began in 1774 and was completed in 1782. The Queen's Hamlet, the Hameau, took longer, but was finished in 1787. The formal grounds were completely relandscaped to create a "natural" garden with leafy glades, ornamental ponds, waterfalls, and a meandering stream, as well as a

Above:
Marie-Antoinette on a walk through the French gardens of the Petit Trianon around 1788. She holds the hand of the duc de Normandie (the future Louis XVII); on the right is the dauphin, Louis Joseph of France.

Facing page:
View of the French pavilion at the Petit Trianon, named for its location in the center of the "French gardens."

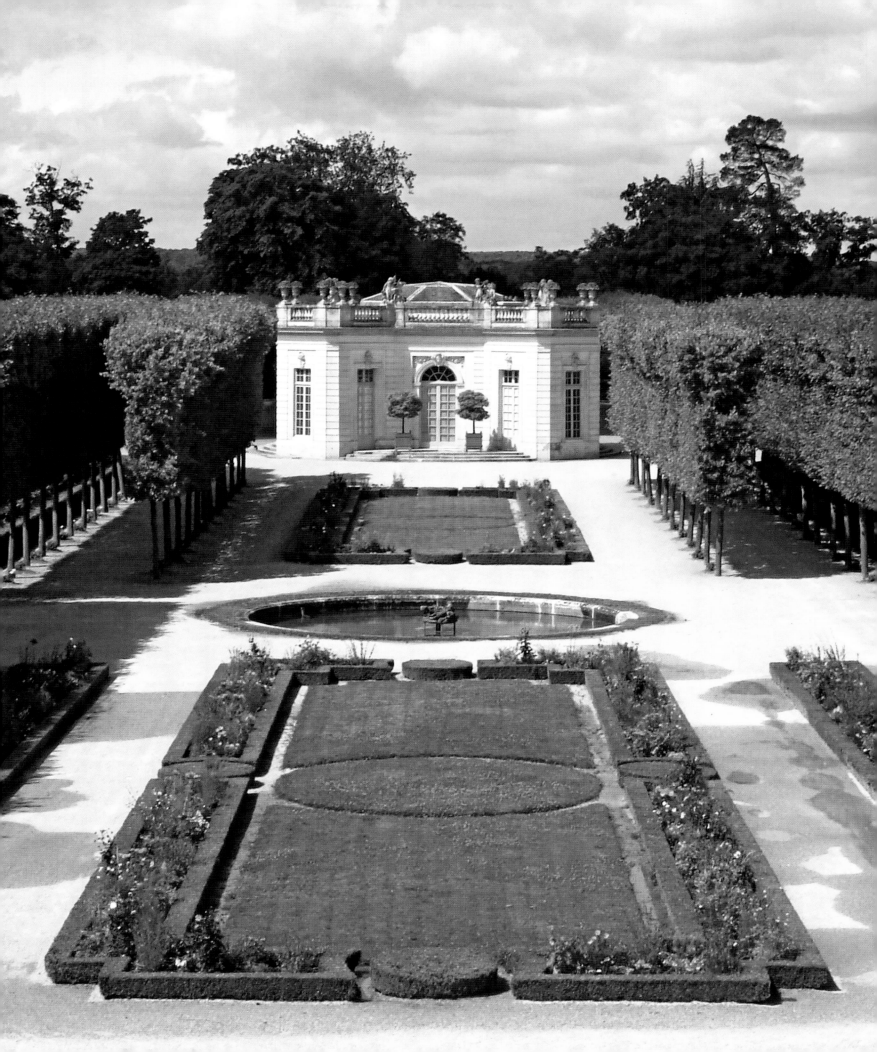

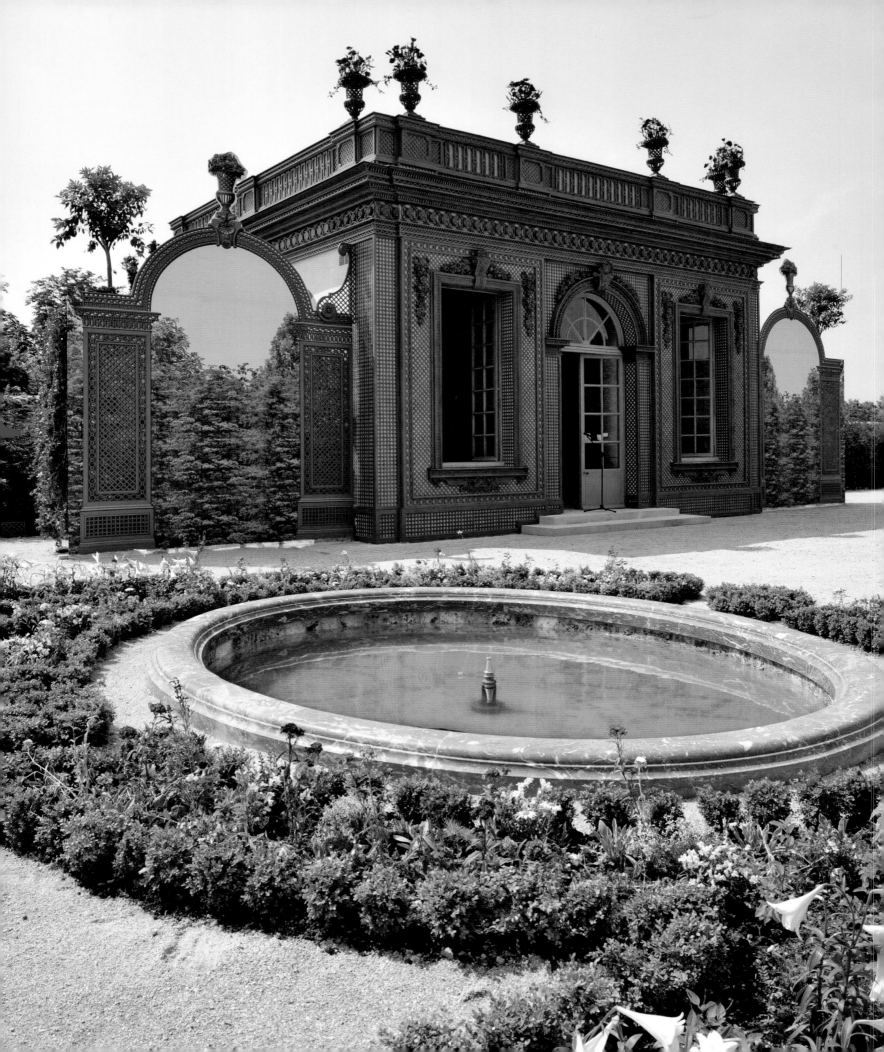

shady grotto, Neoclassical Belvedere and Temple of Love, and even a *jeu de bagues* (a kind of carousel).

The duc de Croÿ, who had not seen the Petit Trianon since Louis XV's death, could not believe what he found: "I thought I must be mad or dreaming when I found rather high mountains, and a rocky outcrop with a river, where once had been Europe's greatest hothouse. Never have two acres of land been changed as much, nor at such great expense."

On her "travels," as she called them, to the château, Marie-Antoinette found a haven beyond the constraints of court etiquette. She offered close friends and relatives simple hospitality, inviting them to share her favorite pastimes, the greatest of which was theater. In the charming "little paper theater," decorated in blue and gold, with pasteboard used to simulate marble, she staged numerous operas in which she took the leading roles, supported by other members of the *Troupe des Seigneurs*. Shows in which the queen was cast as a shepherdess or a maidservant caught the public imagination though there was nothing demeaning about playing this type of role. In his youth, Louis XIV had danced as Mars and Apollo as well as playing bacchantes and furies. Indeed, he continued to do so for twenty years, without ever losing his regal dignity.

The Queen's Hamlet was a rustic fairyland where Marie-Antoinette took refuge among meadows sprinkled with flowers and moss-carpeted grottos, in what the Goncourt brothers described as a "comic opera of nature and the village." Here, cottages had aristocratic refinement, their walls aged with artificial cracks, a barn was a ballroom, milk jugs were made of Sèvres porcelain, and even the lambs were cosseted and perfumed, the swans well fed. The outside world did not intrude. Marie-Antoinette was oblivious to the suffering of the people of France and deaf to the growing rumble of anger from Paris.

Facing page:
View of the Pavillon Frais of the Petit Trianon, where produce from the dairy and the vegetable gardens could be enjoyed. It underwent extensive restoration in 2010.

Right:
"Breast cup" in the form of a female breast, delivered by the Sèvres Porcelain Manufactory for the dairy at Rambouillet in 1788.

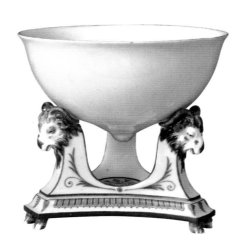

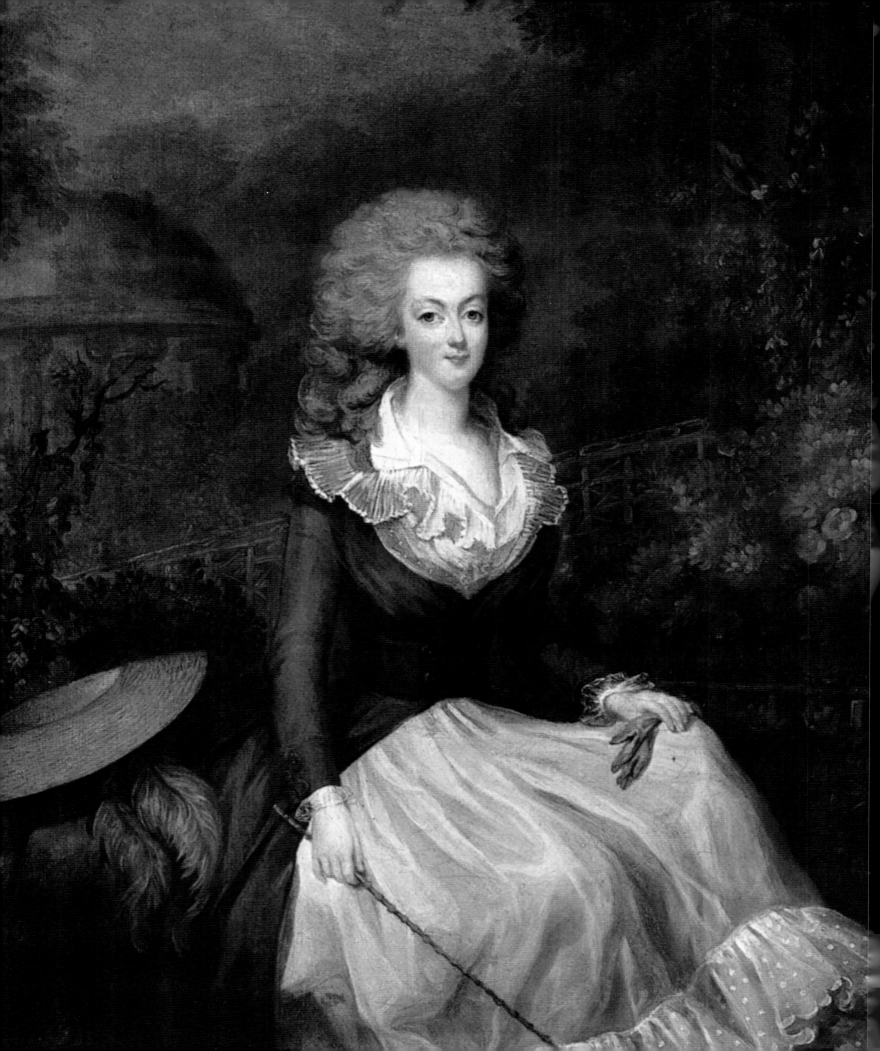

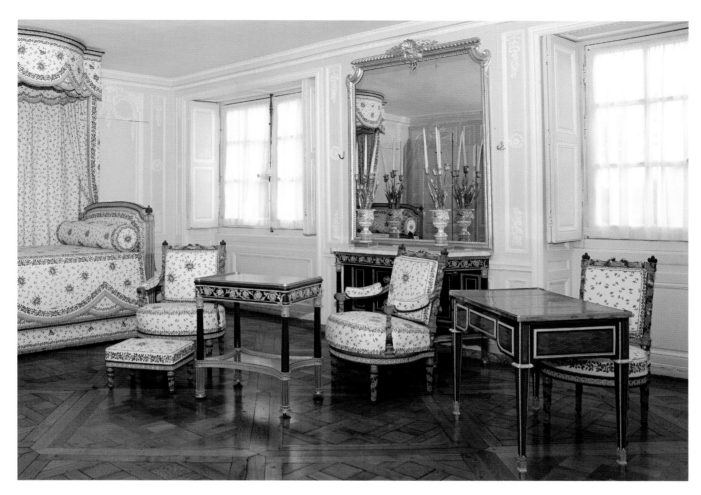

Facing page:
Portrait by Antoine Vestier of
Marie-Antoinette with rattan cane,
gloves, and straw hat in front of the
Temple of Love in the gardens of the
Petit Trianon.

Above:
View of Marie-Antoinette's
bedchamber in the Petit Trianon
with the famous "wheat-ear"
furniture.

Right:
Armchair designed by Georges Jacob
from the queen's bedchamber, also
known as the "trellis chamber," in
the Petit Trianon, with wickerwork
decoration and painted "in the
colors of truth and nature."

Following double page:
Plan of the queen's garden at the
Petit Trianon, with the French
garden on the left and the Anglo-
Chinese garden on the right.

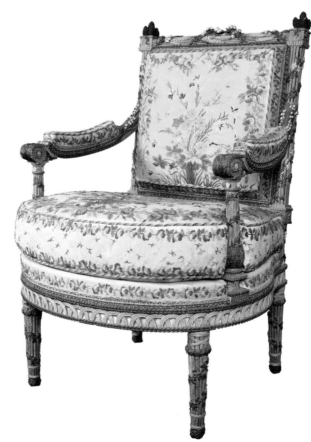

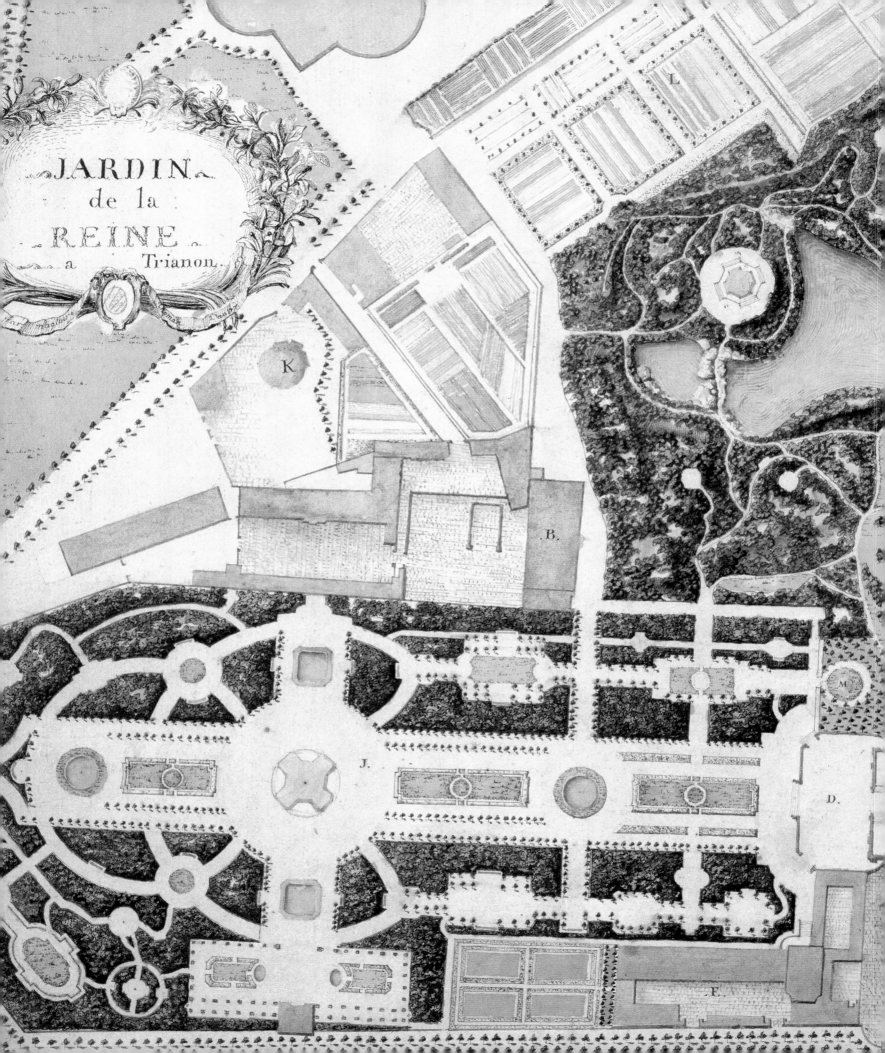

JARDIN
de la
REINE
a Trianon.

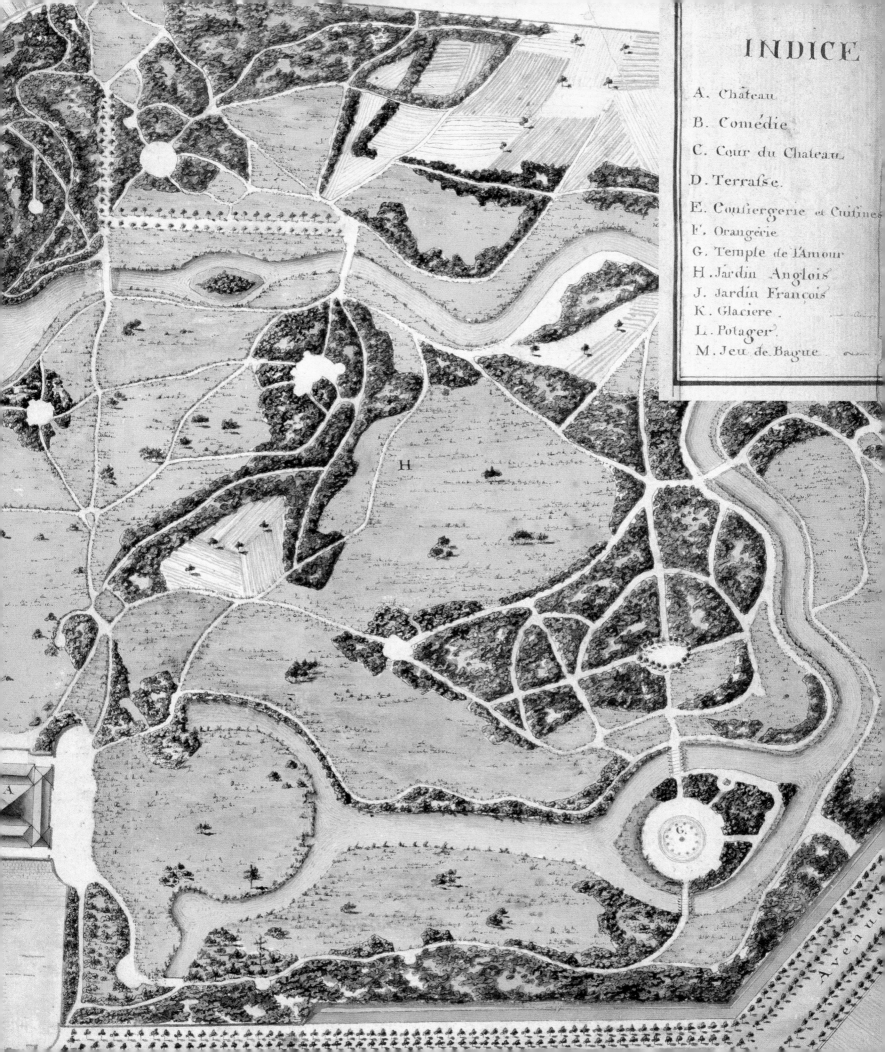

INDICE

A. Château
B. Comédie
C. Cour du Château
D. Terrasse.
E. Conciergerie et Cuisines
F. Orangerie
G. Temple de l'Amour
H. Jardin Anglois
J. Jardin François
K. Glaciere.
L. Potager.
M. Jeu de Bague

VEGETABLE AND HERB GARDENS

Jean-Baptiste de La Quintinie, and those who succeeded him as directors of the royal fruit and vegetable gardens, not only developed new varieties but, thanks to the use of hothouses, also made lettuces available in January and strawberries and asparagus in March. During Louis XV's reign, pineapples were grown successfully for the first time. Now the king could defy the seasons and control the weather! Marie-Antoinette enjoyed fresh produce grown on the farm of her model village on the Petit Trianon estate. Expeditions to faraway lands, which Louis XVI encouraged, also brought home new plant and flower species to be cultivated in the queen's hothouses and recorded for posterity in large herbaria.

Above and below:
The king's vegetable garden at Versailles and the mill of the Queen's Hamlet at the Petit Trianon, where Marie-Antoinette discovered the charms of an idealized rustic life.

Facing page:
Hyacinth called "Maria Antonia," from *Le jardin d'Éden ou le paradis terrestre renouvelé dans le jardin de la Reine à Trianon*. In this work by Pierre-Joseph Buc'hoz, published in 1783–85, 260 engravings of plants pay homage to the travelers and princes who made possible the remarkable botanical collection at the Trianon.

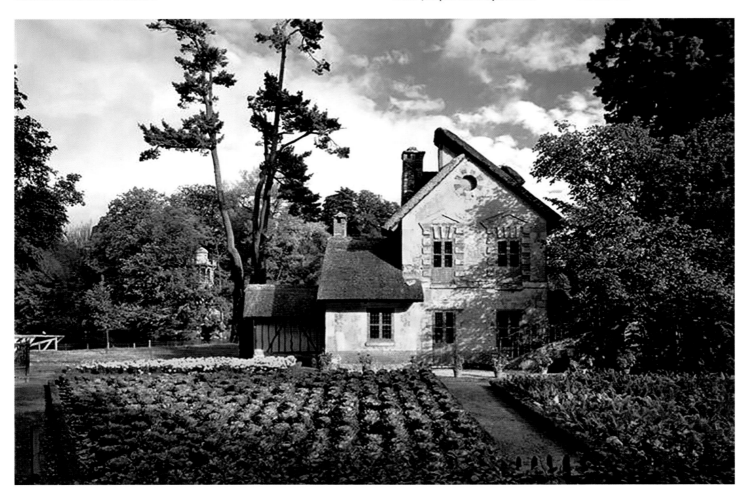

Pl. I.

MARIA ANTONIA REINE DE FRANCE.

GARDENING
AS AN ART

"Does nature constantly employ the square and ruler?" Jean-Jacques Rousseau pondered in *Julie, or the New Heloise*. His novel, published in 1761, would become the modern French gardener's bible, a reaction against André Le Nôtre's traditional, geometric model with its straight paths and patterned parterres. Rejecting tradition, Marie-Antoinette introduced a more naturalistic approach, influenced by English landscape gardening, at the Petit Trianon. On gently rolling terrain, winding pathways led to a succession of picturesque vantage points, revealing plants of varying shapes and colors and stretches of seemingly wild vegetation. These poetic gardens, dotted with rocks, belvederes, and small Neoclassical temples, inspired landscape paintings while also expressing feelings of nostalgia for a lost golden age.

Above:
A tapestry produced at the Gobelins Manufactory depicting child gardeners in the summer. It was created as part of a group of tapestries depicting the seasons.

Below:
Courtiers strolling by the Enceladus Fountain in the gardens of the Château of Versailles.

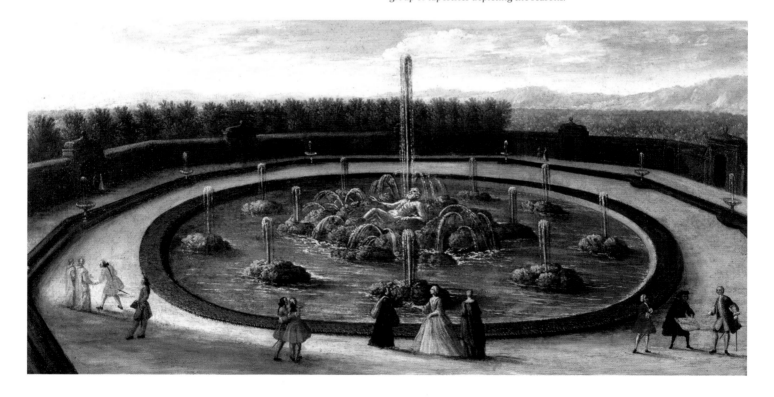

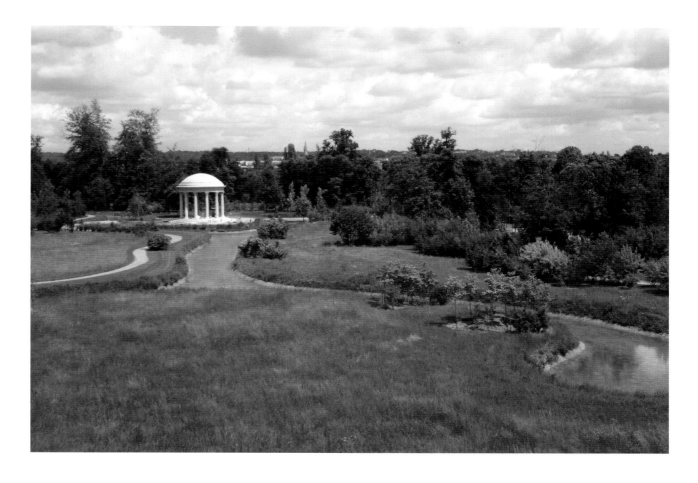

MANIERE DE CONSTRUIRE LES ORNEMENTS DE TREILLAGE

Left:
A book by André-Jacob Roubo on the art of trellising and other forms of carpentry in gardens, 1775.

Above:
View of the Temple of Love in the gardens of the Petit Trianon.

Following double page:
View of the Green Carpet at Versailles, 1774–75, by Hubert Robert. In the foreground are Louis XVI and Marie-Antoinette.

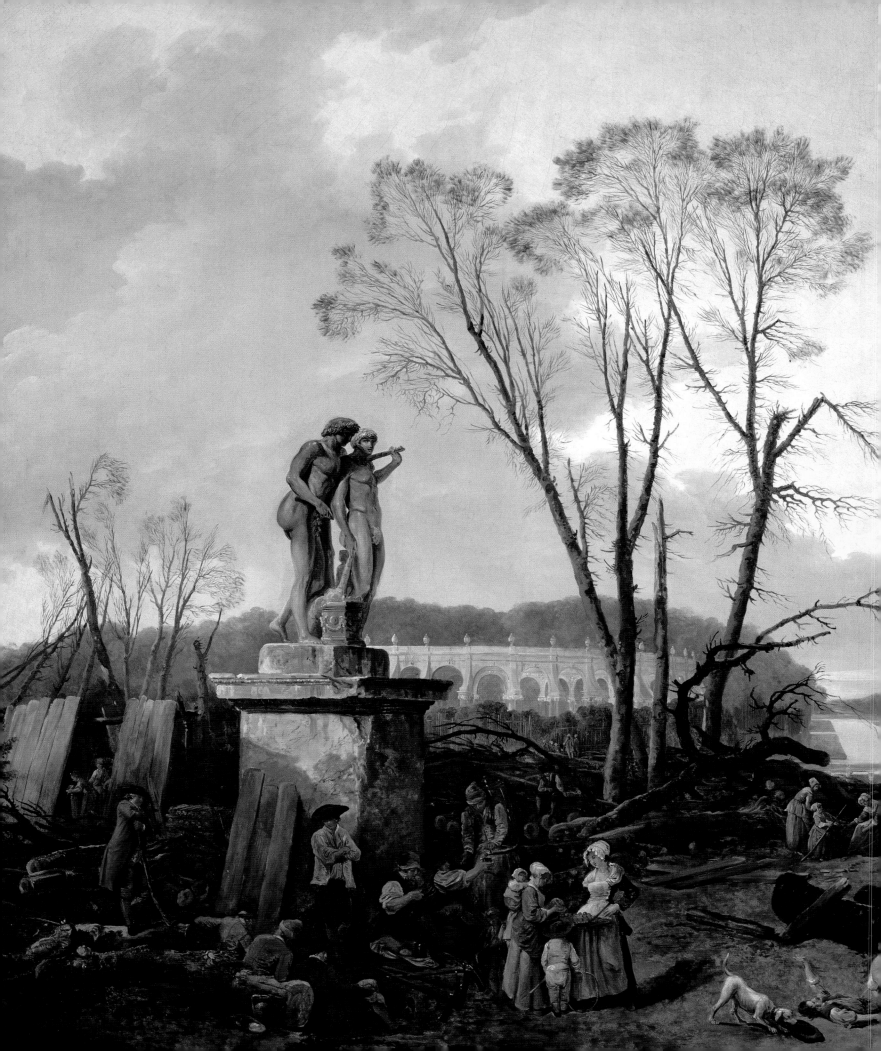

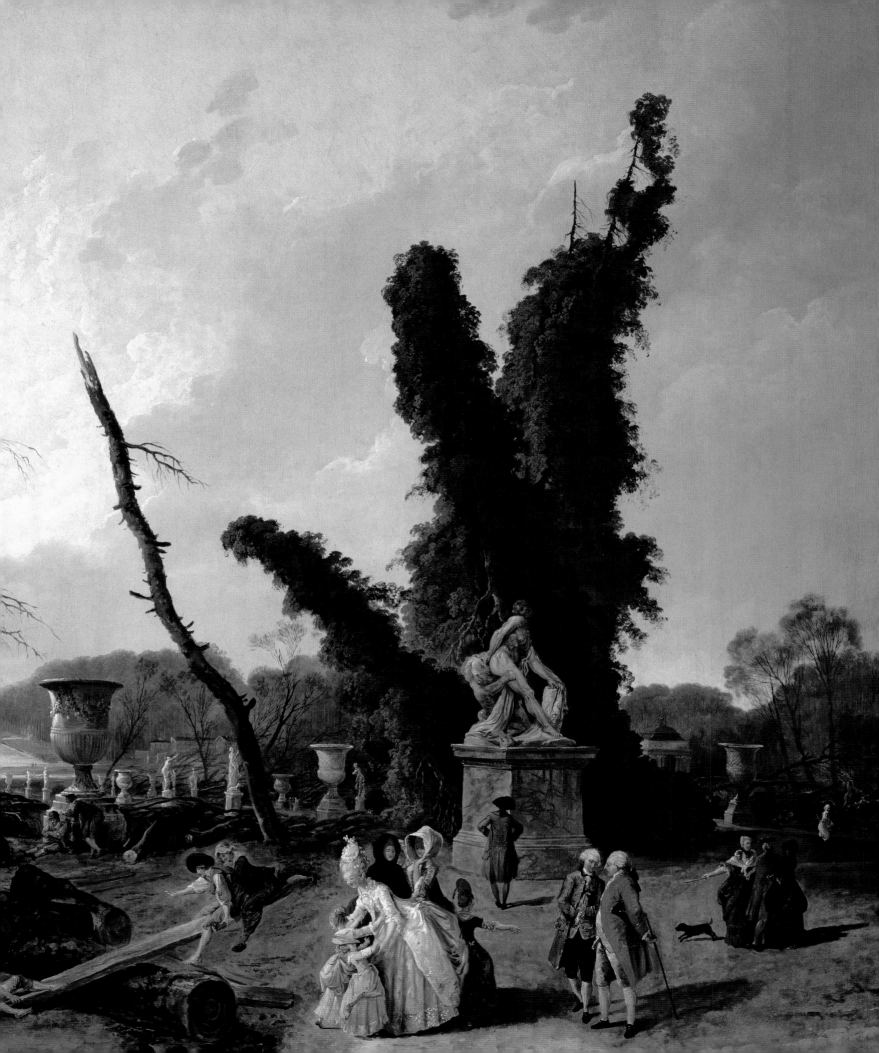

The Fall from Favor

Year after year, the queen's spending got further out of control. The costs of maintaining her household rose steadily: in July 1775, she reestablished the official role of Superintendent of the Queen's Household, a purely ceremonial post that Louis XV had abolished because of its expense, and awarded it to her friend, the princesse de Lamballe. She was losing dizzying sums at the gaming tables, running up debts, and risking public scandal; in 1776, Mercy estimated the debts at 400,000 livres. The annual costs of her wardrobe went from 120,000 livres in 1776 to 260,000 livres in 1785, and it was said that her day dresses alone cost 6,000 livres in 1782! Then there was her jewelry. Although she had received a vast number of diamonds on her marriage, in 1775 Marie-Antoinette asked her husband to settle a bill of 460,000 livres for a pair of diamond earrings—a breathtaking sum that the king had to pay on credit over four years, while also coming up with 250,000 livres the following year for some bracelets. "All the news from Paris tell us that you have spent 250,000 livres on some bracelets [...] and it is supposed you urge the King to these profuse outlays which have been rising again lately and put the State in distress..."[8] Since these colossal debts could not be absorbed by the Royal Treasury, Louis XVI had no choice but to dip into his personal funds. His finance minister Turgot had already doubled the queen's personal allowance from 96,000 to 200,000 livres a year. All these exorbitant expenditures soon earned her the nickname of "Madame Deficit."

Her Paris escapades were the subject of much comment in the gazettes and *libelles*. When she arrived at one Paris ball in a modest carriage, accompanied only by the duchesse de Luynes, there was public outrage. Her free and easy manner provoked malicious gossip; her over-intimacy with her "bosom friends" led to jealousy and envy and suggestions of secret liaisons; her rejection of sacrosanct etiquette alienated noble families, whose status and offices at court depended on it. Irreverent and often irresponsible, she made no attempt to hide her boredom or her opinions, which she could express with scathing sarcasm: she nicknamed the king's aunts "the centuries" and high-ranking nobles "encumbrances." Such behavior created resentment, which little by little grew

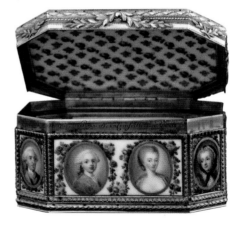

Above:
Gold box with Sèvres porcelain plaques representing the royal family, made by Paul-Nicolas Ménière around 1774–80.

Facing page:
Portrait of Marie-Antoinette in profile at the age of twenty-five by Jean-Joseph Bernard from 1780.

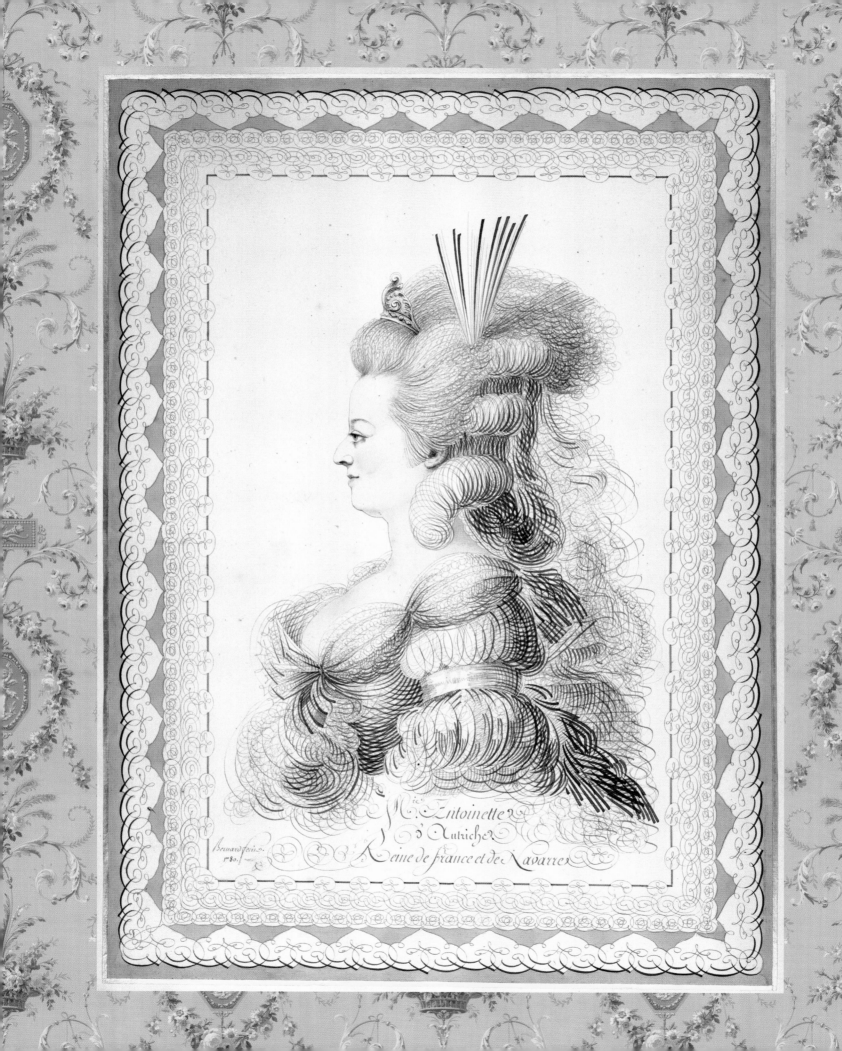

M.ᵉ Antoinette
d'Autriche
Reine de france et de Navarre

Bernard fecit.
1780.

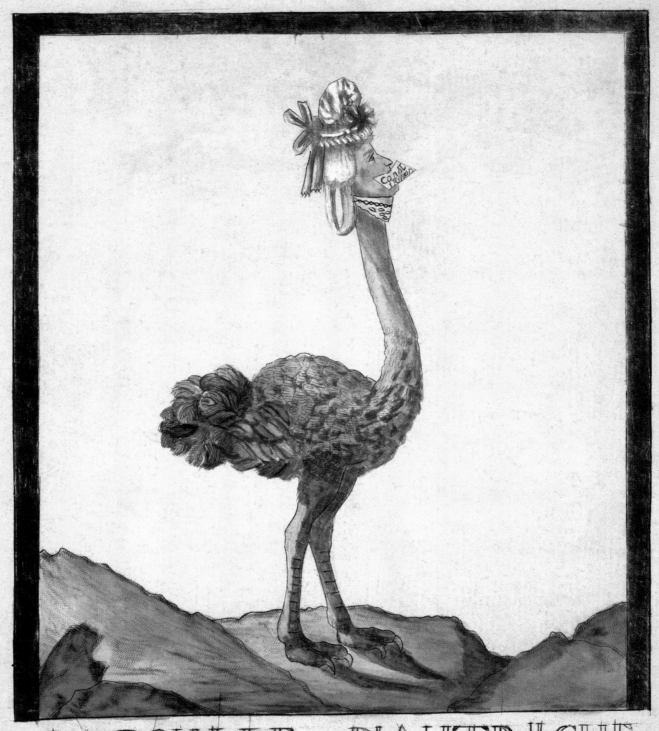

LA POULLE D'AUTRUCHE,

Je digere l'or l'argent avec facilitée, Mais la constitution je ne puis l'avaler

into hatred. Though Marie-Antoinette still had her little coterie of friends, she was also surrounded with embittered enemies. Behind their masks of loyalty, courtiers who had been cast aside, and sometimes humiliated, were planning to take revenge with a formidable weapon: slander.

In September 1774, while she was staying at the château de Marly, a few miles outside Paris, the queen decided to get up at dawn to watch the sun rise. The king did not wish to join her but allowed her to go with a few young friends. The very next day a scurrilous pamphlet in verse entitled *Le Lever d'Aurore* (Daybreak) appeared, which presented in obscene terms the queen's nocturnal outing as a bacchanal of sexual encounters. This was the first *libelle* directly aimed at Marie-Antoinette, and it was clear that it originated from the court. So the insults and ridicule were coming right from the top; aristocrats at the Château of Versailles were spreading slander about Marie-Antoinette throughout Europe. Had not Frederick II of Prussia erected a statue of her in Potsdam, stark naked, with her name in big letters? It was the comte de Provence who, despite his obsequious manner, was responsible for the worst rumors—the same man who had raised doubts about the paternity of the royal children. And it was Madame Adélaide herself, the king's aunt, who had given her the infamous nickname *l'Autri-chienne* (literally, "the Austrian woman," but also a pun on *autruche*, ostrich, and *chienne*, bitch), which would be repeated in hundreds of pamphlets and would accompany Marie-Antoinette to the scaffold. A formidable network of enemies was forming around the queen, ranging from members of the royal family to the hordes of fickle courtiers. People around her had started muttering a warning rhyme: "Little twenty-year-old queen / Since you treat people with no shame / You'll go back from where you came." "The thing that strikes me most," she wrote in distress to her brother Joseph II, "is the determination of some people to present me as a foreigner who never ceases thinking of her homeland and is only unwillingly French. This is shameful: my every act proves that I am doing my duty and that my duty is my pleasure. But it makes no difference. Their slanders continue and the tiniest things become great sins. The other day, a foolish man asked for my permission for himself and a lady to visit *my little Vienna*. This is what he called my Trianon, and this made me realize that there is a malevolent coterie ranged against me who are supporting the rumor that I have renamed the present given me by the king . . ."

Facing page:
Caricature of Marie-Antoinette as an ostrich, entitled the "*poulle d'Autr(u/y)che*" (the hen of Austria/ostrich).

Above:
Caricature of Marie-Antoinette showing her displeasure at articles published in *Le Figaro*.

The Scandalous *Chemise*

Wearing the *grand habit*, with its tight bodice stiffened with whalebone, its wide panniers ("baskets" fastened to the hoops underneath the dress), and the weight of all the superimposed layers of jewel-studded silks and satins, was a real test of physical endurance. From about 1780, Marie-Antoinette stopped making it a requirement to wear the *grand habit* except on very special occasions. She preferred to wear the new fashion from England: white dresses, made of muslin or lawn, known as *gaulles* or *chemises*. Held together by a broad sash round the waist, knotted at the back like children's dresses, they were worn with a wide-brimmed straw hat adorned with flowers and feathers, with the hair flowing freely down over the shoulders. The general trend toward making women's clothes more comfortable was a sign of a new modernity that was breaking with traditional ideas of how royalty should look; it also showed the growing appeal of the simple and free pastoral life praised by Rousseau and the philosophers of the Enlightenment. The *chemise* came to symbolize a new social ideal.

On August 25, 1783, the annual Salon of the Royal Academy opened at the Louvre, and among the paintings exhibited was a new portrait of Marie-Antoinette by Élisabeth Louise Vigée-Lebrun, who had just been admitted to the Academy. The queen is dressed in the new natural fashion with a white *gaulle* and no jewelry, her hair loose beneath a big straw hat decorated with ribbons and feathers. The painting was met with an uncomfortable silence from the startled art critics. The queen's dress, made from a single piece of muslin, looked very much like a piece of underwear, giving the public the impression that they were seeing Marie-Antoinette in a private moment in her negligee. Only the queen herself could have allowed such a portrait to appear. It was not long before someone wrote beneath the painting, "France as Austria reduced to covering herself with straw." There was a scandal. Judged indecent, the portrait was removed from the Salon. Vigée-Lebrun replaced the picture with one known as "à la rose," which today is probably the best-known image of Marie-Antoinette in the world. Against the backdrop of a sylvan landscape, the queen is portrayed wearing a classical tight-fitting *robe à la française*, in shiny satin trimmed with fine lace, with a double row of pearls around her neck and triple rows on her wrists.

Facing page:
Portrait of Marie-Antoinette in a simple muslin *chemise* and wearing a straw hat, by Élisabeth Louise Vigée-Lebrun. The public exhibition of this painting in 1783 caused a scandal.

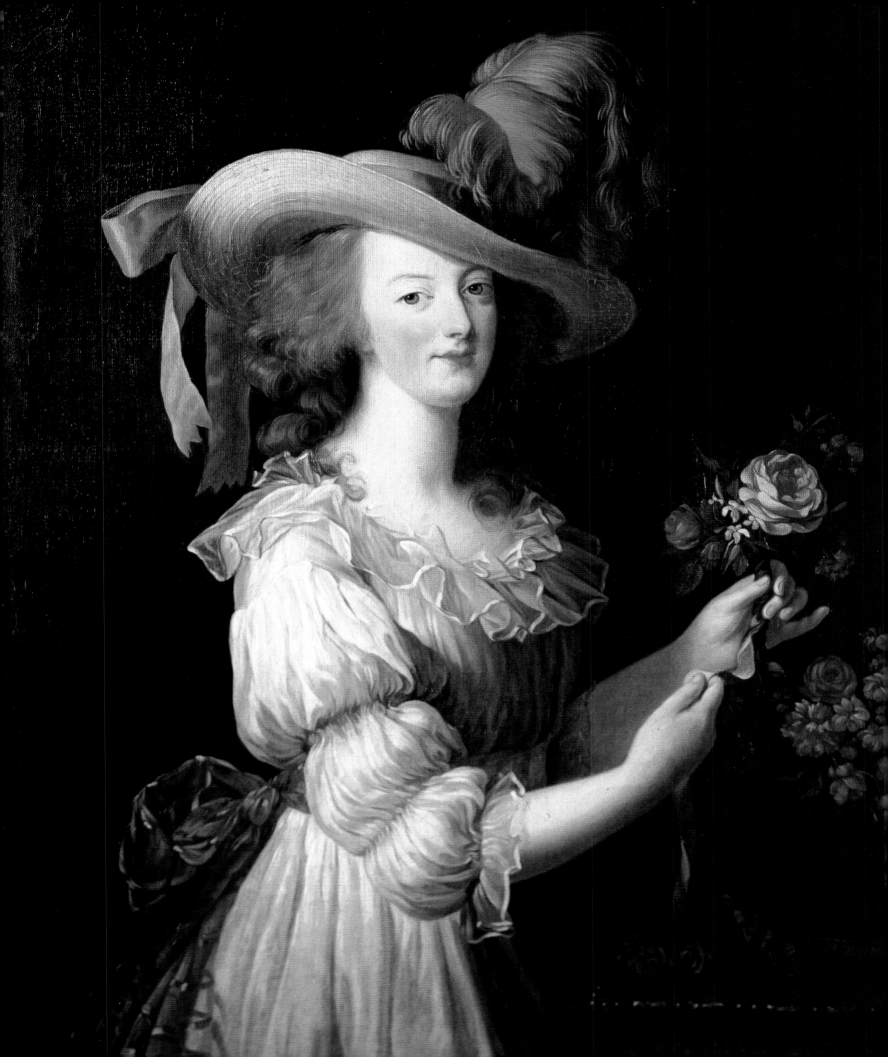

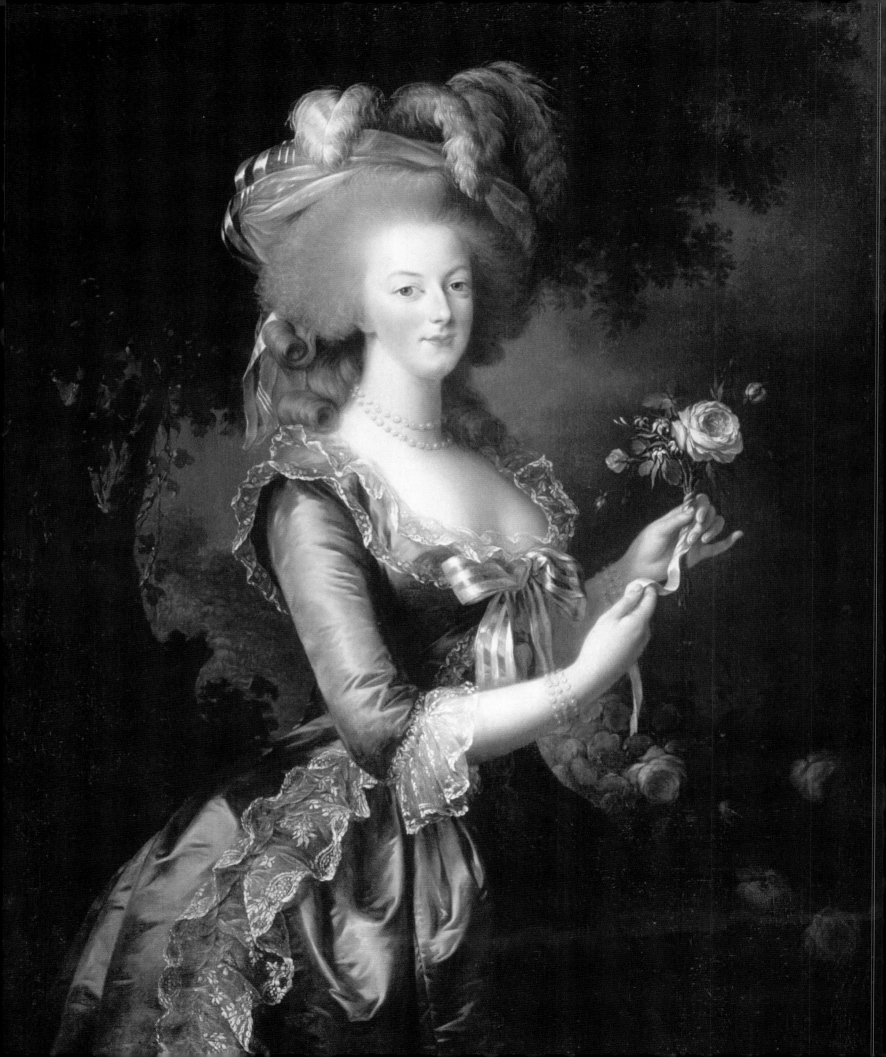

The scandalous painting would have far-reaching consequences. Though Louis XVI never had a mistress, it is a tragic irony that this fact would be turned against him and against Marie-Antoinette. In the eyes of the public, it made him look weak. In the social world of the court, the monarch's mistresses, as they went in and out of favor, served as an outlet for desire and disdain and helped reinforce the pious image of French queens as modest and remote. Marie-Antoinette brought together the two things that were often dangerous for a woman and especially for a queen: seductiveness and sarcasm. In other words, she charmed too much without knowing it and wounded without intention. By acting like some grand female mistress, a Montespan or a du Barry, exposing herself "in her negligee," offering herself to the gaze and the lust of the public, Marie-Antoinette desecrated the royal body, undermined the respect and the distance that were attached to it. And this made her an open target for public passion and fury. It was her fatal mistake.

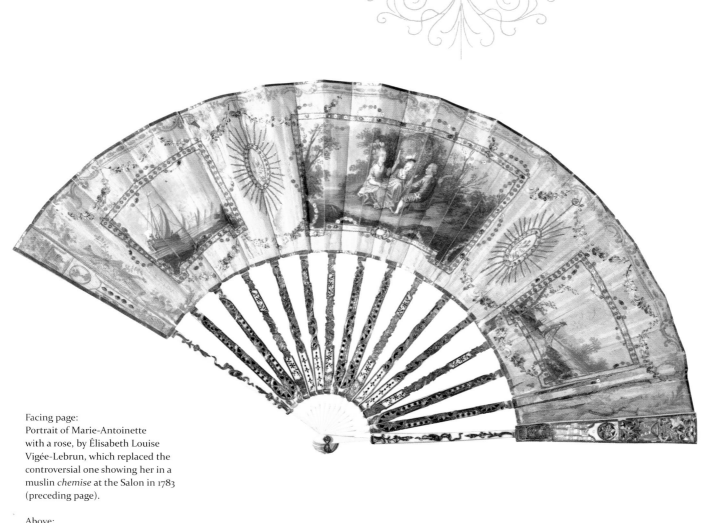

Facing page:
Portrait of Marie-Antoinette with a rose, by Élisabeth Louise Vigée-Lebrun, which replaced the controversial one showing her in a muslin *chemise* at the Salon in 1783 (preceding page).

Above:
Fan belonging to Marie-Antoinette, decorated with landscapes and romantic scenes.

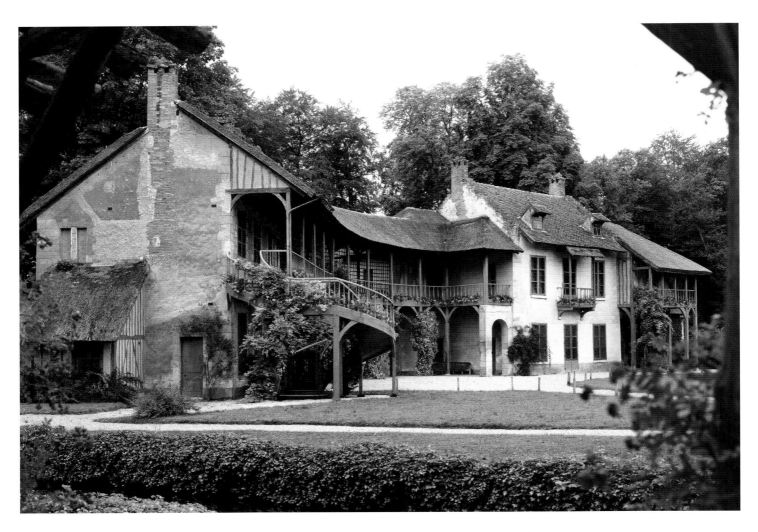

Above:
The Queen's House at the Hameau. Despite its quaint and picturesque exterior, the rooms inside were luxuriously furnished. It was the only building in the Hameau roofed with tiles rather than reeds or thatch.

Below:
Detail from a painting of a rural scene by Nicolas Desportes.

THE SIMPLE LIFE

A taste for pastoral living became fashionable in the latter part of the eighteenth century. Marie-Antoinette followed the trend by turning a piece of land at the northern end of her Petit Trianon estate into the Hameau, the Queen's Hamlet. Work began in 1783 and was completed in 1787. The hamlet consisted of twelve houses arranged in two groups on either side of a river, encircling a small lake. On one side stood the mill and the queen's house, on the other the caretaker's lodge and the Marlborough Tower. All the buildings were artificially aged in "dilapidated style" to look more rustic, with peeling paint and cracked walls. There was a farm, set slightly away from the hamlet, with a henhouse, cows, sheep, goats, pigs, and rabbits. It also produced barley, alfalfa, and oats. Marie-Antoinette also had a cottage, whose inside walls were adorned with seashells, and a dairy at Rambouillet.

Opposite:
Summer straw hat from 1790, in the Musée de la Mode de la Ville de Paris.

Below:
The Marlborough Tower was used as an observatory and a store for angling equipment. The neighboring building is the "refreshments dairy," where milk, creams, and cheeses could be tasted.

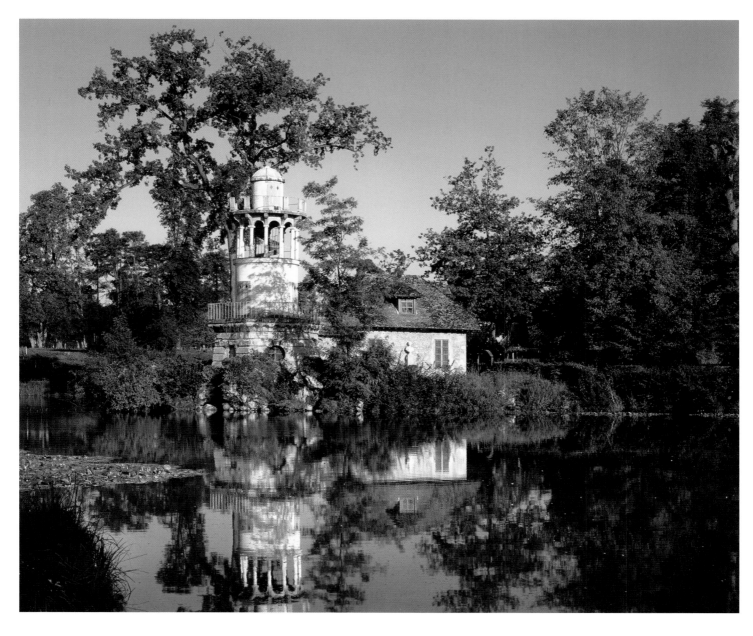

ANIMALS

During Marie-Antoinette's reign, animals had an important place at the Château of Versailles. These included horses but also pets, dogs in particular. The queen had been fond of pugs since her childhood, and they now became fashionable in France. As a mark of friendship, she often gave gifts of little dogs. She presented Count Esterhazy with a spaniel named Marcassin; Fersen gave her a dog called Odin. Marie-Antoinette entrusted Coco, her canine companion at the Tuileries, to Madame de Tourzel before her execution. The queen also kept animals, such as chickens, ducks, cows, and goats at the farm beside her model village. When the time came to replace the billy goat, she insisted on one that was "all white and well-behaved." At Rambouillet, there were attempts to acclimatize merino sheep in France.

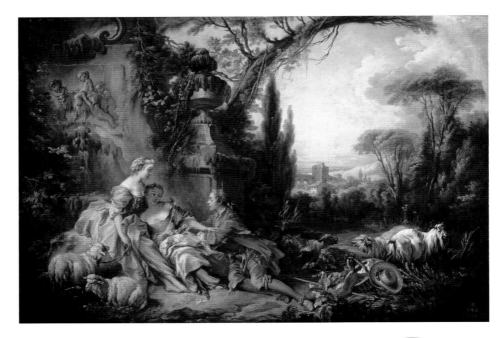

Above:
François Boucher's paintings catered to the taste for country life in the eighteenth century.

Above:
This Japanese lacquer box in the shape of a cockerel was part of Marie-Antoinette's lacquer box collection, which she kept in her *cabinet doré* at the Château of Versailles.

Left:
Detail of gilded woodwork in the French pavilion at the Petit Trianon.

Facing page:
Watercolors and a detail of an eighteenth-century wallpaper. The menagerie created at Versailles by Louis XIV made an important contribution to the development of the scientific study of animals.

Chardonnet.

Damoiselle de Turquie.

Singe.

The Diamond Necklace Affair

atred against the queen reached its peak in 1785. In March of that year, Marie-Antoinette had given birth to a second son. On May 24, as she made her way to Notre Dame for the church ceremony following the birth, bystanders greeted her with an icy silence, leaving her distraught. As she returned to her apartments, she was heard to murmur, "What have I done to them?"

Hitherto, she had appeared to shrug off the jibes and lampoons, which she put down to a kind of national tradition. "Pens and tongues say many things which hearts don't believe," she wrote to her anxious mother on January 14, 1776. But from then on, she was on her guard, noticing day after day the signs of her growing unpopularity. Her every action, however innocent, was seen in a bad light, the most trivial incident could fan the flames. And then, on the Feast of the Assumption and the queen's name day, August 15, 1785, the cardinal de Rohan, Grand Almoner of France, was arrested in the Hall of Mirrors at the Château of Versailles, unleashing what became known as the "diamond necklace affair."

The cardinal, who had been in disgrace with the queen, was ready to do whatever it took to regain her approval. In 1784, he was introduced to a woman called Madame de La Motte, an impecunious descendant of the Valois line, who claimed to be a close friend of the queen's and promised she would help restore him to favor. To achieve this, she dreamt up a strategy worthy of Molière's best comedies. For some years, the crown jewelers, Boehmer and Bassenge, had been trying to sell a sumptuous necklace with 647 diamonds at the astronomic price of 1.6 million livres. In December 1778, Louis XVI considered buying it for the queen to mark the birth of their first child, but Marie-Antoinette refused. She declined again in 1781 when the dauphin was born.

In January 1785, Madame de La Motte convinced the jewelers that the queen had now decided to buy the necklace and had appointed one of France's most important public figures, Cardinal de Rohan, to conduct the negotiations. Madame de La Motte, as devious as Molière's comic hero Scapin, remained behind the scenes, keeping total control of this bizarre intrigue. The cardinal was persuaded to exchange letters about the necklace with someone he fondly

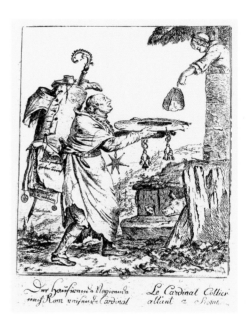

Above:
Caricature attacking the cardinal de Rohan for his involvement in the "diamond necklace affair."

Facing page:
Engraving depicting the notorious necklace composed of 647 diamonds and priced at 1.6 million livres.

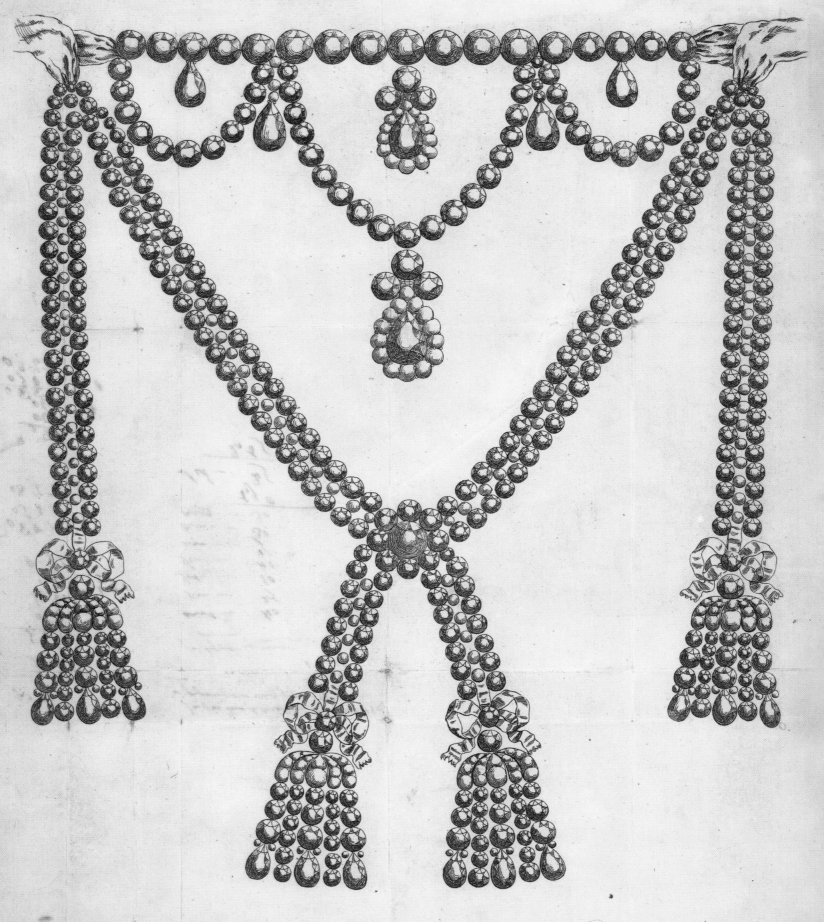

Représentation exacte du grand Collier en Brillants des S.rs Boëhmer et Bassenge

Gravé d'après la grandeur des Diaman.s

LOUIS RENE EDOUARD
Prince de Rohan Guemeneé Cardinal de la S.te Egl. Romaine

JEANNE DE SAINT REMY DE VALOIS
Epouse du Comte de la Motte

M.^R LE COMTE DE LA MOTTE

M.^{LE} DE LA TOUR

M. LE COMTE DE CAGLIOSTRO

SERAPHINIA FELICHIANI
Comtesse de Cagliostro

M.^{LE} LE GUET DESIGNY DOLISVA

M.^R BETTE DETIENVILLE

M.^{ME} MELLA DE COURVILLE SULBARK

M.^R LE BARON DE FAGES

LA FEMME DE CHAMBRE
de M.^{me} la Comtesse de la Motte.

LE PERE LOTH
Minimes

Se trouve à Tours et a Orleans chez les S.rs l'Etourmy Libraires

imagined to be the queen but was surprised to find that, in public, she never gave any indication that he was back in favor. However, he was led to believe that the woman he secretly met in a grove at Versailles on the night of August 11, 1784, and who spoke kindly to him, was indeed Marie-Antoinette herself. Rohan was overjoyed. In fact, the woman was one Nicole Le Guay d'Oliva, a courtesan recruited by Madame de La Motte.

The jewelers duly delivered the necklace to the cardinal, who showed them a letter from the queen, bearing the words: "Approved, Marie-Antoinette, Queen of France," despite the fact she had never written anything of the sort. On February 1, 1785, the cardinal handed the necklace to Madame de La Motte, who then disappeared. The necklace was dismantled and some of the diamonds were sold in England. On July 12, Boehmer sent the queen a letter alluding to the payment of the first installment. But Marie-Antoinette misunderstood, believing that he was again trying to sell her the necklace. Watched by Madame Campan, she burned the letter. Having heard nothing from the queen, the jeweler chased her for money again in August. This time she demanded explanations and finally understood that someone had bought the necklace in her name.

An investigation was launched, and Madame de La Motte was soon arrested. She was convicted, branded with the initial "V"—for *voleuse*, meaning "thief"—and condemned to prison for life. The cardinal was judged by the Parlement of Paris on May 31, 1786, but quite unexpectedly was cleared of any wrongdoing. His acquittal left lingering doubts about the innocence of the queen herself, since her lifelong passion for jewelry was well known, as were the tactics she sometimes used to hide her purchases from the king. Although in reality not involved in this shady affair, Marie-Antoinette was popularly assumed to be guilty. Choking with anguish and rage, she wrote to Madame de Polignac, "Come and weep with me; come and console your friend, my dear Polignac; the judgment just passed is utterly shameful. I am drowning in my tears of pain and despair."

Facing page:
Portraits of the protagonists in the "diamond necklace affair," 1776.

Above:
The cardinal de Rohan, who unwittingly instigated the "diamond necklace affair."

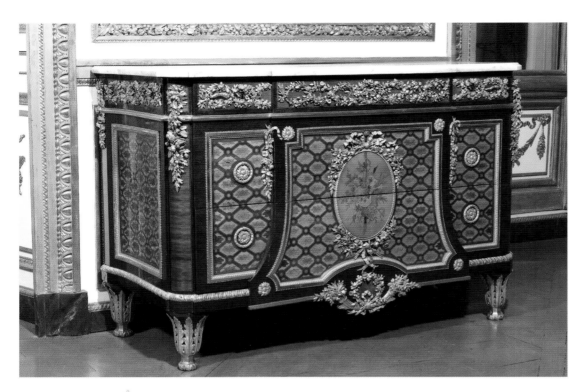

Left:
Commode by Jean-Henri Riesener with marquetry in precious exotic woods. Delivered in 1782 for Marie-Antoinette's bedchamber at the palace of Marly, the commode was transferred to the Château of Versailles the following year.

Facing page:
Jewel casket belonging to Marie-Antoinette. This sumptuous piece of furniture was created by the cabinetmaker Jean-Ferdinand Schwerdfeger in 1787. It is decorated with gilt bronze, mother-of-pearl, reverse glass painting, and porcelain plaques.

Below:
Guéridon topped with petrified wood, made in Vienna in 1770 by Anton Mathias Domanöck and given to Marie-Antoinette by her mother, the empress Maria Theresa.

FURNITURE

French furniture of the period. The queen was captivated by new designs in the Etruscan style and those influenced by an increasing interest in all things Egyptian—two trends that emerged from Neoclassicism in the 1780s. To obtain the type of furniture with which she liked to surround herself, Marie-Antoinette not only used the services of staff from the Garde-Meuble de la Couronne, the royal storehouse for furnishings and objets d'art, but also from her own private Garde-Meuble, to which she gave generous financial support.

Although Marie-Antoinette's taste in furniture changed during her reign, she was always on the lookout for pleasingly shaped and elegantly styled pieces. She particularly admired the work of the German-born cabinetmaker Jean-Henri Riesener, who was responsible for some of the most innovative

Left:
Folding stool from Marie-Antoinette's bedchamber at the Château of Versailles. Made by Nicolas-Quinibert Foliot and Toussaint Foliot, it was part of a set of seventy-two folding stools delivered for the future dauphine in 1769.

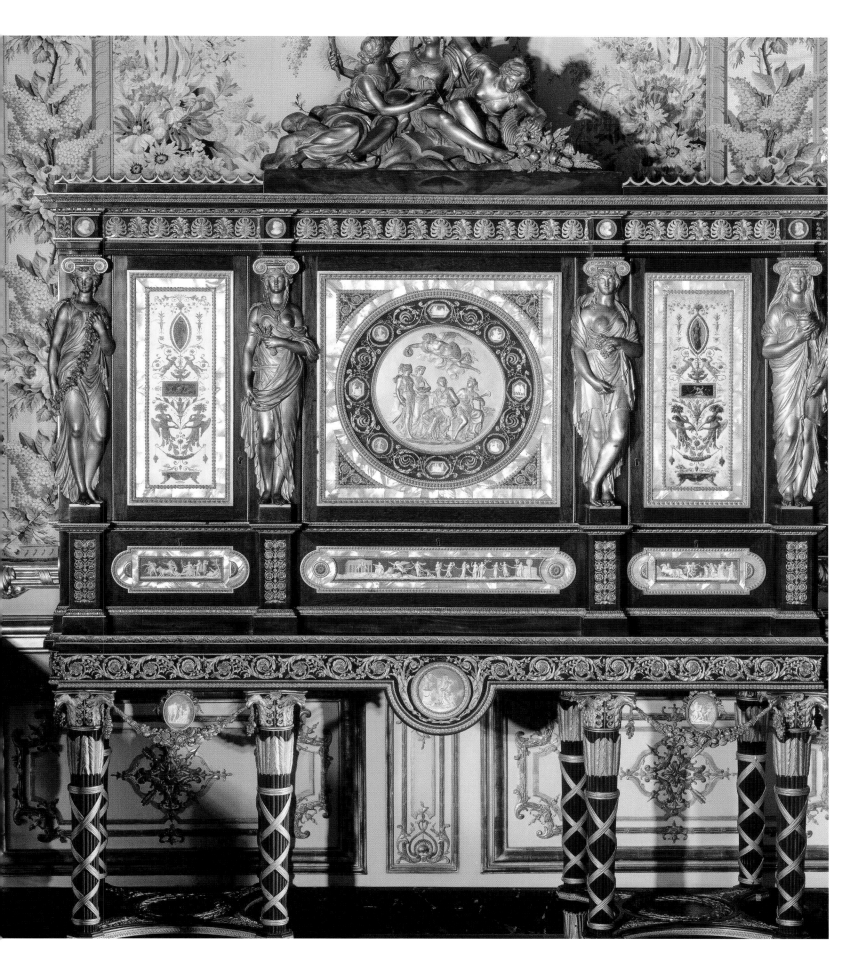

CHINOISERIE

Until the reign of Louis XIV, in France the term "Orient" meant the Ottoman Empire and Persia. But then, via reports from Jesuit missionaries in China, the French began to discover the Far East. By the mid-eighteenth century, the popularity of all things Chinese was at its peak. "China" conjured up utopian visions of a fabulous empire governed by philosophers, producing exquisite silks, fine porcelain, and lacquerware of the deepest black. This idealized world provided a mirror for the new aspirations of eighteenth-century society, and soon the craze for chinoiserie had spread to every aspect of European art. The fashion for porcelain and lacquerware was accompanied by a new repertoire of themes in the decorative arts: Chinese mandarins with drooping moustaches, dressed in robes adorned with dragons; jade pavilions with pagoda roofs; dreamlike mountain landscapes; parasols patterned with flowers; little wooden bridges; colorful birds; and monkeys swinging from bamboo trees.

Facing page:
Detail of a wallpaper with Chinese motifs from the eighteenth century.

Right:
Precious Sèvres porcelain vase decorated with Chinese motifs. The vase was one of a garniture of three vases delivered to the queen in 1775 and displayed in Marie-Antoinette's *cabinet doré* at the Château of Versailles.

Above:
This Japanese lacquer box, in the shape of a Go board game, is in the queen's collection of lacquer boxes. On its lid, a Chinese man holds a tiny round box for the playing pieces.

Left:
Commode by Jean-Henri Riesener in black lacquer with gilt-bronze mounts, delivered in 1783, from the queen's *cabinet doré* at the Château of Versailles.

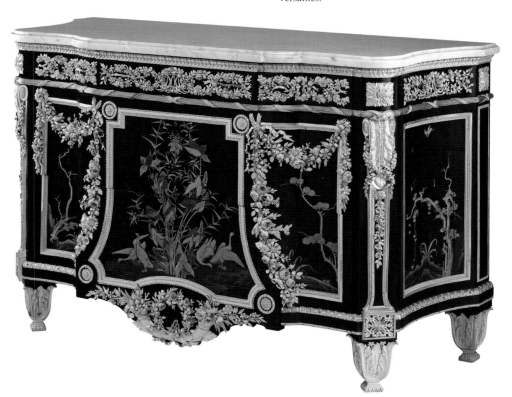

"Slander! Slander! Some of it will always stick."

(Pierre Beaumarchais, *The Barber of Seville*, 1775)

———————

Lampoons, caricatures, and satirical tracts, as well as poems and songs of increasing savagery spread like wildfire in ever-greater numbers. Unpopularity turned to loathing, court intrigues to public discontent. Successive crop failures were causing immense suffering—it was that woman's fault! The Treasury was facing bankruptcy. That was her fault, too! Wild rumors circulated about ludicrous sums of money being squandered on the Petit Trianon, where, it was said, there was a salon carpeted with diamonds, columns bedecked with sapphires and rubies, and a treasure chamber, as well as wild parties continuing late into the night.

Now that there was freedom of the press, peddlers in the city shouted out the titles of the latest pamphlets, always written in a simple style and using bawdy language to stir the imagination of the masses. Jacques-René Hébert, editor of the revolutionary newspaper *Le Père Duchesne*, was by far Marie-Antoinette's most ferocious critic. She was overtaken by the phantasmic power she unleashed. The comte d'Artois, the duc de Coigny, and Madame de Polignac, even cardinals, ex-convicts, and manservants—the list of her putative lovers was almost endless. These claims were reinforced by pamphlets with crude cartoons with titles such as *The Austrian Woman on the Rampage* or *The Royal Orgy* and *The Love Life of Charlie and Toinette*. Marie-Antoinette was christened the "Royal Messalina," a reference to the wife of the Roman emperor Claudius, famed for her promiscuity and her lust for gold and jewels, who kept her husband constantly drunk so that she could govern in his place. The queen was also depicted as an ostrich (*autruche*, punning on *Autriche*, Austria), a female monkey, a tigress, a wild animal, and, without rhyme or reason, as a "female monster"—a dragon, a harpy, or a hydra.

Such a venomous onslaught had no precedent in the history of France. It could be said that defamation was the military wing of the Revolution. When Madame Campan told the queen of her fears that she might be poisoned, Marie-Antoinette replied, "Remember that nobody will waste a single grain of poison on me. . . . Slander kills much more quickly, and they will use slander to kill me."

Facing page, from top to bottom: Cartoon of the people battling with the "hydra of the aristocracy." Engraving depicting the supposed love affair between Marie-Antoinette and the duchesse de Polignac: "I only breathe for you ..." Caricature of Marie-Antoinette as an imaginary harpy. In 1784, a claim that a live harpy had been found in Latin America and brought back to Spain had caused much excitement.

Following double page:
Left:
Lampas on satin foundation (with embroidered silk medallions and arabesques) in Marie-Antoinette's billiard room at the Château of Versailles.

Right:
"Clock of Love" by Robert Bobin, ca. 1785, and in the background a portrait of Marie-Antoinette at the hunt by Louis-Auguste Brun.

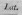

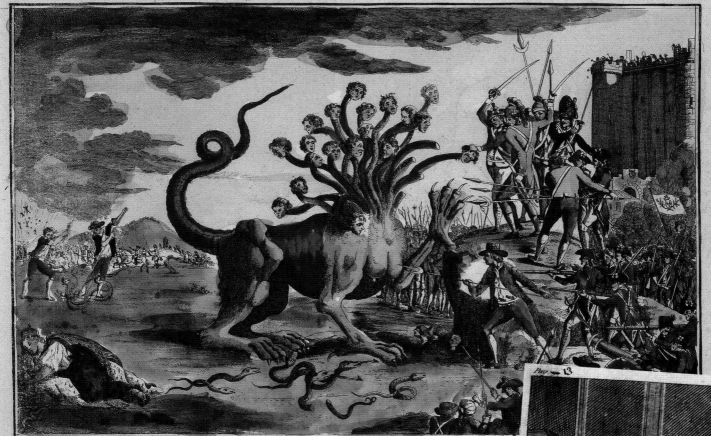

l'Hydre Aristocratique.

HARPIE FEMELLE.

Je ne respire plus que pour toi..
un baiser, mon bel Ange!

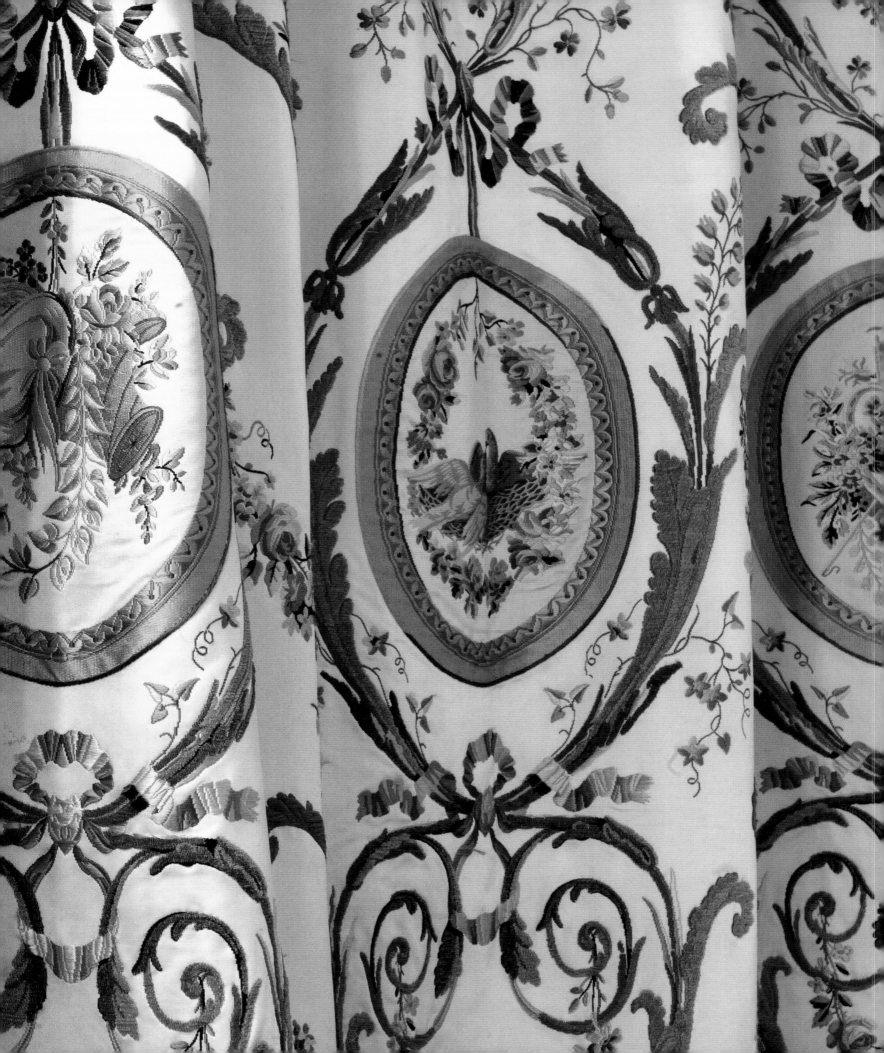

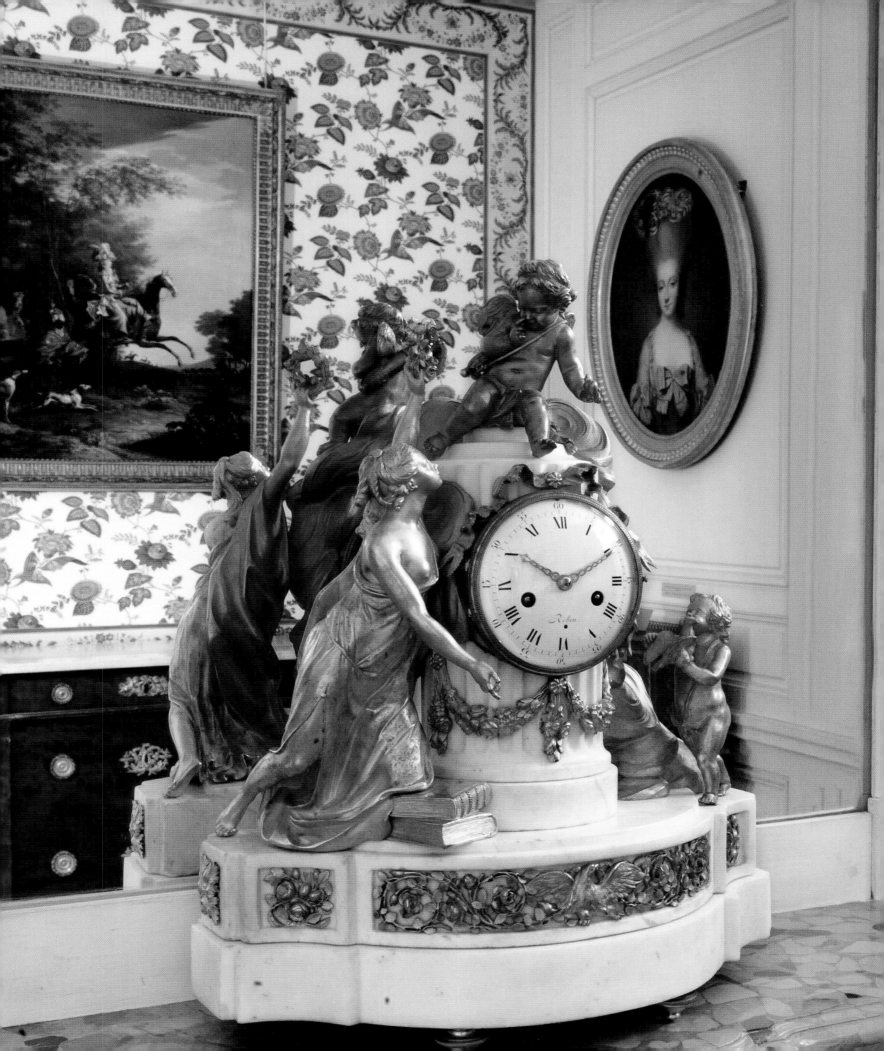

Mother
and Lover

*After Joseph II's visit to France, Marie-Antoinette finally
understood the political urgency and importance of having
a child. It would take time, despite the king's eagerness to
join his wife while she was in bed in the morning sleeping
off a long evening's entertainment. In April 1778, she could
proudly reveal to her mother that she was pregnant. This
first pregnancy went well, and the king was very attentive.
On July 31, 1778, Marie-Antoinette felt her baby move for
the first time.*

Portrait of Marie-Antoinette at the age of twenty-three by Élisabeth Louise Vigée-Lebrun.
Marie-Antoinette had been queen of France for five years.

A Devoted Mother

Marie-Antoinette felt her first labor pains on the night of December 18, 1778. By tradition, the births of *enfants de France*—royal babies—took place in public to guard against the risk of substitution. This meant that a royal birth was a ceremony governed by strict protocol. It was especially challenging for the queen, who was under the constant observation of a crowd of courtiers.

Madame Campan writes that, at the moment of birth at eleven thirty in the morning of December 19, the queen's chamber resembled "some place of public amusement." A few spectators had climbed onto the furniture and clung to the curtains to get a better view. The overcrowded room became so stifling that the queen fainted. There were calls for the window to be opened to let in some air while the doctor bled her from one of her feet. A signal from Madame de Lamballe had already told her that the baby was a girl. Taking the child in her arms for the first time, Marie-Antoinette reportedly said: "A son would have been the property of the state. You shall be mine … you shall share all my happiness and … alleviate my sufferings." The baby was named Marie-Thérèse.

Since her first child was a girl, the queen was under considerable pressure to get pregnant again as soon as possible. She, however, was in no great hurry. Besides, she had also caught the measles and retreated to the Petit Trianon, where four devoted admirers, Coigny, Besenval, Esterhazy, and Guînes, came to keep her amused, which of course set tongues wagging. But as soon as she returned to the Château of Versailles, Marie-Antoinette's maternal feelings were aroused as she watched her daughter grow. A few months later, news came of her second pregnancy, and on October 22, 1781, she gave birth. This time, the delivery was less fraught, faster, and had only about ten witnesses. The baby, baptized Louis Joseph, was the long-awaited dauphin to whom France's luminaries paid homage as he lay in his cradle. He was fed by the royal wet nurse, a strong, healthy woman appropriately named Madame Poitrine (Mrs. Bosom). But the little boy's health remained fragile. His weak constitution, and what his doctors called a "touch of scurvy," were both apparent from an early age. He had to wear an iron corset to correct a curvature of the spine and could only move around in a wheelchair. On March 27, 1785, the queen gave birth to a second son, Louis Charles, duc de Normandie. Marie-Antoinette's last child was Sophie Beatrice, born on July 9, 1786.

Facing page:
The birth of the dauphin sealed the union of the crowns of France and Austria (Holy Roman Empire), whose vows of alliance are symbolized in this picture by the flaming hearts.

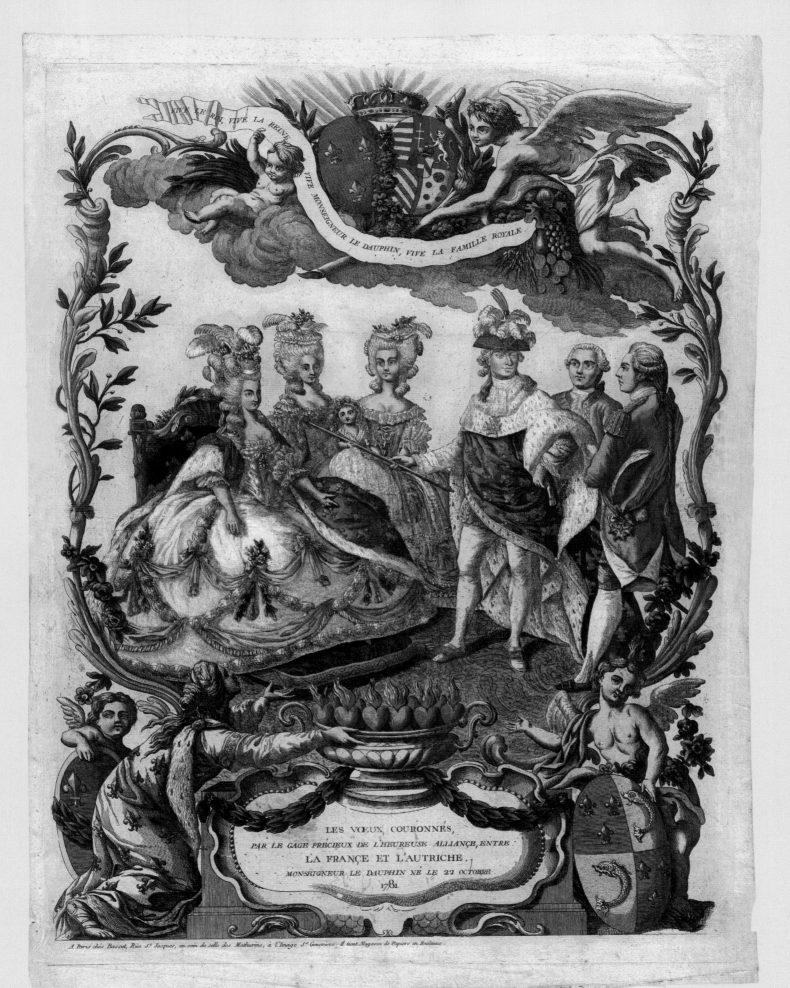

VIVE LE ROY, VIVE LA REINE, VIVE MONSEIGNEUR LE DAUPHIN, VIVE LA FAMILLE ROYALE.

LES VŒUX COURONNÉS,
PAR LE GAGE PRÉCIEUX DE L'HEUREUSE ALLIANCE, ENTRE
LA FRANCE ET L'AUTRICHE.
MONSEIGNEUR LE DAUPHIN NÉ LE 22 OCTOBRE
1781

A Paris chés Basset, Rüe St. Jacques, au coin de celle des Mathurins, à l'Image Ste. Geneviève. Il tient Magasin de Papiers en Feuilles.

520

ACCOUCHEMENT DE LA REINE.
*Notre Auguste Monarque fait voir à la Reine son
Epouse, l'illustre Rejetton que SA MAJESTÉ vient de donner
aux français, tandis que l'amour couronne de Lauriers et
de Roses ces deux Epoux cheris; le jeune Prince est présenté
par Minerve, et le Génie de la santé le tient dans ses bras.
Le Soleil dans son char penchant un peu vers la terre par-
court le Zodiaque ou l'on distingue les signes de la Balan-
ce et du Scorpion sous lesquels est né MONSEIGNEUR LE
DAUPHIN le 22. 8bre 1781. a 1 heure 23. minuttes du
soir. La constellation de Castor annonce que l'accou-
chement fut des plus heureux; on voit sur les
nuages les lettres significatives de la
meilleure et de la plus belle année
du Siecle present.*
Nᵒ

A Paris chez Petit, Rue du Petit Pont, à l'Image Notre Dame.

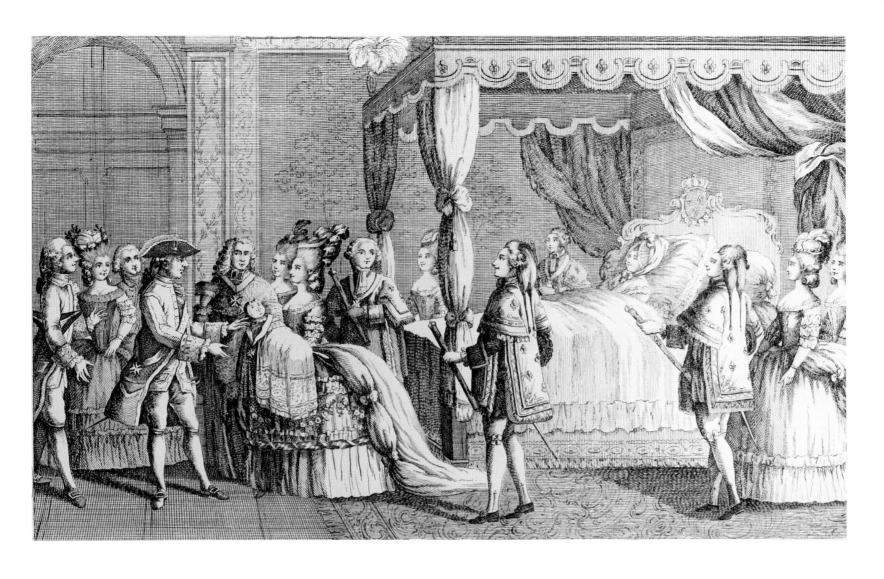

Facing page and above:
Fan decorated with an engraving celebrating the birth of the dauphin, Louis Joseph, on October 22, 1781.

Right:
The dauphin's layette box, made to celebrate his birth, covered entirely in white taffeta decorated with painted scenes of myths and allegories, pastoral landscapes, and popular rejoicing.

The Empty Cradle

The queen's baby daughter Sophie died, stricken with convulsions, when she was less than a year old. Her death is implied by the empty cradle in the large portrait of Marie-Antoinette and her children, which Élisabeth Louise Vigée-Lebrun began in 1786, a few weeks after the girl's premature death. The queen is surrounded by her two sons and her surviving daughter. Marie-Thérèse, her eldest child, otherwise known as Madame Royale, affectionately holds her mother's arm and rests her cheek on her shoulder. Her younger son, Louis Charles, the future Louis XVII, still a babe in arms, sits on his mother's lap. The little dauphin stands on the right, pointing to the empty cradle.

The painting had a political message—the portrayal of her as a mother was intended to boost Marie-Antoinette's public image, which had been greatly tarnished by what became known as the "diamond necklace affair." Visible in the background on the right is a famous jewelry cabinet designed by the architect François-Joseph Bélanger. The cabinet stood in the queen's chamber until 1787, but has since disappeared. Its presence in the picture is an allusion to Cornelia, daughter of the Roman general Scipio and mother of the Gracchi. When asked which of her jewels she most treasured, Cornelia's answer was "my two sons." Here, Marie-Antoinette represents the new Cornelia. Even so, there was so much public hostility to the queen that the portrait was not displayed at the opening of the 1787 Salon du Louvre, as the painter feared it would be vandalized. Some visitors did indeed stand in front of the space reserved for the painting and shout, "There's the Deficit!" Some days later, court officials ordered the painting to be returned to the exhibition. There was praise for the artist's "gentle" touch, but viewers also remarked on the queen's strangely melancholy expression. The work was then moved to the Mars Salon in the King's Grand Apartment at the Château of Versailles, but after the death of Louis Joseph on June 4, 1789, it was taken down because the queen found looking at it too painful.

Facing page and following page: Marie-Antoinette is depicted here as a mother with her three children and the empty cradle of Sophie, who died before her first birthday. It is one of the masterpieces by Élisabeth Louise Vigée-Lebrun, who also painted the portrait of Marie-Thérèse, known as "Madame Royale," and Louis Joseph, the dauphin, playing together with a brood of baby birds.

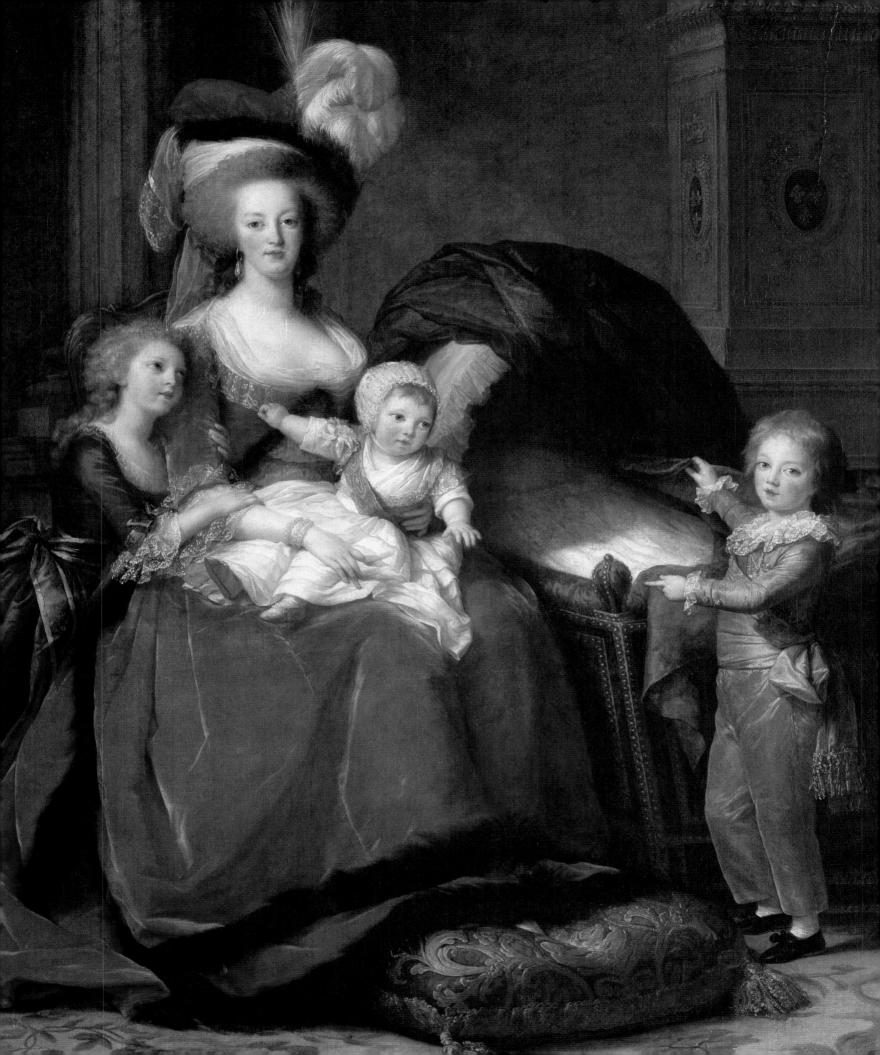

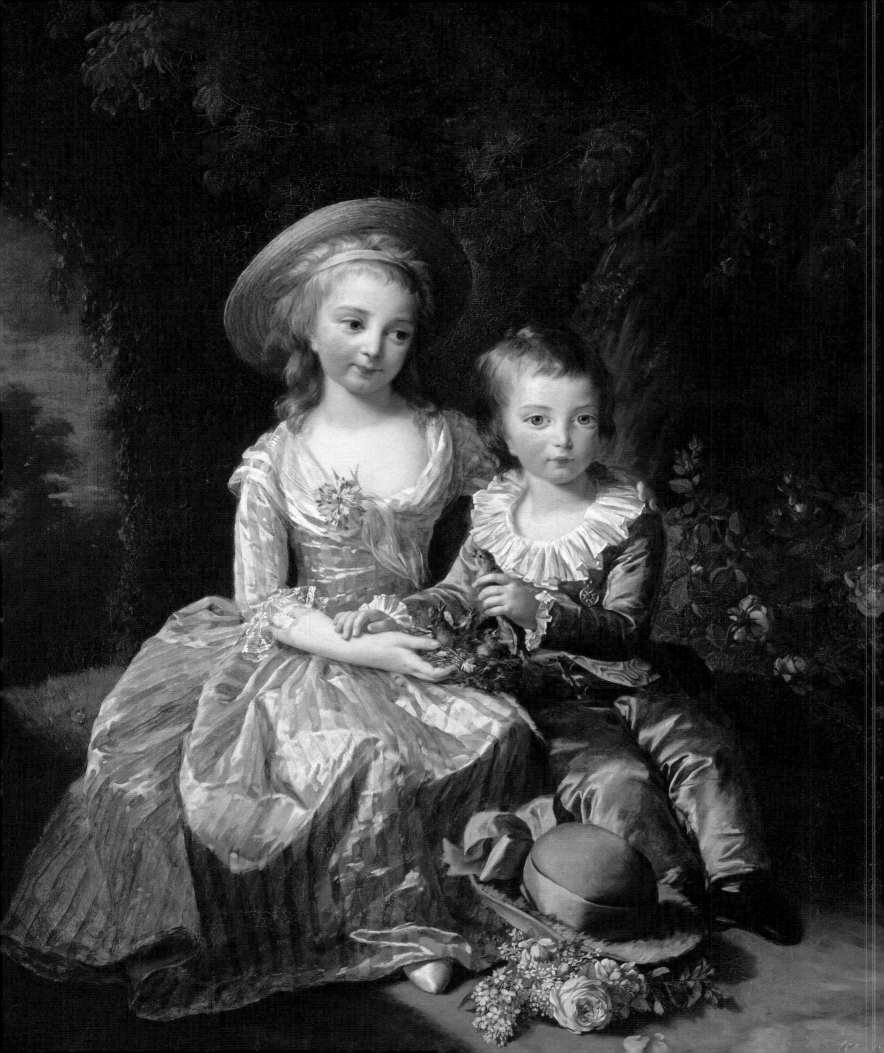

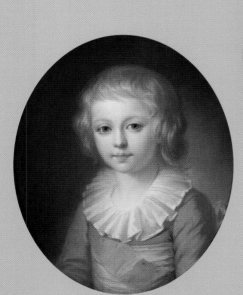

Marie-Thérèse, known as
"Madame Royale,"
born on December 19, 1778.

Louis Joseph, the first dauphin,
born on October 22, 1781.

Louis Charles, the second dauphin
and future Louis XVII,
born on March 27, 1785.

CHILDREN AT COURT

At the Château of Versailles, royal children lived in the southern wing, also known as the Princes' Wing. They were fed by a wet nurse—in the dauphin's case by the renowned Madame Poitrine—and entrusted to the care of a governess. Boys were regarded as men from the age of seven. Marie-Antoinette was very close to her children and proved to be a very affectionate mother. Her pet names for her daughter, her eldest child, were "Mousseline" (Muslin) and "Madame Sérieuse" (Madame Serious), and for little Louis Charles, "chou d'amour" (my little darling) and "sweetheart." She was always ready to join in their fun, playing blindman's bluff or another game called "*guerre pan-pan*" ("bang-bang, you're dead"). Nevertheless, she paid close attention to their upbringing, introducing them to simple rural life in the model village and familiarizing them with La Fontaine's fables, but also encouraging them to read Rousseau and Voltaire.

Right:
The young Louis XVII enjoyed riding along the paths in the gardens of the Château of Versailles in this little carriage (built ca. 1785–89), as perfect in every detail as a full-size one, which was pulled by two goats.

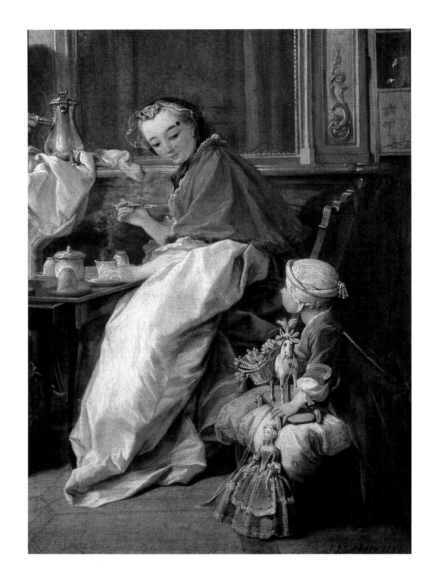

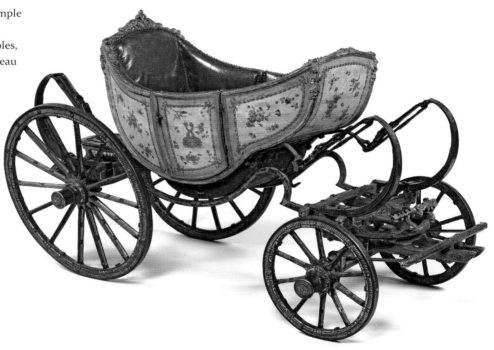

Facing page and right:
As these paintings by François Boucher (facing page) and Nicolas Lancret (right) illustrate, children liked drinking chocolate.

Below:
The second dauphin's little spinning top, which he played with in the Temple.

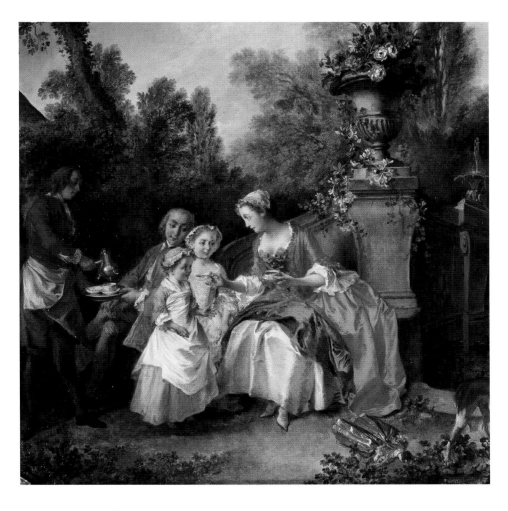

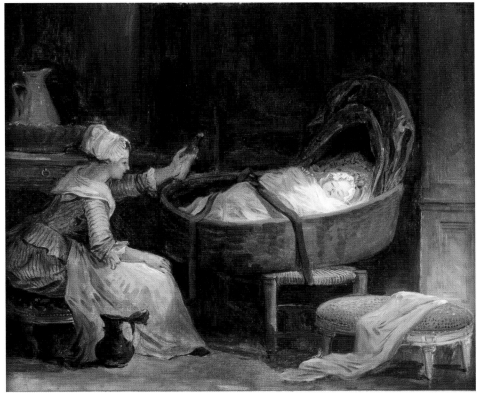

Opposite:
Painting by Hubert Robert of a young woman holding out a bottle to a baby.

Below:
Some of the princes' toys were very precious, such as this rattle made of gilded silver.

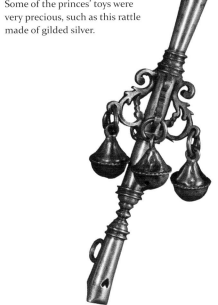

An Enlightened Education

Unlike her mother, Marie-Antoinette herself wished to take charge of her children's education. The eldest child, Marie-Thérèse, was nicknamed "Mousseline" and "Madame Sérieuse" because she was reserved and proud. To encourage her to be less arrogant, Marie-Antoinette found her a playmate from a very modest background, a little girl called Ernestine Lambriquet, whose mother was one of her Women of the Bedchamber. Marie-Thérèse's reading included works by La Rochefoucauld, Montaigne, and La Fontaine as well as Rousseau, Montesquieu, and Voltaire. But Marie-Antoinette preferred her two boys. They were very different: the elder was sickly and weak, the younger, whom she nicknamed "chou d'amour," was lively and mischievous. To teach her children to be generous, she showed them toys and then explained that the money she would have to spend to buy them would be used to give alms to the poor. Above all, Marie-Antoinette was a very loving mother. Like the king, she wanted the children to be happy, but she found it easier to show her feelings than he did.

After the death of the first dauphin on June 4, 1789, she gave all her affection to Louis Charles. When Madame de Tourzel was appointed Governess of the Children of France in July 1789, Marie-Antoinette gave her a description of her son: "My son is four years and four months, minus two days; I will say nothing about his size or general appearance, since you will see for yourself. He has always enjoyed excellent health [. . .] like all strong and healthy children, he is very absent-minded and flighty, and has quite a temper, but he is a good child, gentle and even affectionate when he is not distracted." Concerning his education, the queen was precise, and showed her grasp of psychology: "I say again, he is a good child and if we handle him gently but firmly without being severe we will get him to do what we want, but severity will only make him rebel for he has a strong character for his age and, to give you an example, from his earliest childhood the word 'sorry' has always vexed him: he will say and do all you want but cannot say sorry without a lot of tears and trouble."

The queen paid a great deal of attention to her children's education and showered them with love and kindness. But they were certainly not the only objects of her affection . . .

Above:
Marie-Antoinette and the dauphin Louis Charles walking outside the Tuileries, accompanied by the princesse de Lamballe and "Madame Royale."

Facing page:
The royal family on a walk through the gardens of the Château of Versailles, in front of the statue *Milo of Croton* by Pierre Puget. Detail of a painting by Hubert Robert.

Following double page:
Left:
Painting by Eugène Battaille of Marie-Antoinette walking with her two first children, "Madame Royale" and the dauphin Louis Joseph.

Right:
Detail from a painting of members of the royal family gathered around the dauphin, Louis Joseph, by an unknown artist of the French school.

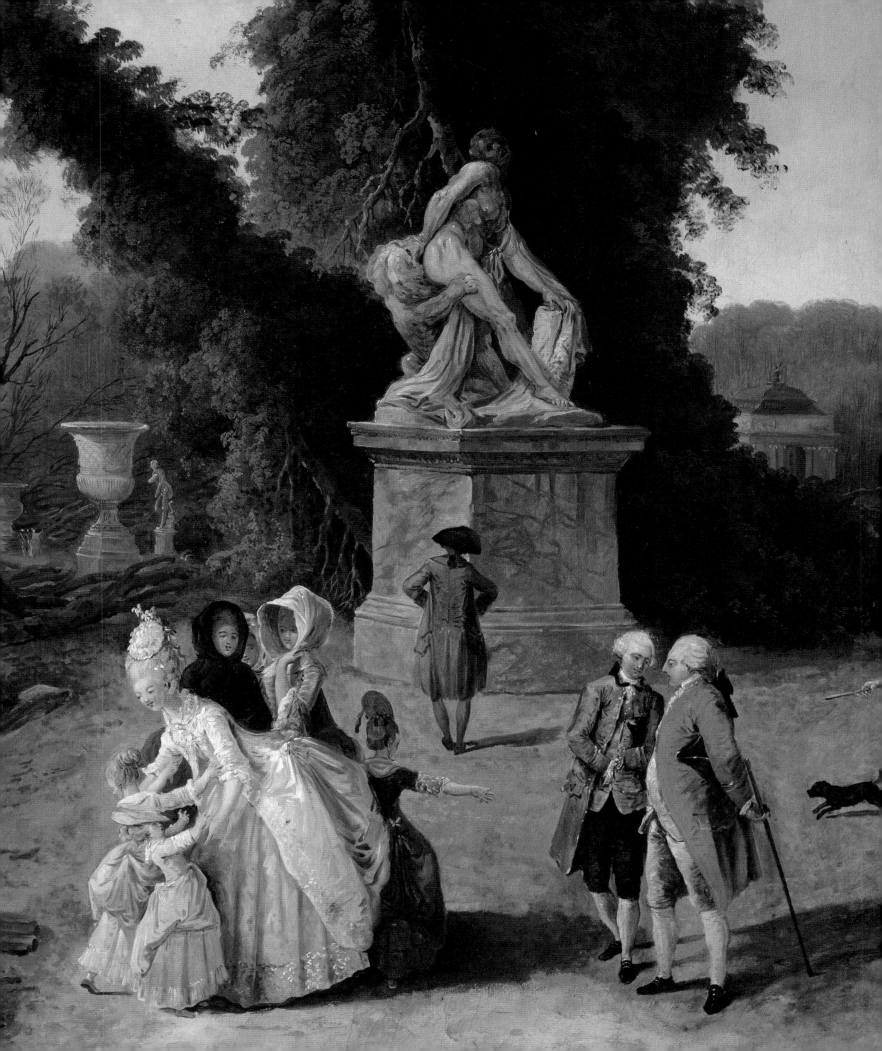

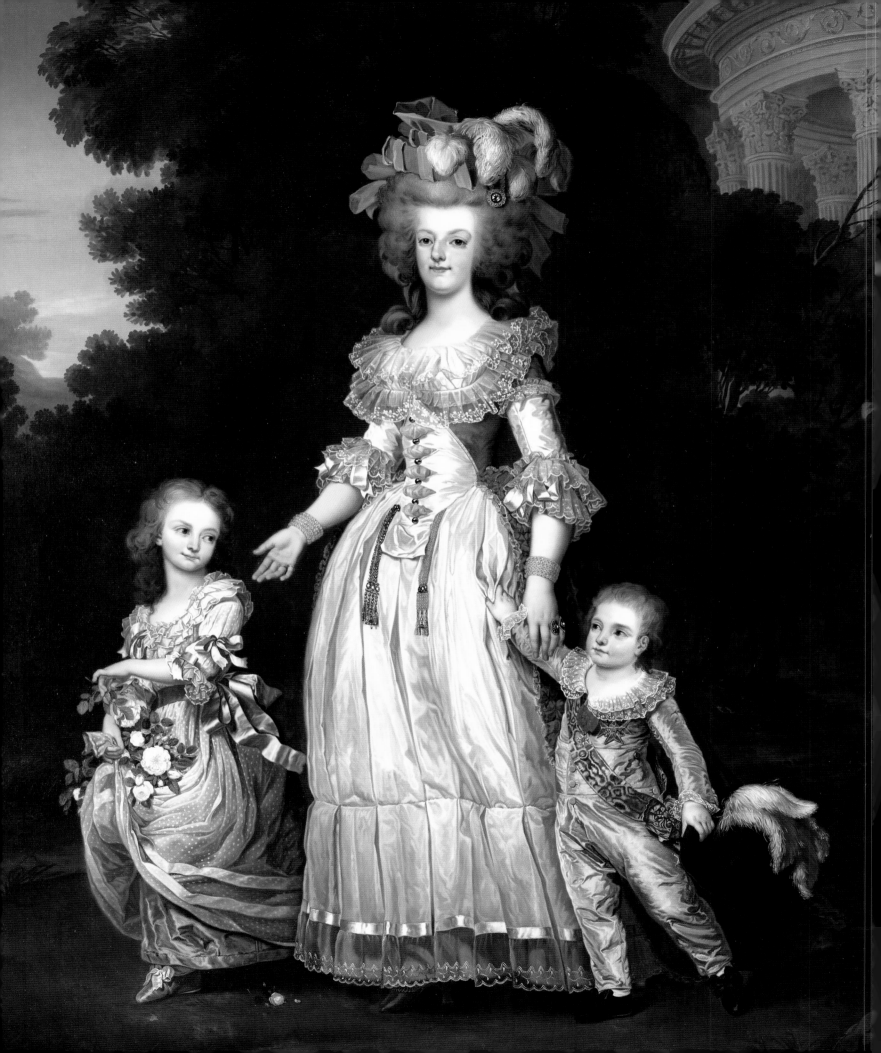

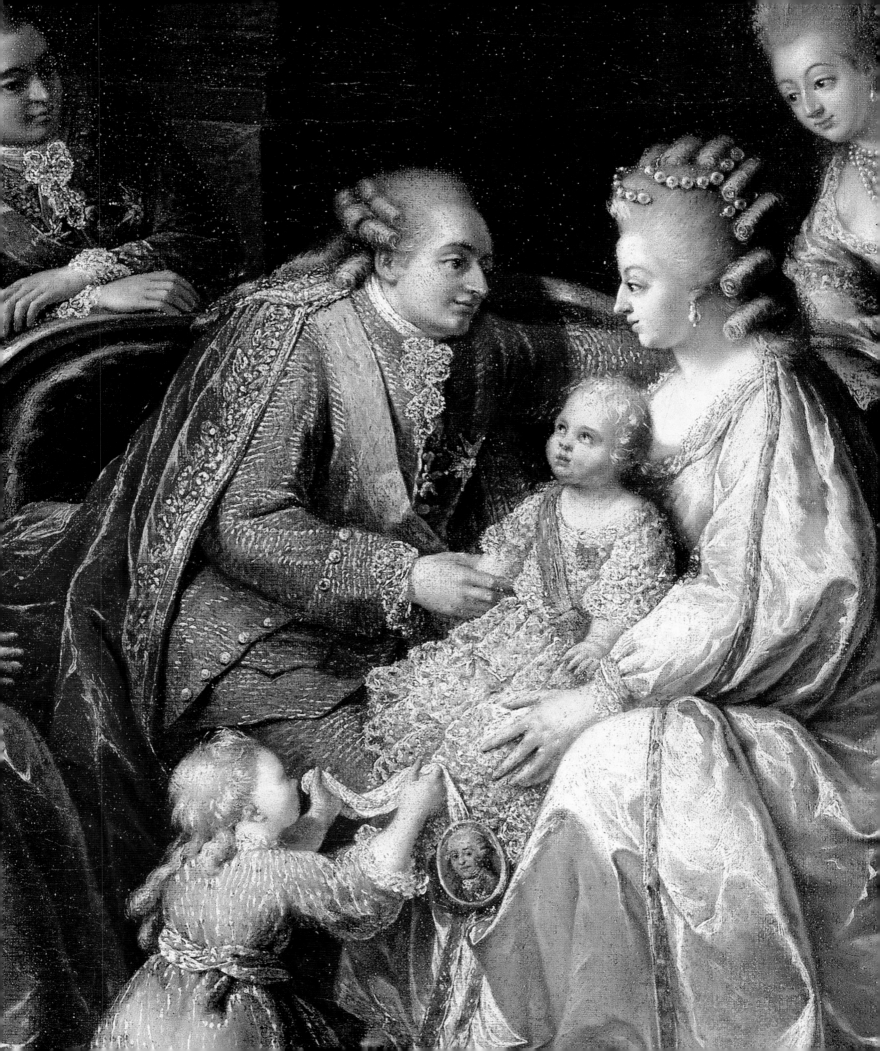

The Swedish Officer

Hans Axel von Fersen was the eldest son of one of the richest and most powerful men in Sweden, Field Marshal von Fersen. While on a Grand Tour to complete his education in Europe's leading courts and academies, Fersen, at the age of eighteen, met Marie-Antoinette for the first time at the Paris Opera in January 1774. Since the event was a masked ball, he did not recognize the dauphine, and they chatted and joked together. When he was officially introduced to the queen four years later, she immediately exclaimed, "Oh, he's an old acquaintance." Fersen had recently proposed to a rich English heiress and been turned down. His pride was hurt because he regarded himself as very seductive, indeed almost irresistible, and he aspired to a brilliant diplomatic or military career.

Marie-Antoinette soon succumbed to his charm, and he became her regular guest at the various parties and entertainments at the Petit Trianon. People quickly noticed the queen's close relationship with the handsome and dashing Swedish officer and began to talk. Fersen and Marie-Antoinette were the same age, both of them blond, seductive, and hedonistic . . . Soon there were so many malicious rumors that Fersen thought it best to keep his distance from the queen. He left to participate in the American Revolution, in which France supported the American revolutionaries in their quest for independence. His absence lasted four years, from April 1779 to June 1783. On his return, Marie-Antoinette used her influence to help him buy a French regiment, the "Royal Swedes." It appears that at this point his relationship with the queen took a new turn: having failed to gain the hand of Germaine Necker, the daughter of Louis XVI's finance minister, he decided that he would not marry, a decision he explained in a letter to his sister and confidante Sophie: "I have taken the decision never to marry [. . .] I cannot belong to the one person to whom I want to belong, and who loves me. So I do not wish to belong to anybody." Fersen's letter seems to confirm that it was love that united the queen and the Swedish officer.

Facing page:
The Swedish officer Axel von Fersen, loved by Marie-Antoinette and perhaps her lover.

Following double page:
Left:
The Belvedere was one of the most pleasant places in the gardens of the Petit Trianon.

Right:
This bust in soft-paste biscuit porcelain by Louis-Simon Boizot shows Marie-Antoinette with a coiffure called "*en tapé*."

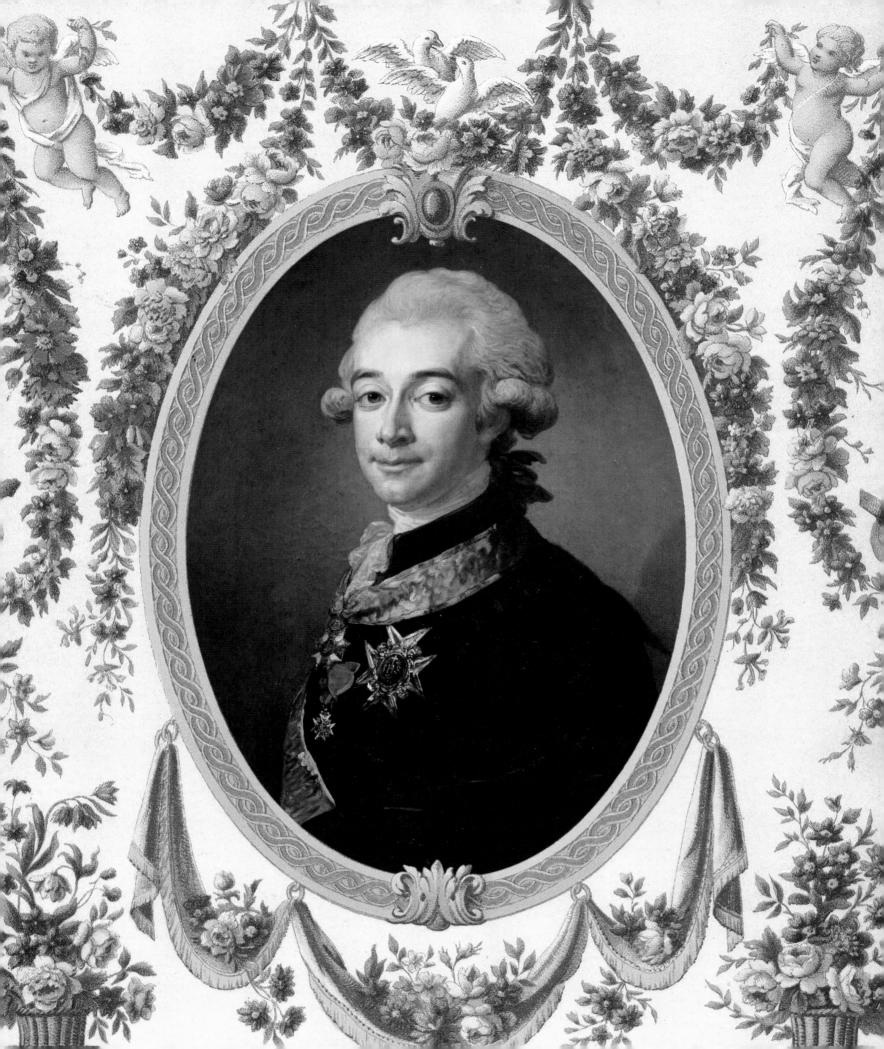

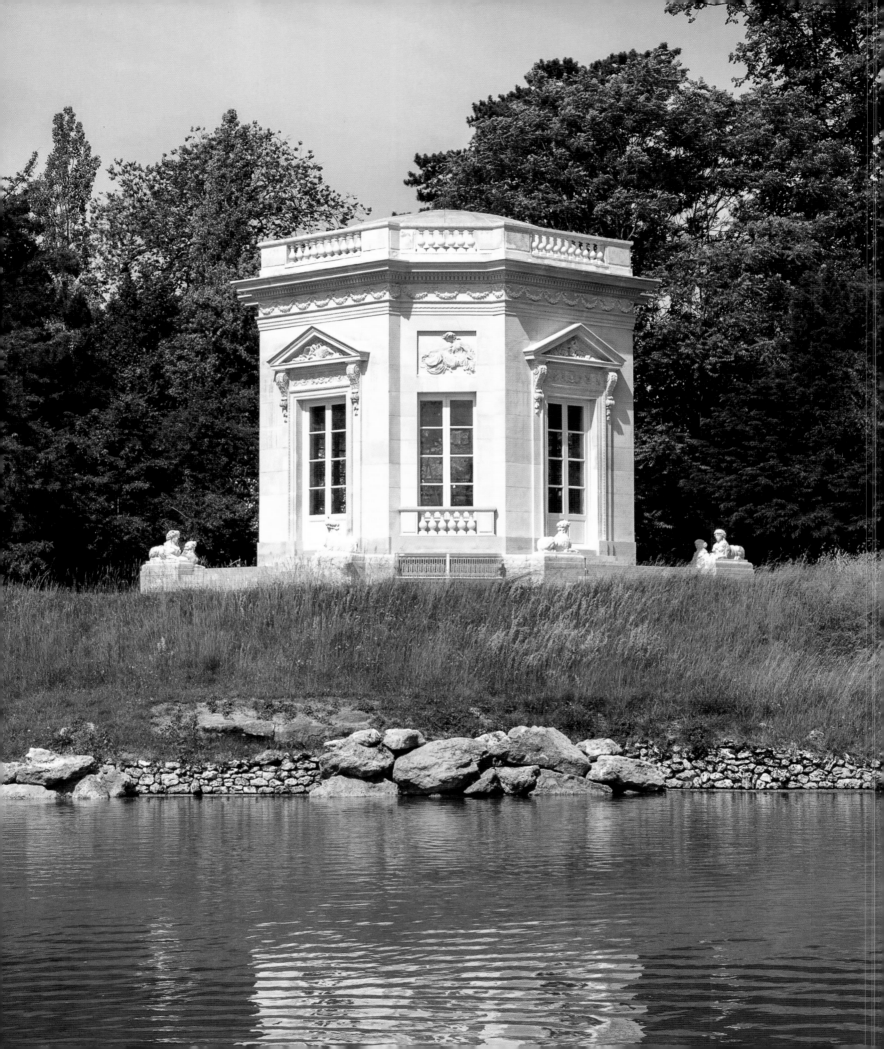

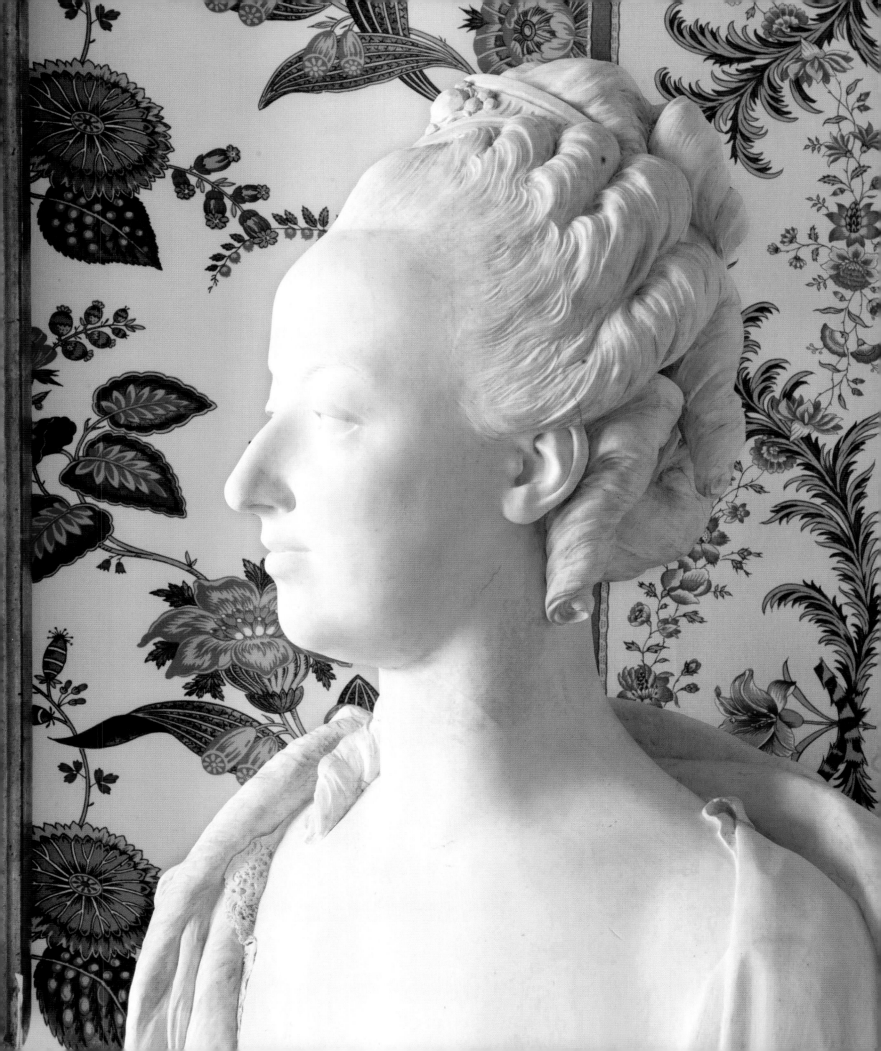

An Impossible Love

Many contemporary witnesses confirmed that Fersen and Marie-Antoinette loved each other, although the pages of Fersen's diary for the years 1776 to 1791 and most of the letters he exchanged with the queen have been destroyed. In 1785, in a letter to his sister Sophie, Fersen described Marie-Antoinette as "an angel of goodness and heroism," and added, "Never have I been so loved." In January 1786, Sophie received a lock of the queen's hair, with this note from Fersen: "This is from her, and she was very touched that you asked for it. She is so good, so perfect, and now that she has become attached to you I feel I love her all the more." From then on the queen was referred to by the code name "Joséphine" and then simply by "She."

Although Fersen spent a lot of time with Marie-Antoinette, he kept a low profile. Being above all concerned about the queen's reputation, which was going from bad to worse, he stayed away from public gatherings and receptions at court. The comte de Saint-Priest, one of Louis XVI's ministers, remarked that the meetings between the two at the Petit Trianon "were the subject of much gossip," but that he appreciated the way in which Fersen was "the most discreet of all the queen's friends." He was certainly the most faithful. When the political crisis drove away all the nobles who had paid court to Marie-Antoinette, Fersen remained loyal and constant in his love. When the royal family was held in the Tuileries, Fersen became obsessed with the idea of rescuing the queen. Thanks to La Fayette, he obtained an official pass giving him private and secret access to the imprisoned queen's apartment. A few months before her death, Marie-Antoinette sent him a final, simple message: a wax impression that she took of the Fersen coat of arms, with the Italian motto *Tutto a te mi guida*, "everything leads me to thee."

Facing page:
A view of the Hameau at the Petit Trianon, painted by Pierre Joseph Wallaert. The Hameau was Marie-Antoinette's secret world. Here we see the lake, the Queen's House, and the Marlborough Tower.

Following double page:
The Temple of Love in the gardens of the Petit Trianon. In the center stands an old copy of the famous sculpture by Edmé Bouchardon, showing Cupid cutting his bow from the club of Hercules, an allegory of the triumph of love.

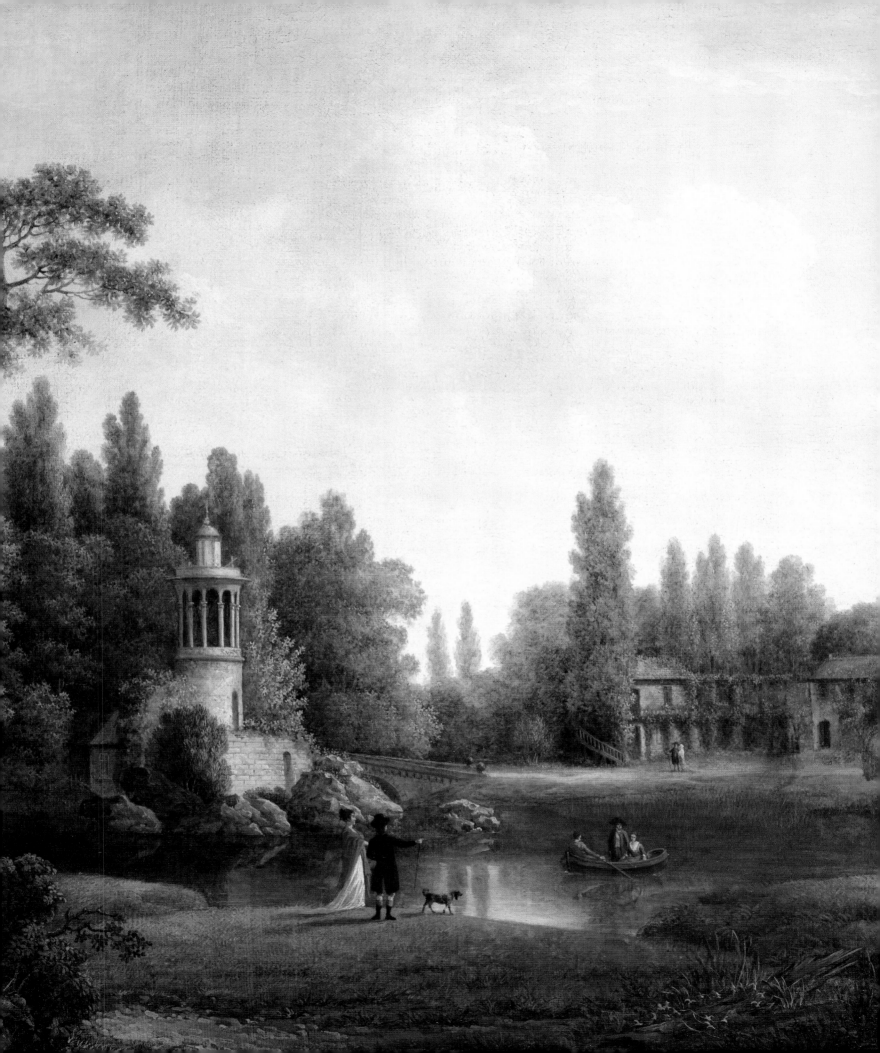

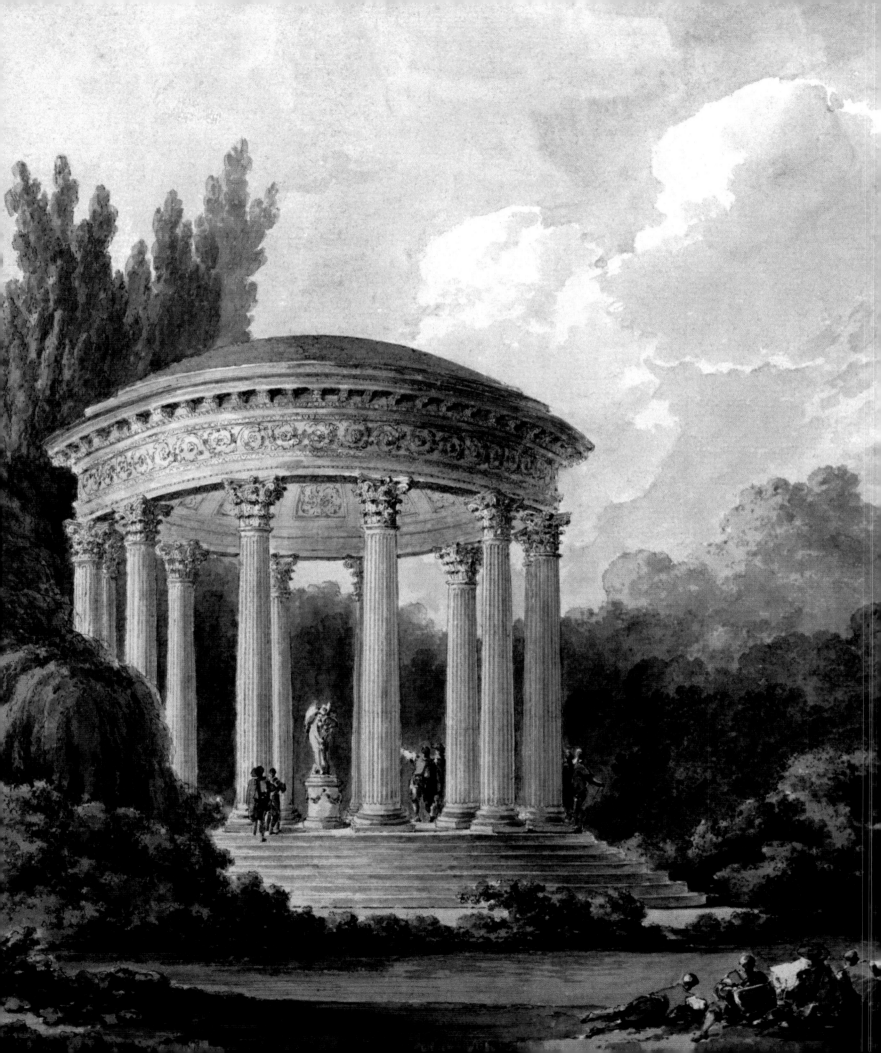

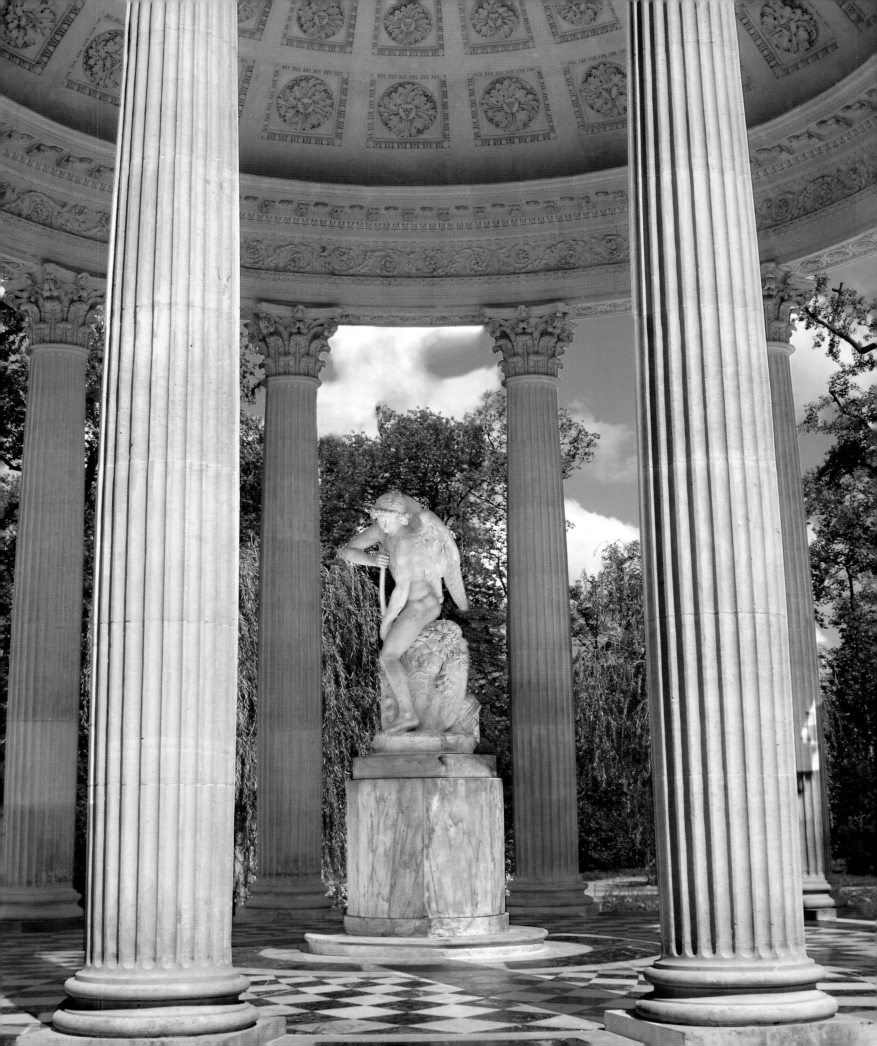

Platonic Love?

The enduring question is whether the love between Marie-Antoinette and Fersen remained platonic or turned into a sexual relationship. Historians have been divided: Stefan Zweig is the most eloquent defender of the view that they did have an intense physical love affair, while the majority of Marie-Antoinette's French biographers believe that it was a platonic one. But contemporaries were certainly convinced that Fersen was the queen's lover. New evidence has given some support to this hypothesis. In early October 1787, Fersen asked "Joséphine" for a space in her private apartments at the Château of Versailles where he could have a wood stove. Historians could not believe that the queen of France lowered herself to look after Fersen's domestic comfort, but a recently discovered document clearly proves that at this same date the queen had indeed hired a "Swedish stove-maker" to install a stove in one of her private rooms.

Clearly, Fersen and the queen were very close at this time. It should be remembered that in 1787 Marie-Antoinette had lost her last child, Sophie, who had died when she was just eleven months old, and that she would give Louis XVI no more children. Simone Bertière has suggested that once the queen decided not to have any more children (or sexual relations with her spouse), there were no barriers to becoming Fersen's lover because "as long as there was no procreation there was no infidelity."[9] It is equally possible that Fersen and the queen were, in the delicate phrase of André Castelot, "restrained lovers." Fersen's last nocturnal visit to the Tuileries, where the queen had been held in her closely guarded apartment since the flight to Varennes, on February 13, 1792, inspired some memorable lines from Stefan Zweig: "Anyone who chooses to do so is, therefore, at liberty to believe that this night was exclusively devoted to platonically chivalrous service and to political conversation. But those who have known the spell of ardent passion, those whose observations of themselves and others have convinced them that hot blood will run its course, can hardly doubt that, even if Fersen had not already long ere this become Marie-Antoinette's lover, he must have become her lover on so fateful a night, a night which when once gone would be lost beyond recall, a night on which he had shown such splendid courage."[10]

Facing page:
This painting after John-Claude Nattes shows the fishery tower, later called the Marlborough Tower, one of the most beautiful buildings of the Hameau, with its impressive external spiral staircase of solid oak. It had a landing stage for rowing boats and was used to store equipment for carp angling.

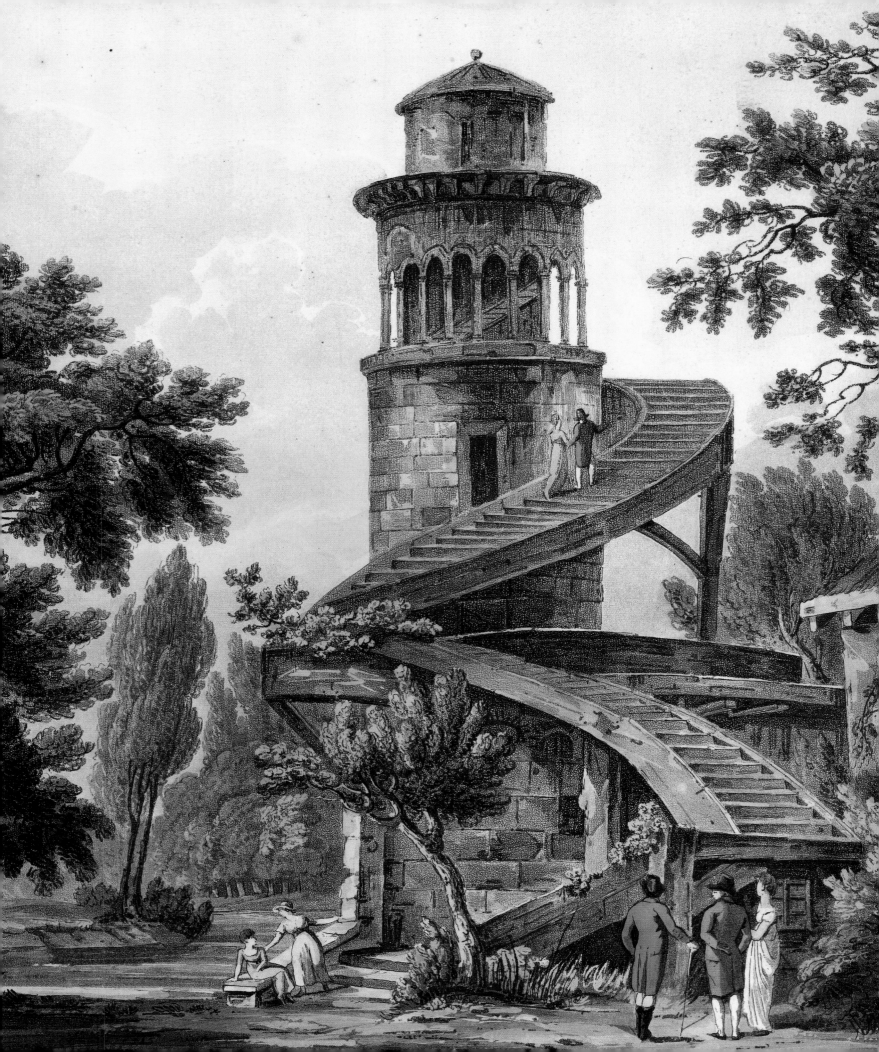

LOVE AND LIBERTINISM

The century of the Enlightenment was also, famously, the age of libertinism. The pleasure-seeking Marie-Antoinette, a frequent participant in masked balls in Paris during her early years at court, was suspected of having numerous sexual liaisons. Various noblemen at the court were mentioned, of course, like the duc de Lauzun, but she was also accused of having affairs with palace guards and valets. And not only with men—because of her close friendships with women, her lovers were said to include the princesse de Lamballe and the duchesse de Polignac. The only person she is known for certain to have loved was the handsome Swedish officer Axel von Fersen. But historians still debate whether this relationship was ever a sexual one.

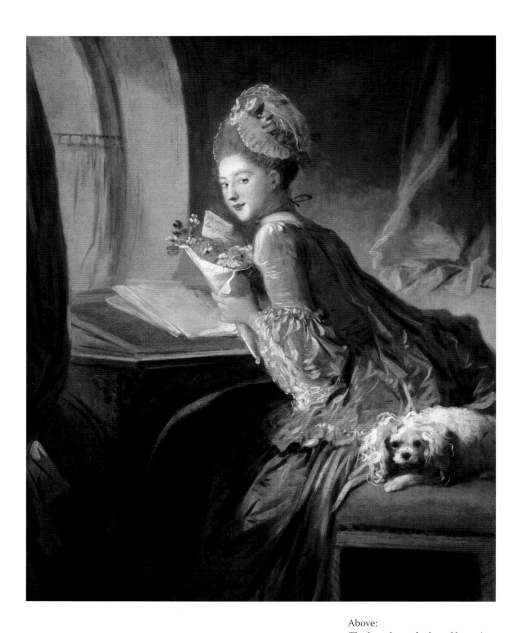

Above:
The Love Letter by Jean-Honoré Fragonard is one of the most beautiful evocations of libertinism in the eighteenth century.

Above:
A little box of gold and porcelain made in the eighteenth century.

Right:
Marie-Antoinette adored stylish shoes. Several pairs from her collection still survive today, including the ones shown here.

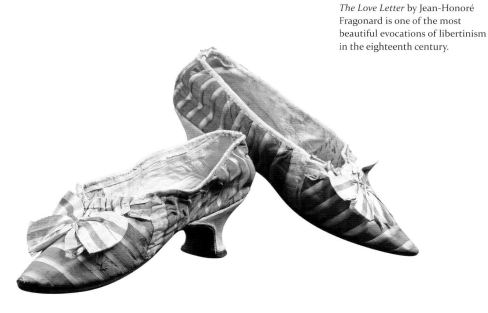

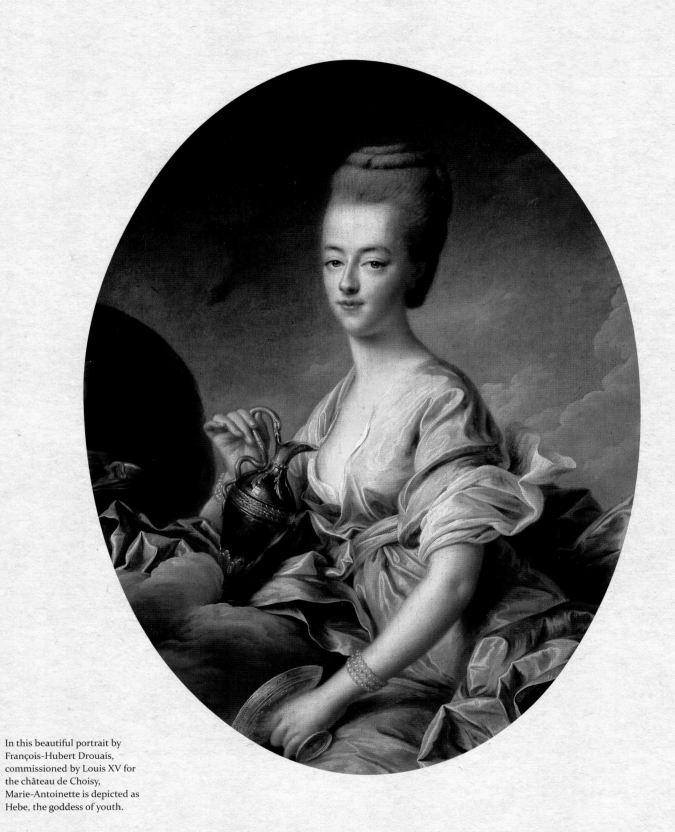

In this beautiful portrait by
François-Hubert Drouais,
commissioned by Louis XV for
the château de Choisy,
Marie-Antoinette is depicted as
Hebe, the goddess of youth.

Torment

The scandals about her behavior, her "special" friendships, her profligate spending, and the campaign of slander that she faced, dealt a fatal blow to Marie-Antoinette. She became the target of popular fury. Paris was a tinder-box, uprisings spread across the country, and the march toward revolution seemed unstoppable. It was only when the monarchy was in grave jeopardy, when she was forced to leave the Château of Versailles to become a prisoner in Paris, that Marie-Antoinette displayed the strength and spirit of a queen.

Depicted in full mourning in the Temple prison by Anne Flore Millet, Marie-Antoinette wears a cameo medallion of her two children and sits beside a bust of Louis XVI.

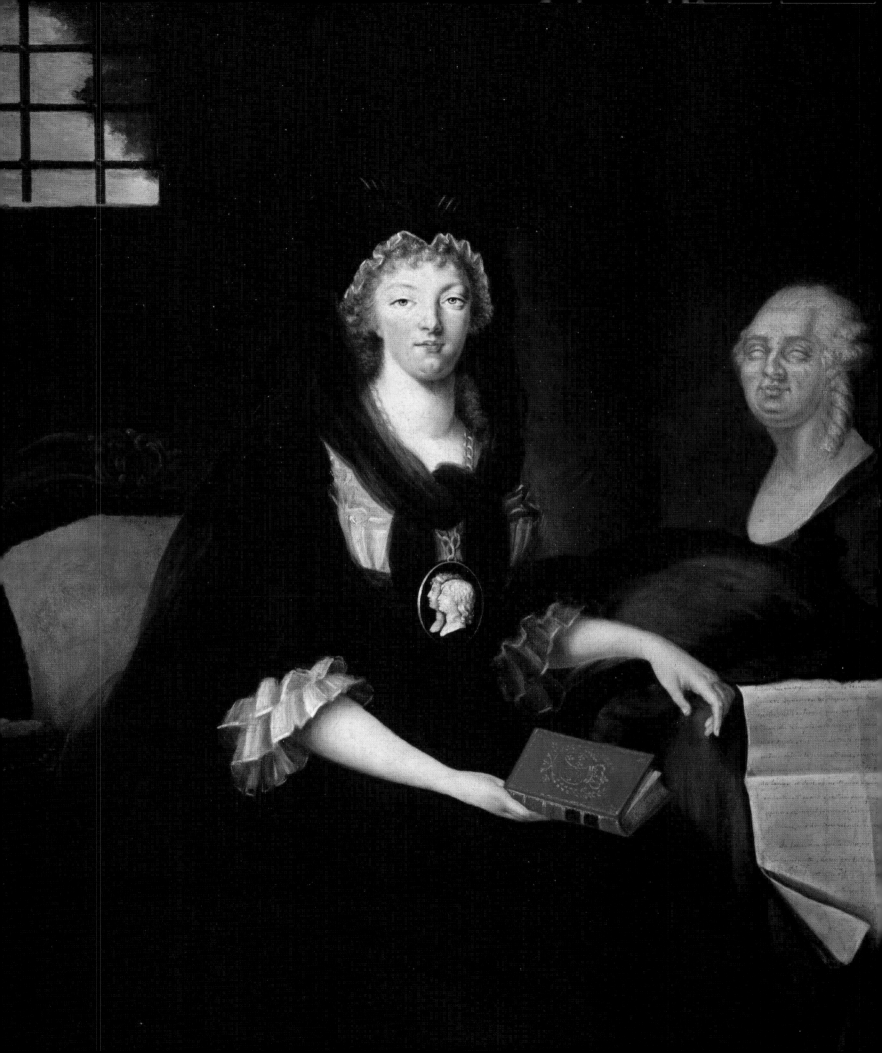

The Road to Revolution

Marie-Antoinette's bungling attempts to play a political role made the situation even worse. She intervened in nominations and promotions, tried to persuade Louis XVI to appoint ministers of her choosing—ministers who rarely lasted longer than a few months—and she managed to get Jacques Necker, whom she loathed, dismissed. As a result, Necker's popularity soared, for he was seen as one more victim of the queen. In a letter, Joseph II fiercely criticized her for tyrannizing her husband and interfering in affairs of state just to satisfy her own whims:

> What do you think you are doing, dear sister, removing ministers from their posts, banishing one to his estates and giving office to another, helping some friend of yours win a lawsuit, creating a new and expensive court appointment, in brief, in discussing matters in a manner that is little suited to your position? Have you asked yourself by what right you meddle in affairs of the French government or monarchy? What studies have you undertaken? What knowledge have you acquired, that you believe your opinions of value? [. . .] You, a charming young woman who thinks only of frivolities, of your toilette, of your daily amusements, who does not read books or listen to serious talk for ten minutes in a month . . .

As the Revolution approached, Marie-Antoinette, the proud daughter of an empress, who knew nothing of France beyond the splendors of its palaces, increasingly gave voice to her absolutist sentiments and her hatred of those supporting even the smallest institutional reforms. She could not understand the new France of the eighteenth century, the France of liberalism and the Enlightenment. Her nickname *l'Autrichienne* was now revived as an insult with redoubled venom.

In the summer of 1787, the Parlement of Paris led a revolt against the reforms of Loménie de Brienne, who had been appointed as finance minister with the help of Marie-Antoinette after the dismissal of Charles-Alexandre de Calonne. When Brienne resigned in 1788, the king brought back Necker, who had always

Above:
The dismissal of Jacques Necker on July 11, 1789, instigated by Marie-Antoinette, helped to trigger a popular uprising in Paris, the prelude to the Revolution.

Facing page:
The storming of the Bastille on July 14, 1789, marked the start of the Revolution.

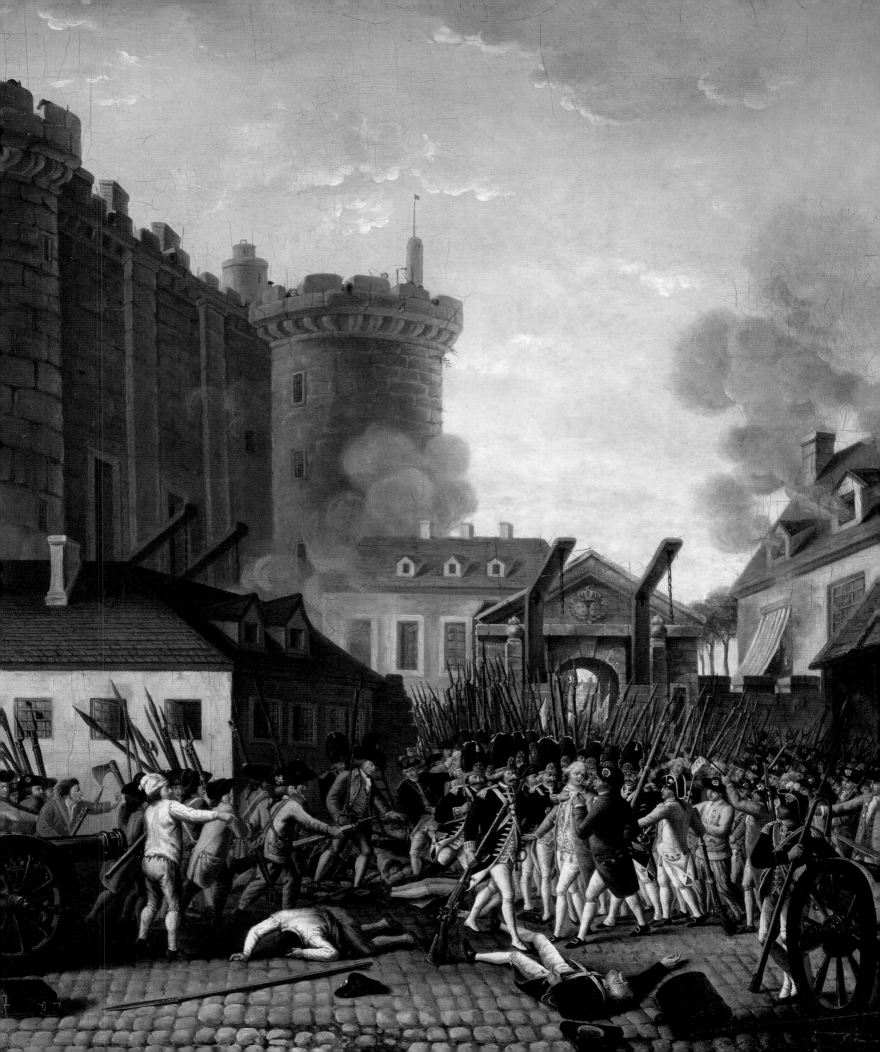

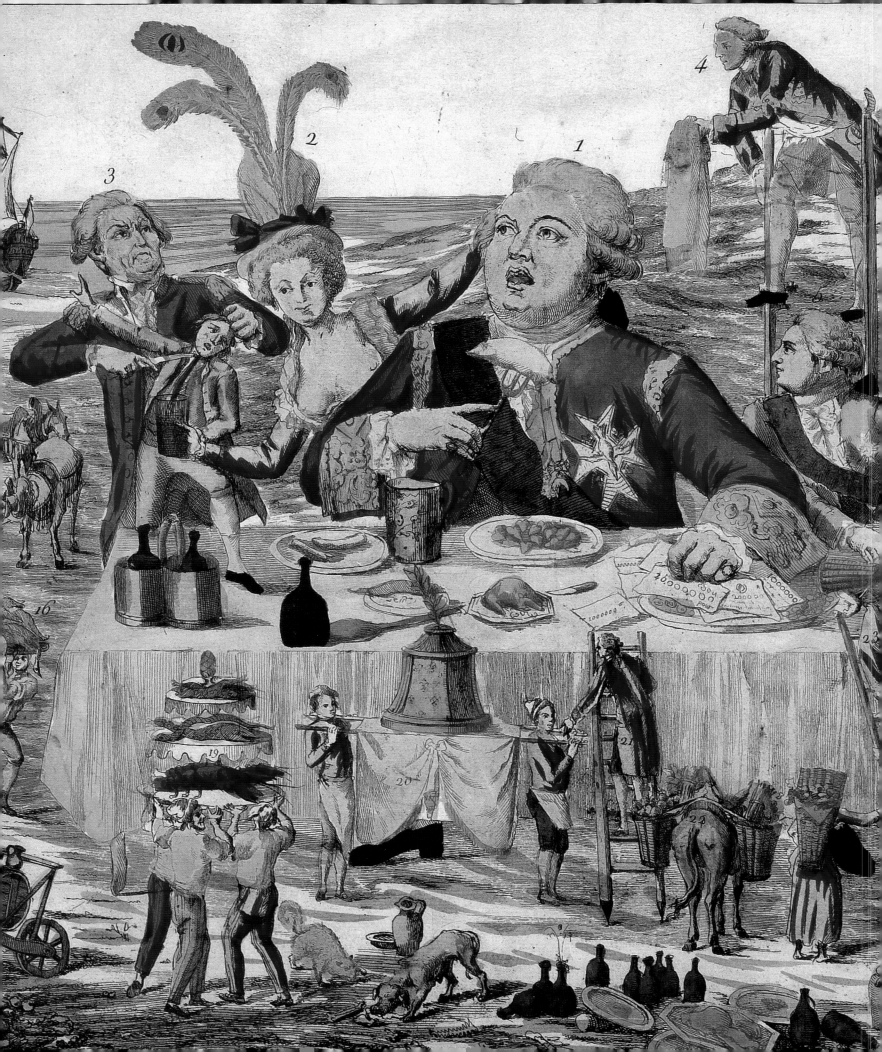

pursued an economic policy of reducing the deficit and curbing state expenditures. Faced with a financial and political crisis of unprecedented gravity, Louis XVI was forced to convoke the Estates-General.

The three orders—clergy, nobility, and the Third Estate—had not been brought together since 1614. On May 5, 1789, the opening meeting of the Estates-General in the Hôtel des Menus-Plaisirs in Versailles marked the beginning of the French Revolution. The assembly was presided over by Louis XVI, who declared himself "his people's best friend." There followed a speech by Necker on the budgetary deficit, in which he merely proposed the levy of new taxes to cover it. The Third Estate, disappointed by his speech, which did not propose any reforms, refused to submit to royal power, and on June 17 solemnly constituted itself as the National Assembly. The king tried to oppose the National Assembly by barring the entrance to the Hall of the Menus-Plaisirs. On June 20, finding the doors closed and guarded, the deputies moved to the Jeu de Paume, a short distance from the Château of Versailles, and there took the famous oath pledging "not to separate and to reassemble wherever circumstances require, until the constitution of the kingdom is established and consolidated upon firm foundations." It was the founding act of French democracy.

On July 11, frightened by the direction of events, the king dismissed Necker again before recalling him under popular pressure four days later. On July 14, anger mounted, and Paris rose up: the Bastille, symbol of arbitrary royal power, was stormed. This event was followed on the night of August 4 by the abolition of the privileges of the nobility and on August 26 by the Declaration of the Rights of Man and of the Citizen.

Facing page:
Louis XVI caricatured as Gargantua, devouring all the fruits of the labors of his subjects.

Right:
In this cartoon, Marie-Antoinette is depicted as a new Pandora, opening her box to spread all the miseries of humanity.

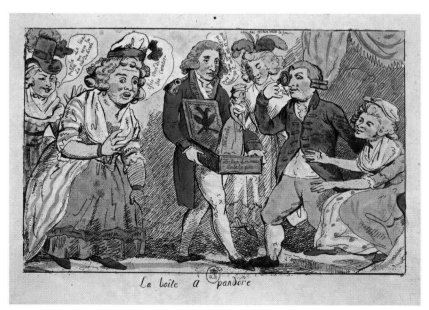

La boîte à Pandore

Last Night at Versailles

A famous—or infamous—meal would precipitate the events of October 1789. On October 1, the king's bodyguards at the Château of Versailles organized a banquet at the Royal Opera in honor of the arrival of a new regiment from Flanders. The wine flowed freely, and emotions were running high. After supper, when the royal family arrived, the guards wanted to demonstrate their loyalty to the king and began singing a famous aria from Grétry's opera *Richard Cœur de Lion*: "Ô Richard, ô *mon roi, L'univers t'abandonne!*" ("O Richard, O my king, the whole world forsakes you!"). Two days later, the account of these festivities in the press scandalized the capital: people believed the story—this had been an anti-democratic orgy, and the national tricolor cockade had been trampled underfoot—and the very idea of organizing a banquet when ordinary people were going hungry appeared hugely provocative.

On the morning of October 5, rioting broke out. The king was out hunting in Meudon forest and Marie-Antoinette was at the Hameau when a page brought her news that a procession of nearly 6,000 women was marching on Versailles to demand bread. The monarchy, so people believed, was plotting to quell the populace and bring down the Revolution by hunger though in fact the harvest in 1789 had actually been a very good one. The royal family withdrew to the palace, and a delegation was received by Louis XVI. At midnight, La Fayette, now commander of the National Guard, arrived at the Place d'Armes with 20,000 men to restore order. He entered the king's bedchamber and said, "Sire, I have come to offer you my head in order to save your Majesty's." After visiting the Assembly, La Fayette ordered everyone to bed. The royal carriages were standing at the gates of the palace grounds, but the queen refused to leave; this was the day that sealed her fate.

At daybreak on October 6, a furious mob armed with bayonets invaded the queen's private apartments. One of the bodyguards only had time to cry out, "Save the queen!" before being brutally murdered. The queen, in a panic, escaped through the inner rooms, fetched her children, and ran to join the king in his apartments. Now the royal family was gathered together in the king's

Above:
The marquis de La Fayette, hero of the American Revolutionary War, was responsible for ensuring the safety of the royal family at the start of the French Revolution.

Facing page:
On October 6, 1793, at about four in the morning, a section of the crowd assembled at the Château of Versailles forced their way into the royal apartments, getting as far as the queen's bedchamber.

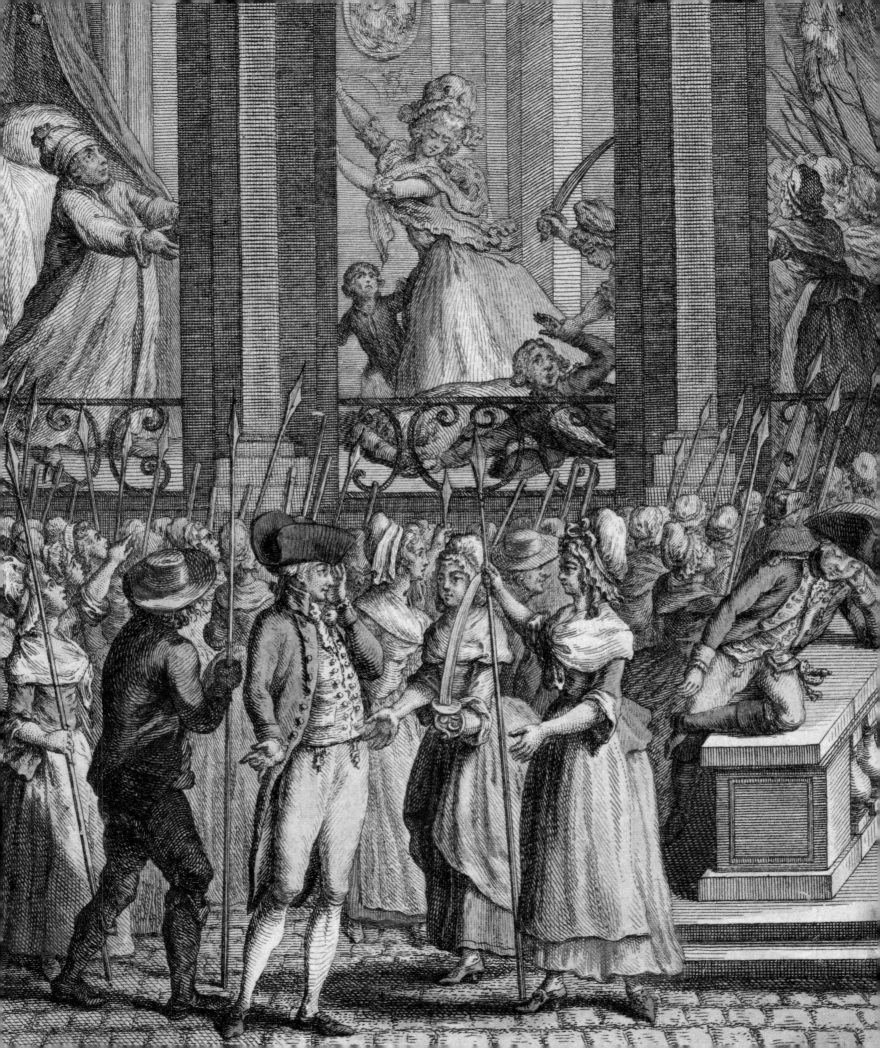

bedchamber. Through the windows overlooking the Marble Courtyard, Marie-Antoinette could hear the crowd's heckling.

La Fayette calmed the troops and asked the king to present himself on the balcony. When Louis XVI appeared, the women enthusiastically cried out, "Long live the king!" and "To Paris!" thereby showing the attachment the revolutionary masses still felt for their king. Now they called for the queen to appear on the balcony. Hesitating at first, Marie-Antoinette stepped out with her two children. "No children!" came voices from the crowd. She ushered the children back inside and again stepped forward. Alone, she stood before the armed crowd of Parisians. Her dignity prompted a surge of pity, the shouting abated, and muskets were lowered. But then the cries returned, louder than ever: "To Paris!" The king had no choice but to comply: "My children, you want me to follow you to Paris, and I will do so, but on condition that I will not be separated from my wife and my children." At one in the afternoon, the king and queen left Versailles in a bizarre procession. Women surrounded the royal carriage, some on horseback, some perched on cannons, others shouting, "We've got the baker, the baker's wife, and the baker's boy—now we'll never want for bread again!" Through the window, Marie-Antoinette could see the two heads, on spikes, of the massacred bodyguards. The journey seemed interminable.

The procession entered Paris around six that evening and stopped at the Hôtel de Ville before arriving at the Palais des Tuileries, which had been unoccupied since Louis XV's childhood. By now it was ten o'clock and nothing had been prepared for receiving them; trestle beds were hastily made up for the first night. In the days that followed a makeshift household took shape, under the ever-watchful eyes of the National Guard. Furniture was brought in, paintings, tableware, tapestries, and clothing. . . All Marie-Antoinette's friends had fled—with Fersen the sole exception. The king appeared resigned; the enforced confinement made him melancholic.

Pact with the Devil

It was at this point that Honoré Gabriel Riqueti, comte de Mirabeau, entered the scene. "Mirabeau!" exclaimed Victor Hugo, "It is not a man, not a nation, but an event which speaks. An immense event! The fall of the monarchy of France." An unrepentant libertine with a tempestuous youth behind him, of gluttony and heavy drinking, scandalous escapades and profligate spending, along with sundry convictions and imprisonments, Mirabeau was also a brilliant orator. With his formidable intelligence and a face so unprepossessing that it startled his contemporaries ("Your nephew is as ugly as Satan," his father told his brother when he was born), Mirabeau could rouse political gatherings with his dazzling eloquence. A deputy of the Third Estate who, with his famous speech of June 23, 1789 ("Go and tell your master that we are here by the will of the people and will leave only by the force of bayonets"), decreed the inviolability of the people's representatives, the man notorious for his impassioned and fearsome diatribes against the "privileged orders," now decided to betray the very cause he had defended.

In May 1790, he sold himself to save the monarchy, effectively entering the royal family's secret service. In return for a considerable sum of money—enabling him to pay off his many debts—he offered to place his popularity and political intelligence at the service of the king without telling the public and his fellow deputies, who trusted him, that he was doing so. Money was his motivation, yet he also imagined himself as the queen's protector and adviser, dreaming of playing a similar role to that of Cardinal Mazarin in the previous century. The queen initially balked at entering an alliance with the man she called "the monster," but in the end the king and queen accepted: only someone who had helped to undermine the monarchy might have the power to restore it. Mirabeau sent discreet messages to the king and secured a clandestine meeting with the queen at the château de Saint-Cloud

Above:
In return for repaying his debts, Mirabeau secretly plotted to help the royal family.

Facing page:
In 1791, Louis XVI was the target of many caricatures, depicting him as Gargantua, as a pig, or, like here, as a wine jug.

ah! Le Cruchon

Le Masque Levé

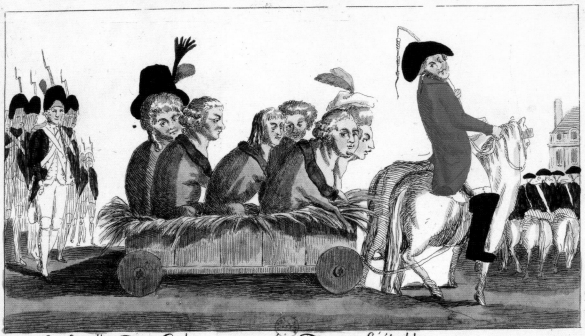

La famille Des Cochons ramenée Dans L'étable

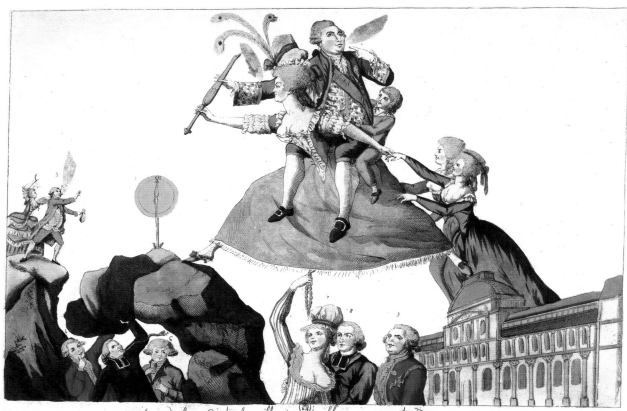

emjambee de la sainte famille des Thuilleries a montmidy

4. *Sgur.* Si le pas Manque je fait bonne tout
5. *Bou.* M.mes el le coup Man que nous Somper f....
6. *Mira beau.* tonet je me Repose Sur elle a votre Santé

5. *M.le lamette....* ce que je montre Ça fait user cranette....
8. *M.sure du Rohan...* je mentions a la Motte....
9. *M.r. ...* Je je la lachera elle Sauteroit Le pas

on July 3, 1790. He suggested establishing a pro-monarchy party within the Assembly, borrowing money to bribe particular opponents, and calling for the election of a new Assembly; he also promised to influence the drafting of the new constitution so that royal powers would be increased. Should all else fail, he proposed a coup: the king should leave Paris for a town on the border and return to the capital leading an army of supporters in order to bring the Revolution to an end.

It seems that this plan was too audacious for the timorous Louis XVI. Secret correspondence from the archives of the Viennese court, published by Alfred von Arneth in 1874, clearly shows that the queen was now taking the lead, using every means at her disposal to thwart the Revolution and reverse the royal family's "horrible position." Marie-Antoinette dispatched a stream of letters to Austria trying to persuade the new emperor, Leopold II, to intervene militarily, and she attempted to secure a loan of several million livres to fund bribery and corruption in France. But foreign courts showed a distinct lack of enthusiasm for coming to the aid of the French monarchy. After Mirabeau's sudden death on April 2, 1791, and under the influence of the absolutist faction, her thoughts increasingly turned to flight. With Fersen, she masterminded an escape to Varennes on the night of June 20, 1791. The aim was to rally support around the royalist stronghold at Montmédy from where the king would launch a counter-revolution. "The event which has just occurred makes us even more resolute in our plans," she wrote to Mercy on April 20, 1791. "We have to give the impression of agreeing to everything until the moment we can act. . . Before we do so it is essential to know if you can send—under whatever pretext you like—15,000 men to Arlon and Virton, and as many again to Mons. Monsieur de Bouillé [a general in the army and one of the organizers of the escape plan] urges you to do so, as this would give him the means to gather troops and munitions at Montmédy. . . It is vital that we conclude the undertaking within the coming month." Yet the escape was poorly prepared, and it failed. The royal family was brought back to the Tuileries by force, a mocking silence greeting the heavy Berlin carriage as it arrived. The bond that connected Paris to its king had been broken, once and for all: the people felt betrayed, their ruler no longer commanded respect, and the royal family were all now truly prisoners.

Facing page:
Above:
Caricature of the royal family being led to the Tuileries after the failed flight to Varennes in June 1791.

Below:
In this caricature, Marie-Antoinette is depicted as the instigator of the flight to Varennes.

Dark Days

Agonized by the king's weakness and indecision, Marie-Antoinette continued her desperate petitioning for armed intervention. "Now our only hope lies with foreign powers; they must come to our aid, at any price. The Emperor must place himself at their head and manage everything," she wrote to Mercy in August 1791. The further the Revolution progressed, the more her absolutist stance hardened: when the king agreed to make compromises with the Assembly deputies, she remained proudly entrenched in her refusal, stubbornly demanding the restoration of the absolute monarchy and aristocratic privileges. She simply could not accept the new concept of the "Nation." Standing against France and the Revolution, the queen was accused of pushing the king to reject reforms and thus acquired a new nickname: "Madame Veto."

On June 20, 1792, the anniversary of the Jeu de Paume Oath, a crowd invaded the Tuileries. The people wanted to force the king to withdraw his royal veto on decrees passed by the Legislative Assembly, specifically on laws directed against émigrés and against refractory priests who refused to swear loyalty to the Civil Constitution of the Clergy. For more than two hours the king allowed the rebels to file past; meekly, he agreed to wear the red Phrygian cap and drink to the health of the Nation—but he refused to withdraw his veto. Since Louis XVI showed unexpected obstinacy and a calm steadfastness of purpose, the crowd failed to achieve what they had come for.

Early in the morning of August 10, 1792, the Tuileries once again came under attack. The king was urged to take refuge in the Legislative Assembly—and this time it was the queen who showed more vigor, demanding that they stay and fight. But Louis XVI agreed to go to the Assembly while his last defenders bravely sacrificed their lives to protect an empty palace and an abandoned cause. Since the constitution did not permit the Assembly to deliberate in the king's presence, the royal family sat huddled in "the logograph's box" (a room where the equivalent of a stenographer recorded proceedings) behind the president's chair during the session that decided the king's provisional suspension and internment. This was the final day of one of Europe's oldest monarchies.

Facing page:
The storming of the Tuileries palace on August 10, 1792. In the carnage, around 600 of the 950 Swiss Guards were killed.

Following double page:
After the sacking of the Tuileries on August 10, 1792, the royal family took refuge in the Legislative Assembly, behind the bars of "the logograph's box."

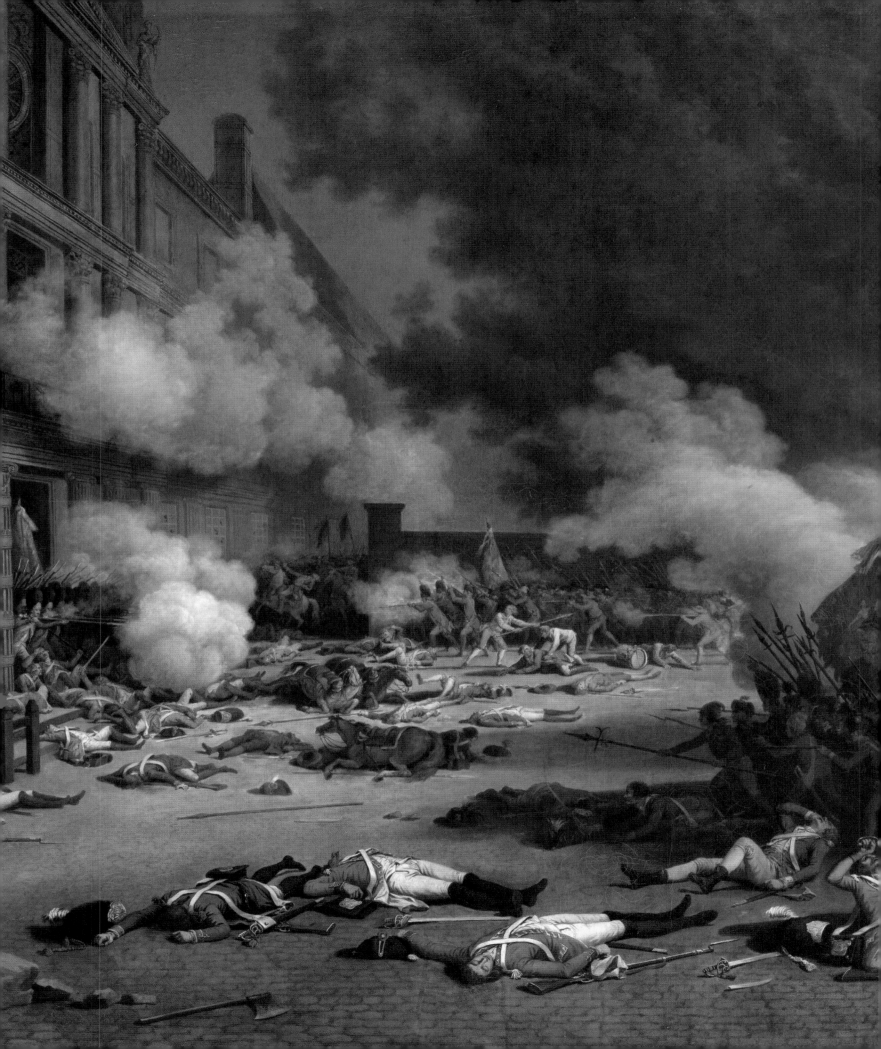

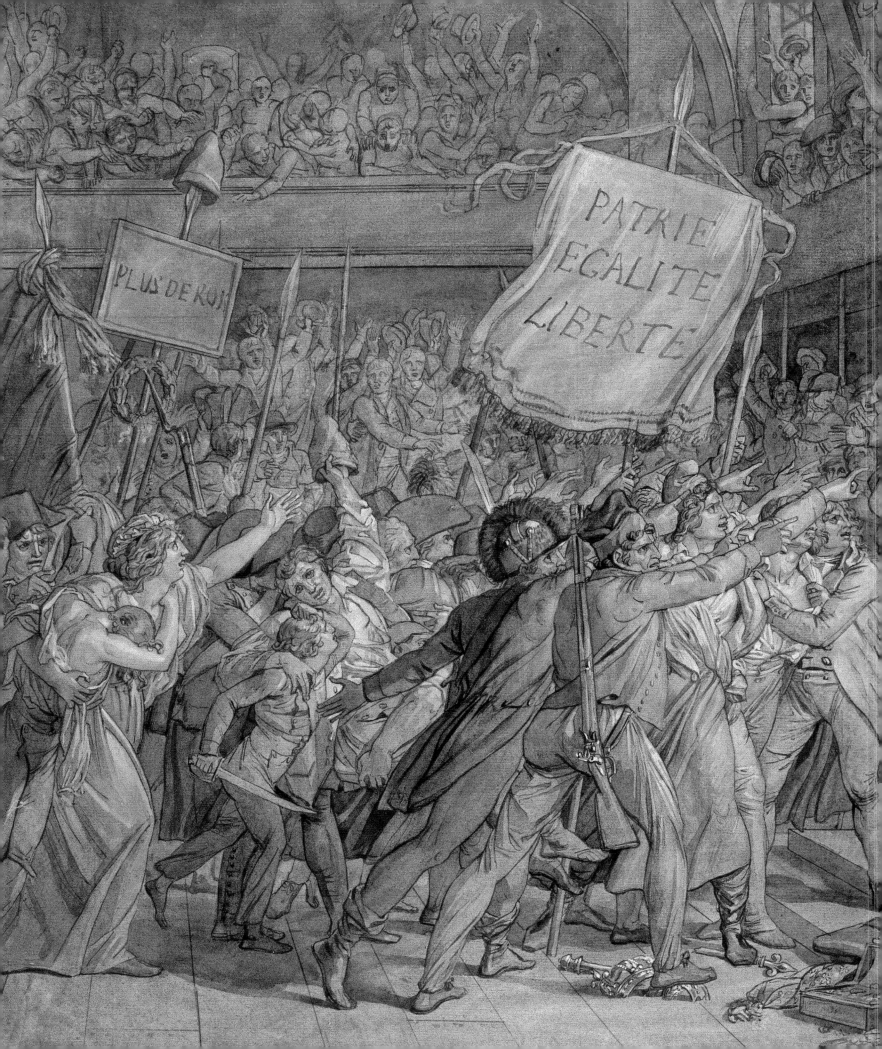

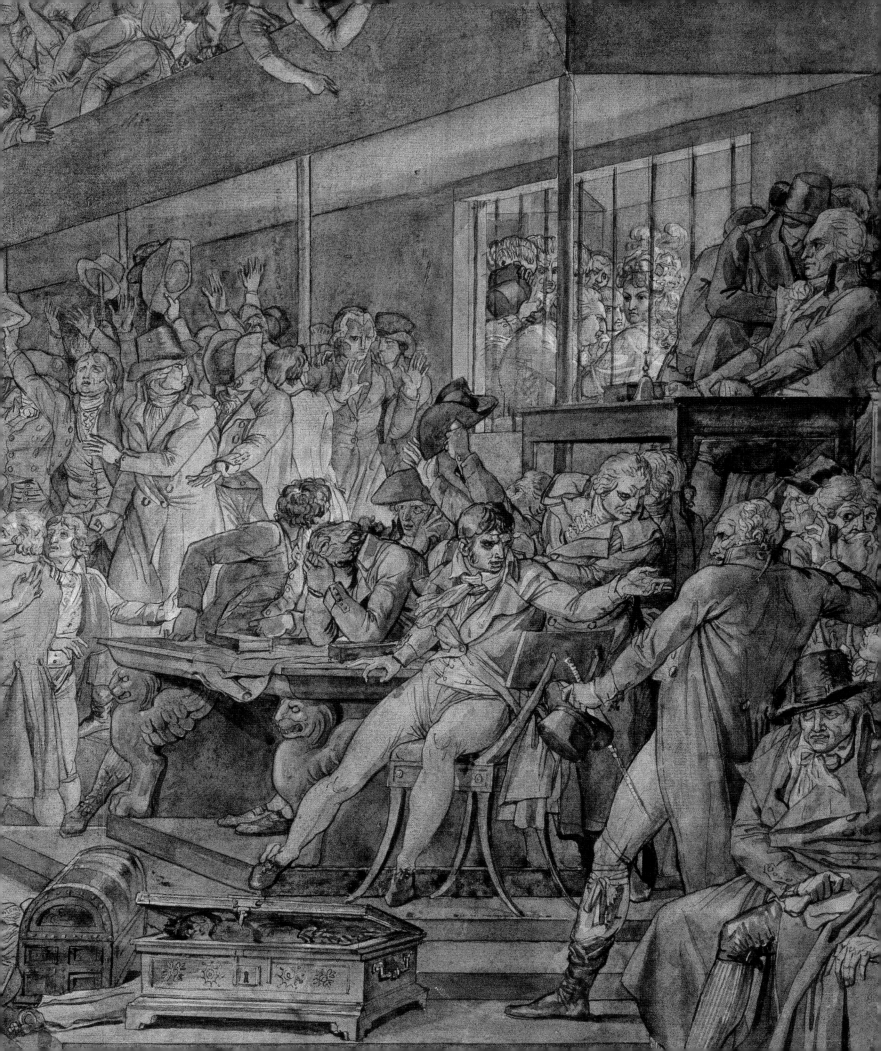

Prisoner in the Temple

Paris was in the throes of revolution. The Assembly ordered the incarceration of the royal family both to keep them under control and to protect them from attacks. On August 13, 1792, at seven in the evening, the king, Marie-Antoinette, their two children, and Madame Élisabeth, the king's sister, were transferred to the Temple tower, having been temporarily accommodated in the former Convent of the Feuillants. After three years of struggle, the Revolution was finally placing the monarchy under lock and key.

This time the captors enforced a more stringent regime. The doors, reinforced with iron bars, were locked at night. No one was allowed to enter the Temple without authorization. Yet the Commune, the revolutionary government of Paris, was keen to ensure the royal family's physical well-being. The family began to settle in to life in captivity as best they could. Tapestries and furnishings were provided, and the king was permitted a library. In the mornings, Louis XVI taught Latin and geography to the dauphin; Marie-Antoinette gave harpsichord lessons to her daughter. The food provided was good and plentiful; at midday the family ate together in the dining room, where the Commune had pinned the revolutionary Declaration of the Rights of Man to the wall. Afterwards the king walked in the garden with his son while the queen attended to her needlework. Evenings, after the children were in bed, were spent talking or playing cards.

The days passed by, one much like another. The royal family was cut off from the world—although noises from the street or alarm bells now and then hinted at the grim events unfolding outside. On the afternoon of September 3, the princesse de Lamballe was murdered, her head stuck on a pike and her naked body dragged through the streets by the mob. Marie-Antoinette fainted when she heard what had happened. On September 21, the sounds were those of jubilant celebration at the abolition of the royalty and the proclamation of the French Republic by the National Convention. Only Marie-Antoinette kept up the struggle, still managing to make connections with the outside world, still hatching escape plans, still rallying support—even among members of the National Guard charged with her surveillance. On December 11, as his trial date approached, the king was separated from his family and cruelly placed just one story below them. Marie-Antoinette was no longer permitted to see him.

Above:
The royal family's furniture in the Temple was very plain, as can be seen from this cherry wood dressing table used by Marie-Antoinette.

Facing page:
The turreted keep of the Temple. This ancient Paris fortress, built by the Templars in the Middle Ages, was turned into a prison and later demolished at the start of the nineteenth century.

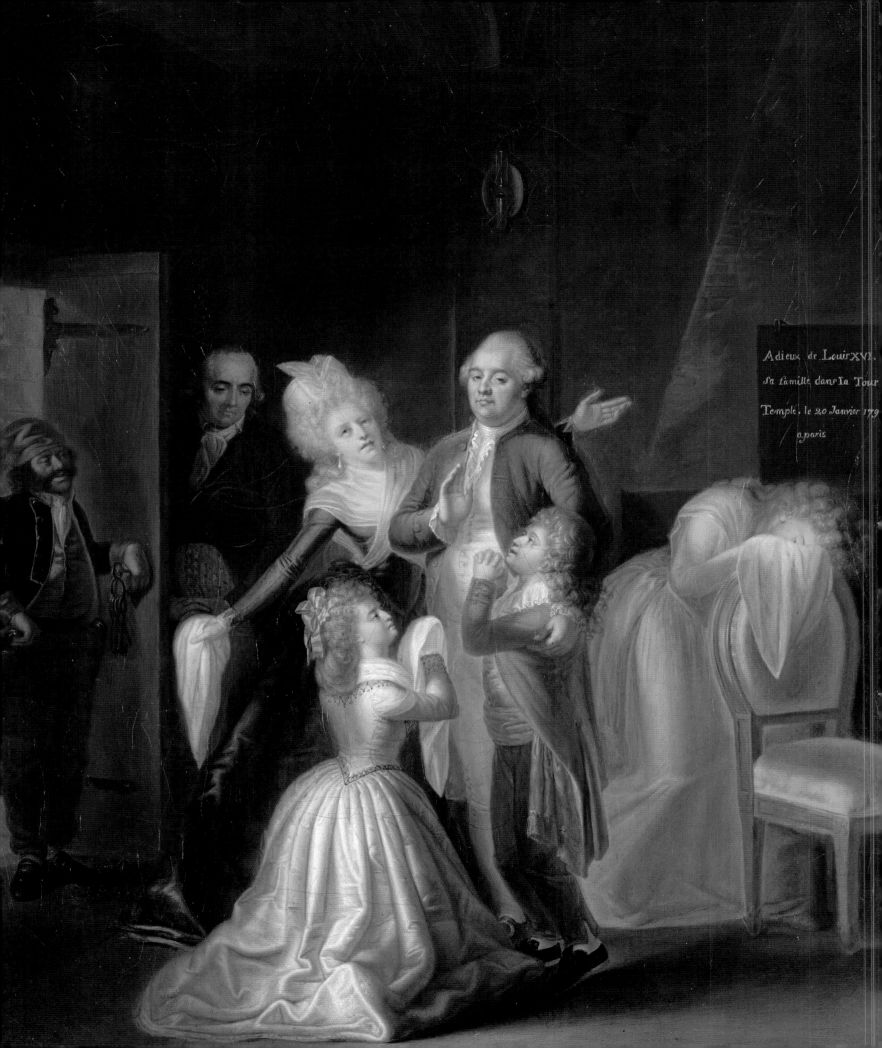

Adieux de Louis XVI
fa famille dans fa Tour
Temple, le 20 Janvier 179
a paris

A Tragic End

After the death of Louis XVI on January 21, 1793, Marie-Antoinette's life took its final, tragic turn. The trial and execution of the king had taken place with due solemnity. But the last months of the queen's life were filled with a series of humiliations that have played their part in creating the myth that surrounds her. Her eight-year-old son was taken away and shamefully forced to bear witness against her. She was denied all privacy in the Conciergerie and had to share a dark and damp cell with two guards while curious spectators crowded at the door to catch a glimpse of her. A sham trial revealed nothing except the fortitude of a defeated queen, condemned in advance. Her execution, meant to be a great moment of jubilation in which the people's hatred could be given full rein, instead displayed all the nobility and courage that the fallen sovereign possessed until the very last.

The Trial of Louis XVI

On December 11, 1792, the king was taken away from his family. Preparations for his trial were underway. To secure his conviction, his accusers were counting on compromising documents found in an iron chest in the Tuileries. These revealed secret negotiations between the constitutional monarch and leading figures in the Revolution, including Mirabeau, whose body was removed from the Panthéon where it had been placed with great ceremony after his death. All the deputies of the Convention assembled in the great hall of the Tuileries, forming the tribunal, since the king had to be judged by the representatives of the people. His fate was to be put to the vote. Many felt that the death sentence was unjustifiable and supported life imprisonment, since banishment seemed out of the question while there was war in Europe. The decision was delayed; counts and recounts went on for hours. Finally, the Convention pronounced the death sentence—by the majority of a single vote. Among those in favor was the former duc d'Orléans, Philippe Égalité, Louis XVI's cousin. The judgment was announced to the king on January 20, 1793. He asked for three days to prepare himself, but his request was refused. The execution was set for the next day.

Sick with fear, Marie-Antoinette had been clinging to the hope of a vote for clemency, but she now learned of the death sentence from the shouts of newspaper sellers in the street outside. She saw her husband for the last time on the eve of his execution, at eight o'clock. The king spent nearly two hours with his wife, his sister, and his two children; he described the trial to them and asked them to forgive the people who were putting him to death, while they sobbed with grief. He promised to see them again the next morning, but the abbé de Firmont, the refractory Irish priest

Facing page:
Painting by Jean-Jacques Hauer of Louis XVI saying his farewells to his family on January 20, 1793. For two hours, the king told them of his trial and asked them to forgive his judges.

who had been allowed to accompany him in his final hours, advised against this. Louis left his silver seal to his son and his wedding ring to his wife, together with an envelope containing locks of hair from the members of his family. Marie-Antoinette spent the night "trembling with anguish and cold." She heard the cortège leaving the Temple with a roll of drums around 8:30 in the morning, and then, at 10:22, more drums and cries of "Vive la République!" Louis XVI had just been guillotined. His last words on the scaffold were, "I die innocent of all the crimes of which I am accused. I pardon those who have occasioned my death."

The Queen in Mourning

The death of Louis XVI was an unbearable blow for Marie-Antoinette. In their last years together, she had found a new relationship with her husband, a king who was too weak and whom she had dominated for a long time. During their imprisonment, first in the Tuileries, then in the Temple, his equanimity, his efforts to maintain a proper family life, as well as the time he devoted to his children and especially to his very young son, had given her some security and helped to calm her anxiety. The adversity they had to face had brought the family closer together. Louis XVI's death had shattered all of this. Fortunately, Marie-Antoinette was at least able to mourn her husband thanks to the compassion of François Adrian Toulan, a revolutionary touched by the misfortunes of the royal family. He had retrieved Louis's seal with the royal coat of arms and his wedding ring, which had both been

confiscated, and she was able to send them to her two brothers-in-law. The silver seal went to the comte de Provence, thus recognizing him as regent in exile, and the ring went to the comte d'Artois. Toulan also managed to obtain a copy of Louis XVI's will, which he gave to Marie-Antoinette. In it she read: "I commend my children to my wife; I have never doubted her maternal tenderness for them. I enjoin her above all to make them good Christians and honest individuals; to make them view the grandeurs of this world (if they are condemned to experience them) as very dangerous and transient goods, and turn their attention toward the one solid and enduring glory, eternity." And, further on: "I beg my wife to forgive all the pain which she suffered for me, and the sorrows which I may have caused her in the course of our union; and she may feel sure that I hold nothing against her, if she has anything with which to reproach herself."

This final message from her husband certainly helped her overcome her misery and pull herself out of the despair and apathy described by her daughter Marie-Thérèse. The care that she owed to her children made her cling on to life. She obtained mourning clothes from the Commune. Now called the "Widow Capet," she expressed the wish to be painted in her new status, wearing her widow's garments, and called on the services of the Polish pastelist Alexandre Kucharsky. He painted several versions of her portrait, of which many copies were made, though not all by his hand and not all accurate.

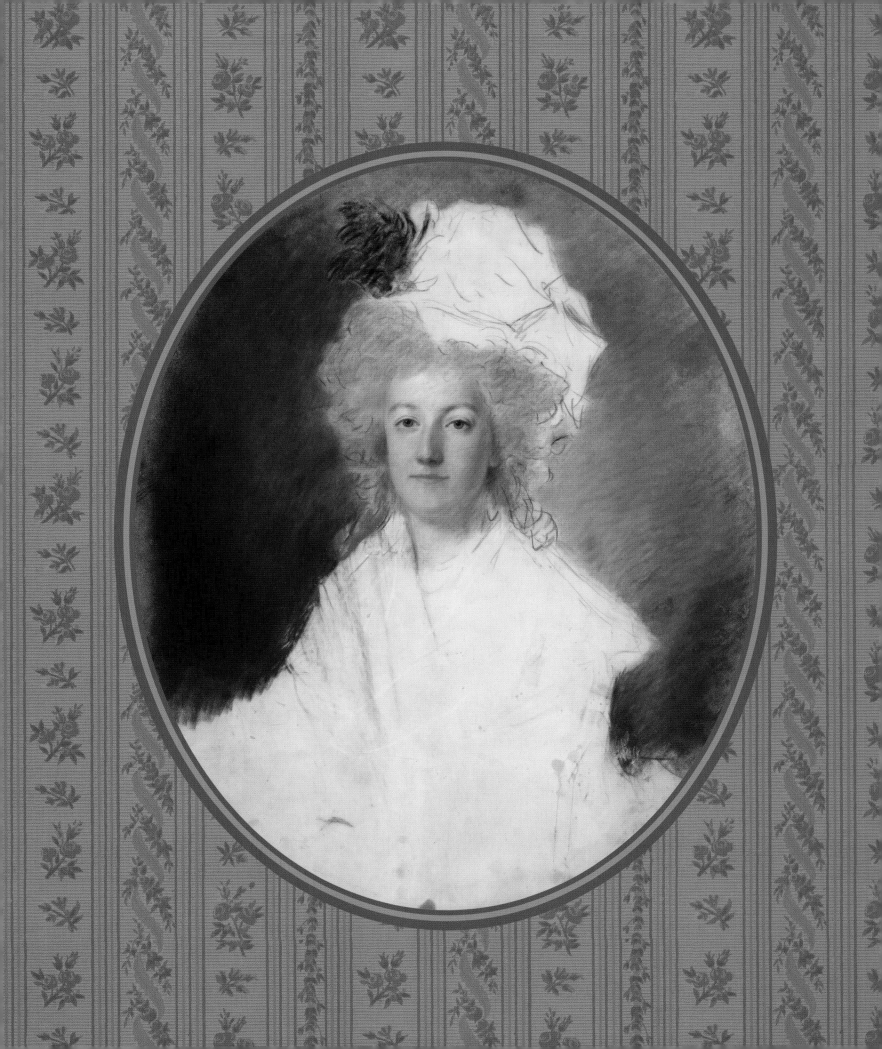

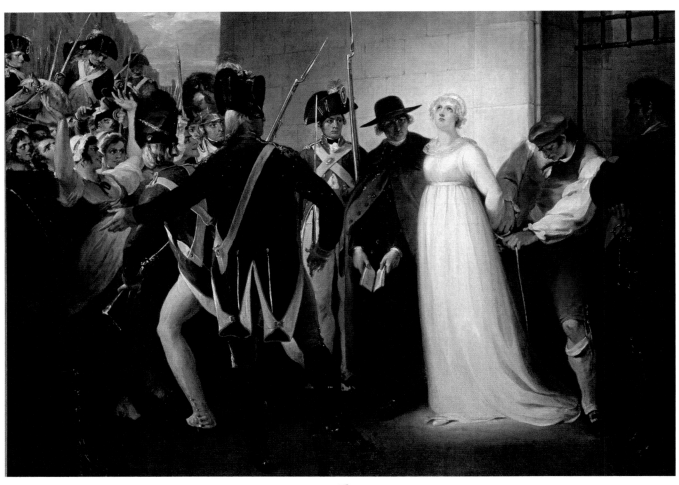

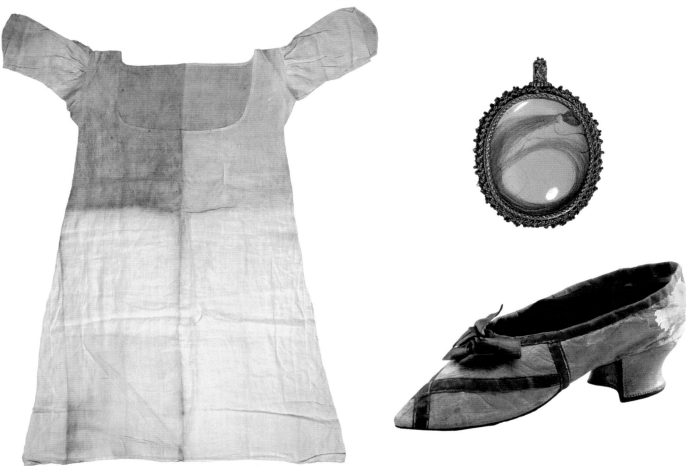

A Mother's Suffering

On July 3, 1793, Marie-Antoinette had to face a new ordeal. The Convention decided to take away her son. The aim was to use him as an additional hostage who might be a useful bargaining counter now that the Revolution was imperiled by foreign armies and the uprising in the Vendée. The Commune also wanted to "re-educate" him by removing him from the influence of his family. According to the account of her daughter Marie-Thérèse, the little boy flung himself into his mother's arms, crying and screaming, and for an hour she managed to stop the Commune officials from taking him. Finally, she had to give in to force and threats. Louis XVII was placed in a room a floor below his family in the Temple and confided to the care of a semiliterate shoemaker named Antoine Simon and his wife. They set to work transforming the fragile personality of this eight-year-old child, who had been a prisoner since the age of four, living without any privacy and in permanent fear. Simon taught him revolutionary songs and got him to drink wine; the couple also managed to make the young child bear witness to having been the victim of incestuous sexual abuse.

It seems that Louis XVII wanted to please the shoemaker who was looking after him. He had once been reprimanded by Marie-Antoinette after she found him masturbating, and so when he was caught doing the same thing by Simon, he chose to put the blame for his behavior on his mother and his aunt Élisabeth. The Commune recorded his statement and confronted the child with his mother. It was a terrible ordeal for the queen, who had to answer the accusations of the son whom she had missed so terribly after he was taken away. She had only once caught a glimpse of him as he climbed the stairs to his room in the Temple.

Three months after the execution of Marie-Antoinette, Louis XVII was locked away in a cell in the Temple. After several months of total isolation, his mental and physical condition had badly deteriorated. Though his living conditions improved in the summer of 1794 with the end of the Terror, it was too late to save the young Louis XVII. He died on June 8, 1795, at the age of ten. Historians had long refused to believe that the Revolution could treat a young child with such cruelty, and some even advanced the theory that he had escaped and been mysteriously replaced by another boy. But DNA analysis carried out in 2000 on the mummified heart of the child, which had been preserved by Philippe-Jean Pelletan, the doctor who attended him during his final days and helped to carry out his autopsy, has confirmed that it was indeed Louis XVII who died in the Temple. In 1975, his heart was placed in a crystal urn in the royal crypt of the Basilica of Saint Denis.

The Conciergerie

Events moved very fast during the early hours of August 2, 1793. Marie-Antoinette was woken from her sleep at two in the morning. Four commissioners from the Commune informed her that she was to be separated immediately from her daughter and sister-

in-law and taken to the Conciergerie prison. It was the antechamber of the guillotine. Marie-Antoinette was to be judged by a special tribunal and not by the Convention like Louis XVI. This time no long farewells were allowed. She bundled together her few belongings, embraced her daughter and sister-in-law, telling them to take care of their health, and left with the commissioners. At the Conciergerie she was put into a damp, ill-lit, thirteen-square-meter cell. Furniture consisted of a table, a bidet, two chairs, and a trestle bed. She had to share the cell day and night with two guards under orders not to let her out of their sight. There was no privacy, apart from a little screen. Visitors would come to take a peek at the "Widow Capet" through her cell window.

But at least the husband and wife who were the prison concierges, the Richards, were not hostile. On the contrary, they treated her well and tried to make her conditions a little more bearable. The food they served her was good, for the suppliers also had sympathy for the queen. And she had a young servant, Rosalie Lamorlière, whose kindness gave her some comfort. The days dragged by with painful slowness while she waited for the trial. A final rescue attempt, the "carnation plot," was planned with the help of a message hidden in a bunch of carnations thrown into the queen's cell. But it was bungled, and after its discovery her treatment became much harsher. The Richards were imprisoned for six months and replaced by the Baults. The queen was moved to a new cell, this time with no contact at all with the outside world. Her

candles, the last of her personal effects, her wedding ring, several other little rings and gold seals, and her Breguet watch were all taken away from her. All that remained was Rosalie, who was the privileged witness to the last weeks of her life.

The Trial of a Queen

Martial Joseph Armand Herman, a close ally of Robespierre, presided over the tribunal established to try the queen. The public prosecutor was Antoine Quentin Fouquier-Tinville. Twelve jurors would decide the queen's fate. It was a parody of justice; the jurors had been chosen because they would do exactly as instructed. Still, it was important that the trial bore at least some resemblance to a real one. But the judges and prosecutor failed to break Marie-Antoinette psychologically, to force her to submit and confess her crimes. Nonetheless, she was put under unbearable pressure. First there was the interrogation. She identified herself as "Marie-Antoinette of Lorraine and Austria, widow of the king of France," refusing to the end to use the title of "Widow Capet." Then there were questions about her relations with her brother, about the flight to Varennes, but she adroitly deflected all this by stressing her duties as an obedient wife, while still defending her husband. She was assigned two lawyers, Claude François Chauveau-Lagarde and Alexandre Tronson-Ducoudray, to represent her at the public trial, which began on October 14.

The trial, which lasted two days, was supposed to allow the people to enjoy watching the humiliation of

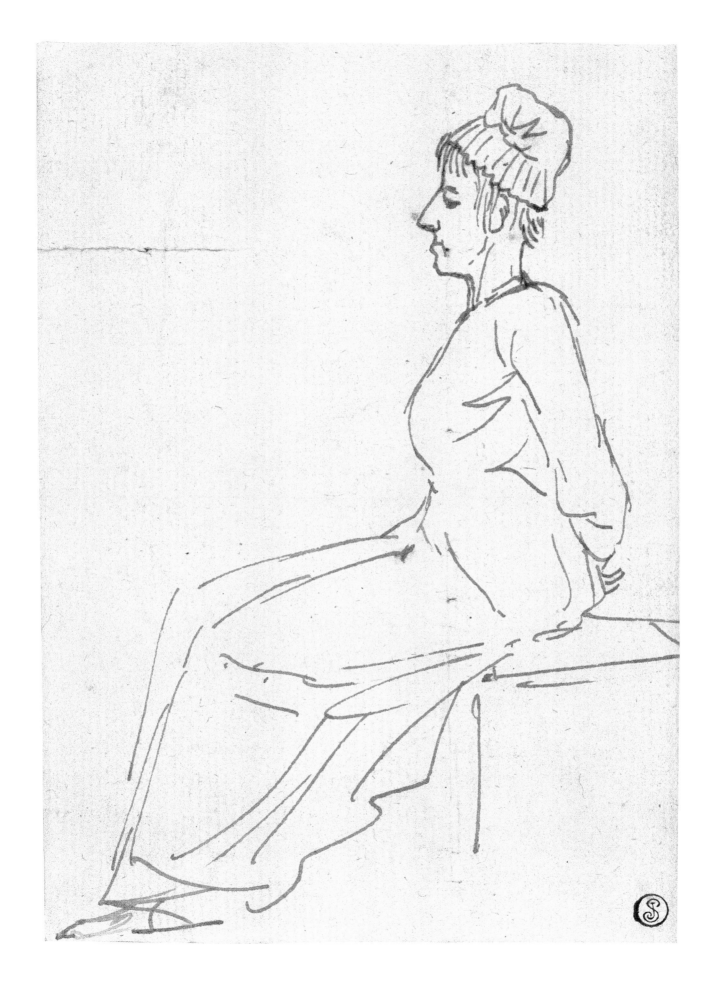

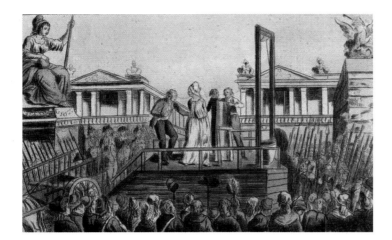

a despised sovereign. But with her dignified manner and the conviction of her answers, little by little the queen seemed to be winning over the crowd. The inconsistency of prosecution witnesses soon became obvious. The journalist Jacques Hébert thought he had caught her off guard by raising the accusations of incest with her son. Marie-Antoinette remained silent. One of the jurors persisted and asked the presiding judge to demand she reply. Marie-Antoinette rose to her feet and answered loudly and forcefully, "If I did not reply, it is because nature refuses to answer such a charge against a mother. I appeal to all the mothers who may be here present." A murmur of sympathy and indignation ran around the hall. This was not how the trial was supposed to go. When Robespierre heard of the incident, he cursed "that imbecile Hébert." After two days, Marie-Antoinette, despite her exhaustion, never deviated from her central line of defense—that she had only been "the wife of Louis XVI." But the verdict had been decided in advance; it was handed down at four in the morning on October 15. Marie-Antoinette was found guilty of "collaborating in machinations and secret dealings with foreign powers" and of "plotting and conspiring to ignite a civil war within the Republic." She was condemned to be guillotined that same day.

The Execution

Back in her dark cell, Marie-Antoinette was able to write a last letter to her sister-in-law Élisabeth:

It is to you, my sister, that I write for the last time. I have just been condemned, not to a shameful death, for such is only for criminals, but to go and rejoin your brother. Innocent like him, I hope to show the same firmness in my last moments. I am calm, as one is when one's conscience reproaches one with nothing. I feel profound sorrow in leaving my poor children: you know that I only lived for them and for you, my good and tender sister. You who out of love have sacrificed everything to be with us, in what a position do I leave you! ... Farewell, my good and tender sister. May this letter reach you. Think always of me; I embrace you with all my heart, as I do my poor dear children. My God, how heart-rending it is to leave them forever!

The letter would never reach Madame Élisabeth, who would herself go to the guillotine seven months later, on May 10, 1794.

Thanks to an account by her servant Rosalie, published in 1824, we have precious information on Marie-Antoinette's final hours. She ate nothing and responded to Rosalie's entreaties to do so with, "I no longer have need of anything, my child, everything is over for me." Finally, she accepted a few mouthfuls of

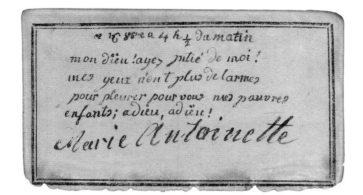

a 16 8bre a 4 h ¼ du matin
mon dieu ! ayez pitié de moi !
mes yeux n'ont plus de larmes
pour pleurer pour vous mes pauvres
enfants ; adieu, adieu !
Marie Antoinette

Left:
When she learned that the tribunal had condemned her to death, Marie-Antoinette wrote these final words on the cover of her prayer book: "My God, have pity on me! My eyes have no more tears to cry for you, my poor children; adieu! adieu!"

Following double page:
Detail from the portrait of Marie-Antoinette with a book by Élisabeth Louise Vigée-Lebrun. The queen has become a myth. Her personality, her beauty, and her tragic fate continue to fascinate each new generation.

broth. She needed to change her clothes because she had been forbidden from wearing her black mourning dress to the scaffold. When she changed her white *chemise* because she had been losing blood, she had to do so under the eyes of the guard. She hid this soiled underwear in "a crack in the wall behind the old, peeling wallpaper," and she put on "the modest white dress that usually served her as a morning gown." And Rosalie concluded, "As she went to her death, all she had on her head was a plain white lawn cap with pleated edges, without any of her emblems of mourning."

The executioner, Henri Sanson, came into her cell and tied her hands behind her back in spite of her protests: "They did not tie the hands of Louis XVI!" Sanson then cut her hair, which was later burned so that it would not become a relic. Unlike Louis XVI, who was allowed to travel to the scaffold in a proper coach, Marie-Antoinette had to sit on a wooden plank in the tumbrel, the cart used for ordinary criminals. Following an ancient tradition, she was forced to sit facing backwards as a sign of shame. The cortège moved very slowly past the huge crowds shouting abuse at her: "Death to the Austrian woman!" Marie-Antoinette sat erect and dignified, impassive amidst the jeers and catcalls. When the cortège finally reached the place de la Révolution (today's place de la Concorde), she descended unaided from the tumbrel, losing one of her shoes as she mounted the scaffold, and then accidentally stepped on the executioner's foot: "I beg your pardon, monsieur" were her last words. She was attached to an upright plank, which then swung down horizontally. The blade of the guillotine fell at a quarter past twelve on October 16, 1793.

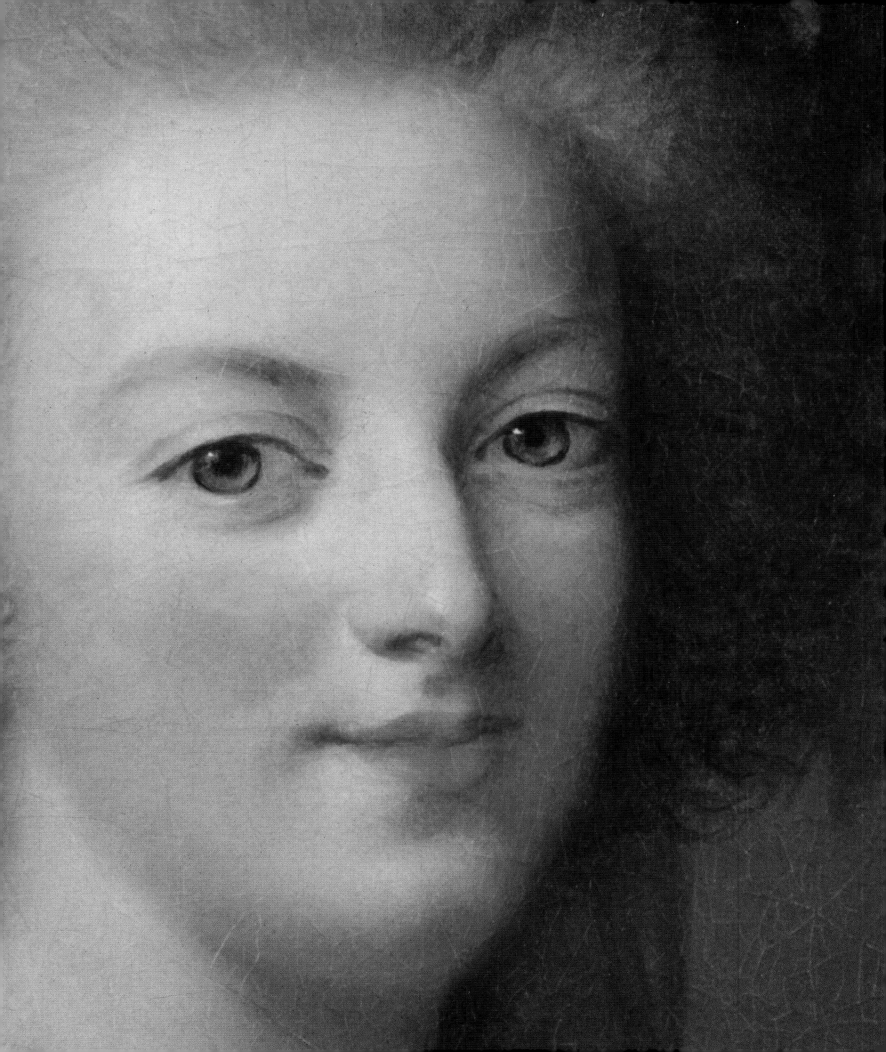

Bibliography

Books

Antoine, Michel. *Louis XV.* Paris: Fayard, 1989.

Berly, Cécile. *Marie-Antoinette et ses biographes. Histoire d'une écriture de la Révolution française.* Paris: L'Harmattan, 2006.

Bertière, Simone. *The Indomitable Marie-Antoinette.* Trans. Mary Hudson. Paris: Fallois, 2014.

———. *Les reines de France au temps des Bourbons. Marie-Antoinette l'insoumise.* Paris: De Fallois, 2002.

Chandernagor, Françoise. *La Chambre.* Paris: Gallimard, 2002.

Delorme, Philippe. *Louis XVII. La vérité. Sa mort au Temple confirmée par la science.* Paris: Pygmalion, 2000.

Duprat, Annie. *Marie-Antoinette. Une reine brisée.* Paris: Perrin, 2006.

de Goncourt, Edmond and Jules. *Histoire de Marie-Antoinette.* Paris: Firmin Didot frères, fils et Cie, 1858.

Gousset, Jean-Paul, and Raphaël Masson. *Versailles. L'Opéra royal.* Versailles: Musée national des châteaux de Versailles et de Trianon, Artlys, 2010.

Jallut, Marguerite. *Marie-Antoinette et ses peintres.* Paris: A. Noyer, impr. de Dehon, 1955.

Lever, Èvelyne. *Les Dernières noces de la monarchie.* Paris: Fayard, 2005.

Lindqvist, Herman. *Axel von Fersen, séducteur et aristocrate.* Trans. Claude Roussel. Paris: Stock, 1995.

de Nolhac, Pierre. *La Dauphine Marie-Antoinette.* Paris: Boussod, Valadon et Cie, 1896 and 1929.

———. *La Reine Marie-Antoinette.* Paris: Boussod, Valadon et Cie, 1890 and 1929.

Petitfils, Jean-Christian. *Louis XVI.* Paris: Perrin, 2005.

Ruppert, Jacques, and Madeleine Delpierre. *Le Costume français.* Paris: Flammarion, 1996.

Salmon, Xavier. *Marie-Antoinette. Images d'un destin.* Neuilly-sur-Seine: Michel Lafon, 2005.

Sapori, Michelle. *Rose Bertin, le ministre des modes de Marie- Antoinette.* Paris: Éditions de l'institut français de la mode et Éditions du Regard, 2003.

Seth, Catriona. *Marie-Antoinette. Anthologie et Dictionnaire.* Paris: Robert Laffont, 2006.

Thomas, Chantal. *La Reine scélérate. Marie-Antoinette dans les pamphlets.* Paris: Seuil, 1989.

Verlet, Pierre. *Le Château de Versailles.* Paris: Fayard, 1985.

Zweig, Stefan. *Marie Antoinette.* Trans. Eden and Cedar Paul. New York: Viking, 1933.

Memoirs, Correspondence, and Other Sources

Arneth, Alfred von, and M. A. Geffroy, eds. *Correspondance secrète entre Marie-Thérèse et le Cte de Mercy-Argenteau.* 3 vols. Paris: Firmin Didot frères, fils et Cie, 1874.

Bernier, Olivier. *Secrets of Marie Antoinette.* New York: Doubleday, 1985.

Campan, Jeanne-Louise-Henriette. *Mémoires sur la vie privée de Marie-Antoinette.* Paris: Baudouin frères, 1826 and 1979.

———. *Memoirs of the Court of Marie Antoinette, Queen of France.* Trans. unknown. Boston: L. C. Page and Company, 1900.

Emmanuel, duc de Croÿ, *Journal inédit du duc de Croÿ (1718–1784).* 4 vols. Paris: Flammarion, 1906–7.

Girard, Georges, ed. *Correspondance entre Marie-Antoinette et Marie-Thérèse.* Paris: Bernard Grasset, 1933.

Lever, Évelyne, ed. *Correspondance de Marie-Antoinette (1770–1793).* Paris: Tallandier, 2005.

de Tilly, Alexandre. *Mémoires pour servir à l'histoire des moeurs de la fin du xviiie siècle.* Paris: Mercure de France, 2003.

Tourzel, Louise-Joséphine. *Mémoires.* Paris: Mercure de France, 1969.

Vigée-Lebrun, Èlisabeth Louise. *Souvenirs.* Paris: Des Femmes, 1984.

Exhibition Catalogues

Arizzoli-Clementel, Pierre, and Xavier Salmon, eds. *Marie-Antoinette.* Exh. cat. Paris: Galeries nationales du Grand Palais and Réunion des musées nationaux, 2008.

de Boysson, Èlisabeth, and Xavier Salmon, eds. *Marie-Antoinette à Versailles. Le goût d'une reine.* Exh. cat. Bordeaux: Musée des Arts décoratifs; Paris: Somogy, 2005.

Maisonnier, Èlisabeth, and Catriona Seth, eds. *Marie-Antoinette, femme réelle, femme mythique.* Exh. cat. Versailles: Bibliothèque municiple de Versailles; Paris: Magellan & Cie, 2006.

Pierrette, Jean-Richard, and Françoise Viatte. *Modes et costumes français (1574–1815). Gravures et dessins.* Exh. cat. Paris: Musée du Louvre and Réunion des musées nationaux, 1966.

Illustration Credits

Frontispiece: One of a Set of Four Wall Lights, about 1781, model by Claude-Jean Pitoin (master 1778); casting and chasing attributed to Louis-Gabriel Féloix (1729–1812). Gilt bronze, height: 55.9 cm. The J. Paul Getty Museum, 99.DF.20.1. **7:** Swivel Chair, about 1787, frame by Georges Jacob (1739–1814, master 1765); carved by Jean-Baptiste-Simon Rode (1735–1799, master 1766). Beechwood, caning, and modern upholstery, height: 85.1 cm. The J. Paul Getty Museum, 72.DA.51. **8 (center):** Joseph Kranzinger, *Portrait de la reine Marie-Antoinette en cavalière* (Portrait of Marie-Antoinette in hunting attire), 1771, pastel, Vienna, Schönbrunn Palace, © Album/Oronoz/akg-images. **8 (background):** Wallpaper, "Louis XVI Medallions" pattern, block printing, eighteenth century, listed Historical Monument, © Zuber. **10–11:** Johann Georg Weikert (attributed to), *Représentation du ballet-pantomime* Le Triomphe de l'amour (Marie-Antoinette and her siblings performing in the ballet *Il Trionfo dell'Amore*), eighteenth century, oil on canvas, 2.880 x 2.110 m, Versailles, musée national des châteaux de Versailles et de Trianon, © Château de Versailles, dist. RMN-Grand Palais/Christophe Fouin. **13:** Martin van Meytens the Younger, *L'empereur François Ier et l'impératrice Marie-Thérèse avec leurs enfants* (Emperor Francis I and Empress Maria Theresa with their children), 1756, oil on canvas, 1.900 x 1.800 m, Versailles, musée national des châteaux de Versailles et de Trianon, © RMN-Grand Palais (château de Versailles)/Daniel Arnaudet. **14 (above):** Jean-Baptiste André Gautier-Dagoty, *Louis XV présentant le portrait de Marie-Antoinette au dauphin* (Louis XV presenting the portrait of Marie-Antoinette to the dauphin), eighteenth century, engraving, 0.644 x 0.802 m, Versailles, musée national des châteaux de Versailles et de Trianon, © RMN-Grand Palais (château de Versailles)/Gérard Blot. **14 (below):** Peter Adolphe Hall, after Louis Michel van Loo, *Louis XVI as Dauphin, after L. M. van Loo,* ca. 1769–70, painted on ivory, paste gems, 0.071 x 0.043 m, London, Wallace Collection, © The Wallace Collection, London, dist. RMN-Grand Palais/The Trustees of the Wallace Collection. **15:** Joseph Ducreux, *Marie-Antoinette, dauphine de France* (Marie-Antoinette, dauphine of France), ca. 1770, oil on canvas, 0.650 x 0.540 m, Versailles, musée national des châteaux de Versailles et de Trianon, © RMN-Grand Palais (château de Versailles)/Gérard Blot. **19:** Joseph Ducreux, *Marie-Antoinette, archiduchesse d'Autriche* (Marie-Antoinette, archduchess of Austria), 1769, pastel on vellum, 0.648 x 0.495 m, Versailles, musée national des châteaux de Versailles et de Trianon, © RMN-Grand Palais (château de Versailles)/Gérard Blot. **20:** Antoine Lauson (attributed to), casket with the coat of arms of Marie-Antoinette, dauphine of France, ca. 1770–74, gold-mounted morocco leather, 0.533 x 0.740 x 0.490 m, Versailles, musée national des châteaux de Versailles et de Trianon, © RMN-Grand Palais (château de Versailles)/Gérard Blot. **21:** Unknown artist, *Arrivée du cortège conduisant l'archiduchesse Marie-Antoinette à Versailles le 16 mai 1770* (The arrival of the procession bringing archduchess Marie-Antoinette to Versailles, May 16, 1770), eighteenth century, colored engraving, printed by André Basset, May 1770, with the permission of Antoine de Sartine, Lieutenant General of the Police of Paris, Versailles, musée national des châteaux de Versailles et de Trianon, © RMN-Grand Palais (château de Versailles)/Gérard Blot. **22:** Entry token, serving as a laissez-passer for staff and workmen at the Opera at Versailles for the marriage of the dauphin on May 16, 1770, eighteenth century, copper, 0.045 m, Versailles, musée national des châteaux de Versailles et deTrianon, © RMN-Grand Palais (château de Versailles)/Gérard Blot. **23:** Interior view of the Royal Chapel, château de Versailles, © Château de Versailles, dist. RMN-Grand Palais/Jean-Marc Manaï. **24:** Claude-Louis Desrais, *Cérémonie du mariage du dauphin de France avec l'archiduchesse Marie-Antoinette dans la chapelle royale de Versailles, le 16 mai 1770* (The wedding ceremony of the dauphin of France and archduchess Marie-Antoinette in the royal chapel at Versailles, May 16, 1770), eighteenth century, colored engraving, 0.370 x 0.255 m, Versailles, musée national des châteaux de Versailles et de Trianon, © RMN-Grand Palais (château de Versailles)/Daniel Arnaudet. **26 (above):** Dinner service with a richly colored and gilded border, delivered to Versailles on August 26, 1784, Sèvres interlaced Ls enclosing date letters CG for the year 1784, soft- and hard-paste porcelain, Versailles, musée national des châteaux de Versailles et de Trianon, © Château de Versailles, dist. RMN-Grand Palais/Jean-Marc Manaï. **26 (below):** Cup with a portrait of Marie-Antoinette, with saucer, delivered by the Royal Porcelain Manufactory in Sèvres in 1782, porcelain, Pavlovsk, Pavlovsk Palace, porcelain, © akg-images. **27:** Jean Michel Moreau, also called Moreau le Jeune, *Souper à l'occasion du mariage du dauphin, le futur Louis XVI* (Dinner celebrating the marriage of the dauphin, the future Louis XVI), sepia ink drawing, Berlin, Kunstbibliothek (SMPK), © BPK, Berlin, dist. RMN-Grand Palais/ image BPK. **28:** Foyer of the Royal Opera, Versailles, © RMN-Grand Palais (château de Versailles)/Daniel Arnaudet/ Hervé Lewandowski. **29:** The royal box in the Royal Opera at the palace of Versailles, © Château de Versailles, dist. RMN-Grand Palais/Jean-Marc Manaï. **30 (left):** View of the boxes of the Royal Opera, Versailles, © RMN-Grand Palais (château de Versailles)/J. Derenne. **30 (right):** Jean-Honoré Fragonard, *Marie-Madeleine Guimard,* oil on canvas, 0.815 x 0.650 m, Paris, musée du Louvre, © Photo Josse/Leemage. **31 (above left):** Frontispiece of the score of the opera *Iphigénie en Tauride* by Christoph Willibald Gluck, printed for its performance in Paris in 1779, © DeAgostini/Leemage. **31 (above right):** Costume of Antoinette Saint-Huberty for the title role in Gluck's *Iphigénie en Aulide,* 1777, colored engraving, Opéra de Paris, bibliothèque, © Selva/Leemage. **31 (below):** View from the royal box of the stage at the Royal Opera, Versailles © RMN-Grand Palais (château de Versailles) Hervé Lewandowski. **33:** Franz Xaver Wagenschön, *Erzherzogin Marie Antoinette am Spinett* (detail), about 1770, Kunsthistorisches Museum, Wien, Gemäldegalerie. Photograph and digital image © KHM-Museumsverband. **34 (above):** Niklas Lafrensen the Younger, called Nicolas Lavreince, *Le Roman* (The Novel), gouache on paper, Paris, musée Cognacq-Jay, © Musée Cognacq-Jay/Roger-Viollet. **34 (below):** Books from Marie-Antoinette's library at the Petit Trianon, eighteenth century, calfskin binding, Versailles, musée national des châteaux de Versailles et de Trianon, © RMN-Grand Palais (château de Versailles)/Gérard Blot. **35 (above):** Letter by Marie-Antoinette (1755–1793), queen of France, concerning the birth of the first dauphin, Louis-Joseph of France, dated April 15, 1781, © Roger-Viollet. **35 (below left):** Adam Weisweiler, inkstand, delivered in 1784 for the queen's *cabinet doré* in the Château of Versailles, eighteenth century, ebony and sycamore veneer, Japanese lacquer, steel, gilded bronze, 0.064 x 0.265 x 0.170 m, Paris, musée du Louvre, © RMN-Grand Palais (musée du Louvre)/Daniel Arnaudet. **35 (below right):** François Rémond and Adam Weisweiler, writing table from Marie-Antoinette's private apartments in Saint-Cloud, 1784, oak, ebony, sycamore, chiseled gilt bronze, hard-paste porcelain, 0.737 x 0.812 x 0.452 m, Paris, musée du Louvre, © RMN-Grand Palais (musée du Louvre)/Daniel Arnaudet. **36:** Élisabeth Louise Vigée-Lebrun, *Portrait de la reine Marie-Antoinette tenant un livre à la main* (Portrait of Marie-Antoinette with a book), 1788, oil on canvas, 2.710 x 1.950 m, Versailles, musée national des châteaux de Versailles et de Trianon, © RMN-Grand Palais (château de Versailles)/Christian Jean/Jean Schormans. **37:** Library of the queen's private apartments in the palace of Versailles, château de Versailles, © RMN-Grand Palais (château de Versailles)/All rights reserved. **38:** Martin Carlin, Marie-Antoinette's jewel casket, 1770, rosewood, sycamore, chiseled gilt bronze, hard-paste porcelain, 0.950 x 0.560 x 0.360 m, Versailles, musée national des châteaux de Versailles et de Trianon, © RMN-Grand Palais (château de Versailles)/Michèle Bellot. **39:** Anton von Maron (workshop), *Portrait de Marie-Thérèse de Habsbourg, impératrice d'Autriche* (Portrait of Maria Theresa of Habsburg, empress of Austria), ca. 1772, oil on canvas, 1.150 x 0.795 m, Versailles, musée national des châteaux de Versailles et de Trianon, © RMN-Grand Palais (château de Versailles)/Franck Raux. **40:** Private apartments of Marie-Antoinette, palace of Versailles, © Château de Versailles, dist. RMN-Grand Palais/Thomas Garnier. **41:** Jean-Baptiste Lemoyne, *Marie-Antoinette,* portrait bust, 1771, marble, 0.765 m, Vienna, Kunsthistorisches Museum, © All rights reserved. **42 (above):** Noël Hardivillers, needlework *nécessaire* with case, between 1760 and 1780, fish-scale pattern, gold and inset mother-of-pearl, Paris, musée Cognacq-Jay, © Fr. Cochennec and St. Piera/Musée Cognacq-Jay/Roger-Viollet. **42 (below):** Marie-Antoinette's spinning wheel, 1792, Paris, musée Carnavalet, © Musée Carnavalet/Roger-Viollet. **43 (above left):** Niklas Lafrensen the Younger, called Nicolas Lavreince, *La consolation de l'absence* (Consolation in absence), eighteenth century, gouache on vellum, Paris, musée Cognacq-Jay, 0.260 x 0.200 m, © RMN-Grand Palais/ Agence Bulloz. **43 (above right):** Needlework *nécessaire,* eighteenth century, silver and mother-of-pearl, Lille, Palais des Beaux-Arts, © RMN-Grand Palais/Stéphane Maréchalle. **43 (below):** Jean-Étienne Liotard, *Jeune fille brodant* (Young girl embroidering) (detail), eighteenth century, pastel, 0.655 x 0.496 m, Paris, musée du Louvre, © RMN-Grand Palais (musée du Louvre)/Michèle Bellot. **44:** Philippe de Lasalle, tapestry made for Marie-Antoinette, 1770, silk lampas, Lyon, musée des Tissus, © akg-images/Erich Lessing. **45:** Jean-Étienne Liotard, *Portrait de l'archiduchesse Marie-Antoinette à l'âge de sept an*s (Portrait of the archduchess Marie-Antoinette of Austria at the age of seven), 1762, red chalk, watercolor, and graphite pencil on paper, 0.311 x 0.249 m, Geneva, Musée d'art et d'histoire (on permanent loan from the Fondation de Gottfried Keller), © Lylho/Leemage. **46:** Armand Vincent de

Montpetit, *Portrait de Louis XV* (Portrait of Louis XV), 1774, oil on canvas, 0.740 x 0.620 m, Versailles, musée national des châteaux de Versailles et de Trianon, © RMN-Grand Palais (château de Versailles)/Jean Popovitch. **47:** François Hubert Drouais, *Portrait de Madame du Barry en Flore* (Portrait of Madame du Barry as Flora), 1769, oil on canvas, 0.705 x 0.580 m, Versailles, musée national des châteaux de Versailles et de Trianon, © RMN-Grand Palais (château de Versailles)/Gérard Blot. **49:** A. Meunier, Interior of the Comédie-Française, eighteenth century, watercolor on paper, Paris, Bibliothèque nationale de France, © DeAgostini/Leemage. **50 (above):** Jean-Pierre Charpenat, Marie-Antoinette's *nécessaire*, containing cutlery, porcelain tableware, a wine cup, pestle and mortar, chocolate pots and teapots, bell, mirrors, powder pot, small bottles, creams and lotions, needles and thread, paper knife, inkwell, seal, brush. Gilded silver, copper, ebony, 0.210 x 0.560 x 0.440 m, Paris, musée du Louvre, © RMN-Grand Palais (musée du Louvre)/Jean-Gilles Berizzi. **50 (below left):** Jean-Pierre Charpenat, items from the travel *nécessaire* of Marie-Antoinette, gilded silver, copper, ebony, 0.210 x 0.560 x 0.440 m, Paris, musée du Louvre, © RMN-Grand Palais (musée du Louvre)/Jean-Gilles Berizzi. **50 (below right):** Louis Prieur, *Carrosse du sacre de Louis XVI à Reims, le 2 juin 1775* (Coronation coach of Louis XVI in Reims, on June 2, 1775), engraving, Versailles, musée national des châteaux de Versailles et de Trianon, © RMN-Grand Palais (château de Versailles)/All rights reserved. **51 (above):** Jacques-André Portail, *Vue perspective des jardins et parterres Nord du château de Versailles depuis le bassin de Neptune* (View of the north gardens and parterres at the palace of Versailles from the Bassin de Neptune), ca. 1740, gouache on paper, 0.514 x 0.728 m, Versailles, musée national des châteaux de Versailles et de Trianon, © RMN-Grand Palais (château de Versailles)/Gérard Blot. **51 (below):** Travel trunk bearing the arms of the dauphine Marie-Antoinette, wood, leather, gilt, 0.315 x 0.597 x 0.410 m, Château de Compiègne, musée de la Voiture et du Tourisme, © RMN-Grand Palais (domaine de Compiègne)/Franck Raux. **53:** Copyists of the king's Cabinet of Paintings after Élisabeth Louise Vigée-Lebrun, *Portrait de Marie-Antoinette en robe à panier* (Portrait of Marie-Antoinette in a court dress), ca. 1785, oil on canvas, 2.760 x 1.930 m, Versailles, musée national des châteaux de Versailles et de Trianon, © RMN-Grand Palais (château de Versailles)/Gérard Blot. **54:** Coronation sword of the kings of France (known as *Joyeuse*, or the Sword of Charlemagne), late Middle Ages, silver, gold, gemstones, and glass, musée du Louvre, © RMN-Grand Palais/Philippe Fuzeau. **55:** Joseph-Siffred Duplessis (workshop), *Louis XVI en costume de sacre* (Portrait of Louis XVI in coronation robes), 1777, oil on canvas, Paris, musée Carnavalet, © akg-images/Nimatallah. **56–57:** *Le couronnement du roi* (The coronation of the king), in *L'Album du sacre de Louis XVI*, eighteenth century, gouache and brown ink, 0.680 x 0.976 m, Paris, musée du Louvre, © RMN-Grand Palais (musée du Louvre)/Thierry Le Mage. **58:** Eugénie Tripier-Lefranc after Élisabeth Louise Vigée-Lebrun, *Portrait de Marie-Antoinette, reine de France* (Portrait of Marie-Antoinette, queen of France), ca. 1805–10, sanguine chalk, 0.340 x 0.280 m, Versailles, musée national des châteaux de Versailles et de Trianon, © RMN-Grand Palais (château de Versailles)/All rights reserved. **59:** Jean-Baptiste André Gautier-Dagoty, *Portrait de Marie-Antoinette, reine de France* (Portrait of Marie-Antoinette, queen of France), 1775, oil on canvas, 1.600 x 1.280 m, Versailles, musée national des châteaux de Versailles et de Trianon, © RMN-Grand Palais (château de Versailles)/Gérard Blot. **60 (left):** Perfume fountain, porcelain, China, Kangxi period (1662–1722), gilt-bronze mounts from 1780, Paris, musée du Louvre, © akg-images/Erich Lessing. **60 (right):** Jean-François Bony (attributed to), design for embroidery of headboard, bolster and rear canopy in the queen's bedchamber at Versailles, eighteenth century, gouache, lampas, 0.240 x 1.550 m, Versailles, musée national des châteaux de Versailles et de Trianon, © RMN-Grand Palais (château de Versailles)/Gérard Blot. **61 (above):** Detail of carved wood paneling in the "cabinet of moving mirrors" at the Petit Trianon, © Château de Versailles, dist. RMN-Grand Palais/Christian Milet. **61 (below):** *Portrait de Marie-Antoinette en Hébé* (Portrait of Marie-Antoinette as Hebe), eighteenth century, ivory miniature, private collection, © Lylho/Leemage. **62:** François Dumont the Elder, *Portrait de Marie-Antoinette et de ses enfants* (Portrait of Marie-Antoinette with her children), 1790, ivory miniature portrait delivered to the queen on January, 29, 1790, Paris, musée du Louvre, © RMN-Grand Palais (musée du Louvre)/Michèle Bellot. **63:** Cabinet of the Meridian, in the queen's private apartments at Versailles (detail), © Château de Versailles, dist. RMN-Grand Palais/Thomas Garnier. **64:** Caricature of Marie-Antoinette's marriage by Charles-Germain de Saint-Aubin, in *Livre des caricatures tant bonnes que mauvaises*, 1740–78, Waddesdon Manor, The Rothschild Collection. **65 (above):** Michel Louis van Loo, *Portrait de Louis Auguste de France, duc de Berry et dauphin de France* (Portrait of Louis Auguste of France, duc de Berry and dauphin of France), 1769, oil on canvas, 0.640 x 0.490 m, Versailles, musée national des châteaux de Versailles et de Trianon, © RMN-Grand Palais (château de Versailles)/Daniel Arnaudet. **65 (below):** Jean-Baptiste Charpentier the Elder, *Portrait de Marie-Antoinette, dauphine de France* (Portrait of Marie-Antoinette, dauphine of

France), eighteenth century, oil on canvas, 0.640 x 0.520 m, Versailles, musée national des châteaux de Versailles et de Trianon, © RMN-Grand Palais (château de Versailles)/Daniel Arnaudet. **66–67:** The queen's bedchamber at the palace of Versailles, © RMN-Grand Palais (château de Versailles)/ All rights reserved. **68:** Louis-Auguste Brun, known as Brun de Versoix, *Marie-Antoinette chassant à courre* (Marie-Antoinette hunting with dogs), ca. 1780–83, oil on canvas, 0.995 x 0.800 m, Versailles, musée national des châteaux de Versailles et de Trianon, © RMN-Grand Palais (château de Versailles)/Gérard Blot. **69 (above):** Jan Weenix, *Dead Peacock and Game*, 1707, oil on canvas, 1.158 x 0.967 m, London, Wallace Collection, © The Wallace Collection, London, dist. RMN-Grand Palais/The Trustees of the Wallace Collection. **69 (below):** Hunting horn, 1701, repoussé brass, Dresden, Staatliche Kunstsammlungen, Rüstkammer, © BPK, Berlin, dist. RMN-Grand Palais/Hans-Peter Kluth. **70–71:** Nicolas Pierre Pithou the Elder, after Jean-Baptiste Oudry, *Les chasses de Louis XVI* (Hunting scene with Louis XVI), 1779, painted soft-paste porcelain, Versailles, musée national des châteaux de Versailles et de Trianon, © RMN-Grand Palais (château de Versailles)/Gérard Blot. **72:** Unknown artist of the French School, *Portrait du comte d'Artois* (Portrait of the comte d'Artois), eighteenth century, oil on canvas, 0.720 x 0.580 m, Versailles, musée national des châteaux de Versailles et de Trianon, © RMN-Grand Palais (château de Versailles)/Gérard Blot/Franck Raux. **73:** Élisabeth Louise Vigée-Lebrun, *Portrait de la duchesse de Polignac* (Portrait of the duchesse de Polignac), 1782, oil on canvas, 0.922 x 0.733 m, Versailles, musée national des châteaux de Versailles et de Trianon, © RMN-Grand Palais (château de Versailles)/Gérard Blot. **74 (above):** Louis Jean-Jacques Durameau, *Deux gentilshommes et une dame jouant aux cartes* (Two gentlemen and a lady playing cards), second half of eighteenth century, pen and ink, brown ink, and ink wash on paper, 0.170 x 0.230 m, Paris, musée du Louvre, © RMN-Grand Palais (musée du Louvre)/Michèle Bellot. **74 (below left):** Martin-Guillaume Biennais, Counter box with maker's emblem "au singe violet" (at the sign of the purple monkey), and mother-of-pearl counters, late eighteenth or early nineteenth century, mahogany and mother-of-pearl, 0.310 x 0.240 m, Rueil-Malmasion, musée national des châteaux de Malmaison et de Bois-Préau, © RMN-Grand Palais (musée des châteaux de Malmaison et de Bois-Préau)/Gérard Blot. **74 (below right):** Marie-Antoinette's playing cards, 1786, © akg-images/Jérôme da Cunha. **75:** Norbert Grund, *Gallant Scene in a Park*, 1760, oil on canvas, Prague, National Gallery, © DeAgostini/Leemage. **76–77:** Unknown artist of the French School, *Le Bosquet des Dômes* (The Grove of Domes), eighteenth century, oil on canvas, 0.600 x 1.310 m, Versailles, musée national des châteaux de Versailles et de Trianon, © RMN-Grand Palais (château de Versailles)/Hervé Lewandowski. **78:** Daniel de Loose, Regency commode, 1774, wood, gilt bronze, marble, 0.870 x 0.790 x 0.430 m, Versailles, musée national des châteaux de Versailles et de Trianon, © RMN-Grand Palais (château de Versailles)/Gérard Blot. **79 (left):** Page from the *Gazette des atours la reine* (Marie-Antoinette's pattern book), Paris, Archives nationales, © Cliché Atelier photographique des Archives nationales. **79 (right):** *Queen Marie-Antoinette*, in *Costumes françaises: règne de Louis XVI*, no. 3, 1780, engraving, colored, 0.24 x 0.143 m, Berlin, Archiv für Kunst und Geschichte, © akg-images. **79 (background):** Wallpaper, eighteenth century, © Zuber, from *The World of Ornament*, Taschen. **80:** Joseph Boze, *Portrait de Madame Campan* (Portrait of Madame Campan), 1786, oil on canvas, 0.812 x 0.644 m, Versailles, musée national des châteaux de Versailles et de Trianon, © RMN-Grand Palais (château de Versailles)/Gérard Blot. **81:** Patch boxes from the Meissen manufactory in Saxony, eighteenth century, porcelain, Paris, musée des Arts décoratifs, © Les Arts Décoratifs, Paris/Jean Tholance/akg-images. **82–83:** Élisabeth Louise Vigée-Lebrun, *Portrait de Marie-Antoinette en grand habit de cour et tenant une rose à la main* (Portrait of Marie-Antoinette in court dress, with a rose) (detail), autograph replica of the portrait painted in 1778, ca. 1785, Versailles, musée national des châteaux de Versailles et de Trianon, oil on canvas, 2.760 x 1.930 m, © RMN-Grand Palais (château de Versailles)/Gérard Blot. **84 (above):** Small patch box or snuffbox, decorated with a portrait of the queen, 1780, silver, partially gilded, enameled, with painting on porcelain, © akg-images/Jérôme da Cunha. **84 (below):** Pierre Médard Mothet, after Carle van Loo, toiletry *nécessaire*, 1764–65, gold, silver and gilded silver, Paris, musée Cognacq-Jay, © R. Cochennec et C. Rabourdin/Musée Cognacq-Jay/Roger-Viollet. **85 (center):** Louis-Marin Bonnet, *La toilette*, eighteenth century, private collection in Milan, © Costa/Leemage. **85 (background):** Wallpaper (detail) from the Réveillon factory (1753–91), © Les Arts Décoratifs, Paris/akg-images. **86:** The queen's bathroom on the first floor of the palace of Versailles, wood paneling designed by the architect Richard Mique and executed by the Rousseau brothers, 1784–88, © Château de Versailles, dist. RMN-Grand Palais/Jean-Marc Manaï. **87 (above):** Jean-Baptiste Mallet, *La toilette*, eighteenth century, oil on canvas, Paris, Musée des Arts décoratifs, © Photo Josse/Leemage. **87 (below left):** Ewer and basin, eighteenth century, soft-paste porcelain, blue ground, Paris, Musée des Arts décoratifs, © Photo Josse/Leemage. **87 (below right):** Toilet jar from the Saint-Cloud porcelain factory, between 1730 and 1740, soft-paste porcelain, overglaze enamel, Paris,

Musée des Arts décoratifs, © Photo Les Arts Décoratifs, Paris/Jean Tholance. **88:** Jean-François Janinet, after Jean-Honoré Fragonard, *Mademoiselle Rose Bertin, Dressmaker to Marie-Antoinette*, ca. 1780, hand-colored engraving, New York, The Metropolitan Museum of Art, © The Metropolitan Museum of Art, dist. RMN-Grand Palais/image of the MMA. **89:** Claude-Louis Desrais and J. Pelicier, *Nouvelle circassienne en gaze d'Italie doublée de taffetas des Indes* (New *robe à la circassienne* in Italian gauze lined with Indian taffeta), in the album *29e Cahier de Costume Français bis*, eighteenth century, hand-colored engraving, 0.234 x 0.166 m, Paris, musée du Louvre, © RMN-Grand Palais (musée du Louvre)/ Madeleine Coursaget. **90:** Fashion engraving, after Gabriel Jacques de Saint-Aubin, *Première suite des costumes français pour les coiffures depuis 1776* (First series of French designs for coiffures from 1776), eighteenth century, hand-colored etching, 0.268 x 0.208 m, Blérancourt, musée du château de Blérancourt, © RMN-Grand Palais (Château de Blérancourt)/Franck Raux. **91 (above):** *Jeunes femmes de la noblesse coiffées par un perruquier* (Wigmaker preparing coiffures for young women of the nobility), 1788, engraving, private collection, © Photo Josse/Leemage. **91 (below):** Hair aigrette, between 1726 and 1775, silver, gold, zircon, and amethyst, London, British Museum, © The British Museum, London, dist. RMN-Grand Palais/The Trustees of the British Museum. **92 (above left):** Claude-Louis Desrais, *La comtesse d'Artois revêtue d'une robe de cour* (The comtesse d'Artois in court dress), eighteenth century, hand-colored engraving, 0.270 x 0.180 m, Versailles, musée national des châteaux de Versailles et de Trianon, © RMN-Grand Palais (château de Versailles)/Gérard Blot. **92 (above right):** Claude-Louis Desrais, *La comtesse de Provence revêtue d'une robe de cour* (The comtesse de Provence in a court dress), eighteenth century, hand-colored engraving, 0.310 x 0.213 m, Versailles, musée national des châteaux de Versailles et de Trianon, © RMN-Grand Palais (château de Versailles)/Gérard Blot. **92 (below):** Shoes, eighteenth century, Barcelona, Museu Tèxtil i d'Indumentària, © Prisma Archivo/Leemage. **93:** François-Hubert Drouais, *Portrait de Marie-Antoinette* (Portrait of Marie-Antoinette), eighteenth century, oil on canvas, private collection, © Photo Josse/Leemage. **94:** Antoine-François Callet (workshop), *Portrait de la princesse de Lamballe* (Portrait of Louise of Savoy, princesse de Lamballe), eighteenth century, oil on canvas, 1.230 x 0.960 m, Versailles, musée national des châteaux de Versailles et de Trianon, © RMN-Grand Palais (château de Versailles)/Daniel Arnaudet. **95:** Élisabeth Louise Vigée-Lebrun, *Portrait de la duchesse de Polignac* (Portrait of the duchesse de Polignac) (detail), 1782, oil on canvas, 0.922 x 0.733 m, Versailles, musée national des châteaux de Versailles et de Trianon, © RMN-Grand Palais (château de Versailles)/Gérard Blot. **96:** Jean-Baptiste Sené, *voyeuse* chair from Marie-Antoinette's game room at the palace of Fontainebleau, 1786, wood and satin, Fontainebleau, musée national du château de Fontainebleau, © RMN-Grand Palais (château de Fontainebleau)/Gérard Blot. **97:** Claude-Louis Châtelet, *Illumination du pavillon du Belvédère et du Rocher dans le jardin du Petit Trianon, en 1781* (The Belvedere pavilion illuminated in the gardens of the Petit Trianon in 1781), 1781, oil on canvas, 0.590 x 0.800 m, Versailles, musée national des châteaux de Versailles et de Trianon, © RMN-Grand Palais (château de Versailles)/Daniel Arnaudet. **98 (above):** Franz Xaver Wagenschön, *Erzherzogin Marie Antoinette am Spinett*, about 1770, Kunsthistorisches Museum, Wien, Gemäldegalerie. Photograph and digital image © akg-images. **98 (right):** Wallpaper panel, eighteenth century, from *The World of Ornament*, Taschen. **98 (below left):** Michel Barthélémy Ollivier, *Le thé à l'anglaise servi dans le salon des Quatre-Glaces au palais du Temple à Paris en 1764* (English tea served in the Salon des Glaces at the Palais du Temple in Paris, 1764), eighteenth century, oil on canvas, 0.530 x 0.680 m, Versailles, musée national des châteaux de Versailles et de Trianon, © RMN-Grand Palais (château de Versailles)/Gérard Blot. **99 (above):** Jean-Honoré Fragonard, *The Music Lesson*, ca. 1769, oil on canvas, 1.19 x 1.21 m, Paris, musée du Louvre, © akg-images/Erich Lessing. **99 (below left):** *Instrumens de musique qui se touchent avec l'archet* (Musical instruments played with a bow), in *L'Encyclopédie de Diderot et d'Alembert*, eighteenth century, engraving, Paris, musée Carnavalet, © Musée Carnavalet/Roger-Viollet. **99 (below right):** Wallpaper (detail), eighteenth century, from *The World of Ornament,* Taschen. **100:** View of the queen's *cabinet doré*, palace of Versailles, © Château de Versailles, dist. RMN-Grand Palais/Jean-Marc Manaï. **101:** Jean-Baptiste Gautier-Dagoty, *Marie-Antoinette jouant de la harpe dans sa chambre à Versailles* (Marie-Antoinette playing the harp in her bedchamber at Versailles), 1777, gouache on paper, 0.675 x 0.545 m, Versailles, musée national des châteaux de Versailles et de Trianon, © RMN-Grand Palais (château de Versailles)/ Gérard Blot. **102–103:** *La joueuse de Tympanon* (The dulcimer player) by Peter Kintzing, clockmaker (1745–1816), and David Roentgen, cabinetmaker (1743–1807), 1784, steel, wood, ivory, brass, textile, 1.22 x 1.23 x 0.65 m, Paris, musée des Arts et Métiers, © Musée des Arts et Métiers-Cnam, Paris/photo Pascal Faligot. **104 (above):** Interior view of the Queen's Theater at the Petit Trianon, © RMN-Grand Palais (château de Versailles)/Gérard Blot. **104 (below):** Stage costume, eighteenth century, velvet, silks, metal thread embroidery, spangles, figured ribbons, Galliera, musée de la mode de la Ville de Paris, © Éric Emo/Galliera/

Roger-Viollet. **105 (above left):** A scene from the Comédie Italienne: Harlequin with the actor Luigi Riccoboni, ca. 1720, oil on canvas, Paris, musée Carnavalet, © Musée Carnavalet/Roger-Viollet. **105 (above right):** Jean-Gabriel Augustin Chevallier, Telescopic opera glasses decorated with scenes from plays by Racine, early nineteenth century, painted miniatures, Paris, musée Cognacq-Jay, © R. Cochennec and C. Rabourdin/Musée Cognacq-Jay/Roger-Viollet. **105 (below):** *Parade devant un théâtre des boulevards* (Crowd watching performance of boulevard theater), 1788, oil on canvas, Paris, musée Carnavalet, © Musée Carnavalet/Roger-Viollet. **106 (above):** Niklas Lafrensen the Younger, called Nicolas Lavreince, *La leçon de danse* (The dancing lesson), late eighteenth or early nineteenth century, gouache on paper, 0.300 x 0.370 m, Paris, musée du Louvre, © RMN-Grand Palais (musée du Louvre)/Jean-Gilles Berizzi. **106 (below):** Case for ivory dance cards in the shape of a viola da gamba, eighteenth century, Paris, musée Cognacq-Jay, © Marc Dubroca/Musée Cognacq-Jay/ Roger-Viollet. **107 (above):** Louis-Nicolas van Blarenberghe, *Le bal* (The ball), eighteenth century, gouache with gold highlights, 0.015 x 0.018 m, Paris, musée du Louvre, © Musée du Louvre, dist. RMN-Grand Palais/Martine Beck-Coppola. **107 (below):** Nicolas Lancret, *La Camargo dansant* (mademoiselle de Camargo dancing), ca. 1730–31, oil on canvas, 0.450 x 0.540 m, Nantes, musée des Beaux-Arts, © RMN-Grand Palais/Gérard Blot. **108:** Detail of the decoration of the Belvedere, gardens of the Petit Trianon, © Château de Versailles, dist. RMN-Grand Palais/Thomas Garnier. **109:** The Belvedere, built by Richard Mique between 1778 and 1781, gardens of the Petit Trianon, © Château de Versailles, dist. RMN-Grand Palais/Jean-Marc Manaï. **110:** Louis Nicolas de Lespinasse, *Marie-Antoinette et ses enfants se promenant dans le jardin français du Petit Trianon* (Marie-Antoinette and her children strolling in the French garden at the Petit Trianon), eighteenth century, engraving, 0.183 x 0.245 m, Versailles, musée national des châteaux de Versailles et de Trianon, © RMN-Grand Palais (château de Versailles)/Gérard Blot. **111:** View of the Petit Trianon and its gardens, © Château de Versailles, dist. RMN-Grand Palais/Christian Milet. **112:** View of the Pavillon Frais in the gardens of the Petit Trianon, © Château de Versailles, dist. RMN-Grand Palais/Christian Milet. **113:** Jean-Jacques Lagrenée le Jeune, Breast cup with tripod base from the dining service commissioned for Marie-Antoinette to use at the château de Rambouillet, delivered in 1788 by the Royal Porcelain Manufactory of Sèvres, hard-paste porcelain, 0.125 x 0.122 x 0.133 m, Sèvres, Cité de la céramique, © RMN-Grand Palais (Sèvres, Cité de la céramique)/Martine Beck-Coppola. **114:** Antoine Vestier, *Portrait de Marie-Antoinette devant le Temple de l'Amour* (Portrait of Marie-Antoinette in front of the Temple of Love), 1775, oil on canvas, Private collection, © akg-images. **115 (above):** The queen's chamber at the Petit Trianon, © Château de Versailles, dist. RMN-Grand Palais/Jean-Marc Manaï. **115 (below):** Georges Jacob, arm-chair, part of the "wheat-ear" set of furniture for Marie-Antoinette's bedchamber at the Petit Trianon, 1787, woodwork by Jean-Baptiste Rode, painted decorations by Chaillot de Prusse, embroidery by Desfarges (Lyon), gilded wood, cotton twill, embroidery in wool, 0.951 x 0.625 x 0.622 m, Versailles, musée national des châteaux de Versailles et de Trianon, © Château de Versailles, dist. RMN-Grand Palais/Jean-Marc Manaï. **116–117:** Thomas-Malgloire Daussy, *Plan du jardin de la reine au Petit Trianon dans son état entre 1780 et 1785* (Plan of the queen's garden at the Petit Trianon as it was between 1780 and 1785), eighteenth century, pen and ink, brown ink and watercolor on paper, 0.467 x 0.730 m, Versailles, musée national des châteaux de Versailles et de Trianon, © RMN-Grand Palais (château de Versailles)/All rights reserved. **118 (above):** View of the Potager du roi (vegetable garden) at Versailles, © Collection Jean-Baptiste Leroux/Château de Versailles, dist. RMN-Grand Palais/Jean-Baptiste Leroux. **118 (below):** View of the mill at the Queen's Hamlet, © Collection Jean-Baptiste Leroux/Château de Versailles, dist. RMN-Grand Palais/Jean-Baptiste Leroux. **119:** Hyacinth "Maria Antonia," in *Le jardin d'Éden ou le paradis terrestre renouvelé dans le jardin de la Reine à Trianon* (The Garden of Eden, or the earthly paradise restored in the queen's garden at the Trianon), Pierre-Joseph Buc'hoz, 1783–85, Paris, Bibliothèque nationale de France, © Bibliothèque nationale de France. **120 (above):** Alexandre-François Desportes, after a painting by Charles Le Brun, *Les enfants jardiniers: l'été* (The child gardeners: summer), ca. 1717, tapestry woven in wool and silk, 3.030 x 2.350 m, Pau, musée national du château de Pau, © RMN-Grand Palais (Château de Pau)/René-Gabriel Ojéda. **120 (below):** Unknown artist of the French School, *Promeneurs et courtisans autour du bassin de l'Encelade dans les jardins de Versailles* (Courtiers strolling by the Enceladus Fountain in the gardens of Versailles), eighteenth century, private collection, © DeAgostini/Leemage. **120 (edge of page):** Wallpaper panel, eighteenth century, from *The World of Ornament*, Taschen. **121 (above):** View of the gardens of the Petit Trianon with the Temple of Love, © Château de Versailles, dist. RMN-Grand Palais/Christian Milet. **121 (below):** André-Jacob Roubo, *Manière de construire les ornements de treillage, outillage et exemples d'ornements* (Methods of constructing ornamental trellises, with tools and examples) in *L'Art du treillage ou menuiserie des jardins* (The art of trellising, or carpentry for gardens), 1775, engraving, Versailles, bibliothèque municipale de Versailles,

213

© Jean Vigne/Kharbine Tapabor. **122–123:** Hubert Robert, *Vue du Tapis Vert à Versailles* (View of the Green Carpet at Versailles), 1774–75, oil on canvas, 1.240 x 1.910 m, Versailles, musée national des châteaux de Versailles et de Trianon, © RMN-Grand Palais (château de Versailles)/Daniel Arnaudet/Gérard Blot. **124:** Paul-Nicolas Méniere, Box with portraits of the royal family, between 1774 and 1780, gold and porcelain, Paris, musée Cognacq-Jay, © Fr. Cochennec and A. Llaurency/Musée Cognacq-Jay/Roger-Viollet. **125:** Jean-Joseph Bernard, *Portrait of Marie-Antoinette*, in profile, 1780, drawing, Paris, musée Carnavalet, © Musée Carnavalet/Roger-Viollet. **126:** *La Poulle d'Autryche/Autruche. Je digère l'or et l'argent avec facilité mais la constitution je ne puis l'avaler* (The hen of Austria [with voluntary misspellings] / Ostrich. "I can stomach gold or silver with ease, but I cannot swallow the Constitution"), colored etching by unknown popular artist, ca. 1789, Paris, Bibliothèque nationale de France, © akg-images. **127:** Georges Lafosse (after), *Marie-Antoinette mécontente d'articles parus dans "Le Figaro"* (Marie-Antoinette is displeased by articles published in *Le Figaro*), 1867, engraving on wood, © akg-images. **129:** Élisabeth Louise Vigée-Lebrun, *Portrait of Marie-Antoinette en chemise*, 1783, oil on canvas, 0.900 x 0.720 m, Darmstadt, Schlossmuseum, © akg-images. **130:** Élisabeth Louise Vigée-Lebrun, *Marie-Antoinette dite "à la rose"* (Portrait of Marie-Antoinette with a rose), 1783, oil on canvas, 1.130 x 0.870 m, Versailles, musée national des châteaux de Versailles et de Trianon, © RMN-Grand Palais (château de Versailles)/image RMN. **131:** Fan belonging to Marie-Antoinette, eighteenth century, Paris, musée Carnavalet, © Philippe Ladet/Musée Carnavalet/Roger-Viollet. **132 (above):** View of the Queen's House in the Queen's Hamlet, © RMN-Grand Palais (château de Versailles)/ Daniel Arnaudet. **132 (below):** Nicolas Desportes, *Deux chiens et un lapin* (Two dogs and a rabbit)(detail), 1757, oil on canvas, 0.970 x 1.300 m, Paris, musée du Louvre, © RMN-Grand Palais (musée du Louvre)/René-Gabriel Ojéda. **133 (above):** Summer straw hat, 1790, blue silk, lace, and straw, Paris, Galliera, musée de la mode de la Ville de Paris, © Philippe Joffre/Galliera/Roger-Viollet. **133 (below):** *Vue de l'étang et de la tour de Marlborough au Hameau de la Reine* (View of the lake and Marlborough Tower at the Queen's Hamlet), © Collection Jean-Baptiste Leroux/Château de Versailles, dist. RMN-Grand Palais/Jean-Baptiste Leroux. **134 (above):** François Boucher, *Les charmes de la vie champêtre* (The charms of rural life), eighteenth century, 1.00 x 1.460 m, Paris, musée du Louvre, © RMN-Grand Palais (musée du Louvre)/Jean-Gilles Berizzi. **134 (center):** Box in the shape of a cockerel, eighteenth century, gold, Japanese lacquer, from Marie-Antoinette's collection of Japanese lacquer boxes, 0.128 x 0.184 x 0.085 m, Versailles, musée national des châteaux de Versailles et de Trianon, © RMN-Grand Palais (château de Versailles)/Thierry Ollivier. **134 (below):** Detail of gilded woodwork in the French Pavilion, © Château de Versailles, dist. RMN-Grand Palais /Christian Milet. **135 (above):** *Chardonnet* [Chardonneret] (Goldfinch), 1710, watercolor on paper, © Jean Vigne/Kharbine-Tapabor. **135 (right):** Wallpaper (detail) from the Zuber manufactory, eighteenth century, © Zuber. **135 (below left):** *Damoiselle de Turquie* [Grue demoiselle de Turquie] (Demoiselle crane), 1710, watercolor on paper, © Jean Vigne/Kharbine-Tapabor. **135 (below right):** *Singe* (Monkey), 1710, watercolor on paper, © Jean Vigne/Kharbine-Tapabor. **136:** *Le cardinal de Rohan en voyage pour Rome comme un vagabond mendicant* (Cardinal de Rohan traveling to Rome as a vagabond beggar), 1785, engraving, © akg-images. **137:** *Représentation exacte du grand Collier en brillants des Sr. Boehmer et Bassenge/Gravé d'après la grandeur des diamants* (Exact representation of the great diamond necklace of Messrs. Boehmer and Bassenge/engraved according to the size of the diamonds), eighteenth century, engraving, Versailles, musée national des châteaux de Versailles et de Trianon, © RMN-Grand Palais (château de Versailles)/All rights reserved. **138:** Jean-Baptiste Letourmy, *Portraits des protagonistes de l'affaire du collier de la reine* (Portraits of the protagonists in the affair of the queen's necklace), 1776, colored engraving, Paris, Bibliothèque nationale de France (BnF), © BnF, dist. RMN-Grand Palais/image BnF. **139:** Christophe Guerin, *Louis-Constantin de Rohan*, French cardinal, 1776, hand-colored etching, © akg-images. **140 (above):** Commode by Jean-Henri Riesener, delivered in 1782 for Marie-Antoinette's bedroom in the château de Marly and later transferred to her *cabinet doré* at Versailles, lozenge marquetry with stylized flowers on a purpleheart ground, marble top, Versailles, musée national des châteaux de Versailles et de Trianon, © RMN-Grand Palais (château de Versailles)/Gérard Blot. **140 (below left):** Folding stool from the queen's bedchamber, by Nicolas-Quinibert Foliot and Toussaint Foliot, carved, gilded wood, 1769, Versailles, musée national des châteaux de Versailles et de Trianon, © RMN-Grand Palais (château de Versailles)/Daniel Arnaudet. **140 (below right):** Anton Mathias Domanöck, *Guéridon*, topped with petrified wood, 1770, gilded bronze, 0.855 m, Versailles, musée national des châteaux de Versailles et de Trianon, © RMN-Grand Palais (château de Versailles)/Daniel Arnaudet/Jean Schormans. **141:** Jean-Ferdinand Schwerdfeger, Marie-Antoinette's jewel casket, 1787, mahogany, gilt bronze, mother-of-pearl, 2.00 x 0.650 m, Versailles, musée national des châteaux de Versailles et de Trianon, © RMN-Grand Palais (château de Versailles)/Gérard Blot. **142:** Wallpaper (detail), eighteenth century, from *The World of Ornament*,

Taschen. **143 (above):** One of a garniture of three egg-shaped vases decorated with Chinese motifs, delivered to the queen by the Royal Porcelain Manufactory of Sèvres in 1775, painted decoration by Lecot, principal vase: 0.46 m, side vases: 0.37 m, *cabinet doré* in Marie-Antoinette's private apartments, Versailles, musée national des châteaux de Versailles et de Trianon, © Château de Versailles, dist. RMN-Grand Palais/Jean-Marc Manaï. **143 (below left):** Jean-Henri Riesener, commode ordered for Marie-Antoinette's private apartments, 1783, Versailles, musée national des châteaux de Versailles et de Trianon, purpleheart, rosewood, ebony, holly, black lacquer, marble, velvet, gilt-bronze mounts, 0.933 x 1.435 x 0.597 m, New York, The Metropolitan Museum of Art, © The Metropolitan Museum of Art, dist. RMN-Grand Palais/image of the MMA. **143 (below right):** Rectangular box in the shape of a Go board game, eighteenth century, Japanese lacquer, from Marie-Antoinette's collection of Japanese lacquer boxes, 0.074 x 0.105 x 0.093 m, Versailles, musée national des châteaux de Versailles et de Trianon, © Château de Versailles, dist. RMN-Grand Palais/Jean-Marc Manaï. **145 (above):** *"L'Hydre aristocratique: ce monstre mâle et féméle n'a d'humain que ses têtes; son naturel est féroce, barbare, sanguinaire ; il ne se repais que de sang, de larmes et de la subsistance des malheureux ; il cherche de tous côté à envahir, pour satisfaire son ambition et son insatiable avidité..."* (The hydra of the aristocracy: this male and female monster has no human feature except its heads; its nature is cruel and ravenous, barbaric and bloodthirsty; it feeds on nothing but the blood, the tears and the pittance of the wretched; it seeks only to overrun everything, to conquer and crush, so that it may satisfy its ambition and its insatiable greed), 1789, hand-colored etching, 17.5 x 27 cm, Collection de Vinck, Paris, Bibliothèque nationale de France, © Bibliothèque nationale de France. **145 (below):** *Harpie femelle* (Female harpy), ca. 1784, hand-colored etching, Paris, musée Carnavalet, © Musée Carnavalet/ Roger-Viollet. **145 (right):** *Je ne respire plus que pour toi... Un baiser mon bel Ange !"*, ("I only breathe for you . . . A kiss, my beautiful angel!"), eighteenth century, etching, Paris, musée Carnavalet, © Musée Carnavalet/Roger-Viollet. **146:** Lampas on satin foundation, with embroidered silk medallions and arabesques, Marie-Antoinette's billiard room, © Château de Versailles, dist. RMN-Grand Palais/Thomas Garnier. **147:** *Offrande à l'Amour*, clock by Robert Bobin, ca. 1785, gilt bronze and white marble, 0.50 x 0.40 x 0.18 m; in the background, the portrait of Marie-Antoinette on a hunt by Louis-Auguste Brun, known as Brun de Versoix, private apartments of Marie-Antoinette, château de Versailles, © Château de Versailles, dist. RMN-Grand Palais/Thomas Garnier. **149:** Élisabeth Louise Vigée-Lebrun, *Marie-Antoinette au livre* (Marie-Antoinette with a book), 1778, oil on canvas, 0.933 x 0.748 m, private collection, © akg-images. **151:** Unknown artist of the French school, *Allégorie de la naissance du dauphin, le 22 octobre 1781* (Allegory of the dauphin's birth, on October 22, 1781), hand-colored engraving, 0.712 x 0.531 m, eighteenth century, Versailles, musée national des châteaux de Versailles et de Trianon, © RMN-Grand Palais (château de Versailles)/Gérard Blot. **152:** Unknown artist, *Accouchement de la reine* (Delivery of Queen Marie-Antoinette), eighteenth century, engraving, Paris, musée Carnavalet, © Musée Carnavalet/Roger-Viollet. **153 (above):** *Naissance du dauphin le 22 octobre 1781* (Birth of the dauphin on October 22, 1781), eighteenth century, engraving, 0.209 x 0.266 m, Versailles, musée national des châteaux de Versailles et de Trianon, © RMN-Grand Palais (château de Versailles)/All rights reserved. **153 (below):** The dauphin's layette box, 1781, silk and painted white taffeta, edged with textile flower garlands, 0.480 x 0.690 x 0.400 m, Versailles, musée national des châteaux de Versailles et de Trianon, © RMN-Grand Palais (château de Versailles)/Gérard Blot. **155:** Élisabeth Louise Vigée-Lebrun, *Marie-Antoinette, reine de France et ses enfants* (Marie-Antoinette with her children), 1787, oil on canvas, 2.710 x 1.950 m, Versailles, musée national des châteaux de Versailles et de Trianon, © RMN-Grand Palais (château de Versailles)/Gérard Blot. **156:** Élisabeth Louise Vigée-Lebrun, *Marie-Thérèse-Charlotte de France, dite "Madame Royale", et son frère le dauphin Louis-Joseph Xavier* (Marie Thérèse Charlotte of France, known as "Madame Royale," and her brother, the dauphin Louis Joseph Xavier), 1784, oil on canvas, 1.320 x 0.940 m, Versailles, musée national des châteaux de Versailles et de Trianon, © RMN-Grand Palais (château de Versailles)/Gérard Blot. **157 (left):** *Portrait of Louis-Joseph Xavier, dauphin of France*, eighteenth century, pastel, 0.449 x 0.378 m, Versailles, musée national des châteaux de Versailles et de Trianon, © RMN-Grand Palais (château de Versailles)/Gérard Blot. **157 (center):** Heinrich Friedrich Füger, *Portrait of Marie-Thérèse-Charlotte de France, known as "Madame Royale,"* eighteenth century, ivory miniature, 0.077 x 0.077 m, Versailles, musée national des châteaux de Versailles et de Trianon, © RMN-Grand Palais (musée du Louvre)/All rights reserved. **157 (right):** Alexandre Kucharsky (after), *Portrait of the future Louis XVII*, eighteenth century, pastel, 0.623 x 0.521 m, Versailles, musée national des châteaux de Versailles et de Trianon, © RMN-Grand Palais (château de Versailles)/Gérard Blot. **158 (above):** François Boucher, *Le déjeuner* (Family taking breakfast), 1739, oil on canvas, 0.810 x 0.650 m, Paris, musée du Louvre, © Photo Josse/Leemage. **158 (below):** Small barouche belonging to the dauphin, the future Louis XVII, ca. 1785–89, painted wood, leather, metal, 0.820 m x 1.400 x 0.760 m, Versailles, musée

national des châteaux de Versailles et de Trianon © RMN-Grand Palais (château de Versailles)/Gérard Blot. **159 (above left):** The second dauphin's spinning top, eighteenth century, wood, private collection, © RMN-Grand Palais/Gérard Blot. **159 (above right):** Nicolas Lancret, *A Lady in a Garden Taking Coffee with Some Children*, also known as *The Cup of Chocolate*, 1742, oil on canvas, 0.88 x 0.97 m, London, Tate Gallery, © Photo Josse/Leemage. **159 (below left):** Hubert Robert, *Jeune femme tendant un biberon à un bébé* (Young woman holding out a bottle to a baby), ca. 1773, oil on canvas, 0.220 x 0.270 m, Valence, musée des Beaux-Arts, © RMN-Grand Palais/Michèle Bellot. **159 (below right):** Silver rattle, eighteenth century, private collection, © Photo Josse/Leemage. **160:** *Promenade de Marie-Antoinette et du dauphin en compagnie de la princesse de Lamballe et de Madame Royale devant le palais des Tuileries* (Marie-Antoinette and the dauphin Louis Charles walking outside the Tuileries, accompanied by the princesse de Lamballe and "Madame Royale"), eighteenth century, engraving, Versailles, musée national des châteaux de Versailles et de Trianon, © RMN-Grand Palais (château de Versailles)/Gérard Blot. **161:** Hubert Robert, *Vue du Tapis Vert à Versailles* (View of the Green Carpet Versailles) (detail), 1774–75, oil on canvas, 1.240 x 1.910 m, Versailles, musée national des châteaux de Versailles et de Trianon, © RMN-Grand Palais (château de Versailles)/Daniel Arnaudet/Gérard Blot. **162:** Eugène Battaille, after Adolph Ulrich Wertmüller, *Marie-Antoinette, reine de France, et ses deux premiers enfants* (Marie-Antoinette, queen of France, and her two eldest children), 1867, copy of the portrait commissioned by Empress Eugenie for the dining room at the Petit Trianon, oil on canvas, 2.750 x 1.880 m, Versailles, musée national des châteaux de Versailles et de Trianon, © RMN-Grand Palais (château de Versailles)/Gérard Blot. **163:** Unknown artist of the French School, *Les membres de la famille royale de France réunis autour du dauphin né en 1781* (Members of the royal family gathered around the dauphin, born in 1781) (detail), ca. 1783, oil on canvas, 0.960 x 1.280 m, Versailles, musée national des châteaux de Versailles et de Trianon, © Château de Versailles, dist. RMN-Grand Palais/Christophe Fouin. **165:** *Portrait of Count Hans Fersen*, eighteenth century, oil on canvas, private collection, © Photo Josse/Leemage. **166:** View of the Belvedere, built between 1778 and 1781 in the gardens of the Petit Trianon, © Château de Versailles, dist. RMN-Grand Palais/Thomas Garnier. **167:** Louis-Simon Boizot, Bust of Marie-Antoinette, queen of France, eighteenth century, soft-paste biscuit porcelain, Royal Porcelain Manufactory, Sèvres, 0.315 x 0.200 m, Versailles, musée national des châteaux de Versailles et de Trianon, © Château de Versailles, dist. RMN-Grand Palais/Thomas Garnier. **169:** Pierre Joseph Wallaert, *Vue du Hameau du Petit Trianon* (The Hameau seen from the Petit Trianon), 1803, oil on canvas, 0.560 x 0.725 m, Versailles, musée national des châteaux de Versailles et de Trianon, © RMN-Grand Palais (château de Versailles)/Gérard Blot. **170:** *Vue du Temple de l'Amour* (View of the Temple of Love), in *Recueil des Plans du Petit Trianon, par le Sr Mique, Chevalier de l'Ordre de St. Michel, Premier architecte honoraire, Intendant Général des Bâtiments du Roy et de la Reine*, 1786, gouache, watercolor, and graphite pencil, folio vol. bound in red morocco leather, Modena, Biblioteca estense universitaria, © akg-images/Archives CDA/Guillot. **171:** The Temple of Love (interior), built by Richard Mique in 1778, copy by Louis-Philippe Mouchy of the group by Edmé Bouchardon, *L' Amour se taillant un arc dans la massur d'Hercule* (Cupid cutting his bow from the club of Hercules) (Paris, musée du Louvre), © Château de Versailles, dist. RMN-Grand Palais/Jean-Marc Manaï. **173:** J. Hill after John-Claude Nattes, *La Tour de Marlborough du Hameau de la Reine dans les jardins de Trianon* (The Marlborough Tower of the Queen's Hamlet in the gardens of the Petit Trianon), 1809, aquatint, 0.295 x 0.395 m, Versailles, musée national des châteaux de Versailles et de Trianon, © RMN-Grand Palais (château de Versailles)/Gérard Blot. **174 (above):** Jean-Honoré Fragonard, *The Love Letter*, ca. 1770, oil on canvas, New York, The Metropolitan Museum of Art, © SuperStock/ Leemage. **174 (center):** Charles Gouyn, box in the shape of a young woman wearing a mask, between 1749 and 1754, porcelain and gold, Paris, musée Cognacq-Jay, © Carole Rabourdin/Musée Cognacq-Jay/Roger-Violet. **174 (below):** Pair of silk shoes belonging to Marie-Antoinette, size 36½, green and pink striped silk, decorated on the front with a bow, wooden heel covered with white leather auctioned at Drouot, Étude Coutau-Bégarie, on October 16 and 17, 2012. **175:** François-Hubert Drouais, *Marie-Antoinette en Hébé* (Marie-Antoinette as Hebe), 1773, oil on canvas, 0.93 x 0.80 m, Chantilly, musée Condé, © akg-images/Erich Lessing. **177:** Anne Flore Millet, marquise de Bréhan, *Portrait de Marie-Antoinette en grand deuil au Temple en 1793* (Portrait of Marie-Antoinette in mourning in the Temple in 1793), oil on canvas, Paris, musée Carnavalet, © Musée Carnavalet/Roger-Violet. **178:** Joseph Siffred Duplessis, *Portrait of Jacques Necker*, eighteenth century, Versailles, musée national des châteaux de Versailles et de Trianon, oil on canvas, 0.320 x 0.270 m, © RMN-Grand Palais (château de Versailles)/All rights reserved. **179:** Unknown artist of the French School, *Prise de la Bastille et arrestation du gouverneur de Launay le 14 juillet 1789* (The storming of the Bastille and capture of its governor, Bernard-René de Launay, July 14, 1789), eighteenth century, oil on canvas, 0.580 x 0.730 m, Versailles, musée national

des châteaux de Versailles et de Trianon, © RMN-Grand Palais (château de Versailles)/Gérard Blot. **180:** *Le ci-devant grand couvert de Gargantua moderne en famille* (How the modern Gargantua and his family once dined), 1791, hand-colored etching, 53 x 36 cm, Paris, Bibliothèque nationale de France, © Bibliothèque nationale de France. **181:** *La Boîte à Pandore* (Pandora's Box), hand-colored etching, 20 x 27 cm, 1792–93, Collection de Vinck, Paris, Bibliothèque nationale de France, © Bibliothèque nationale de France. **182:** *Portrait of the Marquis de La Fayette*, eighteenth century, hand-colored engraving, Blérancourt, musée franco-américain du château de Blérancourt, © RMN-Grand Palais (château de Blérancourt)/Gérard Blot. **183:** *La terrible nuit du 5 au 6 octobre 1789* (The terrible night from October 5 to 6, 1789), eighteenth century, hand-colored engraving, 0.142 x 0.0085 m, Versailles, musée national des châteaux de Versailles et de Trianon, © RMN-Grand Palais (château de Versailles)/Gérard Blot. **184:** View of the secret passage leading from the queen's bedchamber at Versailles to the king's apartments, © Château de Versailles, dist. RMN-Grand Palais/Christian Milet. **186–187:** View of the courtyard and the royal golden gate of the palace of Versailles, © lsantilli/Shutterstock. **188:** Joseph Boze, *Portrait of the marquis de Mirabeau*, 1789, pastel, 0.644 x 0.535 m, Versailles, musée national des châteaux de Versailles et de Trianon, © RMN-Grand Palais (château de Versailles)/Gérard Blot. **189:** *Ah! le cruchon. Le masque levé* (Ah! The wine jug. The mask is lifted), 1791, hand-colored etching, Paris, Bibliothèque nationale de France, © BnF, dist. RMN-Grand Palais/image BnF. **190 (above):** *La famille des cochons ramenée dans l'étable* (The family of pigs pulled to the stable), Paris, 1791, hand-colored etching, 15.5 x 23 cm, Collection Michel Hennin, estampes relatives à l'Histoire de France, vol. 125, Paris, Bibliothèque nationale de France, © Bibliothèque nationale de France. **190 (below):** Unknown artist, *Enjambée de la sainte famille des Tuileries à Montmidy* (The holy family stride out from the Tuileries to Montmidy [Montmédy]), eighteenth century, hand-colored etching, 0.315 x 0.474 m, Paris, musée du Louvre, © RMN-Grand Palais (musée du Louvre)/Thierry Le Mage. **193:** Jacques Bertaux, *La prise du palais des Tuileries le 10 août 1792* (The storming of the Tuileries palace on August 10, 1792), eighteenth century, Versailles, musée national des châteaux de Versailles et de Trianon, oil on canvas, 1.240 x 1.920 m, © RMN-Grand Palais (château de Versailles)/Gérard Blot. **194–195:** François Gérard, *Le 10 août 1792* (The 10th of August 1792), pen and brown wash, and gouache, Paris, musée du Louvre, © RMN-Grand Palais (musée du Louvre)/Jean-Gilles Berizzi. **196:** Marie-Antoinette's dressing table in the Temple, eighteenth century, cherry wood, Paris, musée Carnavalet, © E. Emo and Fr. Cochennec/Musée Carnavalet/Roger-Violet. **197:** Unknown artist, *Le donjon du Temple* (The turreted keep of the Temple), eighteenth century, oil on canvas, Paris, musée Carnavalet, © Musée Carnavalet/Roger-Violet. **198:** Jean-Jacques Hauer, *Les adieux de Louis XVI à sa famille le 20 janvier 1793* (Louis XVI saying his farewells to his family on January 20, 1793), 1794, oil on canvas, Paris, musée Carnavalet, © Musée Carnavalet/Roger-Violet. **201:** Alexandre Kucharsky, *Portrait of Queen Marie-Antoinette*, 1792, pastel, 0.803 x 0.642 m, Versailles, musée national des châteaux de Versailles et de Trianon, © RMN-Grand Palais (château de Versailles)/Gérard Blot. **202 (above):** William Hamilton, *Marie-Antoinette conduite à son exécution, le 16 Octobre 1793*, (Marie-Antoinette being taken to her execution, October 16, 1793), 1794, oil on canvas, 1.520 x 1.970 m, Vizille, musée de la Révolution française, © RMN-Grand Palais/Michèle Bellot. **202 (below left):** *Chemise* worn by Marie-Antoinette during her imprisonment, linen, Paris, musée Carnavalet, © Fr. Cochennec and C. Rabourdin/Musée Carnavalet/Roger-Violet. **202 (below right):** Locket with a lock of Marie-Antoinette's hair, chiseled silver, glass, pearls, brown silk, hair, gold mount, Paris, musée Carnavalet, © Philippe Joffre/Musée Carnavalet/Roger-Violet. **202 (below right):** Marie-Antoinette's shoe, retrieved on August 10, 1792, Paris, musée Carnavalet, © Musée Carnavalet/Roger-Violet. **205:** Jacques-Louis David, *Portrait de Marie-Antoinette reine de France, conduite au supplice le 16 octobre 1793* (Marie-Antoinette led to her execution on October 16, 1793), drawing, 0.148 x 0.101 m, Paris, musée du Louvre, collection Rothschild, © RMN-Grand Palais (musée du Louvre)/Thierry Le Mage. **206:** *Exécution de Marie-Antoinette, le 16 octobre 1793: la veuve Capet à la guillotine* (Execution of Marie-Antoinette, October 16, 1793: the widow Capet at the guillotine), 1793, hand-colored etching, Paris, Bibliothèque nationale de France, © BnF, dist. RMN-Grand Palais/image BnF. **207:** Words of the queen on the cover of the prayer book that she kept at the Conciergerie, Office of the Divine Providence, Paris, 1756, 13.6 x 9 cm, Châlons-en-Champagne, bibliothèque municipale, © akg-images. **208–209:** Élisabeth Louise Vigée-Lebrun, *Marie-Antoinette au livre* (Marie-Antoinette with a book) (detail), 1778, oil on canvas, 0.933 x 0.748 m, private collection, akg-images.

Getty Publications
1200 Getty Center Drive, Suite 500
Los Angeles, California 90049-1682
www.getty.edu/publications

Stephanie Emerson, *Project Editor*
Martina Dervis and Malcolm Imrie, *Translators*

Distributed in the United States and Canada by the University of Chicago Press
Distributed outside the United States and Canada by Yale University Press, London

Printed in China

Library of Congress Cataloging-in-Publication Data
Names: Delalex, Hélène, author. | Maral, Alexandre, author. | Milovanovic, Nicolas, author.
Title: Marie-Antoinette / Hélène Delalex, Alexandre Maral, Nicolas Milovanovic.
Other titles: Marie-Antoinette. English
Description: Los Angeles : J. Paul Getty Museum, [2016] | 2016 | Includes bibliographical references.
Identifiers: LCCN 2015047361 | ISBN 9781606064832 (hardcover)
Subjects: LCSH: Marie-Antoinette, Queen, consort of Louis XVI, King of France, 1755-1793—Pictorial works. | Marie-Antoinette, Queen, consort of Louis XVI, King of France, 1755-1793—Homes and haunts—France—Versailles—Pictorial works. | Château de Versailles (Versailles, France)—Pictorial works. | Queens—France—Biography—Pictorial works. | Versailles (France)—Social life and customs—18th century—Pictorial works. | Versailles (France)—Buildings, structures, etc.—Pictorial works. | France—History—Louis XVI, 1774-1793—Pictorial works.
Classification: LCC DC137.1 .D4413 2016 | DDC 944/.035092—dc23
LC record available at http://lccn.loc.gov/2015047361

Endnotes

1 Olivier Bernier, *Secrets of Marie Antoinette* (New York: Doubleday, 1985), 35. © 1985 Olivier Bernier. Used with permission.
2 Ibid., 40.
3 Ibid.
4 Ibid., 41.
5 Ibid., 134.
6 Ibid., 153.
7 Ibid., 168.
8 Ibid., 199.
9 Simone Bertière, *Les reines de France au temps des Bourbons. Marie-Antoinette l'insoumise* (Paris: De Fallois, 2002), 324.
10 Stefan Zweig, *Marie Antoinette*, trans. Eden and Cedar Paul (New York: Viking, 1933), 339–40.